essential skills
Photoshop CS4
a guide to creative image editing >>>>

mark galer
philip andrews

ELSEVIER

AMSTERDAM • BOSTON • HEIDELBERG • LONDON • NEW YORK • OXFORD
PARIS • SAN DIEGO • SAN FRANCISCO • SINGAPORE • SYDNEY • TOKYO
Focal Press is an imprint of Elsevier

Focal
Press

Focal Press is an imprint of Elsevier
Linacre House, Jordan Hill, Oxford OX2 8DP, UK
30 Corporate Drive, Suite 400, Burlington, MA 01803, USA

First published 2009

British Library Cataloguing in Publication Data
A catalogue record for this book is available from the British Library

Library of Congress Control Number: 2008938714

ISBN: 978-0-240-52124-4

For more information on all Focal Press publications
visit our website at: www.focalpress.com

Printed and bound in Canada

08 09 10 11 12 12 11 10 9 8 7 6 5 4 3 2 1

Working together to grow
libraries in developing countries

www.elsevier.com | www.bookaid.org | www.sabre.org

ELSEVIER BOOK AID
 International Sabre Foundation

Acknowledgements

To our families:

> Dorothy, Matthew and Teagan and
> Karen, Adrian and Ellena

for their love, support and understanding.

We would like to pay special thanks to Mark Lewis and Steve Snyder for their advice and editorial input and to David Albon at Focal Press for his hard work in getting this book to press.

Picture credits

Paul Allister; Craig Banks; Magdalena Bors; Haydn Cattach; Abhijit Chattaraj; Dorothy Connop; Samantha Everton; Rory Gardiner; Shari Gleeson; Morten Haugen; John Hay; Eeyong Heng; Kane Hibberd; Jakub Kazmierczak; Jeff Ko; Bronek Kozka; Michelle Lee; Seok-Jin Lee; Chris Mollison; Chris Neylon; Serap Osman; Craig Shell; Daniel Stainsby; Jennifer Stephens; Akane Utsunomiya; Victoria Verdon Roe; Rahel Weiss; Shell Wilkes.

Also our thanks go to www.iStockphoto.com for supporting this venture by supplying various tutorial images.

All other images and illustrations by the authors.

Contents

foundation module

Contents

4. Raw Processing 89

5. Digital Printing 123

Digital Basics – DVD Chapter

digital basics

essential skills

- Gain a working knowledge of digital image structure.
- Understand file size, bit depth, image modes, channels, file format and resolution.
- Understand color theory and color perception.

Contents

advanced skills module

Contents

Contents

imaging projects module

imaging

Contents

projects

Contents DVD

The DVD is a veritable treasure trove of supporting files for the projects in this book as well as a resource for your own creative projects. The images and movies on the DVD are divided into their respective chapters and can be accessed via Bridge (see *Bridge* > page 45). Most of the images in the Foundation and Advanced Skills modules of the book can be found on the DVD together with all of the images from the Imaging Projects module. The movies are an invaluable resource, allowing you to start, stop and rewind so that the skills can be quickly and easily acquired at your own pace. The DVD also contains multi-layered image files (PSDs) of the completed projects, uncompressed TIFF files with saved selections and Camera Raw files. Loadable Actions and Presets are also available to enhance your software, together with a rich stock library of royalty-free images.

Contents

Introduction

Photoshop has helped revolutionize how photographers capture, edit and prepare their images for viewing. Most of what we now see in print has been edited and prepared using the Adobe software. The image-editing process extends from basic retouching and sizing of images, to the highly manipulated and preconceived photographic montages that are commonly used by the advertising industry. This book is intended for photographers and designers who wish to use the 'digital darkroom' rather than the traditional darkroom for creative photographic illustration. The information, activities and assignments contained in this book provide the essential skills necessary for competent and creative image editing. The subject guides offer a comprehensive and highly structured learning approach, giving comprehensive support to guide Photoshop users through each editing process. An emphasis on useful (essential) practical advice and activities maximizes the opportunities for creative image production.

Kane Hibberd

Acquisition of skills

The first section of this book is a foundation module designed to help the user establish an effective working environment and act as a guide for successful navigation through the image-editing process from capture to print. Emphasis is placed on the essential techniques and skills whilst the terminology is kept as simple as possible, using only those terms in common usage.

Application of skills

The subsequent modules extend and build on the basic skills to provide the user with the essential techniques to enable creative and skilful image editing. The guides explore creative applications including advanced retouching, photomontage, vector graphics, special effects and preparing images for the web. Creative practical tasks, using a fully illustrated and simple step-by-step approach, are undertaken in each of the guides to allow the user to explore the creative possibilities and potential for each of the skills being offered.

A structured learning approach

The study guides contained in this book offer a structured learning approach and an independent learning resource that will give the user a framework for the techniques of digital imaging as well as the essential skills for personal creativity and communication.

The skills

To acquire the essential skills to communicate effectively and creatively takes time and motivation. Those skills should be practised repeatedly so that they become practical working knowledge rather than just basic understanding. Become familiar with the skills introduced in one study guide and apply them to each of the following guides wherever appropriate.

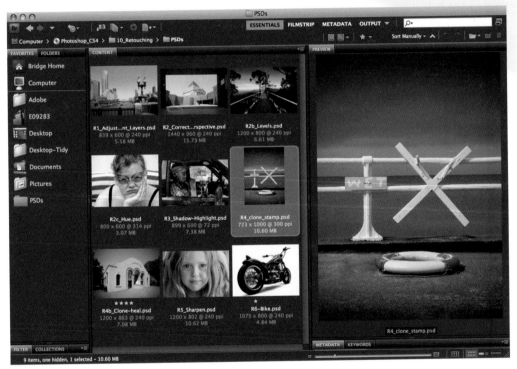

The DVD has images and movies available to support and guide the learning process

Supporting DVD

A supporting DVD and dedicated web log (blog) have been set up to enable users to access current information. The address for the blog site is: **www.photoshopessentialskills.com** The supporting files can be accessed through the Bridge interface (Computer > CS4_DVD).

Research and resources

You will only realize your full creative potential by looking at a variety of images from different sources. Artists and designers find inspiration in many different ways, but most find that they are influenced by other work they have seen and admired.

Essential information

The basic equipment required to complete this course is access to a computer with Adobe Photoshop CS4 (CS3 would suffice for many of the projects contained in the book). The photographic and design industries have traditionally used Apple Macintosh computers but many people now choose 'Windows'-based PCs as a more cost-effective alternative. When Photoshop is open there are minor differences in the interface, but all of the features and tools are identical. It is possible to use this book with either Windows-based or Apple Macintosh computers.

Storage

Due to the large file sizes involved with digital imaging it is advisable that you have a high-capacity, removable storage device attached to the computer or use a CD or DVD writer to archive your images.

Commands

Computer commands which allow the user to modify digital files can be accessed via menus and submenus. The commands used in the study guides are listed as a hierarchy, with the main menu indicated first and the submenu or command second, e.g. Main menu > Command or Submenu > Command. For example, the command for opening the Image Size dialog box would be indicated as follows: Edit > Image Adjustments > Image Size.

Keyboard shortcuts

Many commands that can be accessed via the menus and submenus can also be accessed via keyboard '**shortcuts**'. A shortcut is the action of pressing two or more keys on the keyboard to carry out a command (rather than clicking a command or option in a menu). Shortcuts speed up digital image processing enormously and it is worth learning the examples given in the study guides. If in doubt use the menu (the shortcut will be indicated next to the command) until you become more familiar with the key combinations.

Note > The keyboard shortcuts indicate both the Mac and PC equivalents.

Example: The shortcut for pasting objects and text in most applications uses the key combination Command/Ctrl + V. The Macintosh requires the Command key (next to the spacebar) and the V key to be pressed in sequence whilst a PC requires the Control key (Ctrl) and the V key to be pressed.

the digital darkroom

Bronek Kozka

essential skills

- Set up the computer, monitor and software preferences for effective digital image editing.
- Gain familiarity with the Photoshop interface.
- Overview Photoshop's basic tools and commands for navigating images on screen.
- Overview of the new and changed features in Photoshop CS4.

Digital setup

Photoshop is the professional's choice for digital image editing. Photoshop affords precise control over images that are destined to be viewed on screen and in print. In order to maximize this control it is necessary to spend some time setting up the software and hardware involved in the imaging process in order to create a predictable and efficient workflow.

This chapter will act as a pre-flight checklist so that the user can create the best possible working environment for digital image editing. The degree of sophistication that Photoshop offers can appear daunting for the novice digital image-maker, but the time required setting up the software and hardware in the initial stages will pay huge dividends in the amount of time saved and the quality of the images produced.

Commands and shortcuts

This chapter will guide you to select various options from a list of menus or dialogs on your computer. A command or choice of dialog box can be found in a menu or submenu. This will be listed as follows: 'Menu > Submenu > Choice'. Many of the commands can be executed by pressing one or more of the keyboard keys (known as 'keyboard shortcuts').

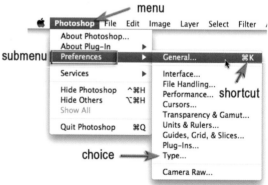

Keyboards: Mac and PC keyboards have different layouts. The 'Alt' key on a PC is the 'Option' key on a Mac. The functions assigned to the 'Control' key on a PC are assigned to the 'Command' key on a Mac (the key next to the Spacebar with the apple on it). When the text lists a keyboard command such as 'Ctrl/Command + Spacebar' the PC user will press the Control key and the Spacebar while the Mac user should press only the Command key together with the Spacebar.

Monitor settings

Resolution and colors

Set the monitor resolution to '1024 × 768' pixels or greater and the monitor colors to 'Millions'. Monitor resolutions less than 1024 × 768 will result in excessively large panels and a lack of 'screen real estate' or monitor space in which to display the image you are working on. A widescreen LCD with a resolution of 1920 × 1200 pixels makes for comfortable editing.

Note > If you are still using a CRT monitor and the 'Refresh Rate' is too low the monitor will appear to flicker. Most CRT monitors are now past their use-by date.

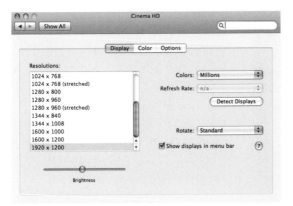 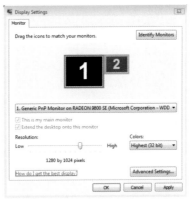

Monitor color temperature – selecting a white point and gamma

The default 'color temperature' of a new monitor is most likely to be too bright and too blue for digital printing purposes (9500K). Reset the 'Target White Point' (sometimes referred to as 'Hardware White Point' or 'Color Temperature') of your monitor to 'D65' or '6500K', which is equivalent to daylight (the same light you will use to view your prints). Setting the white point is part of the 'calibration' process that ensures color accuracy and consistency. Select either the 'Native' gamma for the monitor or a gamma of 2.2 (Mac users should avoid choosing the 'standard' 1.8 gamma).

Calibration and profiling

With the default settings, every monitor displays color differently, even monitors of the same model and make. Calibration attempts to set the monitor to a 'standard' color display. This will help to prevent your images from looking radically different when viewed on different monitors. Use a monitor calibration device from X-Rite (Eye-One Display) or Datacolor (Spyder) to ensure your monitor is accurate.

Note > When you choose 6500 as your target white point and lower the brightness of your monitor as directed by your calibration software the monitor may initially appear dull and a little yellow compared to what you are used to seeing.

Choosing a working space

It is important to select the correct color settings for your workflow in your Adobe software before you start to work with any images. If you are running the Adobe Creative Suite the color settings can be synchronized across the suite of applications in Adobe Bridge (Edit > Creative Suite Color Settings). If setting the 'working space' in Photoshop CS4 go to Edit > Color Settings.

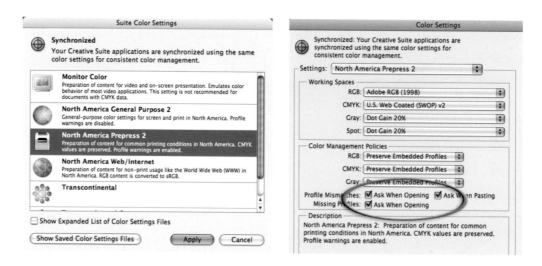

If preparing images for the web or a print service provider using the sRGB profile, select sRGB in the RGB working space or North America Web/Internet in the Settings menu. If preparing images for inkjet printing or for commercial prepress (CMYK) choose Adobe RGB (1998) in the RGB working space menu or North America Prepress 2 in the Settings menu. Check the Profile Mismatches and Missing Profiles boxes so that you will be warned of mismatches or missing profiles when opening or pasting images. You may notice the settings change to Custom after checking these boxes. You can save these Custom Settings as your personal setting.

Note > If you are preparing your color settings for a print workflow consult your print service provider or prepress operator to ensure that you are working with the optimum settings for the intended workflow.

Getting started with Photoshop

The new interface of Photoshop CS4 is highly organized and presents the user with an effective interface offering maximum control over the process of image editing. If all of the information and control relating to a single image were on display there would be no room left on a standard monitor for the image itself. Most of the features of the editing software therefore are strategically grouped, with the most often used on top or at the highest level. Commands and dialogs can be quickly accessed once the user starts to understand how the software is organized. The Photoshop interface consists of the Menu, Tools, Options bar, Image window and Panels.

Note > The user interface (UI) is the same irrespective of the computer platform you are working with (Mac or PC). In practical terms the main difference between the two systems is that Windows and Macintosh use different key stroke combinations for shortcuts.

The menu

The menu at the top of the screen gives you access to the main commands. Each menu is subdivided into major categories. Clicking on each menu category gives you access to the commands in the section. A command may have a submenu for selecting different options or for launching various 'dialog boxes'. Many of the commands can be accessed without using the menu at all by simply pressing a key combination on the keyboard called a 'shortcut'. Menu items can now be modified (hidden or color coded) by going to the Edit menu and selecting Menus. In the top right-hand corner of the Options bar you can switch between workspaces that are optimized for the task in hand. The user can also create and save their own menu layouts and/or import others. This is a useful way of rationalizing the menus and panels or highlighting the key commands if you are a newcomer to Photoshop.

Photoshop's tools can be reset by right-clicking on the tool icon in the Options bar

The Tools panel

To select a tool to work on your image you simply click on it in the Tools panel. If you leave your mouse cursor over the tool Photoshop will indicate the name of the tool and the keyboard shortcut to access the tool. Some of the tools are stacked in groups of tools. A small black arrow in the bottom right corner of the tool indicates additional tools are stacked behind. To access any of the tools in this stack click and hold down the mouse button on the uppermost tool for a second.

The Options bar

The 'Options' bar gives you access to the controls or specifications that affect the behavior of the selected tool. The options available vary according to the type of tool selected.

The image window

The file name, magnification, color mode and document size are all indicated by the image window in 'Standard Screen Mode'. If the image is larger than the open window the scroll bars can control the section of the image that is visible.

The panels

The panels provide essential information and control over the image-editing process. They can be arranged in stacks and moved around the screen and collapsed to icon view. Icons at the base of each panel provide access to frequently used commands while additional options are available from the panel fly-out menu. Clicking the panel tabs or title bars will collapse the panels to save additional screen real estate. Clicking on the double-arrows will collapse the panels to icons only. Clicking on the double-arrows again will expand the panels. Pressing the 'Tab' key will temporarily hide the panels. If you want to access the tools or panels that are hidden just move your cursor to the edge of the screen for them to reappear.

Note > Pressing the 'Tab' key will hide the panels, Options and Application bar. Pressing the Tab key again returns the panels and bars. Holding down the Shift key while pressing the Tab key will hide all the panels but keep the tools on the screen. Panels can be accessed from the Window menu if they are not already open.

Docking panels

Panels can be dragged to the edge of the screen to dock them. Clicking on the two-triangle icon at the top of the dock will expand the panels.

Settings and preferences

Before you start working with an image in Photoshop it is important to select the 'Color Settings' and 'Preferences' in Photoshop. This will not only optimize Photoshop for your individual computer but also ensure that you optimize images to meet the requirements of your intended output device (monitor or print). These settings are accessed through either the 'Photoshop' menu (Mac) or the 'Edit' menu (PC) from the main menu at the top of the screen.

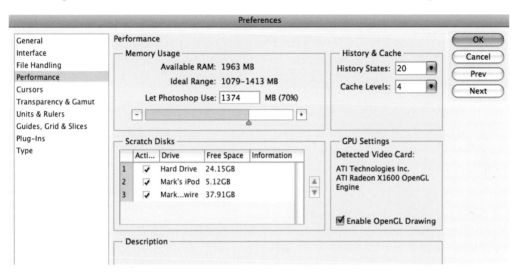

Memory (the need for speed)

If you have a plentiful supply of RAM (1 GB RAM or greater) you have to give permission for Photoshop to tap into these RAM reserves to a greater or lesser extent. Seventy percent of the available RAM will automatically be assigned to Photoshop on a Mac and 60% on a PC. The best advice is to close all non-essential software when you are using Photoshop and allocate more RAM from the 'Performance' preferences if available. You will need to restart Photoshop for the software to take advantage of the new memory allocation.

Cache Levels

The Cache Levels setting is used to control the performance of the screen redraw (how long it takes an image to reappear on the screen after an adjustment is made) and histogram speed. If you are working with very-high-resolution images and you notice the redraw is becoming very slow you can increase the redraw speed by increasing the Cache Levels (it can be raised from the default setting of 4 up to 8 depending on the speed required). Cache also uses RAM, however, and could slow down other operations.

Allocation of RAM:

Remember that the computer's operating system requires a proportion of the available RAM on your computer. The 32-bit version of Photoshop CS4 supports a maximum of 4 gigabytes of RAM with the version available for Vista 64 supporting more because of its 64-bit architecture.

Scratch disks

As well as using RAM, Photoshop also requires a plentiful amount of free memory on the hard drive to use as its 'scratch disk' (a secondary memory resource). To avoid memory problems when using Photoshop it is best to avoid eating into the last few gigabytes of your hard drive space. As soon as you see the space dwindling it should be the signal for you to back up your work to free up additional hard drive capacity. Consider using a second hard drive or an external hard drive (a high-speed drive with a fast connection, e.g. Firewire 800, would be ideal). Add an additional 'Scratch Disk' by going to 'Preferences > Performance'. Select the hard drive that is not being used by your operating system and promote this to the lead position using the arrow icons in the dialog, i.e. your primary scratch disk should not be the same one your operating system is using.

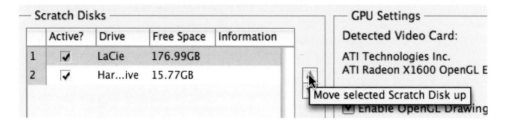

Note > If you are intending to work on a very large image file it is recommended that the scratch disk and image file location are using separate disks or drives. Promoting a fast second hard drive to number 1 in the scratch disk list will help Photoshop's operating speed when working with large or multiple images.

Efficient use of memory

When you have set up your memory specifications you can check how efficiently Photoshop is working as you are editing an image. Clicking to the right of the document size information (at the base of the image window) will reveal that additional information is available. Choosing the 'Scratch Sizes' option will display how much RAM and how much memory from the scratch disk are being used to process the image.

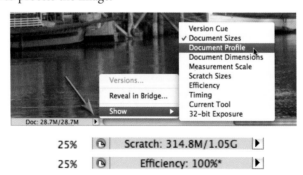

Choosing 'Efficiency' will display whether Photoshop is using the scratch disk to perform the image-editing tasks. Values less than 100% indicate that if more RAM were made available to Photoshop the operations would be faster. Simply closing software or images not being used can often increase efficiency.

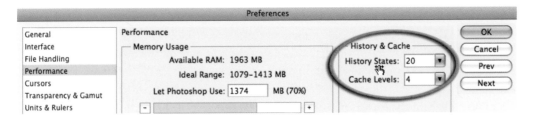

History States

A professional level of image editing can place a strain on a computer's working memory or RAM. If your available RAM is limited to 1 GB or less try shutting down any other applications that you are not using so that all of the available memory is made available to Photoshop. Photoshop keeps a memory of your image-editing process, which it calls the 'History States'. The default setting in the Preferences is 20 History States. Allowing the user to track back 20 commands, or clicks of the mouse, can again place an enormous strain on the working memory. I would recommend that you lower this figure to 10 if available RAM is low. This can be readjusted without restarting the software should you wish to increase Photoshop's memory for your editing actions. Just remember that the more memory you dedicate to what you have just done, the less you have available for what you are about to do.

Default settings

It is possible to reset all of the software preferences to their default settings as the software is launching by pressing and holding Alt + Control + Shift keys (Windows) or Command + Option + Shift keys (Mac). A screen prompt will invite you to delete the Adobe Photoshop Settings File. This is useful when using a shared computer so that each tool behaves as you would expect it to. Return the working space to its default setting when the application is already open by going to 'Workspace' in the options bar.

Navigation and viewing modes

When viewing a high-resolution image suitable for printing it is usual to zoom in to check the image quality and gain more control over the editing process. There are numerous ways to move around an image and each user has their preferred methods to speed up the navigation process.

The Navigator panel

The Navigator panel is simple and effective to use. You can use it to both zoom in and out of the image and move quickly to new locations within the enlarged image. The rectangle that appears when you are zoomed in shows the area being displayed in the main image window. This rectangle can be dragged to a new location within the image. Using the slider directly underneath the preview window or clicking on the icons either side of the slider controls magnification.

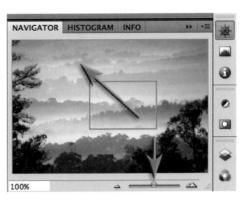

The 'Zoom' and 'Hand' Tools

These tools offer some advantages over the Navigator panel. They can be selected from within the toolbox or can be accessed via keyboard shortcuts. Clicking on the image with the Zoom Tool selected zooms into the image around the point that was clicked. The Zoom Tool options can be selected from the Options bar beneath the main menu. Dragging the Zoom Tool over an area of the image zooms into that area with just the one action (there is no need to click repeatedly).

When you are zoomed into an area you can move the view with the 'Hand' Tool. Dragging the image with the Hand Tool selected moves the image within the image window (a little like using the scroll bars). The Hand Tool can now be used to flick an image so that it slides across the desktop. Clicking the mouse or pressing the Spacebar will stop the image sliding. The real advantage of these tools is that they can be selected via shortcuts. The Spacebar temporarily accesses the Hand Tool no matter what other tool is selected at the time (no need to return the cursor to the toolbox). The Zoom Tool can be accessed by pressing the Control/Command + Spacebar to zoom in or the Alt/Option + Spacebar to zoom out.

Note > When you are making image adjustments and a dialog box is open, the keyboard shortcuts are the only way of accessing the zoom and move features (you may need to click inside the adjustment dialog box first before using a keyboard shortcut when using a PC).

Additional shortcuts

Going to the View menu in the main menu will reveal the keyboard shortcuts for zooming in and out. You will also find the more useful shortcuts for 'Fit on Screen' and 'Actual Pixels' (100% magnification). These very useful commands can also be accessed via the Tools panel by either double-clicking on the Hand Tool (Fit on Screen) or double-clicking the Zoom Tool (Actual Pixels).

Screen modes

Photoshop CS4 on a Mac can now be viewed within an 'Application Frame' in Standard Screen Mode to remove the visual clutter of other applications and windows that may be open (not a new feature for PC users). Switch to Full Screen Mode with Menu Bar in the application bar at the top of the application frame if you wish to enlarge the application frame to fit the monitor. This screen mode will also allow you to drag the open image to a new location within the application frame.

Click the Screen Mode icon located in the application bar or press the letter 'F' on the keyboard to access alternative screen modes. Pressing the F key will cycle through the screen modes and return you to the 'Standard Screen Mode'. The gray background in the application frame, behind your image, can be changed by Ctrl-clicking (Mac) or right-clicking (PC) on the background color (the background color may not be visible depending on the image size and your current zoom level).

Note > The screen can be further simplified by pressing the 'Tab' key. This hides the panels and tools from view. Pressing the Tab key again returns the panels and tools. Holding down the Shift key while pressing the Tab key will hide all the panels but keep the tools on the screen.

New Window

It is possible to have the same image open in two windows. This allows the user to zoom in to work on detail in one window and see the overall impact of these changes without having to constantly zoom in and out. Any changes made in one window will automatically appear in the other window.

Rulers and guides

Guides can help you to align horizontals and verticals within the image area. Select 'Rulers' from the 'View' menu and then click on either the horizontal or vertical ruler and drag the guide into the image area. Guides can be temporarily hidden from view by selecting 'Extras' from the 'View' menu. Drag a guide back to the ruler using the Move Tool to delete it or remove all the guides by selecting 'Clear Guides' from the 'View' menu.

'New and revised' for CS4

Existing users when first opening Photoshop CS4 could be forgiven for thinking that the most significant changes to the program are cosmetic ones. After all, you are immediately confronted with a different user interface and if you are a Macintosh aficionado, you also get a completely new way of interacting with the program. But these aren't the only changes for CS4.

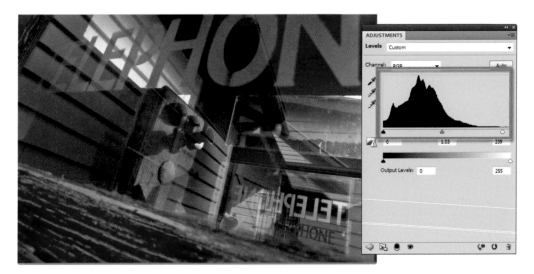

Workflow is king! Non-stop editing

In fact, look a little closer, and you will find that in many ways this revision turns much of the old way of working on its head. In previous versions of Photoshop the process of editing an image often required that the user navigate a path through a series of adjustment dialogs, saving their changes along the way. Each step started with selecting an adjustment type, for instance the Levels feature. Next, changes were made to the picture using the settings in the dialog before clicking the OK button and applying the alterations. Once Levels had done its thing, the user would select another adjustment type and continue the process. The whole workflow was very much a series of steps with each change being committed to the photo before the next one could be commenced.

CS4 changes this whole approach. Now, with the addition of the Adjustments and Masks panels image editing becomes a non-stop affair. You can switch between all the adjustment types (Levels, Curves, Hue/Saturation, etc.) grouped in the Adjustments panel without the need to first commit your changes. Each adjustment is dynamically and non-destructively applied to the photo, providing a 'tweak and tweak again' workflow where image makers can combine a range of changes, gradually adjusting each with reference to their combined effect. Cool! This approach is much more reminiscent to the way that Adobe Camera Raw and Lightroom works and represents the future of professional image manipulation.

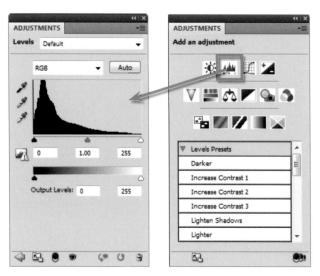

Adjustments panel

The new Adjustments panel is a key component in the workflow change in Photoshop, featuring not just existing core adjustment features such as Levels, Hue/Saturation, Exposure, Black and White, Channel Mixer, Selective Color, Color Balance, Photo Filter, but a completely revised version of the Curves feature and a brand new Vibrance adjustment tool. For existing Photoshop users getting the hang of how to operate the Adjustments panel may take a little while, but once mastered this new approach will provide both efficiency and quality gains way beyond the effort needed to get over the initial hump in the CS4 learning curve. As well as grouping key adjustment features together, the panel also provides 'on-image adjustments' for Hue/Saturation and Curves features. This provides the user with the ability to click onto image areas in the photo and apply changes by dragging the mouse pointer either up or down or side to side. Also included is a wide variety of customizable presets providing more than 20 different starting points for typical image enhancement tasks.

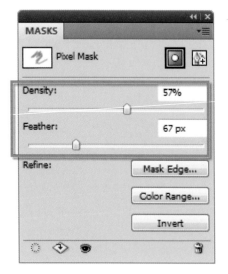

Masks panel

The new Masks panel is now the center for mask-based activity irrespective of whether the masks are pixel or vector based. Here you will find dedicated sliders for altering the density and feather of a mask which in turn will change the strength of the masked effect and the softness of the mask's edge. The powerful Refine Edge feature that was added to Photoshop in the last version can also be accessed from the panel, as can the Invert feature that switches masked and unmasked areas.

To help with color-based mask creation an updated version of the Color Range feature is also located here. The feature has been redesigned to improve its accuracy and power. As well as including the Fuzziness slider present in previous versions, the feature now contains a Range control and a Localized Color Clusters setting, both of which are designed to allow you to hone in on the specific colors and their placement in the photo that you want to include in the selection. With the importance of masks as a key part of every non-destructive workflow it is great that Adobe has provided an easy way to target and alter this mechanism for modifying adjustments.

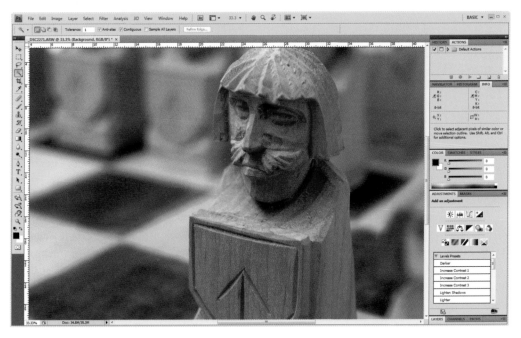

A new face for Photoshop

CS4 sports a new interface for Photoshop and Bridge. Called the Application Frame, the new Photoshop user interface combines:

* the ability to float, dock and group image windows together with a new Arrange Documents feature to help distribute the windows around the screen;

* a new Application Bar which integrates the features and functions of the title and control bars found in previous versions of Photoshop;

* a Screen Mode utility that can be used to individually control the display of documents on multiple monitors;

* new Adjustments and Masks panels; and

* a task-based workflow approach to saving, displaying and using workspaces.

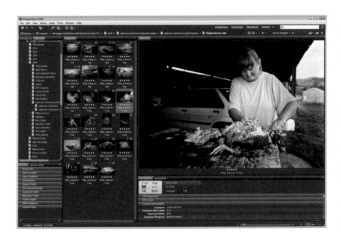

And Bridge as well

The changes for Bridge are a little less radical, but still the aim is to employ a workflow approach to image management and processing inside the program. This is easily seen in the new workspace options buttons that sit across the top of the screen. When selected, these options quickly organise the many Bridge panes and panels to suit different

tasks. As in previous releases you don't have to rely on 'out of the box' workspace presets, you can easily create your own arrangement that suits your own screen or screens (multi-monitor support is included). Bridge now contains a dedicated Output workspace which provides the ability to create Flash-based websites and PDF-based documents (presentations and multi-page) without having to leave the program and go to Photoshop. This continues the trend found in previous versions of Photoshop and Bridge where more tasks are capable of being performed in one or the other program. When you add Adobe Camera Raw into the mix, there is no denying that image processing is no longer a Photoshop centric event. Instead pro photographers will increasingly find themselves moving images between programs depending on the nature of the tasks that they wish to undertake. As far as image management goes, there are also new ways to display images when sorting with the Review Mode (also called the Carousel View) and the new Search field adds operating system-like functionality inside the browser space.

GPU powered display

Adding to the new look and feel is the way that Photoshop CS4 makes use of the awesome power of the modern graphics card to help display pixels on screen. Users with a recently released graphics card containing at least 256Mb of onboard memory and a supported GPU (Graphics Processing Unit) will be able to take advantage of the changes, which include:

- **Fluid Canvas Rotation** – the option to rotate the canvas non-destructively to any angle using the new Rotate View tool from the Application Bar or under the Hand Tool in the toolbar.

- **Smooth Accurate Pan and Zoom functions** – Unlike previous versions where certain magnification values produced less than optimal previews on screen, CS4 always presents your image crisply and accurately. Yes, this is irrespective of zoom and rotation settings and is available right up to pixel level (3200%).

- **Animated Zoom and Toss functions** – Because of the extra power gained from leveraging the processing abilities of the GPU you can now 'toss' the enlarged image around the screen with the Hand Tool in an animated paning motion. Zoom changes are animated with the photo sliding and then snapping into place.

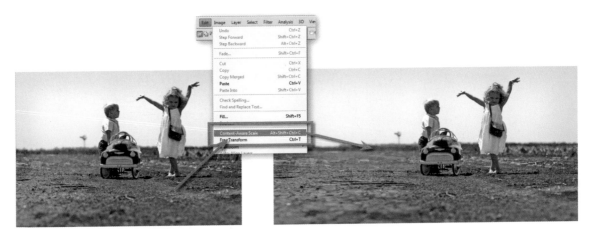

Recomposing your picture after capture

With the new Content Aware Scaling feature (Edit > Content Aware Scaling) you can now push and pull different image parts around the canvas and have Photoshop fill in the gaps. Yes it seems strange but it is now possible to move, stretch and resize different sections of your photo at different rates. This is drastically different from the Free Transform command, which when used in conjunction with the Shift key always resizes all picture content at the same rate. Content Aware Scaling (CAS), which is also known as Seam Carving, changes all this. The image is scaled by keeping detailed areas the same and up or downsizing the parts of the photo that are featureless. CAS works with images, layers and selections in RGB, CMYK, Lab and Grayscale modes and at all bit depths, but not with Smart Objects, 3D or Video layers.

There are two controls in the tool's options bar that help ensure that only the areas that you want to be squashed or stretched are scaled by the feature. They are:

Skin Protection (person icon): This setting attempts to keep any skin tone areas in the image from change during CAS actions.

Protect drop-down menu: Provides a list of current alpha channels associated with the photo. Selecting one of these entries will force the protection of the masked image parts stored in the alpha channel during CAS scaling.

Fisheye lenses and spherical panoramas

One of the standout changes for CS3 was the much improved Photomerge feature. In that release we saw vastly improved stitching abilities and a new form of sophisticated blending that provided truly stunning results. In CS4 the wide vista photography revolution continues. With vignetting and geometric distortion correcting now included, Photomerge has again been updated. The feature can now create 360 degree panoramas, automatically detect, and account for, source images taken with fisheye lenses and has a new Collage option which allows for rotation and scaling of source files as they are being montaged.

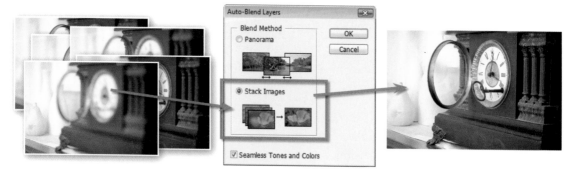

Maximum depth of field

In related changes, the layer auto-blending options (Edit > Auto-Blend Layers) in Photoshop get an extra mode designed to combine photos of the same scene but with different focus points to create an image with extreme depth of field (DOF). That is, the result displays the visual sharpness from the very front of the scene right into the distance. Using this new feature you can capture a series of images of a subject with a wide aperture, that typically produces a shallow depth of field effect, and combine the results to create a photo that combines the DOF of all source photos. What's more the feature automatically color corrects the source files while blending as well.

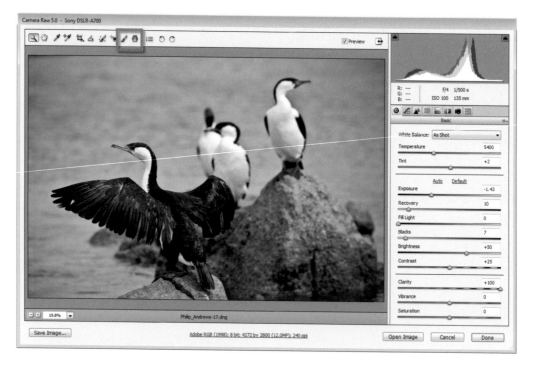

Adobe Camera Raw 5.0

As you would expect, the version for Adobe Camera Raw (ACR) that accompanies Photoshop CS4 brings the Raw utilities feature sets and functionality in line with those available in Lightroom 2.0. This means that the two key very popular localized adjustment tools found

in Lightroom, the Adjustment Brush and Graduated Filter, now also appear in ACR. The Adjustment Brush allows the user to paint on a range of adjustment changes (Exposure, Brightness, Saturation, Clarity, Sharpness and Color) to specific areas of the photo. The Graduated Filter applies a selected effect (darkening, lightening, changing color, etc.) via a gradient that starts with the effect fully applied and transitions to no effect. Also new for this release is the ability to apply vignetting changes to images after they have been cropped in ACR. This solves the problem of applying aesthetic darkening of a photo's edge to only have the effect cropped, or worse, partially removed when the photo is cropped. There are also Roundness and Feather sliders to adjust the shape and softness of the edge of the vignetting effect.

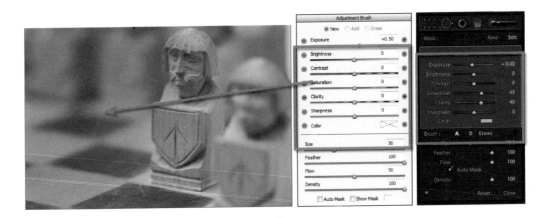

Integration with Lightroom 2.0

As you would expect, with the changes in ACR 5, the abilities of this utility and Lightroom 2 are almost exactly the same. Thankfully the changes made in one program are also reflected in the other. This means that you can freely pass your Raw photos between Lightroom, Adobe Camera Raw and Photoshop with the changes being respected in each program. Lightroom 2.0 also includes more ways to pass photos to Photoshop. You now have the option to open a Lightroom managed file in Photoshop as an embedded Smart Object. You can also pass a series of photos to the Merge to HDR or Photomerge features.

Revamping old favorites

It seems strange to even be mentioning 'old skool' features such as the Dodge, Burn and Sponge tools in a summary of what is new in CS4. After all, for the last few releases we have been busy advocating alternative non-destructive ways of adjusting your images rather than encouraging readers to employ these tools, but it seems that there are still users who prefer their 'simplicity'. So to modernize their adjustments all three tools get a revamp that promises better control and more predictable results than their predecessors. Burn and Dodge get a new Protect Tones

option designed to reduce the muddiness that plagued so much of their work previously. The Sponge Tool is dragged into the 21st century with the addition of a Vibrance switch which converts from making basic saturation changes to concentrating adjustments on pastel or desaturated colors. That said, we still put these tools along with the Brightness/Contrast feature in the 'yes, better than before, but still not enough control for me box'. There are many more advantages in using other non-destructive approaches that provide similar results but protect your pixels, as the projects in the ensuing chapters will demonstrate.

Even smarter Smart Objects

With Smart Objects being the basis of many non-destructive workflows it is good to see that some changes have been made in this area as well. In CS4 you can now apply Perspective transformations to a Smart Object. This is a change from CS3 where scaling was the only option available. Added to this is the ability to work with linked layer masks and sample the content of the layers within the Smart

Object with the new Eyedropper Tool. Though the improvements may seem small, at least there is continued development in this important area and the changes will definitely increase the variety of techniques that can use Smart Objects at their base.

Live Preview Cursor Tips

One of the great options available with the Vanishing Point feature was the way that the Clone Stamp displayed a preview of the sampled image at the cursor tip. This provided the user with much needed visual information when trying to line up sampled image parts with background information during stamping actions. In CS4 we now have Live Preview Cursor Tips available with both the Clone Stamp and Healing Brush; this means we have the same alignment aids outside of the Vanishing Point feature.

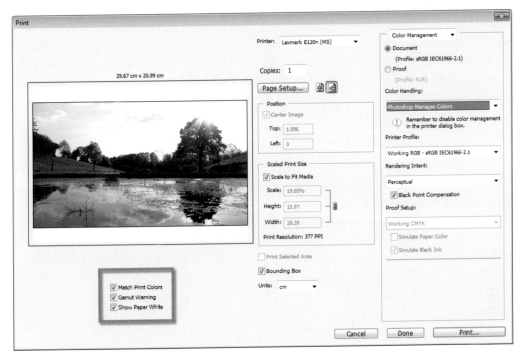

Supersizing Photoshop's Print options

Printing is one of those photographic activities that we all assume, to our detriment, should be very simple. In reality the act of printing should be approached with all the care and control that we are used to bringing to other processing steps such as enhancing or editing. The changes in the Print dialog of Photoshop CS4 helps users create better quality prints in three distinct ways:

1. The Print dialog has been streamlined so that more of the information you need is to hand when first opening,

2. Files that are stored in16-bit color depth can be printed directly from Photoshop, and

3. Out of gamut colors can be previewed inside the print dialog.

Share My Screen

Building on the popularity of the Adobe Connect technology that allows users to capture the activities on their screen, mix it with live narration and distribute it around the world to interested parties who view via their web browsers, Photoshop now has a dedicated 'Share My Screen'

feature inside the program (File > Share My Screen). The feature instantly connects those users who have signed up for a free account with up to three other web connected users. From that point on your screen and/or webcam, microphone, white board and chat comments are shared with the others. I can see that this technology will be very useful for pro photographers talking clients through editing changes to key images, or tutors to help students learn new ways of adjusting their photos.

Photoshop CS4 Extended

Just like CS3, the latest version of Photoshop comes in two different versions – Photoshop CS4 and Photoshop CS4 Extended. Photoshop ships with all the new features listed above and the bulk of the program's core image-editing and enhancement technologies. It is suited for the majority of photographers and contains more options than they will ever use. The Extended version builds on this base feature set with extra tools that are essential when Photoshop is used in conjunction with allied imaging areas such as video production, medical and scientific imagery and 3D modeling. CS4 extends the feature sets in these areas, especially when working with 3D models.

3D editing and compositing

The new and enhanced 3D tools found in Photoshop CS4 Extended are designed to allow the image maker to work with 3D images just as easily as they have traditionally been able to work with 2D pictures. New workflows remove the need for complex dialog boxes full of settings. In their place are tools that allow you to interact directly with 3D models and easily composite these models within 2D scenes. Users are now able to edit properties such as lights, materials and cameras, and in the process create high-quality rendered images thanks to a new ray-tracing engine.

Enhanced motion graphics

CS4 increases the ease with which videographers are able to drag motion-based images into Photoshop and provides them with more of the type of tools they need to work on these frames. Photoshop can now work more easily with non-square pixels, any audio associated with video footage, and it is also possible to animate 3D objects, camera position, render settings and even cross-sections.

Volume rendering

Volume rendering is new for Photoshop, providing the ability to convert text, shape or pictures into a volume. Video professionals can use this new functionality to quickly create three-dimensional text, whereas photographers in the medical area can combine several different scientific scans into a 3D model that can be viewed from a range of angles.

Data analysis and counting

Though not the most thrilling area, the ability to count the number of times a specific item appears in a frame is a task often undertaken by users analyzing scientific images. Count and Analysis tools were introduced in CS3; in CS4 their abilities have been expanded to include multiple color-coded counts. The results can be stored in a reference file and then collated in the Measure Log panel for comparison.

Craig Banks

bridge

photoshop photoshop photoshop photoshop photoshop photoshop photos

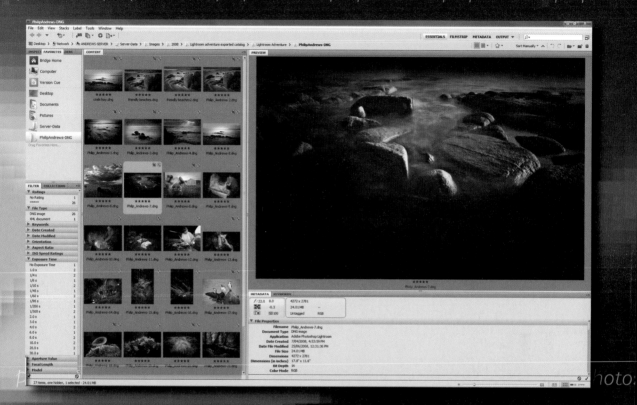

essential skills

- Gain a working knowledge of Bridge.
- Understand how to change the contents and appearance of the workspace.
- Download, sort, add keywords and process files from Bridge.

Introduction

For most photographers the world of digital has heralded a new era in picture taking. The apparent lack of cost (no film or processing charges) involved in the recording of each frame means that most of us are shooting more freely and more often than ever before. More pictures not only means more time processing, enhancing and printing them but also more time sorting, searching, naming, tagging and storing. In fact, recent studies of how photographers spend their time have shown that many spend 10–15% of their working day involved in just these types of management activities. For this reason many use specialized Digital Asset Management (DAM) systems or software to aid with this work. Though, for many image workers, asset management is the least stimulating part of their job, it is a key area where building skills will free up more time for those parts of the process that you enjoy the most – taking and processing pictures.

Bridge – the center for asset management

Over the last few revisions of Photoshop, Adobe has become increasingly more involved with including image management tools for the working photographer as part of the editing program.

Initially this meant the inclusion of a File Browser which could be opened from inside Photoshop but more recently a totally separate program called Bridge has replaced the standard file browser option.

The application can be opened by itself via the program menu, or from within Photoshop with the File > Browse command or button on the Applications bar.

Bridge is a 'super browser' tool that can be used for managing your image assets

The fastest way to open a file from your picture library is to search for, and select, the file from within Bridge and then press Ctrl/Cmd + O or, if Photoshop is not the default program used for opening the file, select File > Open With > Photoshop. If you are opening a photo captured in a Raw file format, then the file will be displayed in Adobe Camera Raw (ACR) first and then transferred into Photoshop. If you select the File > Open With Camera Raw option then the picture will be displayed in the ACR workspace only and will be transferred to Photoshop only if you decide that this is the next step in your processing. Multi-selected files in the browser can also be opened in this way.

Keep in mind that Bridge is a separate stand-alone application from Photoshop, has its own memory management system and can be opened and used to organize and manage your photo files without needing to have Photoshop running at the same time.

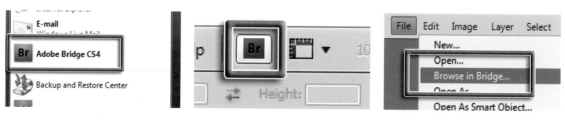

Bridge can be opened in a variety of different ways: individually via the Start menu (left) or from inside Photoshop using the dedicated button on the new Application bar (middle) or the File > Browse command (right)

Panel tabs Content panel Selected image Preview panel

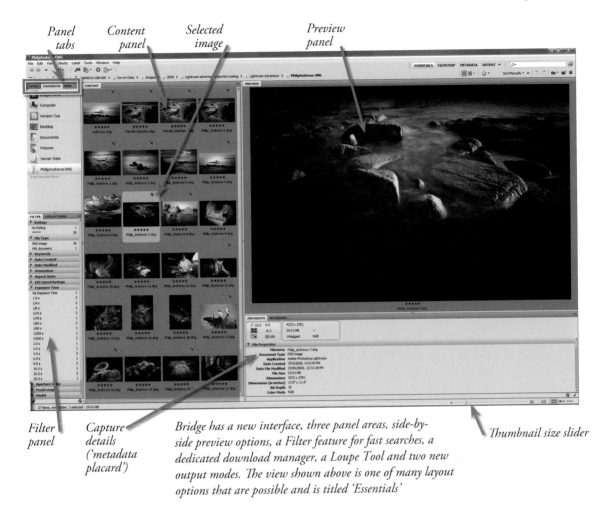

Filter panel Capture details ('metadata placard') Thumbnail size slider

Bridge has a new interface, three panel areas, side-by-side preview options, a Filter feature for fast searches, a dedicated download manager, a Loupe Tool and two new output modes. The view shown above is one of many layout options that are possible and is titled 'Essentials'

The latest version of Bridge

Bridge was first introduced a couple of versions ago; it has quickly become an important part of most photographers' daily workflow. Rather than just being a file browser, Bridge also enables photographers to organize, navigate image assets, add metadata and labels, process Raw files and, in the version that ships with CS4, output your photos directly to web galleries and PDF-based presentations. The interface has changed from the earlier releases of the program. Bridge now has a customizable display with seven layout options, most of which revolve around a three-panel setup (see above). The interface design, and its many variants, make the most of the widescreen displays that many image makers are now using. A variety of panels can be displayed in any of the areas. These include:

- **Folders panel** – displays a folder-based view of your computer.
- **Favorites panel** – provides quick access to regularly used folders you select.
- **Metadata panel** – shows metadata information for the selected file.
- **Keywords panel** – use for adding new or existing keywords to single or multiple photos.
- **Filter panel** – provides sorting options for the files displayed in the Content panel.

- **Preview panel** – shows a preview of selected files or file. Includes the loupe option.
- **Inspector panel** – displays a variety of custom details controlled by options in the preferences.
- **Collections panel** – this panel is new for CS4 and displays all available saved and Smart collections.

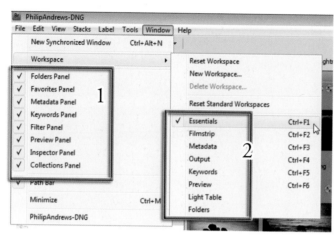

The layout and design of the Bridge interface is customizable by the user. You get to decide what information panels (1) are displayed and where they are placed. The final layout design can be saved and reused and is called a workspace. Several presaved workspaces (2) are supplied with Bridge so that you can quickly flick between screen layouts that suit different image management and editing tasks

Setting up Bridge
Viewing options

As you can see, one of the real bonuses of Bridge is the multitude of ways that the interface can be displayed. So let's look a little closer at the two different controls that alter the way that Bridge appears – Workspace and View.

Workspace controls the overall look of the Bridge window and is centered around the Window > Workspace menu. Panels can be opened, resized, swap positions, be grouped together and pushed and pulled around so that you create a work environment that really suits your needs and specific screen arrangements. It is even possible to stretch Bridge over two screens so that you can use one screen for previewing and the other for displaying metadata, favorites or content. You also have the option to run a synchronized second version of Bridge that displays an alternate view of the photos currently selected. This means that you can display thumbnails and metadata on one screen and a larger preview on another. To activate a second Bridge view go to Window > New Synchronized Window.

Once you are happy with the layout of the workspace use the Window > Workspace > New Workspace option to store your design. Alternatively you can select from a number of preset workspace designs located in the Window > Workspace menu.

Most **View** options are grouped under the View menu and essentially alter the way that Content area data or thumbnails are presented. Here you can choose to show the thumbnails by themselves with no other data (View > Show Thumbnail only) or with metadata details included (View > As Details).

Slideshow – There is also an option to display the content thumbnails as an impromptu slideshow. With no images selected choose View > Slideshow to include all pictures in the content panel in the show. To display a few photos, multi-select the pictures first (hold down the Cmd/Ctrl key as you click on thumbnails), and then pick the Slideshow command. The overall slideshow options such as

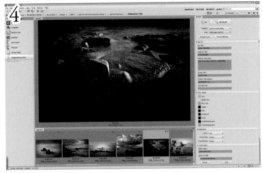

Bridge contains a range of preset workspace options:

1. **Essentials** – displays all panels.
2. **Filmstrip** – Folders, Favorites, Filters, Preview and Collections panels.
3. **Metadata** – Favorites, Metadata and Filters panels.
4. **Output** – Folders, Favorites and Preview panels.
Keywords – Favorites, Keywords and Filters panels.
5. **Preview** – Folders, Favorites, Filter, Keywords and Collections panels.
6. **Light Table** – Just the content area is displayed.
7. **Folders** – Folders and Favorites panels.

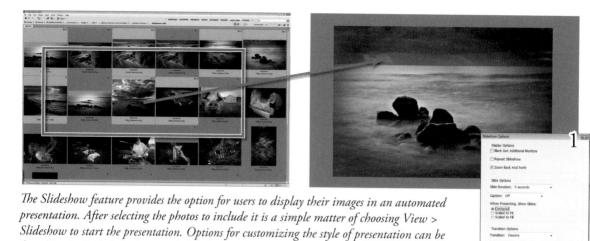

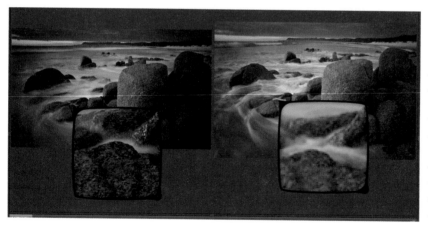

The Slideshow feature provides the option for users to display their images in an automated presentation. After selecting the photos to include it is a simple matter of choosing View > Slideshow to start the presentation. Options for customizing the style of presentation can be found in the Slideshow Options dialog displayed by selecting the entry in the View menu (1)

duration, transitions and caption content can be altered via the option settings (View > Slideshow Options).

In a variation of this type of slideshow display, CS4 also contains the ability to switch to a full screen view of the current selected image. By selecting View > Full Screen Preview or hitting the Spacebar, the Bridge workspace is replaced with a large preview of the selected image. While in the Full Screen Preview mode, a single click of the mouse will display a 100% view of the file. Click-dragging will move the magnified view around the picture. Pressing the Spacebar a second time reverts the display back to the Bridge workspace.

Multi-selecting images in the content space displays the photos in the Preview pane. Clicking onto the preview image displays a loupe designed to magnify a portion of the photo. Holding down the Ctrl/ Cmd key allows the user to synchronize the loupe views of multiple photos as the device is dragged around the images

Multi-image preview – In addition, Bridge also contains a couple of other view options. The first is the ability to display multiple pictures in the preview panel in a side-by-side manner. Simply multi-select several items in the content area to display them in the preview panel in this compare mode.

Loupe Tool – The second feature is the Loupe Tool, which acts like an interactive magnifier. The loupe size changes with the size of the displayed preview image and works best with a large preview image. To use, click the cursor on an area in the preview picture. By default a 100% preview of

this picture part is then displayed, but you can change the degree of magnification of the loupe by clicking the + and – keys. Click and drag the cursor to move the loupe around the photo. When multiple photos are displayed in the Preview pane you can display extra loupe views by clicking onto each photo in turn. The loupes can then be dragged around each photo to check sharpness and subject details like 'someone blinking' in portrait images. Holding down the Ctrl/Cmd key while dragging a loupe will synchronize its movement with other display loupes. This technique is great for checking the same area of similar photos when trying to choose which images to keep and which to discard.

The version of Bridge that ships with CS4 contains a new Review mode that displays images selected in the content panel in a 3D circle. Left and right arrow keys are used for navigating through the group

Close and revert to Bridge

Forward and back buttons *Drop image from review group button* *File name and current rating* *Loupe* *Create new Collection from images*

Review Mode – New for the CS4 version of Bridge is the Review Mode (View > Review Mode), which displays a set of images in a rotating web gallery-like display. The user can move from one image to another by clicking sideways arrow keys or by clicking the mouse on the forward and back arrows; unwanted pictures can be dropped from the display set using the down arrow key and the photos left after reviewing are automatically added to a new collection when returning to Bridge. Dropping images does not delete the photo, it does not remove it from content view; it does remove it from the multi-photo view that shows up in preview after you 'Esc' out of the review mode While in Review Mode you can add or change photo Labels and/or Ratings, and examine pictures closer using the Loupe Tool. This option was added to Bridge to help photographers quickly review their images, make choices about suitable photos that deserve more attention and then save these candidate images in the easily retrievable form of a Collection. When used in combination with the new Collections pane, this workflow should make accessing key photos quicker than in previous version of Bridge.

Custom panel display

Some panels also contain custom options that govern the type of information displayed and the way that it is presented in the panel. For both the Keyword and Metadata panels, these options are located in the fly-out menu accessed at the top right of the panel. You can add folders to the Favorites panel by right-clicking on them in the Folder panel and then choosing the Add to Favorites entry from the menu that appears. To remove listed folders right-click the entry and choose the Remove from Favorites option. The Inspector panel display and the types of data shown with thumbnails in the Content panel are controlled by settings in Preferences (Edit > Preferences).

The content of some panels and the way that this information is displayed can be adjusted using either the fly-out menus at the top right of the panels, right-click menu options for panel items or Bridge preference settings. Fly-out menu for the Metadata panel (left) and right-click menu for Favorite panel entries (right) are shown

Speedy thumbnail and preview generation

The images that you see in the Content and Preview panels are both based on thumbnails generated by Bridge. By default Bridge initially uses the thumbnails generated by your camera at the time of capture and then creates higher resolution images that will be used in the preview pane. Via the settings in Preferences the user has control over whether the thumbnails are built to a standard size or optimized specifically for your screen or monitor. Choose the Generate Monitor-Size previews option in the Advanced section of Bridge's Preferences (Edit > Preferences).

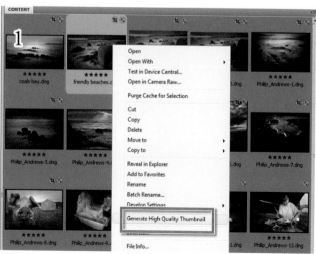

You can force the generation of high quality thumbnails manually for an individual image or groups of multi-selected photos by selecting the pictures in the Content pane and then choosing the Generate High Quality Thumbnail entry from the right-click menu. Images with low quality thumbnails are displayed in the content area with a black line border.

Images with low quality, but fast to display, thumbnails are displayed with a black border (1). Create a higher quality thumbnail by selecting the option from the right-click menu

Caching decisions

The cache is an allocated space on your hard drive that is used to store thumbnail and metadata information (Labels and Ratings) for the images displayed in the Content panel. Bridge uses this cache to speed up the display of thumbnails. The information in the cache is generally built the first time the contents of a specific folder are displayed. This process can take some time, especially if the folder contains many pictures. For this reason, there is also an option to build the cache of a selected folder in the background while you continue other work. Select the directory to be cached in the Folder panel and then choose Tools > Cache > Build and Export Cache. If for any reason you want to remove a previously created cache from a specific directory, then select the folder and choose the Tools > Cache > Purge Cache for Folder option.

You can speed up the display of images by pre-caching the folders they are saved in using the Build and Export Cache option in the Edit > Preference >Cache menu. After selecting the entry you can then choose to build 100% previews for faster display and to export the cache, which helps with display on other machines

The location of the cache impacts indirectly on performance for two reasons:

1. Cache files can become quite large and it is important to ensure that the drive selected to house the cache has enough space to be able to adequately store the file.
2. When image files are copied to another drive or location, a new cache has to be constructed when the folder is first viewed unless the cache is copied along with the picture files.

The settings contained in the Cache section of the Preferences dialog provide the option to select the place where the central cache is stored. Use this setting to ensure that the cache file is located on a drive with sufficient space. Also included here is an option for exporting cache files to folders whenever possible. Use this setting to employ a distributed cache system (rather than a centralized one), which enables image and cache files to be stored together in the same folder. If this folder is then moved, copied or written to a new location the cache will not have to be rebuilt for the photos to be displayed in Bridge. The cache should also be copied to CD, DVD or other locations that are locked. New changes will be written to the central location but, overall, browsing will be speeded up by the cache.

New for this version of Bridge is the addition of controls for the number of items stored in the cache. More items means faster display but more disk space is required for cache storage. The dialog also includes a button for compacting the cache, which helps improve performance, and another for purging or deleting all cached thumbnails and previews. This option is useful if you are having problems with the consistency of quality of thumbnail and preview images.

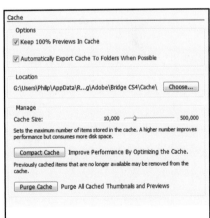

The location of centralized cache files as well as the ability to store the cache in the same folder as the images is controlled by settings in the Cache section of the Preferences dialog

Using Bridge

It is important to view Bridge as a key component in the photographer's workflow. From the time that the photos are downloaded from the camera, through the selection, editing and processing stages and then onto archiving and, later, locating specific pictures, the application plays a pivotal role in all image management activities. Let's look a little closer at each of these areas.

Downloading pictures

For the last couple of releases Bridge has included the Adobe Photo Downloader (APD) utility. The downloader manages the transfer of files from a camera or a card reader to your computer. In doing so the transfer utility can also change file names, convert to Adobe's Digital Negative format (DNG) on the fly, apply pre-saved metadata templates and even save copies of the files to a backup drive. This feature alone saves loads of time and effort for the working photographer over performing these tasks manually and for this reason should be your first point of call when downloading from your camera.

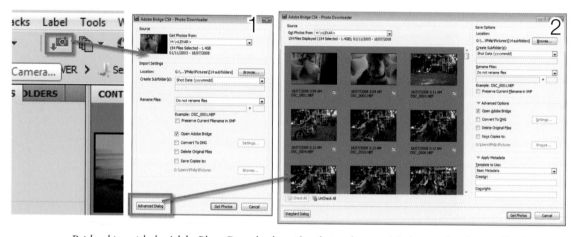

Bridge ships with the Adobe Photo Downloader utility designed to simplify the transfer of image files from camera or card reader to computer. When working with the Downloader you have a choice of two modes – Standard (1) and Advanced (2)

Transferring with the Adobe Photo Downloader

Step 1: Select the Get Photos from Camera option from the File menu inside Bridge or click the new Get Photos button in the Applications bar. Next you will see the new Adobe Photo Downloader dialog. The utility contains the option of either Standard or Advanced modes. The Advanced option not only provides thumbnail previews of the images stored on the camera or card, but the dialog also contains several features for sorting and managing files as they are downloaded. But let's start simply, with the options in the Standard dialog.

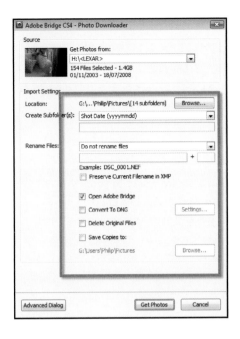

Step 2 Standard mode: To start you need to select the source of the pictures (the location of the card reader or camera). In the Standard mode all pictures on the card will be selected ready for downloading. Next set the Import Settings. Browse for the folder where you want the photographs to be stored and if you want to use a subfolder select the way that this folder will be named from the Create Subfolder drop-down menu. To help with finding your pictures later it may be helpful to add a meaningful name, not the labels that are attached by the camera, to the beginning of each of the images. You can do this by selecting an option from the Rename File drop-down menu and adding any custom text needed. At the same time selecting the Preserve Current Filename in XMP option will ensure the image can be found at a later date using the original file name. There are also options to open Bridge after the transfer is complete and convert to DNG or save copies of the photos on the fly (great for backing up images). Clicking the Get Photos button will transfer your pictures to your hard drive – you can then organize the pictures in the Bridge workspace. For more choices during the download process you will need to switch to the Advanced mode.

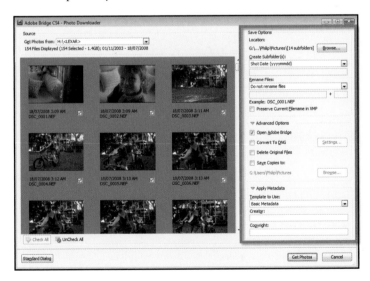

Step 3 Advanced mode: Selecting the Advanced Dialog button at the bottom left of the Standard mode window will display a larger Photo Downloader dialog with more options and a preview area showing a complete set of thumbnails of the photos stored on the camera or memory card. If for some reason you do not want to download all the images, then you will need to deselect the files to remain, by unchecking the tick box at the bottom right-hand corner of the thumbnail. This version of the Photo Downloader has the same location for saving transferred files, rename, convert to DNG and copy files options that are in the Standard dialog. In addition, this mode also contains the ability to add metadata to the photos during the downloading process. You can also select a predefined metadata template (created with the File Info dialog in Bridge or Photoshop) from the drop-down menu or manually add in author and copyright details. Pressing the Get Photos button will start the download process.

Locating files

Files can be located by selecting the folder in which they are contained using either the Favorites or Folders panel or the Look In menu (top of the dialog). Alternatively, the Edit > Find command can be used to search for pictures based on filename, file size, keywords, date, rating, label, metadata or comment.

Locate specific pictures or create collections of photos using the sophisticated Find options in Bridge

Filtering the files displayed

In the last version of Bridge, Adobe introduced a new interactive way to find specific photos among the thousands of files that sit on photographers' hard drives. The feature, called Filters, became a popular way for photographers to hone down large numbers of images to just a few. Filters are housed in a panel of their own which displays a list of file attributes such as file type, orientation, date of creation or capture, rating, labels, keywords and even aspect ratio.

Clicking on a heading activates the filter and alters the Content display to show only those files that possess the selected attribute. Selecting a second Filter entry reduces the displayed content further. Using this approach, it is possible to reduce thousands of photos to a select few with several well-placed clicks in the Filter panel.

To remove all filters and view all items in a folder click the folder icon in the bottom right of the panel or Ctrl/Cmd + Alt/Opt + A.

The Filter panel contains a selection of file attributes that can be selected as ready-made search criteria in order to quickly create a subset of photos. 1) Menu of Sort choices. 2) Remove or clear all filters. 3) Lock current filtration settings while browsing

To continue using the filtration settings when navigating to other folders or directories press the Map Pin icon in the bottom left of the pane.

Stacking alike photos

One way to help organize pictures in your collection is to group photos of similar content together. Bridge contains a stacking option designed just for this purpose. After multi-selecting the pictures to include from those displayed in the content area, select Stacks > Group as Stack. All images will be collated under a single front photo like a stack of cards. The number of images

Collapsed stack *Expanded stack*

Stacked images previewed *Front image only previewed*

Expand image stacks by clicking on the circled number in the top left of the thumbnail of the stacked photos (1). Collapse image stacks by clicking on the same circled number positioned on the first thumbnail in the series (2). Preview all images in a collapsed stack by selecting the front and back image (3). Select the front image only to display this picture in the Preview panel (4)

included in the stack is indicated in the top left of the stack thumbnail. Stacks can be expanded or collapsed by clicking on this number (stacks expand downwards in workspaces where the thumbnails are arranged vertically).

Selecting the top of the front image of a collapsed stack displays this picture only in the Preview panel. Clicking onto the frame of the bottom image in the collapsed stack (it will change color when selected) will display all stacked photos in the Preview panel.

Options for ungrouping the photos in a stack or changing the picture used as the front image can be located in the Stacks menu.

New auto stacking options

Added to this existing stacking functionality is the ability for Bridge to automatically collect High Dynamic Range (HDR) sets and panoramas and collate the files as stacks and then process them in Photoshop. This new functionality can be accessed in two ways, via an option in the Stacks menu (Stacks > Auto Stack Panorama/HDR) or by choosing Tools > Photoshop > Process Collections in Photoshop.

When building stacks Bridge uses the EXIF information stored with each picture to search groups of photos looking for images taken with less than an 18-second gap. Once located these images are grouped into those that have exposure differences of more than one stop; these are earmarked for processing as HDR source files, and those with similar exposure settings are marked as candidates for Photomerge processing. Next Bridge searches through the images a second time, but this time the program looks at the images themselves with Photoshop's Auto Align feature. Sequential images that are assessed to overlap by at least 80% are assumed to be HDR candidates. Photos that overlap by no more than 80% are considered to be panorama source images and are stacked as such. Finally the stacked photos are transferred to Photoshop and either processed using the Merge to HDR or Photomerge features.

The Path bar sits below the Menu and Options bar and visually maps the folder structure for the current location (1). Clicking on the right sideways arrow at any point on the path will display the folders located in the displayed directory in a drop-down menu (2)

Always know where you are with the new Path bar

Also new for the latest version of Bridge is the Path bar. Located just below the menu and shortcuts bar at the top of the Bridge workspace the bar provides a folder trail, working from parent directories on the left to child or subdirectories on the right. In its simplest form this bar visually displays the name and location of the folder currently selected, but this is not the end of the feature's functionality. By clicking the sideways arrow after a folder entry a drop-down menu of all the subfolders for this directory will be displayed. Navigating to a different directory option is then just a matter of selecting the folder from the menu. Just like the other interface components in Bridge, the Path bar can be displayed or hidden by selecting its entry on the Window menu.

Using Bridge's Collections

Collections are a way for photographers to group together images that relate to each other in some way. You might want to group all the photos of a particular subject, those taken for a single client or pictures captured with a specific camera and lens combination. Once created selecting the collection entry will then display all the photos contained within the group. The collections features in Bridge are now centered around the new Collections panel. Here you can view and manage existing collections and create new ones. If not displayed it can be selected from the Window menu.

Bridge uses two different collection types – **Smart Collections** and **Standard Collections**.

Collections

Standard Collections contain a selected group of images which represent a subset of all the photos in your collection and are related in some way – content, event, subject, photo, style, etc. The pictures contained in a collection are displayed when the collection entry is selected in the Collections panel. New collections can be created in several different ways:

- **From the Collections panel** – When the Collections panel is displayed, simply right-click on the panel area and choose the New Collection option from the pop-up menu. This will create a new entry in the panel that you can then name. To add images to the collection, select

the photo or photos in the content area of Bridge and drag them over the collection entry in the panel.

- **From Review Mode** – A new collection can also be created from the results of selection editing using the new Review Mode. Start by selecting some images in the Content panel. Next choose the Review Mode option from the View menu or click Ctrl/Cmd + B. Flick between the images using the sideways arrows. When you come across a photo that you want to remove from the group press the down arrow key. Once you have only the images that you want in the group displayed, click the Create New Collection button at the bottom right of the Review Mode screen. You will be returned to the Bridge interface and a new entry will have been added to the Collections panel.

Smart Collections

Smart Collections are created by establishing a set of search criteria. The photos that meet the criteria automatically are added to the collection. These collections are dynamic in that each time the collection entry is selected a new search is conducted and any photos that match the criteria are added to the collection. In this way the contents of Smart Collections are always kept up to date automatically. Smart Collection entries are colored blue.

- **From the Collections panel** – Smart Collections can also be created by right-clicking on the Collections panel and choosing the New Smart Collection entry. A Find dialog will then be displayed in which you can set your search criteria. Clicking the Find button will execute the search and create a new Smart Collection entry.

- **As the result of a search** – Another way to create a Smart Collection is to locate the images to include via a search. Select the Find option from the Edit menu. Using the settings in the Find dialog, establish a set of search criteria to help locate the required files. Click the Find button to execute the search. All images that match the search criteria will be displayed in the Content panel. To add these photos to a new collection press the Save as a Smart Collection button at the top right of the panel.

- **Via a set of filters** – The same functionality is available when you use the settings in the Filter panel to display a selection of images in the Content panel. When filters are being applied the Save as a Smart Collection button is displayed in the top right of the Content panel. Clicking the button will create a Smart Collection based on the current filter settings.

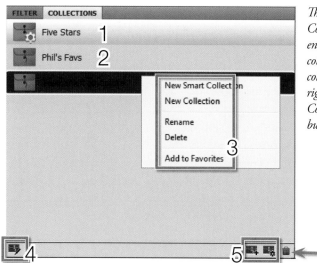

The Collections panel displays both Smart Collection (1) and Standard Collection (2) entries. There are options for creating new collections, renaming, deleting and adding collections to the Favorites panel in the right-click menu (3). Edit button (4). New Collections buttons (5). Delete Collection button (6)

Collections can also be added as an entry in the Favorites panel. Simply right-click on the collection entry in the Collections panel and choose the Add to Favorites option from the menu. Collection entries can be removed from the panel by right-clicking on the entry and choosing the Delete option from the menu. Existing collections can also be renamed in the same way. The search criteria used in a Smart Collection can be adjusted by selecting the entry and then either clicking on the Edit button at the bottom left of the panel or by selecting the Edit entry from the right-click menu.

Labeling pictures

As you are probably realizing Bridge is more than just a file browser; it is also a utility that can be used for sorting and categorizing your photos. Using the options listed under the Label menu, individual or groups of photos can be rated (with a star rating) or labeled (with a colored label).

These tags can be used as a way to sort and display the best images from those taken at a large photo-shoot or grouped together in a folder. Labels and ratings are applied by selecting (or multi-selecting) the thumbnail in the Bridge workspace and then choosing the tag from the Label menu. Shortcut keys can also be used to quickly attach tags to individually selected files one at a time.

In addition to adding the star ratings and the colored labels you can also mark photos as a reject (Label > Reject) and then have these photos hidden from view (View > Show Reject Files).

Labels or ratings are often used as a way of indicating the best images in a group of pictures taken in a single session. The photos displayed in the Content panel can be sorted according to their label or rating using the settings in the Filter panel

Keywords are words that summarize the content of the photo. They are used extensively by photo libraries for cataloging multiple photos. Keywords can be created and applied in Bridge using the Keywords panel (1). Also in CS4 the keywords and metadata associated with individual images can be displayed using the new Keywords workspace (2)

Adding keywords

Along with labeling and rating photos for easy editing and display options, it is also possible to assign specific keywords that help describe the content of your images. The keywords are stored in the metadata of the photo and are used extensively not only by Bridge as a way of locating specific photos but also by photo libraries worldwide for cataloging.

Most keyword activity is centered around the Keywords panel in Bridge. Here you can create and apply keywords to images or groups of images. To help manage an ever growing list keywords can also be grouped into keyword sets. To apply a keyword to a photo, select the image first and then click on the check box next to the keyword or keyword set to add. Click on the check box again to remove a keyword. Buttons for creating keywords and sub-keywords as well as for deleting existing keywords can be found at the bottom of the panel. A search pane is also located here making the task of finding specific keywords a simple job. Use the Find feature to locate images that have a specific associated keyword.

The settings menu for the Keywords panel (1) contains options for adding and removing keywords as well as the ability to import and export keyword sets. The bottom left of the panel contains a search field (2) and the three buttons on the right are for creating keywords, sub-keywords and deleting keywords (3)

A summary of all the Assigned Keywords for a specific photo is displayed at the top of the panel. New keywords or keyword sets are created, and existing ones deleted, using the buttons at the bottom right of the panel. Keep in mind that the CS4 version of Bridge also has a special Keywords workspace (Window > Workspace > Keywords), that can also be used to display metadata and associated keywords for individual files in the Content panel.

Keywords are often used as the primary method for locating appropriate images in stock libraries. For this reason accurate allocation of keywords is an important task for photographers wanting to ensure that their images feature prominently in search results. Some libraries should supply a list of pre-compiled keywords that are used by photographers to categorize their photos. Working this way helps ensure consistency in approach. To add saved keyword lists to Bridge select the Import option from the Settings menu (top right of the Keywords panel) and choose the file in the browser dialog that is displayed. Similarly the keywords lists that you create can be exported and reused using the Export option in the Settings menu.

Tools used in Bridge

Although no real editing or enhancement options are available in Bridge, it is possible to use the browser as a starting point for many of the operations normally carried out in Photoshop. For instance, photos selected in the workspace can be batch renamed, printed, used to create a Photomerge panorama, compiled into a contact sheet or combined into a PDF-based presentation, all via options under the Tools menu or the new Output workspace. Some of these choices will open Photoshop before completing the requested task whereas others are completed without leaving the browser workspace.

Bridge is a great starting place for many of the tools contained in the File > Automate menu in Photoshop as you can select the images to include before starting the editing feature from the Tools > Photoshop menu

Processing Raw inside Bridge

One of the real bonuses of Bridge is the ability to open, edit and save Raw files from inside the browser workspace. There is now no need to open the files to process via Photoshop. All key enhancement steps can be handled directly from the browsing workspace by selecting (or multi-selecting) the files and then choosing File > Open in Camera Raw. All Raw processing is undertaken by the latest version of Adobe Camera Raw (ACR) which ships with Photoshop CS4 and both TIFF and JPEG files can also be processed with the feature as well.

Previous versions of Adobe Camera Raw were only able to enhance globally. That is, the changes they made to the picture were made to the whole of the image. Enhancing specific picture parts was strictly a task for Photoshop. Now ACR is capable of local correction or applying changes to just some of the picture, so more of the image enhancement tasks can occur in ACR and via Bridge. More details on localized correction can be found in the Raw Processing chapter.

Raw, TIFF and JPEG files can be processed with Adobe Camera Raw from inside Bridge without having to open Photoshop first

To open a file directly into Photoshop you can right-click the thumbnail and choose Open With > Photoshop or, as long as the file type is associated with Photoshop, you can also double-click the photo inside the Content panel

Processing in Photoshop

It is a simple matter to transfer photos from the Bridge workspace into Photoshop. You can either double-click a thumbnail or select the image and then choose Open With > Photoshop CS4 from the right-click menu. By default double-clicking Raw images will open them into the Adobe Camera Raw utility inside Photoshop, but this behavior can be changed to process the file inside Bridge by selecting the Automatically Open option in the JPEG and TIFF Handling section of the Camera Raw Settings (Edit > Camera Raw Settings) in Bridge.

New for Bridge is the ability to output selected files to a Flash-based Web Gallery or a PDF-based presentation. The style and type of output is controlled by the settings in the Output panel (1) and the presentation or website is previewed in the Output Preview panel (2)

New output options

One of the big changes for Bridge is the ability to handle output to web and output to PDF from inside the Browser. A new Output workspace (Workspace > Output) ships with this release.

Once this workspace is selected, the right-hand panel is used to display the output options and settings in a format that will be familiar to many Lightroom or Photoshop Elements users. You can choose between creating a PDF document (presentation or print document) or a web gallery (mostly Flash based) via the buttons at the top of the Output panel. Next the settings for the design and the information to be included are added via the various controls and text fields and the final design is previewed in the special Output Preview panel by clicking the Refresh Preview button.

PDF

The PDF output option allows the user to create either screen-based presentations or PDF documents that are designed for printing. The feature ships with a range of predesigned output options listed in the Template drop-down menu (at the top of the Output panel). Here you will find designs for documents as diverse as greeting cards, contact sheets, triptychs (three images to a page) and full page images. Selecting a template is a good starting point for designing your PDF document and the options in the next sections of the Output panel will help fine-tune or customize the design. The Document and Layout sections adjust the page size and the number and position of images upon it. The Overlay and Watermark sections contain options for the inclusion of text with the photos and the Playback controls are used when the PDF will be used in a screen presentation format. With all the settings adjusted the selected images can be previewed in the design by clicking the Refresh Preview button at the top of the panel. Finally use the Save button to store the PDF document.

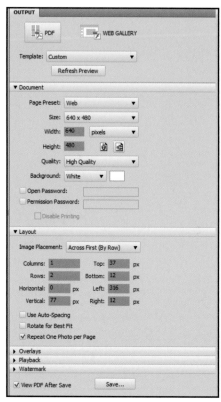

The Output panel contains a range of options to control the creation of the final PDF document

Web galleries

Also included as a new Output option is the ability to produce a web gallery from the selected images in the Bridge Content panel. Yes it was possible to create a gallery inside Photoshop in previous versions of the software but in this release the production happens inside Bridge, the website can be previewed before creation and, once produced, the whole site can be uploaded via FTP directly to the web.

To start the process click the Web Gallery button at the top of the Output panel. Next pick the Template and then Style of gallery to create, add in the Site Info, adjust the Color Panel used and the Appearance settings before setting up the Create Gallery options. Finally, click the Save button to output the gallery to your own computer or press the Upload button to transfer the completed site to the web.

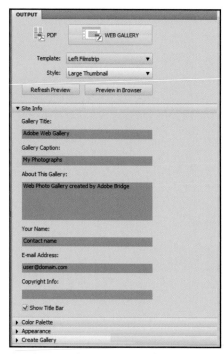

Similar controls are present in the Output panel for the production of web galleries

Using Bridge to access the project resources

Use Bridge to access the project resources that are available on the supporting DVD. Access the DVD from the Favorites panel in Bridge. Double-click the Photoshop_CS4 DVD icon to access the chapter folders. Images can be opened directly from Bridge or alternatively a folder of images can be dragged from the Content panel in Bridge to a location on your hard drive if required.

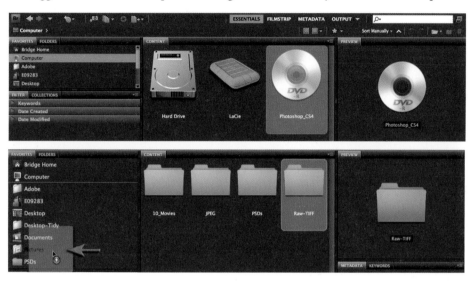

Inside each chapter folder the resources are divided into the different file formats. The same images can be accessed as JPEG, TIFF or Raw files (.dng). The JPEG images are compressed versions (lower quality) but take up little hard drive space. The TIFF files are uncompressed and may contain saved selections that can be used to speed up the editing process in some projects.

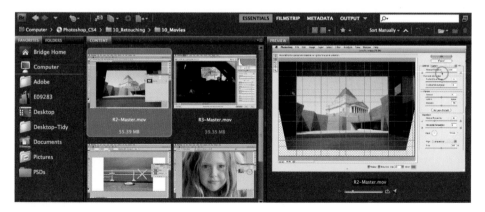

Most of the images are available as Raw files. These are required for many projects in the Advanced Retouching and Montage chapters, where some of the editing process is performed in the Adobe Camera Raw workspace (see Adobe Camera Raw). Each project in the 'Imaging Projects' module (last four chapters) is also supported by a movie. Movies can be watched in Bridge or can be opened directly in the QuickTime player (when installed) by double-clicking the movie file icon in the Content panel.

Seok-Jin Lee

workflow

Sam Everton

essential skills

- Examine different professional workflows.
- Capture high-quality digital images for image editing.
- Gain control over the color, tonality and sharpness of a digital image.
- Duplicate, optimize and save image files for print, presentation and for web.

Introduction

Over the last few years the way that photographers manage, edit and present their images has changed. Now we have more choices about the workflow that we use when optimizing our images for specific outcomes. In recognition of these changes this chapter will look at current professional workflow practice and the capture, editing and enhancing steps it involves.

Options for capture

When it comes to decisions about capture, if camera equipment considerations are put to one side, it boils down to a choice of shooting format. Do we shoot in JPEG or Raw?

This decision not only impacts on issues such as how many shots will fit on a memory card, but more importantly, it determines the nature of the photographer's workflow as well as the degree of control that he or she has over the adjustments made to the image.

In this book we unashamedly promote a Smart Raw Workflow which is based firmly on the idea that there is a direct relationship with the quality of the final image produced, and being able to perform as much editing/enhancing as possible on the virgin pixels that exited the camera as a Raw file.

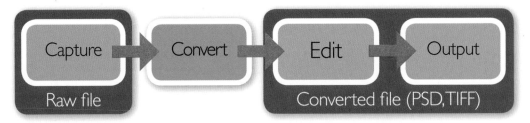

*The **'Convert then Edit'** approach is the most popular workflow currently used by Raw shooting photographers. The Raw file is downloaded from the camera and the first task in the process is to convert the file to a type that is more readily supported by Photoshop, such as TIFF or PSD*

Processing your photos

Photos captured in JPEG do not require any intermediate processing before the images can be edited in programs like Photoshop. Raw images, on the other hand, need to be processed using a special Raw enabled utility such as Adobe Camera Raw (ACR) initially before further Photoshop-based editing is possible. In the process often the file is converted from its Raw state to a file format that can be easily edited and enhanced in Photoshop. Despite the fact that programs designed specifically for working with Raw files such as ACR are becoming more and more sophisticated and feature rich most photographers still convert their Raw photos and move them to Photoshop for further processing.

Gradually this approach of 'convert and then edit' for Raw files is changing. With the increasing abilities of ACR, along with the Smart Object technology found in Photoshop, Raw shooters can put off the file conversion process while still taking advantage of the majority of the feature set of Photoshop. Keeping your photos in a Raw state maintains the flexibility of the format and is the basis of many non-destructive editing techniques designed for high-quality production. See Chapter 4 for more specific details on Raw processing.

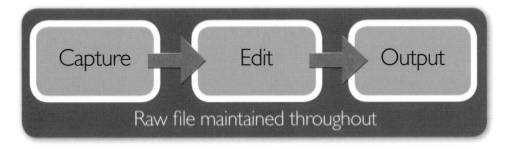

In contrast to the previous way of working, a **'Full Raw Workflow'** *approach maintains the Raw file throughout the whole digital imaging process. This completely non-destructive workflow is the way of the future for Raw shooters and it is growing in support, with special editing and enhancement techniques for Photoshop and Bridge users now being promoted*

Editing and enhancing

Once the captured image is in a usable form the next step is to edit or enhance the photo. Digital shooters have much more control over their images in this editing and enhancement phase than was ever possible when working with historical darkroom methods. This is largely thanks to the host of tools, features and commands available in programs such as Photoshop, Bridge and Adobe Camera Raw.

In this phase of the workflow the digital photograph can be enhanced and edited in many ways, including changes to color, brightness, contrast and sharpness (see Foundation Project 1). In addition it is also possible to make more substantial changes such as retouching marks and dust spots, montaging several photos together, and adding text and special effects to the photo.

Producing your pictures

Even these days, many precious pictures end up as prints. Sometimes the prints are kept in an album, on other occasions they are hung on a wall, or they may just be simply passed from friend to friend or photographer to client, but gradually other production outcomes are becoming easier to use and therefore more popular.

Now you can just as easily produce a web gallery, photo book or multimedia slideshow as output a bunch of 6 × 4 inch prints. On the whole the same software that is used for editing and enhancing digital photos also contains the ability to output pictures in a range of different forms. The latest version of Bridge, for instance, is able to produce high-quality PDF slideshows as well as polished Flash-based websites directly from inside the program.

Sharing your imagery

For many photographers having their images seen is one of the key reasons they capture pictures in the first place. With so many ways of producing your photos there are now a host of different ways of sharing your images. Modern image makers are no longer limited by distance or geographic borders. With the ability to easily produce web galleries, attach photos to e-mails or create High Definition slideshows, the whole world is truly a smaller place.

A few key concepts before we start...

Raw – the ultimate 'capture' and 'processing' format

Until recently, Raw files were viewed as a capture-only format with the first step in any workflow being the conversion of the picture to another file type so that editing, enhancing and output tasks could be performed. I say recently because with the latest release of products such as Adobe Camera Raw, Photoshop and Bridge it is no longer necessary to change file formats to move your pictures further through the production workflow.

Photoshop and Bridge are now sufficiently Raw-aware to allow the user to edit, enhance, print and even produce contact sheets, PDF presentations, picture packages and web galleries all from Raw originals. Yes, sometimes the files are converted as part of the production process for these outcomes, but I can live with the intermediary step of conversion if it means that my precious pictures stay in the Raw format for more of the production workflow. With a little trickery associated with Photoshop's Smart Object technology it is now even possible to edit individual pictures inside a standard Photoshop document without having to convert the file first, thus maintaining the untouched capture pixels throughout the editing process.

Differences between Raw and other formats

Raw files differ from other file types in that some of the options that are fixed during the processing of formats such as TIFF or JPEG can be adjusted and changed losslessly with a Raw format. In this way you can think of Raw files as having three distinct sections:

- **Camera Data**, usually called the EXIF or metadata, including things such as camera model, shutter speed and aperture details, most of which cannot be changed.

- **Image Data** which, though recorded by the camera, can be changed in a Raw editor and the settings chosen here directly affect how the picture will be processed. Changeable options include color space, white balance, saturation, distribution of image tones (contrast) and application of sharpness.

- **The Image itself**. This is the data drawn directly from the sensor sites in your camera in a non-interpolated form (Bayer pattern form). For most Raw cameras, this image data is captured in either 12- or 14-bit per pixel color depth. This color depth provides substantially more colors and tones to work with when editing and enhancing than the standard 8-bit JPEG or TIFF camera file.

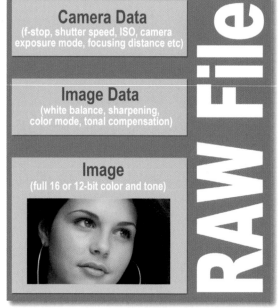

Camera Data
(f-stop, shutter speed, ISO, camera exposure mode, focusing distance etc)

Image Data
(white balance, sharpening, color mode, tonal compensation)

Image
(full 16 or 12-bit color and tone)

RAW File

The importance of DNG

No discussion about Raw files is complete without mentioning the importance of Adobe's Digital Negative format or DNG. As we have mentioned (and will see throughout the book) capturing in Raw has many advantages for photographers, offering them greater control over the tone and color in their files, but there is only one standard available for the Raw files. One problem is that each camera manufacturer has their own flavor of the file format.

Adobe developed the DNG or Digital Negative format to help promote a common Raw format that can be used for archival as well as editing and enhancement purposes. As well as including output DNG options in Photoshop, Lightroom and Photoshop Elements, Adobe provides a free DNG converter that can change proprietary Camera Raw formats to DNG. The converter can be downloaded from www.adobe.com. Also files imported into Bridge with the Adobe Photo Downloader can be automatically converted to DNG on the fly (during the transfer process).

Raw files can be converted to the DNG format either at time of import via the Photo Downloader, when saving from Adobe Camera Raw or batches of images converted via the free DNG converter utility

In addition to providing a common Raw file format, the DNG specification also includes a lossless compression option which, when considering the size of some Raw files, helps to reduce the space taken up by the thousands of images that photographers accumulate. The specification includes the ability to embed the original proprietary capture file (e.g. .nef, .crw, .arw etc.) if required. Also all development settings applied to the photo are self-contained within the DNG file instead of being stored in an extra file (called a sidecar file) that is linked with the original Raw file.

Synchronizing development settings

Archiving is one reason to switch to using the DNG format but by far the most important reason to use DNG is that it makes the synchronizing of development settings between Raw enabled editing programs such as Adobe Camera Raw and Photoshop Lightroom easier.

Preparing your system to use Raw files

One of the difficulties when working with Raw files is that sometimes the computer's operating system is unable to display thumbnails of the images when viewing the contents of folders or directories. When using Windows XP it was necessary to install Microsoft's Raw Image Thumbnailer and Viewer utility before the operating system was able to recognize, and display, Raw files. The system was slow and most users reverted to employing Bridge as the main way they viewed their files.

Now Windows users are migrating to the Vista operating system. Recognizing that Raw files are a key component of the photographer's workflow, Microsoft has taken a different approach to the problem in its latest operating system offering. In creating a more 'Raw aware' operating system, Microsoft has made use of a structure where the various camera manufacturers supply their own CODECs (Compression Decompression drivers) to be used with their particular type of Raw files inside Vista.

In this approach the user has to install the CODEC for the camera that he or she uses before they are able to view their images in the system folders or directories. This process is also needed to view thumbnails of your DNG files as well. Though a little troublesome to start with, as you need to install CODECS for all the cameras you use or have used in the past, this approach will hopefully 'future proof' the operating system's support for Raw files. Supporting the latest camera, or Raw file type, is a simple upgrade installation of the latest CODEC from the manufacturer. Use the following steps as a guide for Raw enabling your own Windows Vista machine.

Locate the CODEC – Step A

Start by searching the internet, or your camera manufacturer's support site, for the specific Vista CODEC that supports your Raw files. Once located, download, and in some cases extract or decompress, the files to your desktop ready for installation.

Follow the instructions – Step B

Next follow the install instructions. Here I am installing the Nikon Raw CODEC for Vista. As part of the process, the user is required to input location and language selections.

Reboot the computer – Step C

As the CODEC forms part of the file processing functions of the operating system it may be necessary to reboot (turn off and turn back on again) your computer after installing the software.

Test the install – Step D

After rebooting check to see that the CODEC is functioning correctly by displaying an Icon View of an image folder that you know contains Raw files. You should see a series of thumbnails representing your image files.

What about Mac machines?

The ability to display thumbnails of Raw files in the Macintosh operating system is driven mainly by the Preview and iPhoto utilities. Ensuring that these programs are always up to date will help guarantee that the latest camera formats are supported by the system and thumbnails and previews are displayed in the computer's browser windows.

The need for enhancement

Every digital capture or scanned image should be enhanced further so that it may be viewed in its optimum state for the intended output device. Whether images are destined to be viewed in print or via a monitor screen, the image usually needs to be resized, cropped, retouched, color-corrected, sharpened and saved in an appropriate file format. The original capture will usually possess pixel dimensions that do not exactly match the requirements of the output device. In order for this to be corrected the user must address the issues of 'Image Size', 'Resampling' and 'Cropping'.

To end up with high-quality output you must start with the optimum levels of information that the capture device is capable of providing. The factors that greatly enhance final quality are:

- A 'subject brightness range' that does not exceed the exposure latitude of the capture device (the contrast is not too high for the image sensor).
- Using a low ISO setting to capture the original subject.
- The availability of 16 bits per channel scanning or the camera Raw file format.

Optimizing image quality

In the next section of this chapter we will step our way through a typical digital capture workflow using Raw files. We will focus on the standard adjustments made to all images when optimum quality is required without using any advanced techniques. Standard image adjustments usually include the process of optimizing the color, tonality and sharpness of the image. With the exception of dust or blemish removal, these adjustments are applied globally (to all the pixels). Most of the adjustments in this chapter are 'objective' rather than 'subjective' adjustments and are tackled as a logical progression of tasks. Automated features are available for some of these tasks but these do not ensure optimum quality is achieved for all images. The chapter uses a 'hands-on' project to guide you through the steps required to achieve optimum quality.

Save, save and save

First, good working habits will prevent the frustration and the heartache that are often associated with the inevitable 'crash' (all computers crash or 'freeze' periodically). As you work on an image file you should get into the habit of saving the work in progress and not wait until the image editing is complete. It is recommended that you use the 'Save As' command and continually rename the file as an updated version. The Photoshop (PSD) file format should be used for all work in progress. Before the computer is shut down, the files should be saved to a removable storage device or burnt to a CD/DVD. In short, save often, save different versions and save backups. Also when working with programs that make use of Library or Catalog structure such as the system used in Lightroom, be sure to back up this database as well.

Stepping back

Digital image editing allows the user to make mistakes. There are several ways of undoing a mistake before resorting to the 'Revert' command from the File menu or opening a previously saved version. Photoshop allows the user to jump to the previous state via the Edit > Undo command (Command/ Ctrl + Z). The user can 'Step Backward' through several changes by using the keyboard shortcut Ctrl + Alt + Z (PC) or Command + Option + Z (Mac). Alternatively, 'Histories' allows access to any previous state in the History panel without going through a linear sequence of undos.

Advantages and disadvantages of 16-bit editing

When the highest quality images are required there are major advantages to be gained by starting off the editing process in '16 Bits/Channel' mode. In 16 bits per channel there are trillions, instead of millions, of possible values for each pixel. Spikes or comb lines, that are quick to occur while editing in 8 bits per channel, rarely occur when editing in 16 bits per channel mode. Thankfully, cameras capable of Raw capture record their images in either 12 or 14 bits per channel (which are then saved in a 16 bits per channel file) which means that Raw shooters get the advantages of high-bit capture inherently.

The disadvantages of editing in 16 bits per channel are:

- Not all digital cameras are capable of saving in the Raw format.
- The size of file is doubled when compared to an 8 bits per channel image of the same output size and resolution.
- Some editing features (including many filters) do not work in 16 bits per channel mode.
- Only a small selection of file formats support the use of 16 bits per channel.

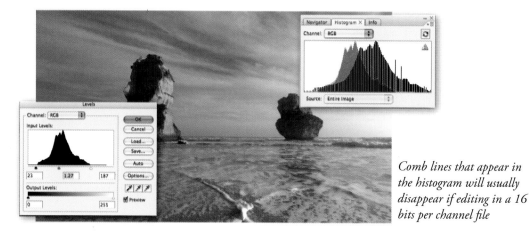

Comb lines that appear in the histogram will usually disappear if editing in a 16 bits per channel file

Choosing your bit depth

It is preferable to make all major changes in tonality or color to the Raw file in Adobe Camera Raw (ACR). This ensures that the enhancement steps are performed on high-bit data. Using a Smart workflow involving embedded Raw files the decisions about depth and space can be further delayed as we have the option of re-opening the file in ACR and adjusting the color and tone at 12 or 14 bits and changing the gamut to accommodate a larger or small gamut output device. Non-Raw images can be converted from 8-bit (Image > Mode > 16 Bits/Channel) or captured in 16-bit (the preferred choice). Most scanners now support 16 bits per channel image capture with many referring to the mode as 48-bit RGB scanning. Some offer 14 bits per channel scanning but deliver a 48-bit image to Photoshop. Remember, you need twice as many megabytes as the equivalent 8-bit image, e.g. if you typically capture 13.2 megabytes for an 8 × 10 @ 240ppi you will require 26.4 megabytes when scanning in 16 bits per channel.

Note > Photoshop also supports 32 Bits/Channel editing which is primarily used for editing images with a high dynamic range (see Montage Projects – High Dynamic Range).

Foundation Project 1

Follow the ten steps over the following pages in order to learn how to create one image optimized for print and one image optimized for web viewing from the same image file.

Image capture – Step 1

Capture a vertical portrait image using soft lighting (low-contrast diffused sunlight or window lighting would be ideal). The image selected should have detail in both the highlights and shadows and should have a range of colors and tones. An image with high contrast and missing detail in the highlights or shadows is not suitable for testing the effectiveness of the capture or output device. An example file for this project is located on the book's DVD.

Pro's Tips for Best Capture

To achieve optimum image quality ensure as many of the following steps as possible are carried out.

1. Set the camera's ISO setting to no more than double the base level ISO of the sensor (typically 100 or 200 ISO for most digital cameras). Alternatively use a low ISO film, e.g. 100 ISO.

2. Avoid using either the minimum or maximum apertures on the camera lens.

3. Mount the camera on a sturdy tripod and switch off any image stabilization, steady-shot or vibration reduction settings.

4. Use a remote shutter release or self-timer to release the shutter.

5. Ensure accurate exposure metering and setting of the camera's shutter speed and aperture.

6. Match the camera's white balance setting for the light source that is illuminating the subject. If need be, use a custom white balance setting in mixed lighting to ensure cast-free capture.

Digital capture via a digital camera

Images can be transferred directly to the computer from a digital camera or from a card reader if the card has been removed from the camera. Images are usually saved on the camera's storage media as JPEG or Raw files. If using the JPEG file format to capture images you should choose the high or maximum quality setting whenever possible. If using the JPEG file format, it is important to select low levels of image sharpening, saturation and contrast in the camera's settings to ensure optimum quality and editing flexibility in the image-editing software. If the camera has the option to choose Adobe RGB instead of sRGB as the color space this should also be selected if one of the final images is destined for print.

Tethered Image Capture

Many DSLR cameras now offer the option of capturing Raw photos while the camera is connected to a computer. Some photographers would never need, nor see the benefits of, shooting in this fashion; for their chosen area of speciality the added burden of dragging around a laptop computer as well as all their camera gear is a complication that they can well do without. However, for studio, product, architectural,

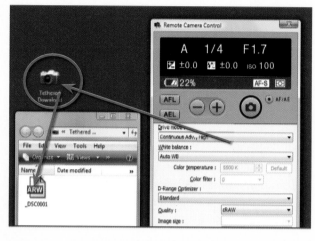

commercial and even some landscape photography the ability to preview, and even process, the photos captured almost immediately on a large screen ensures better results.

The utility software that comes bundled with most mid- to high-end DSLR cameras and medium-format camera backs does an admirable job of providing the required software link between camera and computer. The physical connection is generally provided via a USB or Firewire connection, although some models can now connect wirelessly using a pretty standard setup. The 'remote capture' software supplied by the camera companies ranges from something as simple as a dialog containing a shutter release button right up to a full control panel that allows focus, metering, drive and exposure control right from your desktop. Once on the desktop the files can be imported into Bridge and even displayed in Adobe Camera Raw.

There are several advantages for viewing pictures in this type of setup:

- You can review images on a larger, higher resolution camera LCD screen at the time of shooting either via the remote capture software or after downloading into Bridge,
- Critical exposures can be checked closely using histograms derived from the full high-bit Raw image data rather than a processed JPEG, as is the case with most back of camera histograms, and
- It is possible to quickly apply some post-capture processing to the images when in Bridge to display the style of the treatment that will be applied to the final photos. This is a great way to show a client how the images will look seconds after they are shot.

Use the following steps to set up for tethered shooting:

Install camera drivers – Step A

Before connecting the camera ensure that you have installed any camera drivers that were supplied with the unit. These small pieces of software ensure clear communication between the camera and computer and are usually installed along with other utility programs such as a dedicated browser (e.g. Nikon View, Canon's ZoomBrowser/ImageBrowser or Sony's Image Data Suite) and camera-based Raw conversion software (e.g. Nikon Capture, Canon's Digital Photo Professional or Sony's Remote Camera Control). Follow any on-screen installation instructions and, if necessary, reboot the computer to initialize the new drivers.

Connect the camera – Step B

The next step is to connect the camera to the computer via the USB/Firewire cable or wireless network. Make sure that your camera is switched off, and the computer is on, when plugging in the cables. For the best connection and the least chance of trouble it is a good idea to connect the camera directly to a computer USB/Firewire port rather than a hub.

Check the connection – Step C

With the cables securely fastened, switch the camera on and, if needed, change to the PC connection mode. Most cameras have two connection modes – one that uses the camera as a card reader (often called 'Mass Storage'

mode) and another that connects the device as a camera (generally referred to as 'PTP' mode but sometimes also called Remote PC mode). The remote capture software will work with one of these modes only. Most cameras no longer require a change from whatever mode is selected by default, but check with your camera manual just in case. If the drivers are installed correctly the computer should report that the camera has been found and the connection is now active and a connection symbol (such as PC) will be displayed on the camera. If the computer can't find the camera try reinstalling the drivers and, if all else fails, consult the troubleshooting section in the manual. To ensure a continuous connection use fully charged batteries or an AC adaptor.

Start the remote shooting software – Step D

With the connection established you can now start the remote capture software (e.g. Nikon Capture Camera Control, Canon's Digital Photo Professional or Sony's Remote Camera Control). With some models the action of connecting the camera will automatically activate the software. In other cases it will be necessary to start the software and wait for the program to locate the attached camera. Most versions of these utilities provide more than just a means of releasing the shutter from the computer and instantly (well nearly, it does take a couple of seconds to transfer big capture files) viewing captured photos. The utilities contain options to set most camera functions including items such as shutter speed, ISO, aperture, capture format, contrast, saturation and white balance controls.

Set download options – Step E

With all these settings to play with, where do you start? Start by adjusting the download options found in the remote capture software. The four big settings are:

- Where the files are to be transferred to,
- How they are to be labeled,
- What metadata is to be added to the files during this process, and
- What happens to the file once it is transferred.

Save in :
G:\Users\Philip\Desktop\Tethered Download
Open in Image Data Lightbox SR
Transferred image: (_DSC0001.ARW), 0 files remaining

It is a good idea to create a new folder or directory for each shooting session and to select this folder as the place to download the captured files. Now choose a naming scheme that provides enough information to allow easy searching later. This may mean a title that includes date and name of shoot or subject as well as a sequence number. In terms of additional metadata at the very least you should always attach a copyright statement as well as any pertinent keywords that describe the subject. If these last options aren't available with your software then keywords can be added, and filenames changed, using the features in Bridge.

Finally you need to choose what happens to the captured files. Most users will want to transfer the pictures directly to a preview utility such as one of the browser programs or alternatively if you want to process the photo on the spot you could pass the file directly to a Raw converter. In our case we will set the download folder to the Hot or Watched folder for Lightroom's Auto Import function.

Compose, focus and release the shutter – Step F

Now to the nuts and bolts of the capture. Most remote capture systems don't offer a live preview feature so composing and framing is still done through the viewfinder and lens event. Some photographers adopt a shoot and review policy, preferring to shoot a couple of test images and review these full size on their computer screens to check composition, focus and even exposure. Once you are happy with all your settings, release the shutter and automatically the file is captured and transferred from camera to computer.

Disconnecting the camera – Step G

Before turning the camera off or disconnecting the cable make sure that any transfer of information or images is complete. Interrupting the transfer at this point will mean that you lose files. Mac users can drag the camera volume from the desktop to the trash. Windows users should click the Safely Remove Hardware icon in the system tray (bottom right of the screen) and select Safely Remove Mass Storage Device from the pop-up menu that appears.

Downloading files – Step 2

For all photographers apart from those using a tethered shooting setup the very next step after capture is transferring the photos to your desktop machine. For this workflow we will assume that Bridge will be the center of all image management and that the Adobe Photo Downloader (APD) will be used for transferring files. You could just as easily use a system-based 'copy' or 'move' function, but APD contains inbuilt features that make the process easier and relieve you of some tasks such as renaming that you would normally have to undertake manually.

In the last chapter we looked at the basic steps involved in using APD to transfer your images so we won't repeat them here, but instead we'll concentrate on the other options that you may want to use to fine-tune your downloads. Most are accessed by clicking on the Advanced Dialog button in the APD dialog (see opposite for details).

Storage location – *A good workflow starts with the transfer of images to your computer. Choosing an appropriate storage location and folder hierarchy for saving your pictures is a key decision. Some photographers use date-based storage, others create a folder structure based on client or job type. Once you have decided on a system, stick to it as this will help with locating your images later*

Rename photos – *The renaming options revolve around three key pieces of data – the current date, the shot date, a custom name and a sub-folder name. Each menu entry uses a different combination or sequence of these details. There are 21 different naming formats and when dates are part of the renaming process both US- and UK-based date formats are included*

Preserved filename – *It is handy to have the option to include the original filename stored in the XMP data associated with the photo as XMP data is searchable via the Find option in Bridge's Edit menu*

Open Adobe Bridge – *When APD starts automatically because you have attached a camera or card reader to the computer you then have the option of opening Bridge and displaying the transferred files in a new window*

Convert to DNG – *Adobe's Digital Negative format or DNG is an open source Raw file format designed to be used as the primary file type for archiving. To help reduce the steps involved in managing the thousands of photos that are transferred each year, the Adobe team has included an automatic conversion option in APD. When selected, the picture files are converted from their native Raw format (i.e. .NEF, .CRW) to the DNG automatically. From this point onwards they can still be processed as standard Raw files*

Delete Original Files – *Deletes the photos from the camera card after transferring is complete*

Save Options

Location:

G:\Users\Philip\Pictures\20080730 [Browse...]

Create Subfolder(s):

Today's Date (yyyymmdd) [▼]

Rename Files:

Custom Name + Shot Date (yyyymmdd) [▼]

PHILIPANDREWS + 1

Example: PHILIPANDREWS_20070427_0001.inf

☑ Preserve Current Filename in XMP

▽ Advanced Options

☑ Open Adobe Bridge

☑ Convert To DNG [Settings...]

☑ Delete Original Files

☑ Save Copies to:

G:\Users\Philip\Pictures [Browse...]

▽ Apply Metadata

Template to Use:

Basic Metadata [▼]

Creator:

Philip Andrews

Copyright:

Apply Metadata – *The Apply Metadata section contains an option for inserting author and copyright information quickly and easily. To display these input fields you will need to select the Basic Metadata option in the Template to Use drop-down menu. Also listed on this menu are any other metadata templates you have created and saved, either in Bridge (via the Metadata panel) or in Photoshop (with the File Info dialog)*

Automated backup – *The 'Save Copies to' option provides the ability to automatically store a separate copy of each downloaded file as a primary backup. This saves having to manually back up photos at a later date or transfer the files twice from the camera or memory card – once to the drive used for processing and a second time to the backup device. It is important to note that even when the Convert to DNG setting is selected the file type of the photos copied as a backup is in the original capture format and not DNG*

Image management – Step 3

Now I know that you are eager to get editing but a largely overlooked step in any good professional workflow is image management, sometimes called DAM (Digital Image Management). Directly after downloading is a good time to start to manage your files. A little discipline shown at this point will save time later. As we saw in the last chapter Bridge is not just a tool for viewing your photos, it is a key technology in the managing, sorting and enhancing of those files. And this pivotal role is never more evident than when one is managing Raw files. So the next step is to add keywords to your images and then select the best photos from the group and label these with ratings.

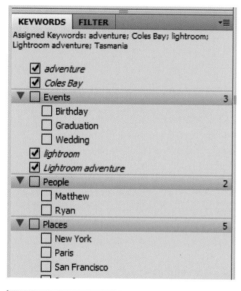

Add keywords

Keywords are single-word descriptions of the content of image files. Most photo libraries use keywords as part of the way they locate images with specific content. The words are stored in the metadata associated with the picture. Users can allocate, edit and create new keywords (and keyword categories) using the Keywords panel in the Bridge browser and File Info panel in Photoshop.

New keywords (categories or sets of keywords) and sub-keywords can be added to the Keywords panel by clicking the New Keyword Set and New Keyword buttons at the bottom of the panel. Unwanted sets or keywords can be removed by selecting first and then clicking the Delete button. Unknown keywords imported with newly downloaded or edited pictures are stored in the panel under the Other Keywords set.

Rate and label files

One of the many ways you can organize the Raw files displayed in the Bridge workspace is by attributing a label to the picture. In CS4 the labels option is supplied in two forms – a color tag, called a Label, or star rating, called a Rating. Either or both label types can be applied to any picture. The Label tag can then be used to sort or locate individual pictures from groups of photos.

Labels and/or Ratings are attached by selecting the thumbnail(s) in the workspace and then choosing the desired label from the list under the Label menu. Keyboard shortcuts are also provided for each label option, making it possible to quickly apply a label to a thumbnail, or group of thumbnails, or you can quickly add star ratings by clicking beneath the thumbnail in the workspace. Labels can also be attached to pictures in Adobe Camera Raw, the new Review Mode and Slideshow features. Windows also has a right-click menu for accessing Rating and Label options.

Image processing steps

The next steps are concerned with basic processing and optimizing of the photo. With the growing use of Raw files as the basis of professional capture these changes will be made to a Raw file using Adobe Camera Raw (ACR). Make sure that the ACR plug-in is the latest available by selecting Help > Updates in Bridge. In previous editions of this book we have used Photoshop for these steps; this is still possible, but would generally require the Raw file to be converted to a non-Raw format before any enhancements could be applied. For readers using non-Raw formats we have included a summary of the Photoshop steps as well. The example file 'foundations project 1.dng' located on the book's DVD can be used to practice these steps.

Rotating and cropping an image – Step 4

The easiest way to open the file into ACR is by right-clicking on the thumbnail in Bridge and then selecting Open in Camera Raw. Working with ACR in Bridge allows for faster Raw processing as the conversions take place without the need to share computer resources with Photoshop at the same time. Next you can rotate the image using either of the two Rotate buttons at the top of the workspace. If you are the lucky owner of a recent camera model then chances are the picture will automatically rotate to its correct orientation. This is thanks to a small piece of metadata supplied by the camera and stored in the picture file that indicates which way is up.

Pro's tip: The preferences for Bridge can be adjusted so that double-clicking a thumbnail of a Raw picture will automatically open the file in Camera Raw in the Bridge workspace. If this option is not selected then double-clicking will open the file in ACR in the Photoshop workspace.

You can fine-tune the rotation of the picture with the Straighten Tool. After selecting the tool click and drag a straight line along an edge in the photo that is meant to be horizontal or vertical. Upon releasing the mouse button ACR automatically creates a crop marquee around the photo. You will notice that the marquee is rotated so that the edges are parallel to the line that was drawn with the Straighten Tool. When you exit ACR by saving or opening (into Photoshop) the picture, the rotated crop is applied.

The Crop Tool in ACR can be used for basic cropping tasks as well as for cropping to a specific format. The feature works just like the regular Crop Tool in Photoshop proper, just select and then click and drag to draw a marquee around the picture parts that you want to retain. The side and corner handles on the marquee can be used to adjust the size and shape of the selected area. The crop is applied upon exiting the ACR dialog.

Custom Crop

Predefined crop formats are available from the menu accessed by clicking and holding the Crop Tool button. Also included is a Custom option where you can design your own crops to suit specific print or other outcome requirements.

In this instance we will crop the picture to fit a standard 6:4 format, so select choose the Custom option from the Crop menu, input the 6 to 4 ratio and then drag a crop marquee around the image. There is no need to be concerned about units of measure or the resolution of the file at this point. These options will be set when the file is saved or passed to Photoshop.

Also keep in mind that any crops you make with ACR are reversible. Just open the file back into ACR and select the Crop Tool and then hit the Esc key to remove the current crop.

In Photoshop:

After opening the captured image in Photoshop, click on the Crop Tool icon in the Tools panel. In the Options bar type '4in' in the Width field and '6in' in the Height field. Type in '240' in the Resolution field and set the resolution units to 'pixels/inch'. When sizing an image for the intended output it is important to select the width and height in pixels for screen or web viewing and in centimeters or inches for printing. Typing in 'px', 'in' or 'cm' after each measurement will tell Photoshop to crop using these units. If no measurement is entered in the field then Adobe will choose the default unit measurement entered in the Preferences (Preferences > Units & Rulers). The unit preference can be quickly changed by right-clicking on either ruler (select View > Rulers if they are not currently selected).

Note > The Image Size dialog box can also change the size of an image but it cannot crop an image to a different 'format' or shape, e.g. you cannot change an oblong image to a square image unless you crop or remove a portion of the image using the Crop Tool.

The action of entering measurements and resolution in Photoshop at the time of cropping ensures that the image is sized and cropped or 'shaped' as one action. Entering the size at the time of cropping ensures the format of the final image will match the printing paper, photo frame or screen where the image will finally be output. To quickly delete all of the existing units that may already be entered in the fields from a previous crop, select the 'Clear' option. To quickly enter the current actual measurements of a selected image, click on the 'Front Image' button. This option is useful when you are matching the size of one or more new images to an existing one that has already been prepared.

Note > If both a width and a height measurement are entered into the fields the proportions of the final crop will be locked and may prevent you from selecting parts of the image if the capture and output formats are different, e.g. if you have entered the same measurement in both the width and height fields the final crop proportions are constrained to a square.

Perfecting the crop

Click and drag to place the cropping marquee on the image; you can resize the marquee with the corner handles. The marquee can be click-dragged to reposition and when cropping in Photoshop the keyboard arrow keys can be used to fine-tune the positioning. If the image is crooked you can rotate the cropping marquee by moving the mouse cursor to a position just outside a corner handle of the cropping marquee. A curved arrow should appear, allowing you to drag the image straight. In ACR you need to click-drag outside the crop marquee to see the curved arrow.

Before completing the crop, you should check the entire image edge to see if there are any remaining border pixels that are not part of the image. Photoshop users can click on the 'Change Screen Mode' icon at the bottom of the Tools panel to change the screen mode to 'Maximized Screen Mode' or 'Full Screen Mode'. Alternatively you

can press Ctrl/Cmd + 0 to see all the image and Ctrl/Cmd + to zoom in, or Ctrl/Cmd – to zoom out. Holding down the Spacebar activates the Hand Tool so that you can quickly move the window. Press the 'Return/Enter' key on the keyboard to complete the cropping action. Alternatively press the 'Esc' key on the keyboard to cancel the crop.

In Photoshop:

In Photoshop the Crop Tool is programmed to snap to the edges of the document as if they were magnetized. This can make it difficult to remove a narrow border of unwanted pixels. To overcome this problem you will need to go to the 'View' menu and switch off the 'Snap To > Document Bounds' option or hold down the Ctrl/Cmd key when defining a crop area.

Note > See 'Retouching – Project 2' for more information on cropping images.

Color adjustments – Step 5

Unlike other capture formats (TIFF, JPEG) the white balance settings are not fixed in a Raw file. This fact provides much greater control over the colors in the photo than when such settings are fixed. ACR contains three different ways to balance the hues in your photo:

Preset changes

You can opt to stay with the settings used at the time of shooting ('As Shot') or select from a range of light source-specific values in the White Balance drop-down menu of ACR. For best results, try to match the setting used with the type of lighting that was present in the scene at the time of capture. Or choose the Auto option to get ACR to determine a setting based on the individual image currently displayed.

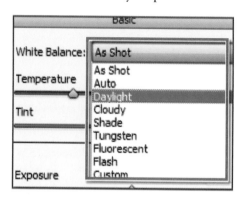

Manual adjustments

If none of the preset White Balance options perfectly matches the lighting in your photo then you will need to fine-tune your results with the Temperature and Tint sliders (located just below the Presets drop-down menu). The Temperature slider settings equate to the color of light in degrees kelvin – so daylight will be 5500 and tungsten light 2800. It is a blue to yellow scale, so moving the slider to the left will make the image cooler (more blue) and to the right warmer (more yellow). In contrast the Tint slider is a green to magenta scale. Moving the slider left will add more green to the image and to the right more magenta.

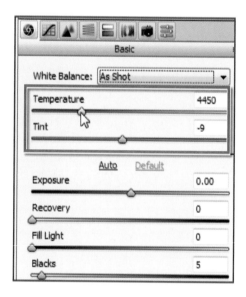

The White Balance Tool

Another quick way to balance the light in your picture is to choose the White Balance Tool and then click onto a part of the picture that is supposed to be neutral gray or white. ACR will automatically set the Temperature and Tint sliders so that the selected picture part becomes a neutral gray and in the process the rest of the image will be balanced. For best results when selecting lighter tones with the tool ensure that the area contains detail and is not a blown or specular highlight (reflected light source with no details).

In Photoshop:

Color correction using Levels: If you select a Red, Green or Blue color channel (from the channel's pull-down menu) prior to moving the Gamma slider (middle slider) you can remove a color cast present in the image. For those unfamiliar with color correction, the adjustment feature 'Variations' in Photoshop gives a quick and easy solution to the problem.

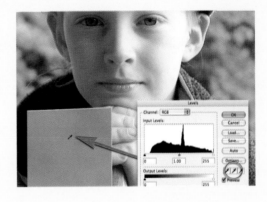

Setting a gray point: Start by changing the Eyedropper sample to 5 × 5 Average. Next click on the 'Sample in image to set gray point' eyedropper in the Levels dialog box and then click on any neutral tone present in the image to remove a color cast. Introducing a near white card or gray card into the first image of a shoot can aid in subsequent color corrections for all images shot using the same light source.

Note > See 'Retouching Projects – Project 2' for more information.

Variations (not available when editing 16-bit files):
The 'Variations' command allows the adjustment of color balance, contrast and saturation to the whole image or just those pixels that are part of a selection. For individuals that find correcting color by using the more professional color correction adjustment features intimidating, Variations offers a comparatively user-friendly interface. By simply clicking on the alternative thumbnail that looks better the changes are applied automatically. The adjustments can be concentrated on the highlights, midtones or shadows by checking the appropriate box. The degree of change can be controlled by the Fine/Coarse slider. Variations can be accessed from the Adjustments submenu in the Image menu.

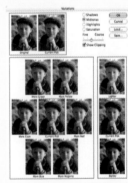

The downside of this feature is that it can't be implemented via an adjustment layer and for this reason most professionals avoid using it.

Note > Clicking on a thumbnail more than once will result in repeated, and increasing, intensity of the chosen correction. Editing with the highlights, shadows or saturation button checked can lead to a loss of information in one or more of the channels. If the 'Show Clipping' is checked, a neon warning shows areas in the image that have been adjusted to 255 or 0. Clipping does not, however, occur when the adjustment is restricted to the midtones only.

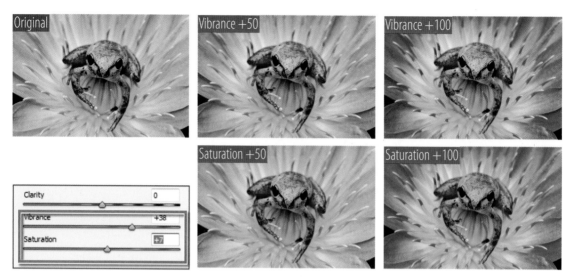

Both the Vibrance and Saturation sliders control the strength of the colors in your photos

Other ACR color controls

As well as options for adjusting the white balance in a photo, Adobe Camera Raw also contains two sliders that are concerned with controlling the strength of the hues in your pictures – Vibrance and Saturation.

Vibrance

The Vibrance slider, like the Saturation control, increases the vividness of the colors in photos but applies the changes selectively to only those hues that are desaturated in the first place. This means that the slider targets the more pastel tones and doesn't boost those colors that are already rich and vibrant. In addition, the Vibrance slider tends to safeguard Caucasian skin tones when it is applied.

Saturation

In contrast the Saturation slider increases the saturation, or vividness, of all the colors in a photo irrespective of their original value. These factors make the Vibrance slider perfect when working with portraits or photos where selective adjustment is needed. The Saturation slider, on the other hand, is very useful for bumping the color of the whole photo up a few notches. Moving the slider all the way to the left creates a grayscale image devoid of color, but don't be tempted to create monochromes in this way as ACR contains more appropriate controls for this process. See the Raw Processing chapter for more details about ACR-based grayscale conversions.

Note > Adobe Camera Raw contains a variety of other color controls that are capable of adjusting specific color ranges. These and other more sophisticated ACR features are discussed in the next chapter – Raw Processing.

Tonal adjustments – Step 6

The starting point to adjust the tonal qualities of EVERY image is either the six slider controls (Exposure, Recovery, Fill Light, Blacks, Brightness and Contrast) in the Basic pane of ACR or the 'Levels' dialog box (go to 'Image > Adjustments > Levels') in Photoshop.

It is important to perform tonal adjustments with reference to some objective feedback about the nature of the changes you are making. For this reason the Histograms located at the top right of the ACR workspace or inside the Levels dialog should always be consulted when enhancing your photos. Features like Brightness/Contrast, that don't include this objective feedback, should never be used.

Histograms

Essentially the histogram is a graph of the pixels in your photo. The horizontal axis of the histogram displays the brightness values from left (darkest) to right (lightest). The vertical axis of the histogram shows how much of the image is found at any particular brightness level. If the subject contrast or 'brightness range' exceeds the latitude of the capture device or the exposure is either too high or too low, then tonality will be 'clipped' (shadow or highlight detail will be lost and no amount of adjustment will recover it). ACR's histogram also displays the information of each channel (red, green, blue) that makes up the photos as colored parts of the graph and include clipping warning features in the top corners of the dialog.

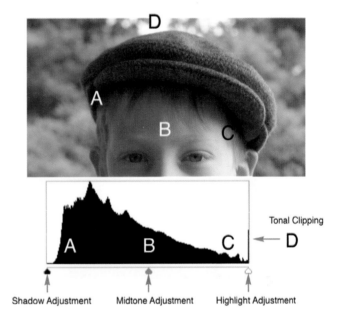

During the capture stage it is often possible to check how the capture device is handling or interpreting the tonality and color of the subject. This useful information can often be displayed as a 'histogram' on the LCD screen of high-quality digital cameras or in the scanning software during the scanning process. The histogram displayed shows the brightness range of the subject in relation to the latitude or 'dynamic range' of your capture device's image sensor. Most digital camera sensors have a dynamic range similar to color transparency film (around five stops) when capturing in JPEG or TIFF. This may be expanded beyond seven stops when the Raw data is processed manually. When capturing using a tethered workflow, the accuracy of the histogram is increased in that you are able to view, and base your exposure decisions on, a graph of the captured Raw file (displayed in ACR) rather than a processed JPEG as is the case for many back of camera LCD histograms.

Note > You should attempt to modify the brightness, contrast and color balance at the capture stage to obtain the best possible histogram before editing begins in the software.

Optimizing tonality

In a good histogram, one where a broad tonal range with full detail in the shadows and highlights is present, the information will extend all the way from the left to the right side of the histogram. The histogram on the left (below) indicates missing information in the highlights (right side of histogram) indicating overexposure. The histogram on the right indicates a small amount of 'clipping' or loss of information in the shadows (left side of histogram) or underexposure.

ACR histograms indicating image is either too light (left) or too dark (right)

Brightness

If the digital file is too light a tall peak will be seen to rise on the right side (level 255) of the histogram. If the digital file is too dark a tall peak will be seen to rise on the left side (level 0) of the histogram. **Solution:** Decrease or increase the exposure/brightness in the capture device.

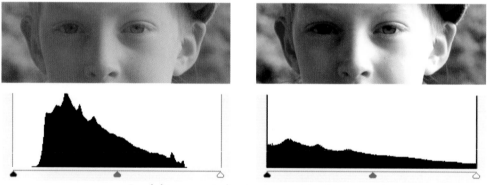

Levels histograms indicating image either has too much contrast or not enough

Contrast

If the contrast is too low the histogram will not extend to meet the sliders at either end. If the contrast is too high a tall peak will be evident at both extremes of the histogram.

Solution: Increase or decrease the contrast of the light source used to light the subject or the contrast setting of the capture device. Using diffused lighting rather than direct sunlight or using fill flash and/or reflectors will ensure that you start with an image with full detail.

Previewing clipping

One of the critical areas of image adjustment is ensuring that any changes to tone or color don't clip captured details in either the shadow or highlight areas of the photo. In ACR the preview image in conjunction with the histogram form a key partnership in providing this clipping feedback to the user when they are making changes to the photo. By activating the highlight

and shadow clipping warnings in the histogram (click on the upwards-facing arrows in the top left, for shadows, or top right, for highlights of the histogram), areas being clipped are displayed in the preview image.

Clipped shadow details are displayed in blue and clipped highlights in red. As well as the warning in the preview image, the actual clip warning arrows in the histogram area reflect the color of the channels (red, green, blue or combinations thereof) being clipped. If details for more than one channel are being clipped then the arrow turns white. If no details are being clipped then the arrow is black.

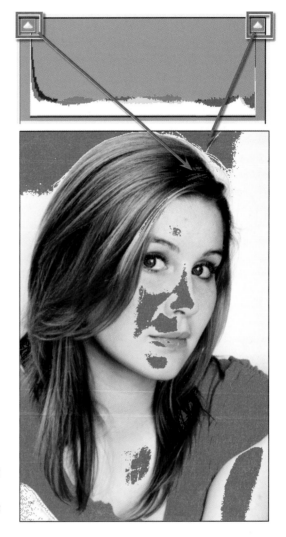

Optimizing a histogram after capture

The final histogram should show that pixels have been allocated to most, if not all, of the 256 levels. If the histogram indicates large gaps between the ends of the histogram and the sliders (indicating either a low-contrast scan or low-contrast subject photographed in flat lighting) the subject or original image should usually be recaptured a second time. In situations when this is not possible use the following ACR controls to adjust the look of the histogram and therefore the tones in the photo.

Setting the white point

To start, adjust the white point with the Exposure slider. Moving the slider to the right lightens the photo and to the left darkens it. The settings for the slider are in f-stop increments (or EVs), with a +1.00 setting being equivalent to increasing exposure by 1 f-stop. Use this slider to place or set the white tones. Your aim is to lighten the highlights in the photo without clipping (converting the pixels to pure white) them. To do this interactively, hold down Alt/

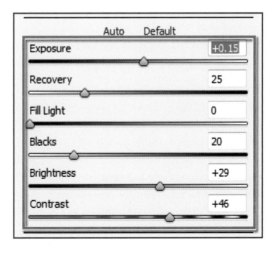

Option while moving the slider. This action previews the photo with the pixels being clipped against a black background. Move the slider back and forth until highlights with detail start to clip; the aim is to lighten the highlights where you want to preserve detail without clipping and losing that detail.

Note > An alternative to holding down the Alt/Opt key is to keep an eye on the clipping warning triangles at the top of the histogram. When they are black no clipping is occurring, when colored the channel containing these pixels is being clipped and when white multiple channels are being clipped. Clicking the warning triangles (so that they are surrounded by a white rectangle) activates the clipping warning in the preview without the need to hold down the Alt/Opt key.

Adjusting the blacks (shadows)

The Blacks slider (previously Shadows) performs a similar function with the shadow areas of the image. Again the aim is to darken these tones but not to convert (or clip) delicate details to pure black. Just as with the Exposure slider, the Alt/Option key can be pressed or the clipping warning triangles consulted, while making Blacks adjustments to preview the pixels being clipped.

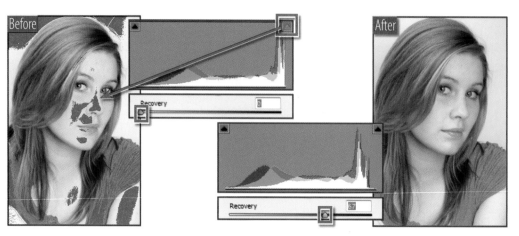

The Recovery slider is designed as a fine control for the highlight tones in your photo

Tweaking problem areas

When a photograph is overexposed, one of the consequences can be that the lighter tones in the image lose detail and are converted to pure white. As we have seen, this process is called clipping. Digital images are created with details from three color channels (red, green, blue). In situations of slight overexposure, when only one channel is clipped, it is possible to recreate the lost detail with the highlight information from the other two (non-clipped) channels. The Recovery slider attempts to recreate lost highlight details in such cases. Moving the slider to the right progressively increases the degree of highlight recovery. The Fill Light slider is used to lighten the darker tones in a picture without affecting the middle to highlight values. Use this control to brighten backlit subjects or boost shadow details. The beauty of this control is that the changes it makes do not generally impact on mid to highlight values.

Brightness changes

The next control, moving from top to bottom of the ACR dialog, is the Brightness slider. At first glance the changes you make with this feature may appear to be very similar to those produced with the Exposure slider but there is an important difference. Yes it is true that moving the slider to the right lightens the whole image, but rather than adjusting all pixels the same amount the feature makes major changes in the midtone areas and smaller jumps in the highlights. In so doing the Brightness slider is less

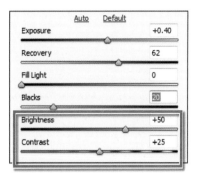

likely to clip the highlights (or shadows) as the feature compresses the highlights as it lightens the photo. This is why it is important to set white and black points first with the Exposure and Blacks sliders before fine-tuning the image with the Brightness control. That said, always make sure that your clipping warnings are activated when making tonal changes as this will mean that any clipping that occurs as a result of your adjustments will be clearly displayed in the preview.

Increasing/decreasing contrast

The last tonal control in the dialog, and the last to be applied to the photo, is the Contrast slider. The feature concentrates on the midtones in the photo, with movements of the slider to the right increasing the midtone contrast and to the left producing a lower contrast image. Like the Brightness slider, Contrast changes are best applied after setting the white and black points of the image with the Exposure and Blacks sliders.

In Photoshop:

Small gaps at either end of the histogram can be corrected by dragging the sliders to the start of the tonal information. Holding down the Alt/Option key when dragging these sliders will indicate what, if any, information is being clipped. Note how the sliders have been moved beyond the short thin horizontal line at either end of the histogram. These low levels of pixel data are often not representative of the broader areas of shadows and highlights within the image and can usually be clipped (moved to 0 or 255). Moving the 'Gamma' or midtone slider can modify the brightness of the midtones. After correcting the tonal range using the sliders, click 'OK' in the top right-hand corner of the Levels dialog box.

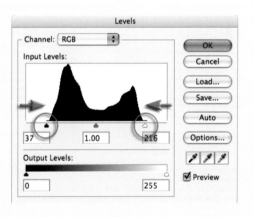

Note > Use Levels for all initial brightness and contrast adjustments. The Brightness/Contrast adjustment feature in Photoshop CS and CS2 should be avoided as this will upset the work performed using Levels and can result in a loss of information.

More sophisticated tonal control

When the overall tonality has been optimized using either the sliders in ACR, or the Levels feature in Photoshop, the midtone contrast and appearance of the details in the shadow and highlight areas may require further work. One of the limitations of Photoshop's Levels adjustment feature is that it cannot focus its attention on only the shadows or the highlights, e.g. when the slider is moved to the left both the highlights and the shadows are made brighter. More control is available with the four key tonal sliders in ACR (Exposure, Recovery, Fill Light and Blacks) where specific attention can be paid to these areas.

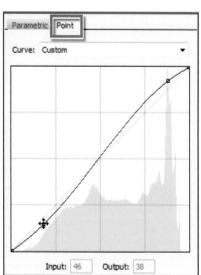

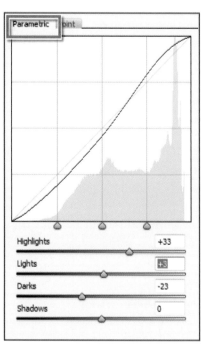

The Curves feature in ACR has two different modes for adjusting how the tones in your images are spread between black and white. The Point mode (immediate right) works in a similar way to the curves feature in Photoshop whereas the Parametric mode (far right) provides four sliders that can be used to tweak specific tonal ranges

More targeted adjustments can be achieved using the Curves adjustment features found in both ACR (Tone Curve tab) and Photoshop (Image > Adjustments > Curves). Curves allows the user to target tones within the image and move them independently of other tones within the image, e.g. the user can decide to make only the darker tones lighter while preserving the value of both the midtones and the highlights. It is also possible with a powerful editing feature such as Curves to move the shadows in one direction and the highlights in another. In this way the contrast of the image could be increased without losing valuable detail in either the shadows or the highlights. Slightly different approaches are taken with the feature in ACR and Photoshop. See 'Advanced Retouching – Projects 1 and 2' for more information on using Curves in Photoshop. Adobe Camera Raw provides two different Curve modes – Parametric and Point.

Parametric: This version of the ACR Curves feature provides four slider controls (Highlights, Lights, Darks and Shadows) as the means to adjust the shape of the curve. The slider controls tend to offer a fast way to manipulate different parts of the curve.

Point: The Point mode works in a similar way to Curves in Photoshop. Control points can be added to the different parts of the curve. These points can then be pushed and pulled to change

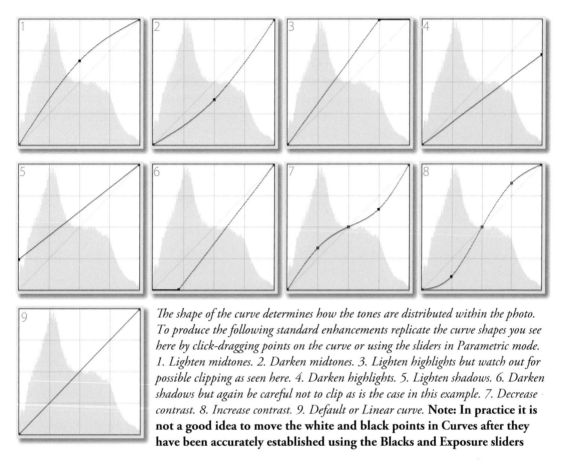

The shape of the curve determines how the tones are distributed within the photo. To produce the following standard enhancements replicate the curve shapes you see here by click-dragging points on the curve or using the sliders in Parametric mode. 1. Lighten midtones. 2. Darken midtones. 3. Lighten highlights but watch out for possible clipping as seen here. 4. Darken highlights. 5. Lighten shadows. 6. Darken shadows but again be careful not to clip as is the case in this example. 7. Decrease contrast. 8. Increase contrast. 9. Default or Linear curve. **Note: In practice it is not a good idea to move the white and black points in Curves after they have been accurately established using the Blacks and Exposure sliders**

the curve shape. Points can also be used to anchor specific tonal values so that they don't change while altering other parts of the curve. Holding down the Ctrl/Cmd key allows the user to place a control point on the curve by clicking on a specific part of the preview image. Using the Color Sample Tool it is also possible to add a sample entry by clicking on a part of the photo. This displays RGB values of the selected point at the top of the ACR dialog.

Other tonal control options available in Photoshop

Photoshop's Shadow/Highlight adjustment feature (Image > Adjustments > Shadow/Highlight) offers an alternative to Curves and is similar to the Fill Light and Recovery sliders in ACR. This targets and adjusts tonality in a non-destructive way and in many ways offers superior control than the Curves adjustment feature (midtone contrast) in a user-friendly interface. The disadvantage is that the adjustment is not available as an adjustment layer. See 'Advanced Retouching' for more information.

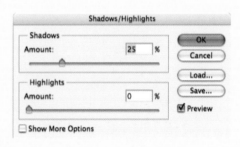

Note > See 'Retouching Projects – Project 3' for more information on shadow and highlight control.

Targeting key values

To ensure highlights do not 'blow out' and the shadows do not print too dark it is possible to target, or set specific tonal values, for the highlight and shadow tones within the image using the Color Sample Tool in ACR or the eyedroppers (found in Photoshop's Levels and Curves dialog boxes). The tones that should be targeted are the lightest and darkest areas in the image with detail. The default settings of these eyedroppers are set to 0 (black) and 255 (white). These settings are only useful for targeting the white paper or black film edge. After establishing the darkest and lightest tones that will print using a step wedge (see 'Digital Printing') these target levels can be used as a guide with the Color Sample Tool display or assigned to the Photoshop eyedroppers.

Here we will use some generic values. When using ACR look for maximum RGB values around 250 for highlights and close to 5 for shadows. Make sure that you ignore specular highlights when adjusting highlight areas. These areas are generally reflections of light sources and can have a value of 255 as they typically contain no texture. Now unless you are targeting a neutral tone, the three color values will be different; make sure that the highest, for highlights, and lowest, for shadows, are close to these targets. In Photoshop we will use a Brightness setting, taken from the HSB readout, of between 4 and 8 for shadows and 92 and 99 for highlights.

Setting target values in Adobe Camera Raw

To help with keeping an eye on how changes are affecting key parts of the picture, ACR has a special Color Sample Tool which can be used to display the RGB values of these picture parts. Use the following steps to use the Color Sample Tool:

1. Start by selecting the tool from the toolbar at the top of the workspace. Now move the tool around the image until you find the darkest part of the photo. To help with this process, turn on the clipping warnings and temporarily drag the Black slider to the right until you start to see clipping occur in the preview. The parts of the picture where the clipping is first noticeable will be the darkest part of the image.

2. Click the Color Sample Tool on this picture part. Notice that a small crosshairs icon has been placed on the picture and an entry area is now displayed below the toolbar and a new RGB entry is present. Now adjust the Black and/or Fill Light sliders until the RGB display shows 5 as the lowest of the values.

3. With the highlight clipping warning selected, drag the Exposure slider to the right until the preview shows a part of the photo that is being clipped. Place a second Color Sample Tool on this part of the photo. Using the Exposure and Recovery sliders adjust the picture part until the highest of the three values is around 250.

Note > Because the ACR Color Sample Tool displays RGB values, the targeted clipping areas might not necessarily be the blackest or whitest parts of the picture. For instance, in the example portrait we use here, portions of the girl's red shirt are the areas being most clipped with careless Exposure or Recovery adjustments. In this instance it is these areas that should be targeted with ACR's Color Sample Tool.

Setting target values in Photoshop

Note > The following procedure is recommended for quick corrections only. The procedure is useful for a semi-automated approach to target the important shadow and highlight tones.

1. Double-click the black or white eyedropper tool in the Levels dialog box to display the Color Picker (now called the 'Select target shadow color' or 'Select target highlight color' dialog box).
2. Enter a value in the 'Brightness' field (part of the Hue, Saturation and Brightness or 'HSB' controls) and select OK. A value between 4 and 8 would be considered 'normal' for shadow target tones while values between 92 and 99 could be considered for target highlight tones.
3. Carefully view the image to locate the brightest highlight or shadow with detail. Be careful to select representative tones, e.g. for the target highlight do not select a specular highlight such as a light source or a reflection of the light source which should register a value of 255.
4. Using the black and white eyedropper tools, with the altered values, click on the appropriate image detail to assign their target values.

Note > When setting the target values of a color image it is important to select neutral highlight or shadow tones, otherwise a color cast may be introduced into the image. If a color cast is introduced using this technique the color can be corrected by using the center eyedropper 'Sample in image to set gray point' and then clicking on a neutral tone within the image.

Cleaning an image – Step 7

The primary tools for removing blemishes, dust and scratches are the Spot Removal brush in Adobe Camera Raw and the 'Clone Stamp Tool', the 'Healing Brush Tool' and the 'Spot Healing Brush Tool' in Photoshop. The process for using ACR's Spot Removal brush borrows from both the Clone Stamp and Spot Healing Brush Tools in Photoshop. The tool contains two components: a circle that indicates the target of the retouching, which is generally placed over the mark to remove, and a circle to select the source area that will be used as a reference for the color, tone and texture that will be painted over the mark. Sound familiar? It should – this is how the Clone Stamp Tool works. The difference is that with ACR's Retouch Tool, the target area is selected first by click-dragging the cursor to the size of the mark. ACR then automatically searches for a suitable source point in the nearby pixels.

For ease of recognition the target circle is colored red and the source circle is a green hue. Both circles are linked with a straight line to indicate which source belongs to which target.

For the majority of the time ACR does a pretty good job of selecting a source point, but there will be occasions when you may want to choose your own. This is a simple matter of click-dragging the source circle to a new location. The same technique can be used for moving the target circle. To change the target size use the Radius slider in the tool's options bar at the top of the dialog. Holding down the Alt/Option key while clicking on the target circle deletes or cuts the retouching entry.

To Heal or Clone

The tool works in two modes – Heal and Clone. The Heal mode uses the technology found in the Spot Healing Brush to help match texture and tone of the source area to the target surrounds. The Clone option gives more weighting to the specific qualities of the source area when over-painting the mark.

1. Start the process by ensuring that the preview window is enlarged to at least 100%. Select the magnification level from the pop-up menu on the bottom left of the dialog. Viewing the image zoomed in helps guarantee accuracy when specifying both target and source areas and presents a more precise preview of the results. Switch to the Hand Tool using the H keyboard shortcut, to click-drag the preview area around the photo. You can switch back to the Retouch Tool by pressing the letter B key.

2. Now drag the preview until you locate an area to be retouched. Select the Retouch Tool from the ACR toolbar at the top of the dialog. By default the tool draws from the center, so move the pointer over the middle of the mark and click-drag the circle until it encompasses the blemish. This action sets the red target circle or the area to be retouched.

3. Unlike the situation with the Clone Stamp or Healing Brush Tools there is no need to select the sample area separately. Adobe Camera Raw automatically searches the surrounds of the target area for a likely source and draws a corresponding circle attached with a single straight line. The source circle is colored green to distinguish it from the red target circle. If the source circle has been positioned incorrectly or is providing less than acceptable results in the target area then simply click-drag the circle to a new location.

4. Once the target and source have been positioned, the retouching entry can be modified in a couple of different ways. The size of the target circle can be adjusted by clicking onto the circle and then changing the Radius setting in the tool's options contained in the right panel of the dialog (use the up and down arrows for 1 pixel changes). The mode used for retouching

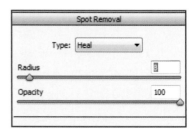

can be switched between Heal (the technology used by the Spot Healing Brush) and Clone (which simulates the way that the Clone Stamp Tool functions) using the drop-down menu also contained here. The Opacity option can be used to let more of the spot details below show through the correction.

5. Individual retouching entries can be removed or deleted altogether by cutting the entry. With the Retouch Tool selected, hold down the Alt/Opt key while positioning the cursor over either the source or target circles of the retouching entry. The cursor will switch shapes to a pair of scissors (see aside). Clicking the mouse button will then delete the entry.

6. Once you have positioned and adjusted all retouching entries for a given image you can preview the results, without the target and source circles, by deselecting the Show Overlay setting in the tool's options. To re-display the circles, reselect the option.

7. As all retouching entries created in Adobe Camera Raw are non-destructive they can be removed at any time, even if the file has been saved and reopened. To remove all retouching entries for the current image, select the Clear All button in the Retouch Tool options bar.

In Photoshop:

The Clone Stamp is able to paint with pixels selected or 'sampled' from another part of the image. The Healing Brush is a sophisticated version of the Clone Stamp Tool that not only paints with the sampled pixels but then 'sucks in' the color and tonal characteristics of the pixels surrounding the damage. The Spot Healing Brush Tool requires no prior sampling and is usually the first choice for most repairs. The following procedures should be used when working with the Spot Healing Brush Tool or Healing Brush Tool.

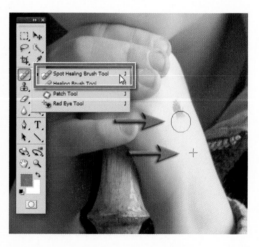

1. Select the Spot Healing Brush Tool from the Tools panel.

2. Zoom in to take a close look at the damage that needs to be repaired.

3. Choose an appropriate size, soft-edged brush from the brushes panel that just covers the width of the blemish, dust or scratch to be repaired.

4. Move the mouse cursor to the area of damage.

5. Click and drag the tool over the area that requires repair.

6. Increase the hardness of the brush if the repair area becomes contaminated with adjacent tones, colors or detail that does not match the repair area.

7. For areas proving difficult for the Spot Healing Brush to repair switch to the Healing Brush Tool or the Clone Stamp Tool. Select a sampling point by pressing the Alt/Option key and then clicking on an undamaged area of the image (similar in tone and color to the damaged area). Click and drag the tool over the area to paint with the sampled pixels to conceal the damaged area (a crosshair marks the sampling point and will move as you paint).

Note > If a large area is to be repaired with the Clone Stamp Tool it is advisable to take samples from a number of different points with a reduced opacity brush to prevent the repairs becoming obvious.

Sharpening an image – Step 8

Sharpening the image is the last step of the editing process. Many images benefit from some sharpening even if they were captured with sharp focus. The sliders in Adobe Camera Raw's Detail pane and Photoshop's 'Unsharp Mask' and the 'Smart Sharpen' filters from the 'Sharpen' group of filters are the most sophisticated and controllable of the sharpening filters. They are used to sharpen the edges by increasing the contrast where different tones meet. The pixels along the edge on the lighter side are made lighter and the pixels along the edge on the darker side are made darker.

In the latest versions of ACR the sharpening controls have been increased to four from a single slider a couple of versions ago. Where originally users were only able to control the Amount of sharpening, now it is possible to manipulate how the effect is applied. Sharpening effects are controlled via the following sliders – Amount, Radius, Detail and Masking.

The **Amount** slider controls the strength of the sharpening effect. Move the slider to the right for stronger sharpening, to the left for more subtle effects. The **Radius** slider determines the number of pixels from an edge that will be changed in the sharpening process. The **Detail** slider is used to increase the local contrast around edge parts of the picture. An increase makes the picture's details appear sharper. The **Masking** control channels the sharpening effect through an edge locating mask.

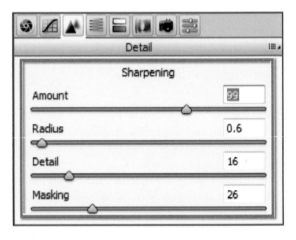

Both the Detail and Masking sliders are used to target the sharpening more precisely in the image. Increasing the Detail value will raise the local contrast around smaller picture parts. Reducing the value will decrease the appearance of haloes around these areas. Moving the Masking slider to the right gradually isolates the edges until the sharpening is only being applied through the most contrasty sections of the photograph.

Previewing sharpening effects

With the preview at 100% magnification, holding down the Alt/Opt key will display different previews for each of the Sharpening sliders. The preview for the Amount slider shows the

sharpening applied to the luminosity of the image. Both Radius and Detail sliders preview the value of the slider and the Masking option displays the mask being used for restricting where the sharpening is being applied. Remember the black areas of the mask restrict the sharpening and the light areas allow the sharpening to be applied.

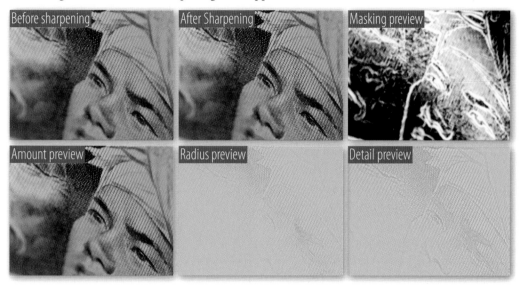

In Photoshop:

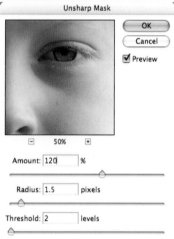

Before you use the Unsharp Mask go to 'View > Actual Pixels' to adjust the screen view to 100%. To access the Unsharp Mask (the slightly simpler of the two sophisticated sharpening filters) go to 'Filter > Sharpen > Unsharp Mask'. Start with an average setting of 100% for 'Amount', a 1- to 1.5-pixel 'Radius' and a 'Threshold' of 3. The effects of the Unsharp Mask filter are more noticeable on-screen than in print. For final evaluation always check the final print and adjust if necessary by returning to a previously saved version or by going back one step in the History panel. The three sliders control:

Amount – This controls the strength of the sharpening adjustment. Eighty to 180% is normal.

Radius – Controls the width of the adjustment occurring at the edges. There is usually no need to exceed 1 pixel if the image is to be printed no larger than A4/US letter. A rule of thumb is to divide the image resolution by 200 to determine the radius amount, e.g. 200ppi ÷ 200 = 1.00.

Threshold – Controls where the effect takes place. A zero threshold affects all pixels whereas a high threshold affects only edges with a high tonal difference. The threshold is usually kept very low (0 to 2) for images from digital cameras and medium- or large-format film. The threshold is usually set at 3 for images from 35mm. Threshold is increased to avoid accentuating noise, especially in skin tones.

Note > See 'Retouching Projects – Project 5' for more information on sharpening images.

Saving a modified file – Step 9

Now to the business end of the optimization task – outputting the file. When working with Raw files in Adobe Camera Raw you have more options at this point than if you were enhancing the photos in Photoshop. There is no longer a need to convert the picture from its Raw state in order to save the changes you have made. These alterations can be either

- stored with the Raw file,
- applied to the file and the photo then saved as a non-Raw format such as TIF or PSD,
- applied to the photo which is then passed to Photoshop, or
- the Raw file can be embedded as a Smart Object in a new Photoshop document.

Controlling color depth/space and image size/resolution

The section below the main preview window in ACR contains the Workflow Options settings. Here you can adjust the color depth (8 or 16 bits per channel), the color space (ICC profile), the image size (maintain capture dimensions for the picture or size up or down) and the image resolution (pixels per inch or pixels per centimeter). It is here that you adapt image characteristics to suit different outcomes. You can resize images to suit screen dimensions and also adjust the resolution of

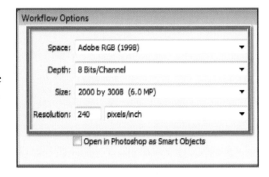

the file to match the dpi of the monitor or upsize a photo, select an appropriate ICC profile and depth for a poster print. With these options set you can then move onto deciding how to output the file.

Opening into Photoshop

The most basic option is to process the Raw file according to the settings and adjustments selected and then open the picture into the editing workspace of Photoshop. To do this click the Open Image button at the bottom right of the dialog. Select this route if you intend to edit or enhance the image beyond the changes made during the conversion. This option will maintain the Raw file in Bridge and create a new Photoshop document of the converted (no longer Raw-based) photo.

Saving the processed Raw file

There is also the ability to save converted Raw files from inside the ACR dialog via the Save button. This action opens the Save Options dialog which contains settings for inputting file names, choosing file types and extensions as well as file type-specific characteristics such as compression. Opt for this approach for fast processing of multiple files without the need to open them in Photoshop.

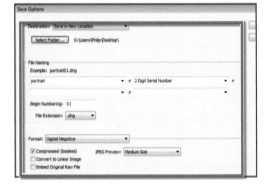

Applying the Raw conversion settings

ACR also allows the user to apply the current settings to the Raw photo without opening the picture into Photoshop. Just click the Done button. The great thing about working this way is that the settings are applied to the file losslessly. The photo remains in the Raw format. No changes are made to the underlying pixels, only to the instructions that are used to process the Raw file. When next the file is opened, the applied settings will show up in the ACR dialog ready for fine-tuning, or even changing completely. When the ACR dialog is closed the thumbnail for the photo is updated in Bridge to reflect the changes. If adjustment settings have been applied to the photo, then a small settings icon is placed in the top right-hand corner of the thumbnail. When a picture has been cropped, a crop icon is displayed as well.

Foundations_Project_01.NEF

Creating a Smart Object

If you are wanting to continue working with your unconverted Raw file inside Photoshop then you will need to embed the file in a Smart Object layer within a Photoshop document. Unlike the earlier versions of

ACR where this process had to be accomplished manually, it is now possible to embed the file using a single button inside ACR. While holding down the Shift key, press the Open Object button. This action automatically creates a new Photoshop document and embeds the Raw file in a Smart Object layer. Alternately you can set this as a default option in the workflow options dialog box.

In Photoshop:

Go to the 'File' menu and select 'Save As'. Name the file, select 'TIFF' or 'Photoshop' as the file format and select the destination 'Where' the file is being saved. Check the 'Embed Color Profile' box and click 'Save'. Keep the file name short using only the standard characters from the alphabet. Use a dash or underscore to separate words rather than leaving a space and always add or 'append' your file name after a full stop with the appropriate three- or four-letter file extension (.psd or .tif). This will ensure your files can be read by all and can be safely uploaded to web servers if required. Always keep a backup of your work on a remote storage device if possible.

Resize for web page viewing

Duplicate your file by going to 'Image > Duplicate Image'. Rename the file and select OK. Go to 'Image > Image Size'. Check the 'Constrain Proportions' and 'Resample Image' boxes. Type in 600 pixels in the 'Height' box (anything larger may not fully display in a browser window of a monitor set to 1024 × 768 pixels without the viewer having to use the scroll or navigation bars). Use the Bicubic Sharper option when reducing the file size for optimum quality.

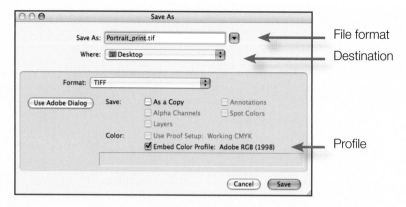

File format

Destination

Profile

Using the Crop Tool (typing in the dimensions in pixels, e.g. 600px and 400px) will also resize the image quickly and effectively. This technique does not, however, make use of Bicubic Sharper and images may require sharpening a second time using the Smart Sharpen or Unsharp Mask filter.

Note > Internet browsers do not respect the resolution and document size assigned to the image by image-editing software – image size is dictated by the resolution of the individual viewer's monitor. Two images that have the same pixel dimensions but different resolutions will appear the same size when displayed in a web browser. A typical screen resolution is often stated as being 72ppi but actual monitor resolutions vary enormously.

JPEG format options

After resizing you should set the image size on screen to 100% or 'Actual Pixels' from the View menu (this is the size of the image as it will appear in a web browser on a monitor of the same resolution). Go to 'File' menu and select 'Save As'. Select JPEG from the Format menu. Label the file with a short name with no gaps or punctuation marks (use an underscore if you have to separate two words) and finally ensure the file carries the extension .jpg (e.g. portrait_one.jpg). Click 'OK' and select a compression/quality setting from the 'JPEG Options' dialog box. With the Preview box checked you can check to see if there is excessive or minimal loss of quality at different compression/quality settings in the main image window.

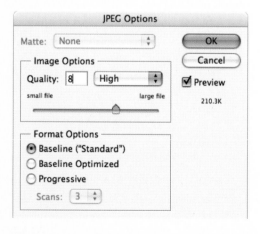

Note > Double-clicking the Zoom Tool in the Tools panel will set the image to actual pixels or 100% magnification.

Choose a compression setting that will balance quality with file size (download time). High compression (low quality) leads to image artifacts, lowering the overall quality of the image. There is usually no need to zoom in to see the image artifacts as most browsers and screen presentation software do not allow this option.

Image Options: The quality difference on screen at 100% between the High and Maximum quality settings may not be easily discernible. The savings in file size can, however, be enormous, thereby enabling much faster uploading and downloading via the Internet.

Format Options: Selecting the 'Progressive' option from the Format Options enables the image to be displayed in increasing degrees of sharpness as it is downloading to a web page, rather than waiting to be fully downloaded before being displayed by the web browser.

Size: The open file size is not changed by saving the file in the JPEG file format as this is dictated by the total number of pixels in the file. The closed file size is of interest when using the JPEG Options dialog box as it is this size that dictates the speed at which the file can be uploaded and downloaded via the Internet. The quality and size of the file is a balancing act if speed is an issue due to slow modem speeds.

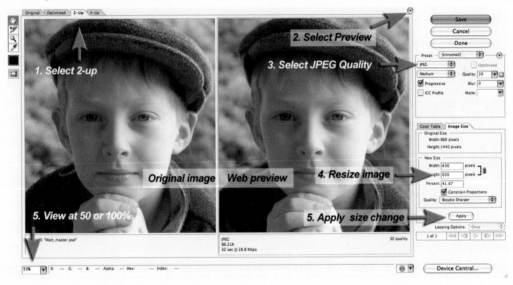

Save for Web & Devices

The Save for Web & Devices command from the File menu offers the user an alternative, all-in-one, option for resizing, optimizing and previewing the image prior to saving the file in the JPEG format. Access the Save for Web & Devices feature from the File menu. Click on the 2-up tab to see a before and after version of your image. Click on the second image and, from the 'Preview Menu', choose either the Mac or Windows options. This will enable you to anticipate how your image may be viewed in software that cannot read the ICC profile that Photoshop normally embeds as part of the color management process, e.g. most web browsers.

To adjust the color or tone prior to saving as a JPEG exit the Save for Web feature and go to View > Proof Setup and then choose either Macintosh RGB or Windows RGB depending on the intended monitor that the image will be viewed on. With the Proof Setup switched on, adjustments may be required to both image brightness and saturation in order to return the appearance of the image to 'normal'. Brightness should be controlled via the 'Gamma' slider in the 'Levels' adjustment feature and color saturation via the 'Hue/Saturation' adjustment feature.

Capture and enhance workflow overview

1. Capture an image with sufficient pixels for the intended output device.
2. Download or transfer files.
3. Rate and add keywords to files.
4. Resize and crop the image.
5. Adjust the color.
6. Tweak the tonality.
7. Clean the image.
8. Sharpen the photo.
9. Apply the processing and output the picture

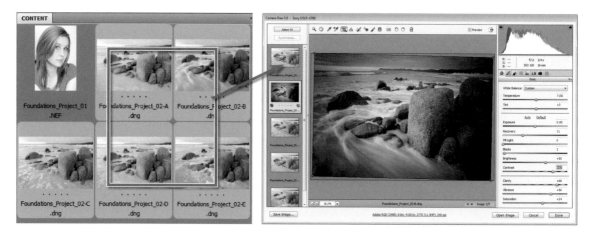

Multiple photos can be selected in Bridge and passed to ACR for speedier processing

Foundation Project 2

We now have an idea about the types of changes that are regularly applied to images in order to optimize them for a specific outcomes. Although there are not many steps, applying them to a number of images could be a time-consuming task. This is especially true when shooting Raw as there are extra processing options available with this format than if you capture in TIFF or JPEG. For this reason there are several 'batch' processing features available in Bridge, ACR and Photoshop that can help speed up the enhancement of groups of photos.

Quality versus quantity

Now some of you might already be thinking to yourselves that any type of processing applied to groups of photos rather than individual images will have to be less than optimal for each picture, and you would be right. But because of the nature of non-destructive editing and enhancing techniques that we are advocating here it is possible to apply some generic enhancement settings to groups of images quickly and then 'drill down' to each individual photo to apply the fine-tuning. This way of working is often used by photographers who take multiple images under the same lighting conditions or in the same environment.

General, overall adjustments are made to all the photos before working through each photo to fine-tune the results. And while we are talking of speeding up our photo workflow don't forget that other parts of the process such as adding metadata and outputting photos to a specific format, size and ICC profile can also be handled by batch processing. Let's see how.

Image capture – Step 1

Capture a series of images under similar lighting to be used in this batch processing project. The photos don't have be studio based; the processing of landscape, architectural and even editorial images can all be quickened using the following techniques. If you are stuck for examples, then use the Friendly Beaches series contained on the book's DVD.

Multi-select and open – Step 2

As well as being able to process files one at a time, Adobe Camera Raw is capable of queueing multiple Raw files and working on this either in sequence or in sets of pictures. After several Raw photos are selected inside Bridge and then opened into ACR (File > Open in Camera Raw), you will notice the pictures are listed on the left side of the dialog. The same scenario occurs when selecting multiple pictures in the File > Open dialog from inside Photoshop. Once loaded into ACR the files can be worked on individually by selecting each thumbnail in turn, making the necessary changes and then moving to the next picture in the list. But there is a more efficient way to process multiple files. First, select a group of images either taken under the same conditions with similar subject matter, or that you are wanting to process in a similar way (e.g. convert to grayscale and then sepia tone).

Multi-processing – Step 3

Next open these into ACR using the keyboard shortcut Ctrl/Cmd + R. Now pick one of the photos that best represents the characteristics of the group and proceed to make the corrections to color, tone and sharpness.

When complete, pick the Select All button at the top of the queue section of the dialog to pick all queued photos, or multi-select a subset

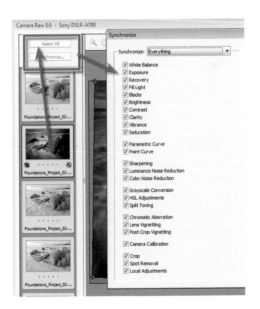

of photos and then push the Synchronize button. The Synchronize dialog will be displayed, listing all the ACR controls that can be copied from the initial photo to the rest of the group. Select, or deselect, the controls as desired, and then click OK. Automatically the settings are synchronized across all the selected photos.

It is important to check each individual file in ACR after synchronizing a set of adjustments across multiple files. That way you can customize the general corrections for each photo while they are still open in the program

Fine-tune – Step 4

This provides a good starting point for the enhancement process; all that now remains is to flick through each individual image and double-check that the settings are working for that specific photo. If need be, then the settings can be fine-tuned to better suit any image.

Output enhanced files – Step 5

Once the settings have been applied in ACR, the images can be saved, opened, copied or opened as objects just like any other files in Photoshop. When more than one picture is selected from the queue grouping, the output button titles change to plural to account for the fact that multiple photos will be saved, opened, copied, etc.

Note > Another way to select a subset of images from those displayed on the left of the workspace in ACR is to rate the pictures you want to apply common settings to and then select these photos with the Select Rated button (hold down the Alt/Opt key). With the Alt/Opt key still depressed, clicking the Synchronize button will synchronize using the last settings without displaying the Synchronize dialog.

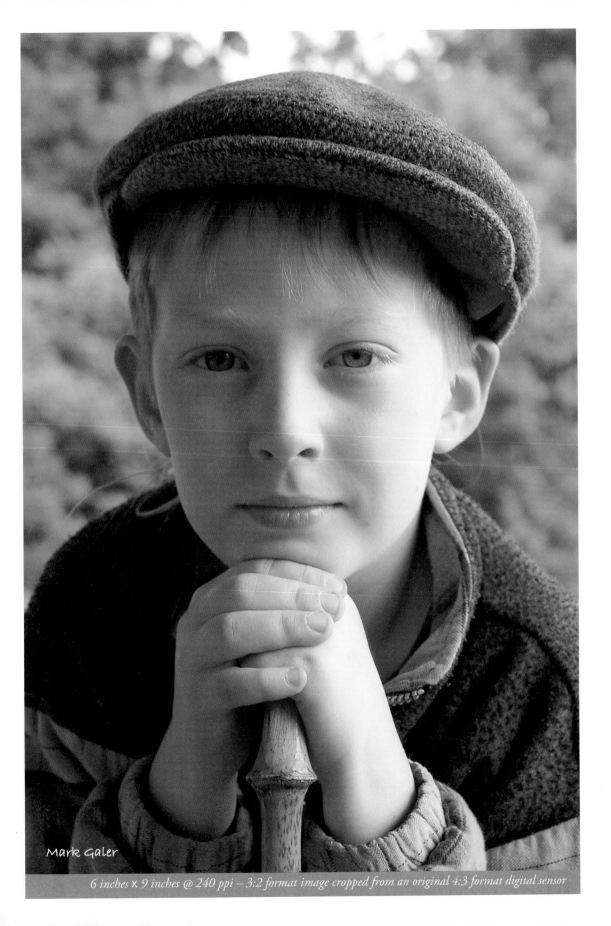

Mark Galer

6 inches x 9 inches @ 240 ppi – 3:2 format image cropped from an original 4:3 format digital sensor

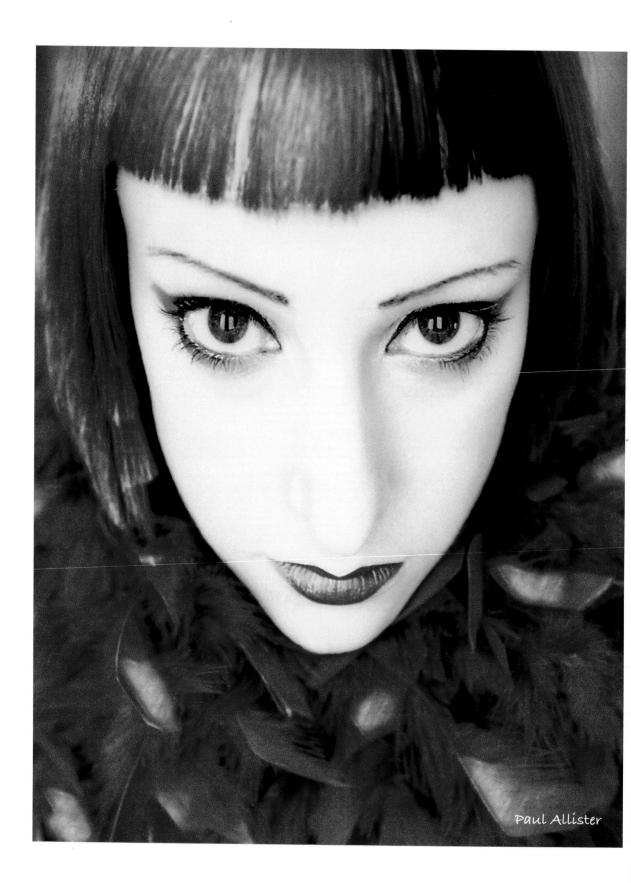

Paul Allister

raw processing

Philip Andrews

essential skills

- Take Raw processing beyond the basics outlined in the last chapter.
- Apply localized corrections to images inside Adobe Camera Raw.
- Convert Raw files to digital negatives for archival storage.

Introduction

One of the big topics of conversation over the last few years has been the subject of 'Raw' files and 'digital negatives'. During this time the capture format has gone from being an option for high-end work only to a key part of most professionals' workflows. For this reason we have reworked much of the content of the book to take into account Raw enabled workflows. In the last chapter we looked at the first few steps involved in optimizing a digital capture, be it Raw based or TIFF or JPEG. Here we will delve further into Raw processing and pay particular attention to the other editing and enhancement options that are possible when altering your photos directly in Adobe Camera Raw or as an embedded Raw file within Photoshop CS4.

Note > Keep in mind that for many of the techniques there is no longer the need to convert your file from its native Raw format in order to continue editing the picture in Photoshop. This way of working ensures that not only are your images always derived from the primary capture data and not a second generation derivative, but that you maintain the flexibility of the Raw format for altering characteristics such as white balance, tonality, color space and sharpness non-destructively.

Camera Raw

All digital cameras capture in Raw but only Digital SLRs and the medium- to high-end 'Prosumer' cameras offer the user the option of saving the images in this Raw format. Selecting the Raw format in the camera instead of JPEG or TIFF stops the camera from processing the color data collected from the sensor. Digital cameras typically process the data collected by the sensor by applying the white balance, sharpening and contrast settings set by the user in the camera's menus. The camera then compresses the bit depth of the color data from 12 to 8 bits per channel before saving the file as a JPEG or TIFF file. Selecting the Raw format prevents this image processing taking place. The Raw data is what the sensor 'saw' before the camera processed the image, and many photographers have started to refer to this file as the 'digital negative'. The term 'digital negative' is also used by Adobe for their archival format (.dng) for Raw files.

Processing Raw data

In the last chapter we saw that unprocessed Raw data can be edited and enhanced in Adobe Camera Raw (ACR) which ships with Photoshop and can be opened in Photoshop or Bridge. Variables such as bit depth, white balance, exposure, brightness, contrast, saturation, sharpness, noise reduction and even the crop can all be assigned as part of this process. In the version of ACR that ships with CS4 the utility can also be used for performing localized corrections. Think 'dodge and burn' but with the power to paint on changes of saturation, contrast, exposure, clarity and sharpness in portions of the photo. Cool!

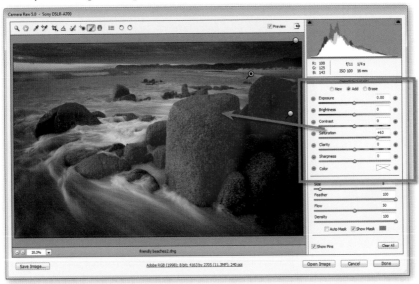

Performing these image-editing tasks on the full high-bit Raw data (rather than making the changes after the file has been processed by the camera) enables the user to achieve a higher quality end-result. Double-clicking a Raw file, or selecting 'Open in Camera Raw' in Bridge, opens the Adobe Camera Raw (ACR) dialog box, where the user can prepare and optimize the file which can then be passed to Photoshop for further processing. If the user selects 16 Bits/Channel in the Workflow Options, the 12 bits per channel data from the image sensor is rounded up – each channel is now capable of supporting 32,769 levels instead of the 256 levels we are used to working with in the 8 bits per channel option. Choosing the 16 Bits/Channel option enables even more manipulation in the main Photoshop editing space without the risk of degrading the image quality.

When the optimized raw file is passed to Photoshop from ACR we have the option of converting a copy of the photo from Raw to a Photoshop document (.psd) or embedding the picture in a Smart Object, which in turn is stored in a new Photoshop document. The advantage of the second approach is that as an embedded Smart Object the Raw file format of the original capture is maintained (and protected). In both pathways any changes you make to the appearance of the image in the ACR will be applied to the image that is opened in Photoshop's main editing space but won't alter the original image data of the Raw file. The adjustments you make in the ACR dialog box are instead saved as either a sidecar file (.xmp) or in the computer's Camera Raw database.

Foundation Project 3

In the last chapter we looked at the basic adjustments that you would make to a Raw file in order to optimize the photo; here we will employ some of the new features to take our ACR-based editing even further. If you don't have your own Raw files to work on, the example file, named Foundation_Project_03, is located on the book's accompanying DVD. The reader should not see this as a rigid step by step but instead use the project file to get a feel for the techniques discussed here.

One of the strengths of working with Raw files is their ability to capture and use large amounts of data. This project uses the power of the new local correction tools in ACR together with the extra detail contained in high-bit Raw capture to reveal hidden detail in the blown highlight area or this photojournalism photo

Straighten, crop and size – Step 1

Start the process by straightening and cropping the photo. Select the Straighten Tool on the top left-hand side of the ACR dialog box. Click on one end of a part of the framing in the roof structure that is meant to be horizontal, and drag the cursor to the other end and then let go of the mouse button to automatically straighten the image. Cropping in ACR does not delete pixels but merely hides them and these pixels can be recovered if necessary.

Crop the image to the correct aspect ratio or shape using the Crop Tool. Select one of the existing aspect ratios or create your own using the 'Custom' command found in the Crop menu. The aspect ratio of the bounding box will change when a new format is selected. Click and drag on any corner handle to alter the composition or framing of the image. Use the keyboard shortcut Command/Ctrl + Z to undo any action that you are not happy with.

Note > The Crop Tool setting affects the Straighten Tool; make sure Crop is set to normal.

The Crop Size (pixel dimensions) and Resolution can also be set in ACR. If your target output is specified in inches or cms you will need to perform some calculations to ascertain the optimum crop size (divide the dimensions of the document needed by the optimum image resolution required by the output device). As crop sizes are only approximate in ACR you should choose a size that is slightly larger than the actual dimensions required.

Color space – Step 2

There are four choices of color space in the ACR dialog box and it is important to select the most appropriate one for your workflow before you start to assign color values to the image in ACR (using the controls located in the Workflow Options dialog displayed by clicking the highlighted blue text at the bottom of the screen). ColorMatch RGB is rarely used these days (it was a space commonly used before color management came of age back at the end of the last decade) so the choice is now limited to just three. The main difference between the three major spaces is the size of the color gamut (the range of colors that each space supports). There is not much point in working with a color space larger than necessary as the colors outside of the monitor space will not be visible and they cannot be reproduced by an output device with a limited gamut range. The three color spaces are as follows:

sRGB – This is the smallest of the three common color spaces (with a range of colors similar to a typical monitor) and should be selected if your images are destined for screen viewing or are destined to be printed by a print service provider using the sRGB color space.

Adobe RGB (1998) – This space is larger than the sRGB space and is the most common color space used in the commercial industry, where the final image is to appear in print. It is a good compromise between the gamut of a color monitor and the gamut of an average CMYK printing press. It is also a space that is suitable for some Print Service Providers and standard quality inkjet prints, e.g. a budget inkjet printer using matte or semi-gloss paper.

The wide gamut ProPhoto space (white) compared to the Adobe RGB (1998) space (color)

ProPhoto RGB – This is the largest color space and can be selected if you have access to a print output device with a broad color gamut (larger than most CMYK devices are capable of offering). When working in ProPhoto the user must stay in 16 Bits/Channel for the entire editing process. Converting to smaller color spaces in Photoshop's main editing space usually results in loss of data in the channels regardless of the rendering intent selected in the conversion process. This loss of data may not be immediately obvious if you do not check the histogram after the conversion process. The data loss is most apparent in bright saturated colors where texture and fine detail may be missing as the color information in the individual channels has become clipped in the conversion process.

Choosing a bit depth – Step 3

Select the 'Depth' in the Workflow Options (click on the blue text at the base of the ACR dialog box). If the user selects the 16 Bits/Channel option, the 12 bits per channel data from the image sensor is rounded up – each channel is now capable of supporting 32,769 levels. In order to produce the best quality digital image, it is essential to preserve as much information about the tonality and color of the subject as possible. If the digital image has been corrected sufficiently in ACR for the requirements of the output device, the file can be opened in Photoshop's main editing space in 8 bits per channel mode. However, if the digital image has further corrections applied in the 8 bits per channel mode, the final quality will be compromised. Sixteen-bit editing is invaluable if maximum quality is required from an original image file that requires further editing of tonality and color in Photoshop after leaving the Camera Raw dialog box. If you have assigned the ProPhoto RGB color space in ACR you must use the 16 Bits/Channel color space in Photoshop to avoid color banding or posterization.

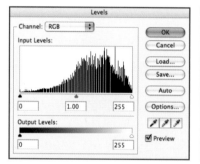 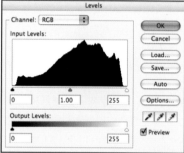

Final histograms after editing the same image in 8 and 16 bits per channel modes

The problem with 8-bit editing

As an image file is edited extensively in 8 Bits/Channel mode (24-bit RGB) the histogram starts to 'break up', or become weaker. 'Spikes' or 'comb lines' may become evident in the resulting histogram after the file has been flattened. This is due to the fact that there are only 256 levels or tones per channel to describe the full color range of the image. This is usually sufficient if the color space is not huge (as is the case with ProPhoto RGB) and the amount of editing required is limited. If many gaps start to appear in the histogram as a result of extensive adjustment of pixel values this can result in 'banding'. The smooth change between dark and light, or one color and another, may no longer be possible with the data supplied from a weak histogram. The result is a transition between color or tone that is visible as a series of steps in the final image.

A 'Smart' solution

By opening a Raw file as a Smart Object (Open Object – hold down the Shift key if this option is not visible or better yet set as the default opening action in the Workflow Options dialog) the user can open a Raw file in 8 Bits/Channel but keep the integrity of the histogram by returning to the ACR dialog box to make any large changes to hue, saturation or brightness (luminosity) values. Though working with 16 bits per channel is always preferable, with some filters there is only the option to apply the changes to an 8 bits per channel file.

Control the White Balance in your image using either the drop-down presets, the Temperature and Tint sliders or the White Balance tool

White balance – Step 4

As we saw in the last chapter, the first step in optimizing the color and tonal values for the color space we have chosen to work in is to set the white balance by choosing one of the presets from the drop-down menu. Remember that there are three approaches to setting white balance:

- Select a preset White Balance option based on specific lighting sources – Daylight, Cloudy, Shade, Tungsten, etc.
- Manually adjust the 'Temperature' and 'Tint' sliders to remove any color cast present in the image, or
- Alternatively you can simply click on the 'White Balance' eyedropper in the small tools panel (top left-hand corner of the dialog box) and then click on any neutral tone you can find in the image.

For more details on using these features with your image, revisit the White Balance section in the previous chapter.

Note > Although it is a 'White Balance' you actually need to click on a tone that is not too bright. Clicking on a light or mid gray is preferable. A photographer looking to save time may introduce a 'gray card' in the first frame of a shoot to simplify the task.

Advanced WB fine-tuning

If precise white balance is extremely critical the photographer can shoot a GretagMacbeth ColorChecker Chart that uses a range of color and gray patches. The user can then target the Red, Green and Blue patches and fine-tune the white balance using the Calibrate controls in ACR.

Though daunting to start with, the options found here do provide an amazing amount of control and are used by many professional photographers to 'profile' the way that the color from their cameras is interpreted by the

A GretagMacbeth ColorChecker Chart

Raw converter. This is particularly useful for building a profile for neutralizing the casts that are present in images photographed under mixed artificial lighting conditions.

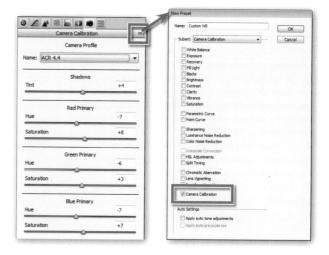

The Calibrate control provides the ability for photographers to fine-tune the white balance in their pictures to match difficult non-standard lighting conditions. After making these settings you can then save the values to be used with other pictures photographed under the same lighting conditions

The process involves photographing a GretagMacbeth ColorChecker reference board under the lighting conditions that are typical for the scene. The Raw file is then opened into Adobe Camera Raw and the color and tones of the captured file are adjusted to match the 'true' values of the patches. The RGB values that each patch should be (in a variety of color spaces) can be obtained from Bruce Lindbloom's great website (www.brucelindbloom.com). These synthetic values will act as a reference when making your adjustments.

Start by setting a basic white balance by clicking onto the light gray patch of the ColorChecker with ACR's White Balance Tool. Next use the Exposure and Blacks sliders to adjust the contrast of the image. Use the Color Sampler Tool to check the patch values in the Raw preview against those synthetic values found on Lindbloom's site.

Next switch to the Calibrate tab and use the sliders to start to adjust the color of the test patches. Your aim is to match as closely as possible the captured (sampled from the preview) values with the synthetic values of the ColorChecker. This can be a pretty exacting task as moving one slider will not only affect its color but also the value of the other two. Matching the two values is a process of adjust, check and then adjust again, but once completed the final color settings can be saved as a new settings subset and applied to all photographs taken under the same lighting conditions.

Performing this process manually is tedious and takes a lot of time; a better approach is to employ the help of a specially written custom script that automates the process. The cross-platform script is available from the Chromoholics website (http://www.fors.net/chromoholics/) and once installed automates the fine-tuning procedure detailed here.

Global tonal adjustments – Step 5

In the last chapter we looked at how careful adjustment of the tonal controls listed directly beneath the White Balance sliders will allow you to get the best out of the dynamic range of your imaging sensor, thereby creating a tonally rich image with full detail. For more details on using these controls revisit the appropriate section in the last chapter.

In this example we will start by adjusting the tones and color 'globally'. That is, making changes to the whole of the image. Next, unlike in the previous chapter, we will fine-tune the results by

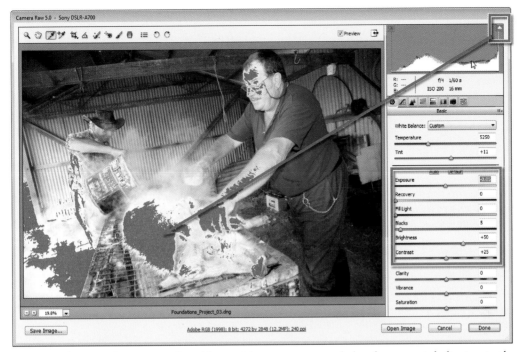

The example image has some real problems with overexposure and therefore potential clipping in the highlight areas of the photo. Careful adjustment of the Exposure and Recovery sliders will help with this problem but not totally remove it

using the new Adjustment Brush to alter specific sections of the photo. These types of changes are brand new to ACR and are called 'local' corrections.

But we're getting ahead of ourselves. To start with the global changes you will need to set the brightest points within the image using the 'Exposure' slider and darkest points using the 'Blacks' slider. Make sure that the clipping warnings for both highlights and shadows are active when making these changes. Immediately you will notice how much of the highlight detail is displayed with the red highlight warning. Dragging the Exposure slider to the left will help reduce this problem, but don't go so far as to render the face of the subjects too dark. Some clipping will still be apparent at this point. Use the 'Recovery' slider to help rescue these highlight tones, which may otherwise clip, and also employ the 'Fill Light' slider to lighten the very dark shadow tones that may not print with any texture or detail (think of Recovery and Fill Light as non-destructive variants of the shadow/highlight adjustment feature). The 'Brightness' and 'Contrast' sliders can be used to fine-tune the midtone values. If the image becomes too dark because you are dragging the Exposure slider to the left in order to protect highlight detail, instead use the Recovery slider to darken the highlight detail without darkening the midtone values.

Advanced clipping information

Remember that holding down the 'Alt/Option' key when adjusting either the 'Exposure' or 'Blacks' slider will also provide an indication in the image window of the channel, or channels, where clipping is occurring. Excessive color saturation for the color space selected, as well as overly dark shadows and overly bright highlights, will also influence the amount of clipping

that occurs. Clipping in a single channel (indicated by the red, green or blue warning colors in the arrows) will not always lead to a loss of detail in the final image. However, when the secondary colors appear (cyan, magenta and yellow), you will need to take note, as loss of information in two channels starts to get a little more serious. Loss of information in all three channels (indicated by black when adjusting the shadows and white when adjusting the exposure) should be avoided.

The channel, or mix of channels, being clipped are also displayed as a change of color of the arrow in the clipping warning buttons at the top left and right of the histogram

Note > Large adjustments to the 'Brightness', 'Contrast' or 'Saturation' sliders may necessitate further 'tweaking' of the Exposure, Recovery, Fill Light or Blacks sliders.

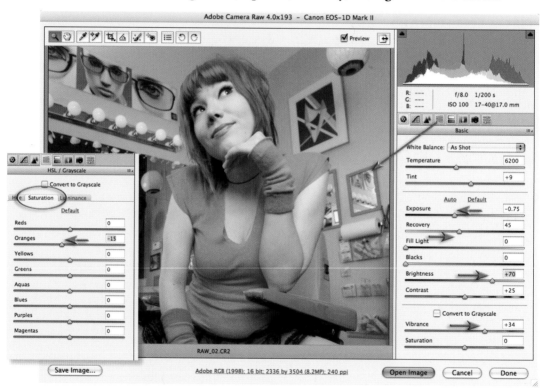

High levels of saturation clipping present in this file were corrected with the help of the Saturation controls in the HSL tab – saturation could then be increased reasonably non-destructively using the Vibrance slider.
Image of Melissa Zappa by Victoria Verdon Roe

Controlling saturation and vibrance – Step 6

Increasing saturation in ACR can lead to clipping in the color channels. Clipping saturated colors can lead to a loss of fine detail and texture. Saturation clipping is especially noticeable when you have selected the smaller sRGB color space and have captured an image with highly

saturated colors. As this image will end up being a split-toned monochrome we'll step away from the example photo for a moment in order to illustrate saturation and vibrance. Instead we will use the more colorful image to illustrate these issues. The Vibrance slider applies a non-linear increase in saturation (targeting pixels of lower saturation). It is also designed to protect skin tones in order to prevent faces from getting too red. It should create less clipping problems when compared to the Saturation control.

In images where some colors readily clip due to their natural vibrance (especially when using a smaller gamut such as sRGB), lowering the global saturation in order to protect the clipping of a single color can result in a lifeless image. In these instances the user can turn to the HSL tab to edit the saturation of colors independently.

Note > Choosing a larger color space such as ProPhoto RGB, where the colors rarely clip, is only a short-term solution. The color gamut must eventually be reduced to fit the gamut of the output device. ACR is currently the best place in CS4 to massage these colors into the destination space.

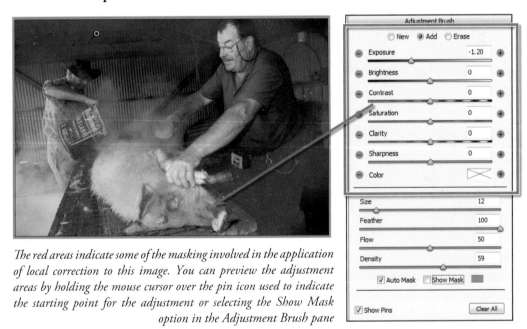

The red areas indicate some of the masking involved in the application of local correction to this image. You can preview the adjustment areas by holding the mouse cursor over the pin icon used to indicate the starting point for the adjustment or selecting the Show Mask option in the Adjustment Brush pane

Localized correction – Step 7

In previous versions of ACR, with the exception of the Spot Removal Tool, which corrected dust marks on small portions of the image, all alterations were applied to all of the image. This meant that for those of us who wanted to perform a seemingly simple operation, such as a little dodging or burning, we needed to transfer the file from ACR to Photoshop where the editing changes could be made. 'Okay this is only a small inconvenience' you may say, but it was the changes made to the file during this transfer that had Raw devotees frustrated. In moving the picture from ACR to Photoshop, the file needed to be converted from its Raw origins to a standard file format such as PSD (Photoshop), TIFF, or JPEG. All the advantages of non-destructive editing changes that constitute the very basis of enhancement steps in ACR

are lost in the conversion process. There is no getting around the fact that after conversion any alterations applied to the dodged and burnt file were being made to processed pixels, not the virgin captured pixels of the original file.

ACR 5.0 changes all this. Now it is possible to perform localized corrections (as opposed to global ones) directly inside the program. More important is the fact that these corrections are applied in the same non-destructive manner as all other alterations in the program. In other words, the changes are made via a series of parameter settings which are stored in an associated file and are used to create a preview of how the Raw file would look with the settings applied. It is this processed preview that we see in the ACR preview and Bridge Content and Preview panes. The primary Raw file is never converted to a non-Raw format (except when exporting or opening in Photoshop) and as the enhancements are simply a series of stored settings, the file can be restored to its original appearance at any time.

Two new local correction features are contained in the ACR toolbar
– the Adjustment Brush (shortcut key – K) and the Graduated Filter (shortcut key – G)

But how do local corrections work?

Most localized corrections are based around a new tool called the Adjustment Brush (shortcut key – K). The tool uses a brush type icon and is grouped together with the other tools in the toolbar that sits at the top of the workspace. Here you will also find a new Graduated Filter Tool as well, but more on this later.

Applying a localized correction is essentially a two-step process. First you mark out the adjustment area (similar to making a correction) and then you fine-tune the degree and type of adjustments made to this area. It is important to understand that unlike an action such as dodging and burning, performed in Photoshop, working with local adjustments in ACR means that you can manipulate the degree of adjustment and, if need be, you can also switch the image parameter you are adjusting as well after the changes have been made. For example, after painting on the adjustment area using an Exposure value of –2.80 EV so that the effects can be clearly seen on the image, you can then change to the Edit mode for the tool and drag the Exposure value back to 0 and input a value for Saturation instead. If that isn't powerful enough you can also create a custom adjustment mix that includes settings for multiple image characteristics all applied to the same adjustment area.

Adjustment Brush workflow:

A. Select the Adjustment Brush – The first step in the process of using localized corrections in Adobe Camera Raw involves selecting the new Adjustment Brush Tool situated in the toolbar at the top of the workspace. This

will open up a new pane containing a range of image characteristics that you can adjust within your image. Select the primary effect that you wish to change from the pane. Here I used Exposure with a setting of – 2.74 EV.

B. Set brush tip characteristics – Next you need to set the brush tip characteristics. You essentially have four controls here – Size, Feather, Flow (similar to airbrush where multiple strokes build up the effect) and Density or level of effect. The brush tip is displayed with two concentric circles. The outer one represents the edge of the brush, the inner circle outlines where the brush is solid and the space between is the width of the feather.

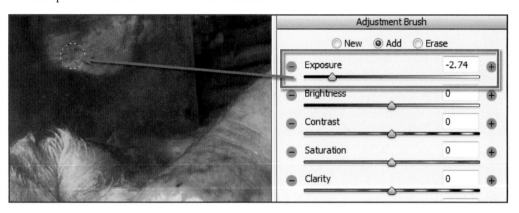

C. Paint in the adjustment mask – With the effect and the brush tip now set, move the cursor over the image and paint in the area to be adjusted. Notice that the adjustment is made in real time on your image. I purposely used a strong 'underexposure' setting so that I could clearly see the extent of the painted area. Don't be concerned if the effect is too strong or not the style required as these can be tweaked later. Continue to build up the mask by painting in the areas to be adjusted. Alternatively you can click the Show Mask option to display the selected areas.

D. On-the-fly masking – At the bottom of the Adjustment Brush pane is an Auto Mask option. Use this setting to get ACR to only apply the adjustment up to the edge of a painted area. When painting with this option selected make sure to keep the inner circle within the area to be adjusted.

E. Fine-tune the adjustment – Notice that once you start to paint, the mode at the top of the pane switches from New to Add. While in the Add mode you can proceed to fine-tune the changes made to the various image characteristics using the sliders. Despite the fact that I initially selected the Exposure slider, I can now include other characteristics in the mix.

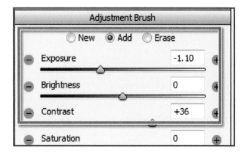

Adding to, subtracting from and creating new localized corrections

Adding to – Once an adjustment area or mask has been created it is possible to extend the area by selecting the Pin icon for the area. This activates the Add mode for an existing painted area. Now continue to paint with the brush tip. The enhancement changes for the newly painted area will be exactly the same style and degree as those already existing in the previously painted section.

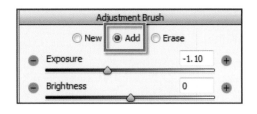

While in the Add mode it is possible to change the image's characteristics (e.g. Exposure, Brightness, Contrast, etc.) that are being changed by the adjustment. The tool is automatically placed in this mode after creating a new mask. You must select another mode (New or Erase) or choose another tool from the ACR toolbar to cease the Add function.

Subtracting from – As well as being able to add to an existing adjustment area you can also remove parts from this mask. To do so either hold down the Alt/Opt key and paint away the areas to remove or click on the Erase entry in the Adjustment Brush pane. While in this mode you

can refine the areas of the picture that are being affected by the localized adjustment.

Creating new – When first selecting the Adjustment Brush the feature is placed in the New mode in anticipation of creating a fresh or initial localized adjustment. The Adjustment Brush automatically changes from New to Add modes when you apply the first stroke of a new mask. From that time forward additional

painting strokes will continue to build the mask until a new mode is selected or you select another tool. **Note > To jump out of the Adjustment Brush mode, just click on another tool.**

Project application: Using the example image and the Adjustment Brush, make two separate localized corrections to the photo. First, burn in extra detail to the lower left part of the picture and the back of the pig by painting in negative Exposure. Next, use the Auto Mask to isolate the blue shirt area on the subject on the right and reduce the saturation of the shirt. Try switching between Add and Erase modes to fine-tune the areas being adjusted.

Raw versus JPEG corrections

Being able to perform localized corrections in ACR is a real improvement in tricky situations such as the example image used here. This is because the corrections are performed on the Raw file. Stated like that, this fact may seem a little underwhelming but have a look at the example images on the next page and you will see why this is a key issue. The original was shot in an open barn on one of the back roads of Tasmania. The lighting

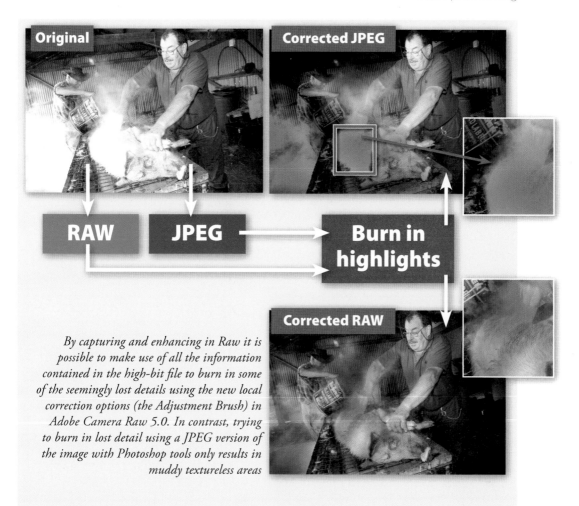

By capturing and enhancing in Raw it is possible to make use of all the information contained in the high-bit file to burn in some of the seemingly lost details using the new local correction options (the Adjustment Brush) in Adobe Camera Raw 5.0. In contrast, trying to burn in lost detail using a JPEG version of the image with Photoshop tools only results in muddy textureless areas

was always going to be tricky so to help even out the foreground some fill flash was added to the foreground. This worked fine in that portion of the image, but further back and to the left, the extra light coming into the barn blew out the highlights.

It is easy to lose detail in highlight and shadow areas with incorrect exposure settings. When a camera is set to JPEG as the capture format, often subtle details that would be held in the high-bit Raw file are lost during the conversion to the lower-bit JPEG format. If we take the process one step further and try to burn the lost detail back into the photo using the Burn Tool in Photoshop you will start to see the problem. Rather than ending up with extra visual information we end up with a muddy mess.

If, instead, the image was captured and stored in Raw and then processed in Adobe Camera Raw 5.0 using the new localized correction tools then the outcome would be drastically different (see above for the comparisons). Because of the extra bit depth of the Raw file, more of the original details are retained in the highlight areas of the image. When ACR is put to work on these details a substantial amount of seemingly lost information can be revealed. If you have been wavering about whether to switch from JPEG capture to Raw then this example should help you with the decision.

Grayscale conversion and toning – Step 8

At this point the example image has been adjusted both globally and locally and, if we wanted a color outcome, we would apply some sharpening and noise reduction (see Step 10) and then output the file (see Step 11), but in this instance the end result is a split-toned monochrome. So the next part of the process is to convert to gray and then we'll tint the photo with separate colors for highlights and shadows.

HSL/Grayscale

Drawing inspiration from the type of features located in Lightroom, the options in the HSL/Grayscale pane provide control of the Hue, Saturation and Luminance of each color group (red, orange, yellow, green, aqua, blue, purple and magenta) independently.

This is a great improvement over what was available previously, when color changes were limited to red, green and blue channel-based divisions and saturation control. There are also three tabs across the top of the pane that allow color range adjustments to be made to the Hue (color), Saturation (color strength) and Luminance (brightness) independently. Clicking the Grayscale tickbox switches the pane to a monochrome conversion mode where the color range sliders adjust the type of gray that the hue is being mapped to. Let's look at each section in turn.

Hue – The Hue tab in the HSL control provides the ability to tweak the flavor of a specific color range. Unlike the drastic changes brought about by the Hue control in Photoshop's Hue/Saturation feature, the sliders here manipulate the color of a selected color within a given range. The Reds slider, for instance, moves from a magenta red through to a pure red to an orange red. Moving this slider would enable the fine-tuning of just the reds in a photo between these limits.

Saturation – The Saturation control provides the ability to customize the saturation of not the whole image as is provided with the Saturation slider in the Basic pane, but a specific range of colors. Try adjusting the Blues slider with the example image and notice the change in the strength of the color of the shirt worn by the subject on the right.

Luminance – The third tab in the HSL control deals strictly with the luminance of specific colors. With the sliders grouped here it is possible to change the brightness of a color grouping, which can translate into altering the color contrast in a photo by selectively increasing and decreasing the brightness of opposite hues.

Grayscale – By clicking the Convert to Grayscale option the feature changes to provide a method for creating custom mapping of the same color groupings to gray. Using this control it

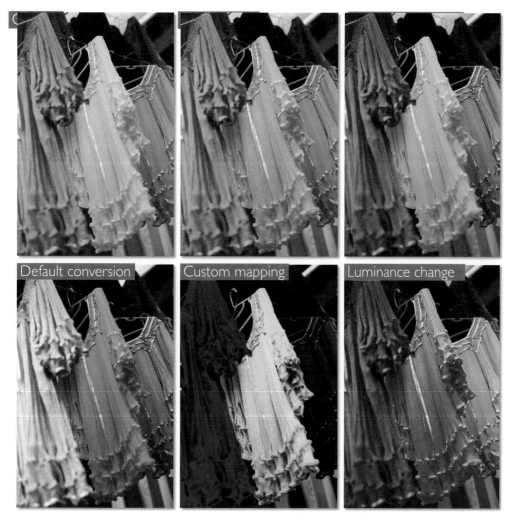

Default conversion | Custom mapping | Luminance change

The HSL/Grayscale pane provides color range-based controls for altering the hue, saturation and luminance of the colors in your photo. In the Grayscale mode you can adjust how specific colors are mapped to gray

is possible to restore contrast to a grayscale conversion when the different colors in the photo have translated to similar tones of gray, producing a low-contrast monochrome.

Project application: In the example image you may need to flip back to the controls in the Basic pane and make some adjustments to Contrast, Exposure and Blacks sliders alongside the changes made with the HSL sliders in order to ensure sufficient contrast results in the conversion.

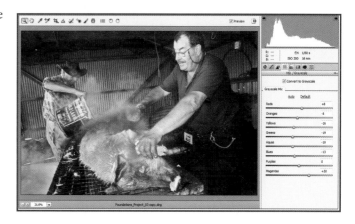

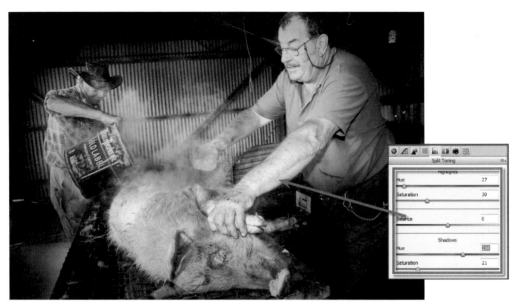

The controls in the Split Toning pane provide the ability to tint shadows and highlights slightly different colors. The Balance slider also allows for the adjustment of the split point between the tint used for highlights and the one used for shadows

Split toning

In the last release of ACR, monochrome workers rejoiced in the addition of the dedicated Split Toning pane as the controls it contains provide the ability to use the included Hue and Saturation sliders to tint highlights and shadows independently. Hue controls the color of the tint, and Saturation controls its strength. Holding down the Alt/Opt key while moving either of the Hue sliders will preview the tint at 100% saturation (full strength), allowing for easier selection of the correct color. After selecting the color you need to adjust the saturation. To understand how the Hue slider works imagine the control moving progressively through the colors of the rainbow from red, through yellow, green and blue to purple and magenta.

Also included is the Balance slider, which provides the ability to change the point at which the color changes. Movements to the right push the split point towards the highlights, whereas dragging the slider to the left means that more mid to shadow areas will be colored the selected highlight hue.

Remember to use split toning with a monochrome image you must make the conversion to grayscale first. Do this by selecting the Convert to Grayscale option in the HSL/Grayscale pane first. Then move back to the Split Toning pane and adjust Highlight and Shadow Hue and Saturation and then the Balance point to suit.

Note: Don't restrict your split toning activities solely to the realms of monochromes. The feature can also be applied to color images as well, providing some rather unusual but striking results.

Project application: Split tone the project image so that the highlights are tinted traditional sepia brown and the shadows contain a slightly blue tinge.

Lens corrections – Step 9

The Lens Corrections pane contains options for correcting three different types of imaging problems associated with lens design – Chromatic Aberration, Fringing and Vignetting.

Chromatic Aberration: Two sliders are available to help with Chromatic Aberration, or the situation where edges recorded towards the outer parts of the frame contain slight misalignment of colors. This is caused by a lens not focusing all the visible wavelengths together on a sensor. The sliders are designed to realign the problem areas and, in so doing, remove the colored edges.

Fringing: Also included is the ability to lessen the sensor 'flooding' caused by overexposure in picture areas such as specular highlights. The Defringe drop-down menu contains three options – Off, Highlight Edges and All Edges. Selecting the Highlight Edges option decreases the purple-colored areas that often surround brightly lit metallic surfaces or sparkly water reflections. These errant colors are not caused by lens aberrations but rather result from a small selection of sensor sites being overexposed. Switching to the All Edges setting applies the effect to all the fringe areas in the image.

Lens Vignetting: Vignetting is the slight darkening or lightening of the corners of a photo due to the inability of the lens to provide even illumination across the whole surface of the sensor. This is most prevalent in lower quality ultra-wide-angle lenses when coupled with cameras with full frame sensors. Two sliders are included in the Lens Vignetting section of the Lens Corrections pane to deal with this problem. When the Amount slider is moved to the right it lightens the corners. Dragging the control to the left has the opposite effect. The Midpoint control alters the amount of the frame affected by the vignetting correction. Higher settings concentrate the corrections to the corners of the frame.

Post Crop Vignetting: New for ACR 5.0 is the ability to apply vignetting adjustments to a cropped photo. In previous

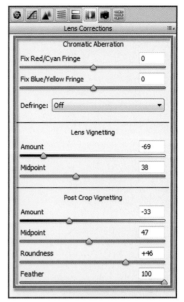

The Defringe option helps remove the purple color that can surround very bright highlights

releases, the vignetting changes were applied to the original full frame image, rather than the cropped picture. This approach was fine when the feature was used for correcting lens-based vignetting, but was not appropriate when photographers used the tools for artistic rather than lens correction purposes, The new, second set of vignetting tools listed at the bottom of the Lens Corrections pane now provide the ability to apply such artistic vignetting to the cropped image. This tool has Amount and Midpoint sliders that function like the sliders found in Lens Vignetting control. Added to these are two new sliders – Roundness and Feather. The Roundness slider changes the vignette shape from round through oval to just the edge of the photo and Feather is used to adjust the sharpness of the vignette edge.

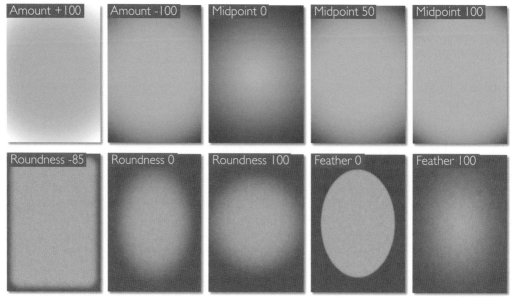

The Lens Corrections pane now contains two different types of vignetting features, one for use on whole images designed for corrections of lens faults and a second that photographers can employ to add artistic vignettes to their cropped photos. In both, the Amount slider controls the strength of the correction effect and the Midpoint alters how much of the image is included in the enhancement. In the Post Crop version the Roundness slider controls the shape of the vignetted area and Feather is used to adjust the softness of the edge of the vignette

Project application: To get you up to speed on the new post-crop vignette tools, darken the edge of the project image using a vignette that has full Feather and a negative roundness value. This will add a soft-edged darkening of the picture edges.

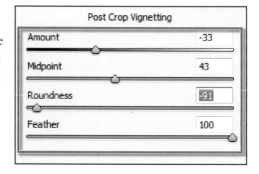

Noise reduction and sharpening – Step 10

To access the sharpness and noise reduction controls click on the Detail tab. Set the image view to 200%. The Luminance and Color sliders (designed to tackle the camera noise that occurs when the image sensors' ISO is high) should only be raised from 0 if you notice image artifacts such as noise appearing in the image window.

Note > Zoom image to 200% to determine levels of noise present in the image.

In the example image above the sensor was set to 400 ISO on a budget DSLR. Both luminance noise (left) and color noise (right) are evident when the image is set to 200%. When using more expensive DSLR cameras that are set to 100 ISO, it may be possible to leave the Luminance and Color noise sliders set to 0.

Warning > The Luminance and Color sliders can remove subtle detail and color information that may go unnoticed if the photographer is not careful to pay attention to the effects of these sliders. Zoom in to take a closer look, and unless you can see either the little white speckles or the color artifacts keep these sliders set at 0.

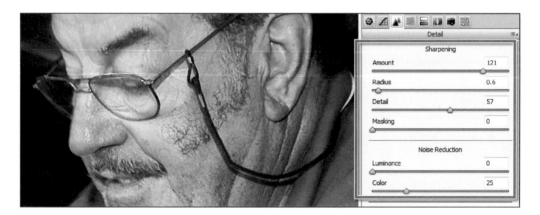

Sharpening is an enhancement technique that is easily overdone and this is true even when applying the changes at the time of Raw file editing. The best approach is to remember that sharpening is applied at two points in the process – capture and output. The settings applied in Adobe Camera Raw are used for capture sharpening and the output side of things is handled as the last step of the editing process, which generally occurs inside Photoshop. In practice this means that all images should be sharpened to some extent in ACR first and then specific sharpening, determined by output size and media surface, applied later in the process.

In the latest version of ACR there are four sliders designed to aid in sharpening fine-tuning. The Amount slider determines the strength of the effect. The Radius slider is used to adjust the range of pixels used in the sharpness calculation. Detail and Masking both control where the sharpening effect is applied. Increasing the Detail value raises the local contrast around small picture parts, making these appear sharper. Moving the Masking slider to the right gradually restricts the sharpening to just the most contrasty edges of the picture.

Don't forget that it is also possible to add localized sharpening using the new Adjustment Brush. Take a look at the example images above. The detail on the right has no sharpening applied and represents the look of a file as it appears 'straight from the camera'. The detail on the left has had global sharpening (via the controls in the Detail pane) and local sharpening (via the Adjustment Brush) applied.

Note > Always make sure that the preview is zoomed to a value of 100% before manipulating these controls so that you can preview the effects. Holding down the Alt/Opt key provides a preview of the settings for each slider as the effect is applied. For more details on these Sharpening controls refer to the Sharpening and Image section in the previous chapter.

Output options – Step 11

Apart from the Open Image button Adobe Camera Raw provides several other options that will govern how the file is handled once all the enhancement options have been set. To this end, the lower part of the dialog contains four buttons, Save Image, Open Image, Cancel and Done, and a further four, Save Image (without the options dialog), Reset and Open Copy when the Alt/Option button is pushed, and Open Object when the Shift key is pushed.

Cancel: This option closes the ACR dialog, not saving any of the settings to the file that was open.

Save Image: The normal Save Image button, which includes several dots (...) after the label, displays the Save Options dialog. Here you can save the raw file, with your settings applied, in Adobe's own DNG format as well as TIFF, JPEG and PSD formats. The dialog includes options for choosing the location where the file will be saved, the ability to add in a new name as well as format-specific settings such as compression, conversion to linear image and/or embed the original Raw file for the DNG option.

It is a good idea to select Save in Different Location in the Destination drop-down at the top to keep processed files separate from archived originals. Clearly the benefits of a compressed DNG file are going to help out with storage issues and compression is a big advantage with DNG. Embedding the original Raw file in the saved DNG file begs the question of how much room you have in the designated storage device and whether you really want to have the original Raw file here.

Save (without save options): Holding down the Alt/Option key when clicking the Save button skips the Save Options dialog and saves the file in DNG format using the default save settings, which are the same as those last set.

Open Image: If you click on the Open Image button ACR applies the conversion options and opens the file inside the Photoshop workspace. At this point, the file is no longer in a Raw format so when it comes to saving the photo from the Editor workspace Photoshop automatically selects the Photoshop PSD format for saving.

Reset: The Reset option resets the ACR dialog's settings back to their defaults. This feature is useful if you want to ensure that all settings and enhancement changes made in the current session have been removed. To access the Reset button click the Cancel button while holding down the Alt/Option key. This action cannot be undone.

Done: Clicking the Done button will update the Raw conversion settings for the open image. Essentially this means that the current settings are applied to the photo and the dialog is then closed. The thumbnail preview in the Bridge workspace will also be updated to reflect the changes. In effect this is also a save button.

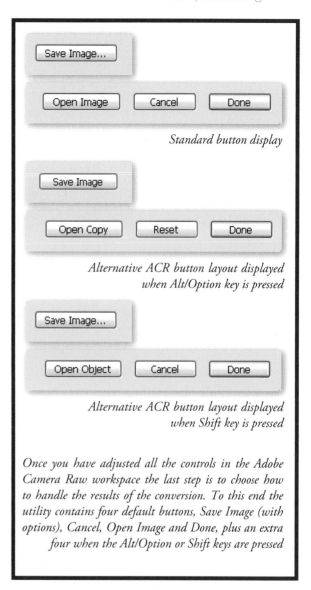

Standard button display

Alternative ACR button layout displayed when Alt/Option key is pressed

Alternative ACR button layout displayed when Shift key is pressed

Once you have adjusted all the controls in the Adobe Camera Raw workspace the last step is to choose how to handle the results of the conversion. To this end the utility contains four default buttons, Save Image (with options), Cancel, Open Image and Done, plus an extra four when the Alt/Option or Shift keys are pressed

Open Copy: Holding down the Alt key while clicking the Open button will apply the currently selected changes and then open a copy of the file inside the Photoshop workspace.

Open Object: The most exciting new addition to the list of ACR output options is the Open Object entry, which is displayed when the Shift key is held down. Choosing Open Object will create a new document in Photoshop and embed the Raw file in the document as a Smart Object. This route for transferring your files to Photoshop is the only one that continues to work with the picture in a lossless manner and is the core of many of the non-destructive editing techniques discussed in the next chapters.

Project application: Click the Save button (bottom left), pick DNG as the file format and input the following title – *foundations-proj-03-after*. This way you will be able to compare the before and after versions of the project files in the Bridge preview pane.

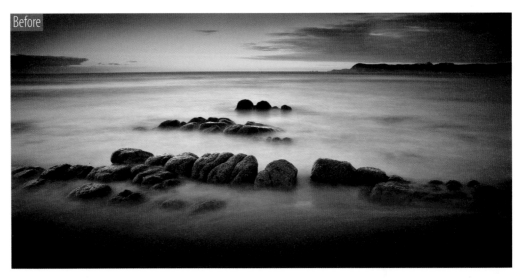

Before

After

Also new for Adobe Camera Raw 5.0 is the Graduated Filter Tool. This feature can be used to apply custom gradients across the full height or width of the photo. Once created, the size, position and rotation of the gradient remains editable along with the image characteristics that can be altered via the gradient

Foundation Project 4

As an extension of the new ability to provide localized corrections found in Adobe Camera Raw, the engineering team at Adobe have also added in a Graduated Filter Tool to the utility. Working like a combination of the Photoshop's Gradient Tool and ACR's new Adjustment Brush, the new feature provides the user with the ability to add graduated enhancement changes to their images. This is useful for picture-wide changes such as darkening skies and can be used in conjunction with the Adjustment Brush in an 'add filtration and paint out the areas it is not wanted' fashion. Again application is a two-step process, just as it was with the Adjustment Brush. First, you define the size, position and direction of the gradient, then you fine-tune the filter effects using the same image parameter slider controls found in the Adjustment Brush.

In this project we'll apply the Graduated Filter Tool to a landscape image and then fine-tune its placement with the Adjustment Brush.

Preliminary enhancements – Step 1

When opening the project file you will notice that no changes have been made to the image. This is the Raw file straight from the camera. Before commencing the application of the Graduated Filter work your way through the steps laid out in the previous project to enhance the image. Once you are happy with the results then move onto the next step.

Add Graduated Filter effect – Step 2

Start by selecting the Graduated Filter Tool from the toolbar at the top left of the ACR workspace. Next select, and adjust the primary enhancement change that you wish to make

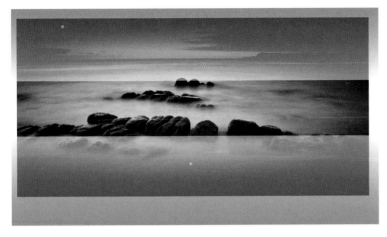

In the project image the upper and lower portions of the photo have been adjusted with two separate Graduated Filters. The lower filter just altered exposure whereas the upper one also changed the Color characteristic as well

from those listed in the Graduated Filter pane that is displayed on the right of the workspace. Here I have chosen Exposure. Locate a starting point on the photo and then click-drag a gradient effect on the image. The starting point (displayed as a green pin) is where the effect is the strongest, gradually lessening until you release the mouse button (marked by a red pin). The longer the drag the more gradual the gradient change. Hold down the Shift key to add gradients either horizontally or vertically. A second Graduated Filter is added to the bottom of the image, dragging the effect up through the rocks.

Adjust the Graduated Filter effect – Step 3

Once you have added a Graduated Filter to the photo you can adjust the gradient to change the enhancement characteristics. Click onto either Pin icon that represents the filter and then adjust the slider controls in the pane. When a pin is selected the feature is switched to the Edit mode. To create a new Graduated Filter you must click onto the New heading in the pane. In addition to these changes you can also rotate, move and adjust the size of the gradient by click-dragging either pin or, once the filter is selected, by moving any of the three lines displayed on screen.

Graduated Filter	
○ New ● Edit	
Exposure	−2.25
Brightness	0
Contrast	+1
Saturation	−100
Clarity	+100
Sharpness	−100
Color	

Gradients may be adjusted individually using this technique. Adjust the upper graduated filter to −100 Saturation, − 3.00 Exposure and then a Color is added to reflect the hue of the sea below. The lower Graduated Filter should be set to −2.50 Exposure only.

Reclaim some of the filtered detail – Step 4

Dragging the lower filter over the foreground rocks causes them to be darkened with an effect that tends to blend into the background. Restore their original visual dominance by selecting the Adjustment Brush, setting it to Auto Mask to keep the corrections to just the rocks and painting on a change to Exposure and Contrast.

Digital exposure

Most digital imaging sensors capture images using 12 bits of memory dedicated to each of the three RGB color channels, resulting in 4096 tones between black and white. Most of the imaging sensors in digital cameras record a subject brightness range of approximately five to eight stops (five to eight f-stops between the brightest highlights with detail and the deepest shadow tones with detail).

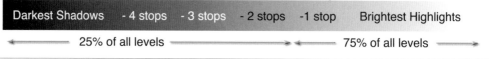

Tonal distribution in 12-bit capture					
Darkest Shadows	- 4 stops	- 3 stops	- 2 stops	-1 stop	Brightest Highlights
← 25% of all levels →		← 75% of all levels →			

Distribution of levels

One would think that with all of this extra data the problem of banding or image posterization due to insufficient levels of data (a common problem with 8-bit image editing) would be consigned to history. Although this is the case with midtones and highlights, shadows can still be subject to this problem. The reason for this is that the distribution of levels assigned to recording the range of tones in the image is far from equitable. The brightest tones of the image (the highlights) use the lion's share of the 4096 levels available while the shadows are comparatively starved of information.

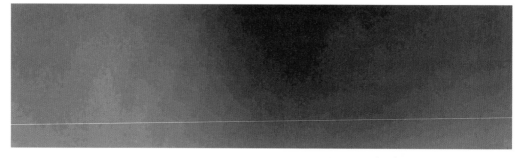

An example of posterization or banding

Shadow management

CCD and CMOS chips are, however, linear devices. This linear process means that when the amount of light is halved, the electrical stimulation to each photoreceptor on the sensor is also halved. Each f-stop reduction in light intensity halves the amount of light that falls onto the receptors compared to the previous f-stop. Fewer levels are allocated by this linear process to recording the darker tones. Shadows are 'level starved' in comparison to the highlights that have a wealth of information dedicated to the brighter end of the tonal spectrum. So rather than an equal amount of tonal values distributed evenly across the dynamic range, we actually have the effect as shown above. The deepest shadows rendered within the scene often have fewer than 128 allocated levels, and when these tones are manipulated in post-production Photoshop editing there is still the possibility of banding or posterization.

Adjusting exposure in ACR

For those digital photographers interested in the dark side, an old SLR loaded with a fine-grained black and white film is a hard act to follow. The liquid smooth transitions and black velvet-like quality of dark low-key prints of yesteryear is something that digital capture is hard pressed to match. The sad reality of digital capture is that underexposure in low light produces an abundance of noise and banding (steps rather than smooth transitions of tone). The answer, however, is surprisingly simple for those who have access to a DSLR camera and have selected the Raw format from the Quality menu settings in their camera. Simply be generous with your exposure to the point of clipping or overexposing your highlights and only attempt to lower the exposure of the shadows in Adobe Camera Raw.

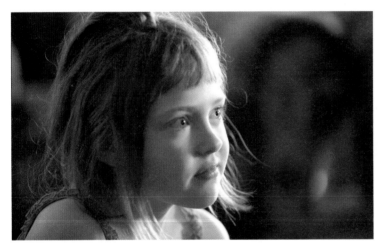
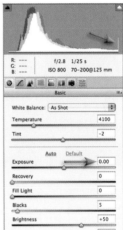

Foundation Project 5

1. **In-camera:** The first step is the most difficult to master for those who are used to using Auto or Program camera exposure modes. Although the final outcome may require deep shadow tones, the aim in digital low-key camera exposure is to first get the shadow tones away from the left-hand wall of the histogram by increasing and NOT decreasing the exposure. It is vitally important, however, not to increase the exposure so far that you lose or clip highlight detail. The original camera exposure of the image used in this project reveals that the shadow tones (visible as the highest peaks in the histogram) have had a generous exposure in-camera so that noise and banding have been avoided (the tones have moved well to the right in the histogram). The highlights, however, look as though they have become clipped or overexposed. The feedback from the histogram on the camera's LCD should have confirmed the clipping at the time of exposure (the tall peak on the extreme right-hand side of the histogram) and if you had your camera set to warn you of overexposure, the highlights would have been merrily flashing at you to ridicule you of your sad attempts to expose this image. The typical DSLR camera is, however, misleading when it comes to clipped highlights and ignorant of what is possible in Adobe Camera Raw. Adobe Camera Raw can recover at least one stop of extra highlight information when the Exposure slider is dragged to the left (so long as the photographer has used a DSLR camera that has a broader dynamic range than your typical fixed-lens compact digicam).

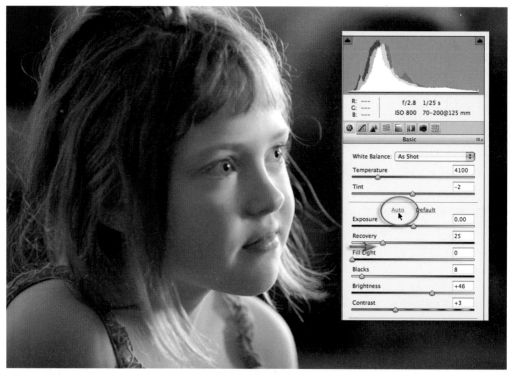

Adobe Camera Raw rescues the highlights – sometimes automatically

'Exposing right'

In ACR when the Auto checkbox in the Exposure slider is selected, Adobe Camera Raw often attempts to rescue overexposed highlights automatically. With a little knowledge and some attention to the camera's histogram during the capture stage, you can master the art of pushing your highlights to the edge. So if your model is not in a hurry (mine is watching a half-hour TV show) you can take an initial exposure on Auto and then check your camera for overexposure. Increase the exposure using the exposure compensation dial on the camera until you see the flashing highlights. When the flashing highlights start to appear you can still add around one extra stop to the exposure before the highlights can no longer be recovered in Adobe Camera Raw. The popular term for this peculiar behavior is called 'exposing right'.

PERFORMANCE TIP

If the highlights are merrily flashing and the shadows are still banked up against the left-hand wall of the histogram, the solution is to increase the amount of fill light, i.e. reduce the difference in brightness between the main light source and the fill light. If you are using flash as the source of your fill light, it would be important to drop the power of the flash by at least two stops and choose the 'Slow-Sync' setting (a camera flash setting that balances both the ambient light exposure and flash exposure) so that the flash light does not overpower the main light source positioned behind your subject. The harsh light from the on-camera flash can also be diffused using a diffusion device.

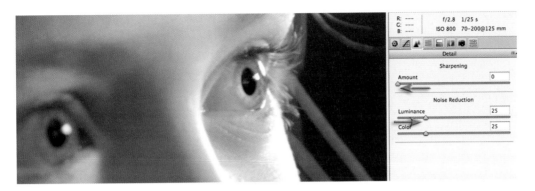

2. Before we adjust the tones to create our low-key image we must first check that our tones are smooth and free from color and luminance noise. Zoom in to 100% magnification for an accurate preview and look for any problems in the smooth dark-toned areas. Setting both the Luminance Smoothing and Color Noise Reduction sliders to 25 (found in the Detail tab) removes the noise in this image. For this example, I would also recommend that the Sharpness slider be set to 0 at this point. Rather than committing to global sharpening using the Adobe Camera Raw dialog box, we can apply selective sharpening either in ACR using the Adjustment Brush or in the main Photoshop editing space. This may help to keep the tones as smooth as possible.

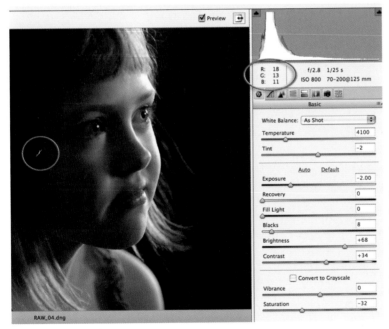

Tip: Click in the Exposure slider text box so it is selected (cursor line appears), then move the White Balance Tool in place over the deeper shadows. You can now use the up/down keys on the keyboard to move the slider and monitor the actual pixel value change on the screen during adjustment

3. Create the low-key look by moving the Exposure and/or the Brightness sliders to the left in the Basic tab. You can continue to drop these sliders until the highlights start to move away from the right-hand wall of the histogram. Select the 'White Balance Tool' and move your mouse cursor over the deeper shadows – this will give you an idea of the RGB values you are likely to get when this image is opened into the editing space. Once you approach an average of 15 to 20 in all three channels the low-key look should have been achieved.

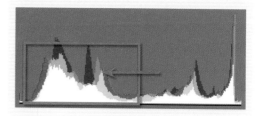

Expose right and adjust left

'Expose right' and multiple exposures

This inequitable distribution of levels has given rise to the idea of 'exposing right'. This work practice encourages the user seeking maximum quality to increase the camera exposure of the shadows (without clipping the highlights) so that more levels are afforded to the shadow tones. This approach to making the shadows 'information rich' involves increasing the amount of fill light (actual light rather than the ACR's fill light) or lighting with less contrast in a studio environment. If the camera Raw file is then opened in the camera Raw dialog box the shadow values can then be reassigned their darker values to expand the contrast before opening it as a 16 Bits/Channel file. When the resulting shadow tones are edited and printed, the risk of visible banding in the shadow tones is greatly reduced.

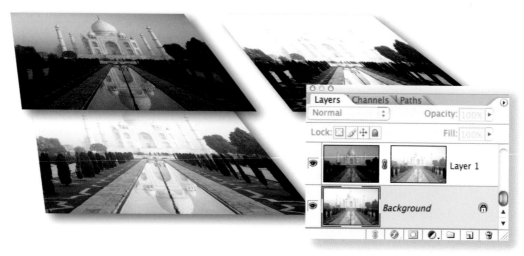

Separate exposures can be combined during the image-editing process

This approach is not possible when working with a subject with a fixed subject brightness range, e.g. a landscape, but in these instances there is often the option of bracketing the exposure and merging the highlights of one digital file with the shadows of a second. Choose 'Merge to HDR' (high dynamic range) from the File > Automate menu or use the manual approach outlined in 'Advanced Retouching'. The example above shows the use of a layer mask to hide the darker shadows in order to access the bit-rich shadows of the underlying layer and regain the full tonal range of the scene.

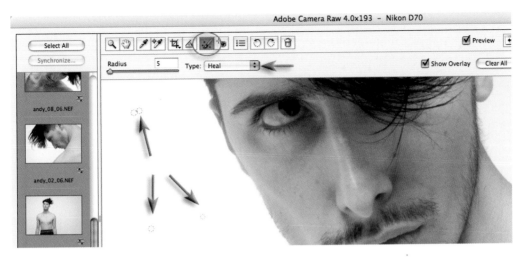

Dust on the sensor – batch removal

As we saw in the last chapter a significant problem arises for many digital cameras when dust is allowed to accumulate on the sensor. This becomes most noticeable in smooth areas of light tone such as sky or white studio backdrops as dark spots. Use the Retouch Tool and click on a spot in the image. Photoshop will automatically choose an area of the image to heal this spot. The Radius can be changed by raising the Radius slider or dragging the red circle bigger. The source for the heal area (the green circle) can be dragged to an alternate location if required. Fortunately the dust is in the same place in each and every image and so after spotting one image you can choose 'Select All' and 'Synchronize' to remove the dust from all images you have open in the ACR dialog box. Be sure to check the Spot Removal option in the Synchronize dialog box before selecting OK.

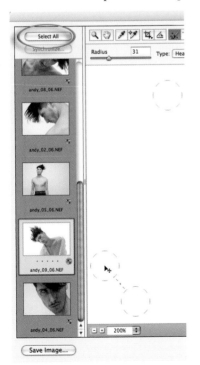

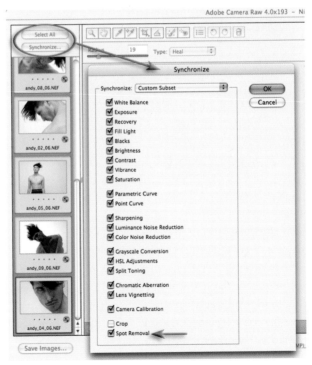

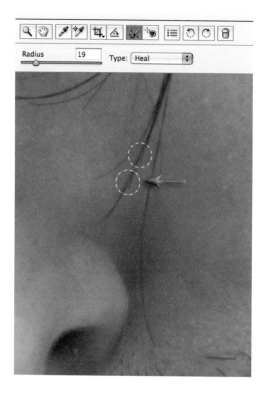

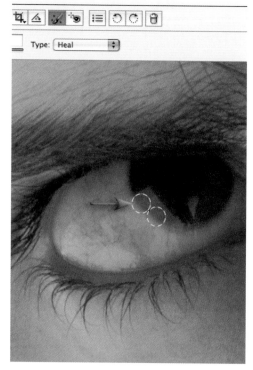

In areas of continuous tone the heal area that is selected automatically by Photoshop is usually OK. In areas of fine detail the healing area may need to be relocated to ensure lines do not appear disjointed.

Archiving Raw files as digital negatives

Working with camera Raw files is going to create some extra strain on the storage capacity found on a typical computer's hard drive. What to do with all of the extra gigabytes of Raw data is a subject that people are divided about. You can burn them to CD or DVD disks – but are the disks truly archival? You can back them up to a remote Firewire drive – but what if the hard drive fails? Some believe that digital tape offers the best track record for longevity and security. Why archive at all you may ask? Who can really tell what the image-editing software of the future will be capable of – who can say what information is locked up in the Raw data that future editions of the Raw editors will be able to access. Adobe has now created a universal Raw file format called DNG (Digital Negative) in an attempt to ensure that all camera Raw files (whichever camera they originate from) will be accessible in the future. The Digital Negative format also includes lossless compression to reduce the size of the Raw files. The Adobe DNG converter is available from the Adobe website or from the supporting DVD. The converter will ensure that your files are archived in a format that will be understood in the future. Expect to see future models of many digital cameras using this DNG format as standard. One thing *is* for sure – Raw files are a valuable source of the rich visual data that many of us value and so the format will be around for many years to come.

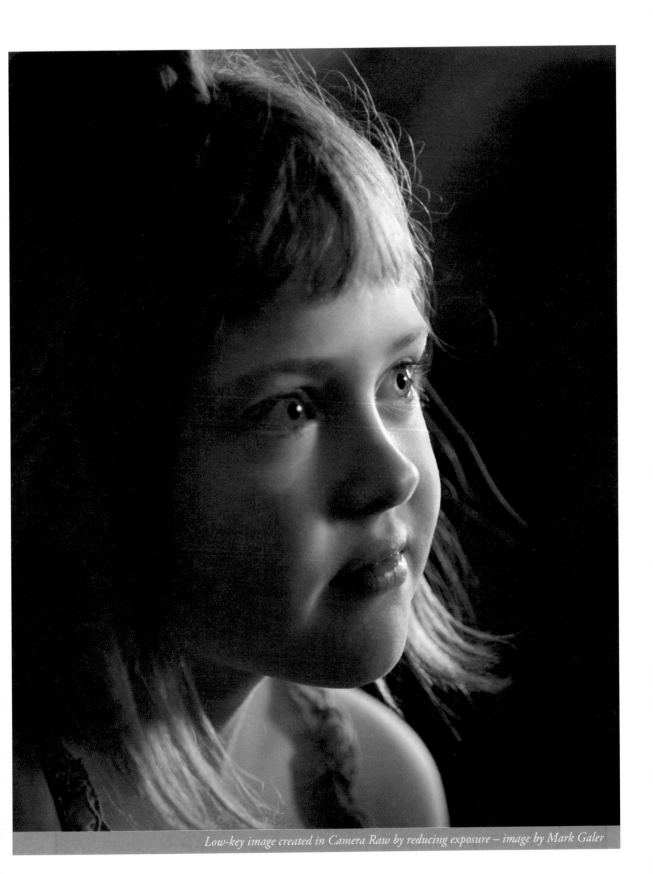

Low-key image created in Camera Raw by reducing exposure – image by Mark Galer

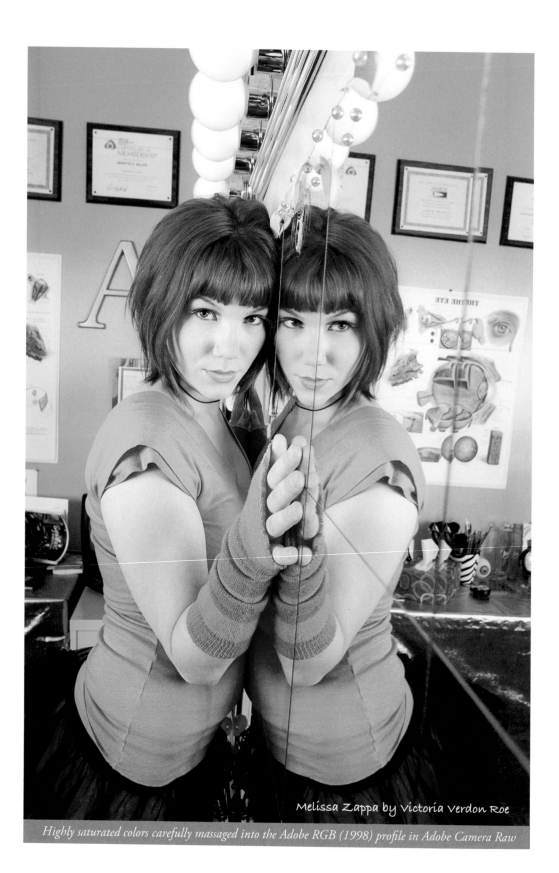

Melissa Zappa by Victoria Verdon Roe

Highly saturated colors carefully massaged into the Adobe RGB (1998) profile in Adobe Camera Raw

digital printing

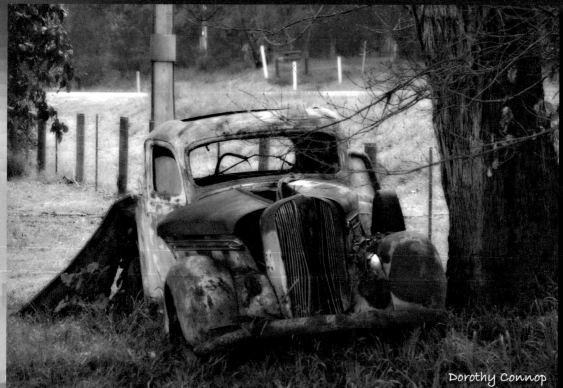

Dorothy Connop

essential skills

- Control the color accuracy between monitor preview and print.
- Understand the procedures involved with producing a digital print.
- Print a color-managed digital image using a desktop inkjet printer.
- Compensate for visual differences between the monitor preview and print.

Introduction

The secret to successful printing is to adopt a professional print workflow that takes the frustration out of seeing the colors shift as your image moves from camera to monitor, and from monitor to print. Color consistency has never been more easy and affordable to implement for the keen amateur and professional photographer. This project guides you along the path to ultimate print satisfaction, so that you will never say those often heard words ever again – 'why do the colors of my print look different to my monitor?'

The reward for your effort (a small capital outlay and a little button pushing) is perfect pixels – color consistency from camera to screen to print. Once the initial work has been carried out predictable color is a real 'no-brainer', as all of the settings can be saved as presets. As soon as you start printing using your new color-managed workflow you will not only enjoy superior and predictable prints, but you will also quickly recover the money you outlaid to implement this workflow (no more second and third attempts).

The range or 'gamut' of colors that each output device is capable of displaying can vary enormously. The Adobe RGB monitor space (shown in white) is able to contain the gamut of a typical inkjet printer and so offers a better alternative than editing in sRGB, which is primarily a monitor space

The problem and the solution

Have you ever walked into a TV shop or the cabin of an aircraft and noticed that all the TVs are all showing exactly the same TV program but no two pictures are the same color? All of the TVs are receiving exactly the same signal but each TV has its own unique way of displaying color (its own unique 'color characteristics'). Different settings on each TV for brightness, contrast and color only make the problem worse.

One signal – different pictures (image courtesy of iStockphoto.com)

In the perfect world there would be a way of making sure that all of the TVs could synchronize their settings for brightness, contrast and color, and the unique color characteristics of each TV could be measured and taken into account when displaying a picture. If this could be achieved we could then send 10 different TVs the same picture so that the image appeared nearly identical on all TVs, irrespective of make, model or age. In the world of digital photography, Adobe has made the elusive goal of color consistency possible by implementing a concept and workflow called Color Management. Color Management, at first glance, can seem like an incredibly complex science to get your head around, but if just a few simple steps are observed and implemented then color consistency can be yours.

Don't position your monitor so that it faces a window and lower the room lighting so that your monitor is the brightest thing in your field of vision (image courtesy of iStockphoto.com)

Step 1 – Prepare your print workshop

The first step is to optimize the room where your monitor lives. Ideally, the monitor should be brighter than the light source used to illuminate the room and positioned so the monitor does not reflect any windows or lights in the room (the biggest problems from light will all be behind you and over your shoulders as you sit at the monitor). Professionals often build hoods around their monitors to prevent stray light falling on the surface of the monitor but if you carefully position the monitor in the room you should be able to avoid this slightly 'geeky' step. Stray light that falls on your monitor will lower the apparent contrast of the image being displayed and could lead you to add more contrast when it is not required. The color of light in the room (warm or cool) is also a critical factor in your judgement of color on the screen. It is advisable to light the room using daylight but this should not be allowed to reflect off brightly colored surfaces in the room, e.g. brightly painted walls or even the brightly colored top you may be wearing when you are sitting in front of your monitor. If the room is your own personal space, or your partner supports your passion/obsession/addiction for digital imaging, then you could go that bit further and paint your walls a neutral gray. The lighting in the room should be entirely daylight – without the possibility of warm sunlight streaming into the room at certain times of the day. The brightness of the daylight in the room can be controlled with blinds or you can introduce artificial daylight by purchasing color-corrected lights, e.g. Solux halogen globes or daylight fluorescent lights. If the above recommendations are difficult to achieve – lower the level of the room lighting significantly.

Overview of Step 1 > Position your computer monitor so that it does not reflect any windows, lights or brightly colored walls in the room (when you sit at the monitor a neutral colored wall, without a window, should be behind you). Use daylight or daylight globes to light the room and make sure the room lighting is not as bright as the monitor (the monitor should be the brightest thing in your field of view).

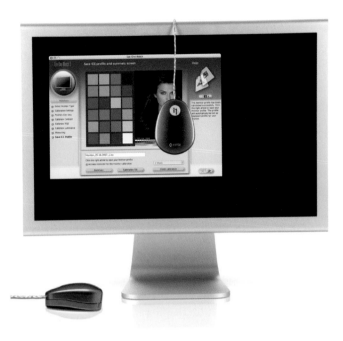

Step 2 – Prepare your monitor

Purchase a monitor calibration device (available for as little as US$100 from X-Rite or Data Color) and follow the step-by-step instructions. The calibration process only takes a few minutes once you have read through the instructions and adjusted a few settings on your monitor. It is now widely accepted that photographers should choose a D65 whitepoint (how cool or warm tones appear on your monitor) and a Gamma of 2.2 (this controls how bright your midtones are on your monitor). The next time you use your calibrated and profiled monitor, Photoshop will pick up the new profile to ensure you are seeing the real color of the image file rather than a version that has been distorted by the monitor's idiosyncrasies and inappropriate default settings.

MONITOR CALIBRATOR RECOMMENDATIONS

If you are on a budget I recommend the DataColor Spyder 2 Express or the Pantone Huey. If you have a little more money and are looking for a really professional tool, then the Eye One Display 2 is my personal favorite, although it costs a little more. If you decide on the Spyder 2 Express I found the only hiccup in an otherwise easy-to-follow guide was the instruction on how to decide whether your LCD monitor had a 'brightness' or 'backlight' control. As the vast majority of LCD monitors use a 'backlight' to control brightness I think this information is a possible source of confusion. The tiny Pantone Huey is really easy to use, completes the process in just a few minutes, and has an option to measure the brightness of the room and then adjust the brightness of the monitor accordingly. I would recommend that you lower the brightness of the LCD monitor to a setting of between 50% and 75% before calibrating an LCD screen with the Huey. The automatic brightness adjustment of the monitor is only useful if you can't maintain a standard level of illumination in your room. If you think small is cute, then the Huey will do an admirable job and you can put it in your shirt pocket when you're done.

Step 3 – Prepare your inkjet printer

Just as the color characteristics of the monitor had to be measured and profiled in order to achieve accurate color between camera and monitor, a profile also has to be created that describes the color characteristics of the printer. This ensures color accuracy is maintained between the monitor and the final print. When an accurate profile of the printer has been created, Photoshop (rather than the printer) can then be instructed to manage the colors to maintain color consistency. Photoshop can only achieve this remarkable task because it knows (courtesy of the custom profile) how the printer reproduces the color information it is handed.

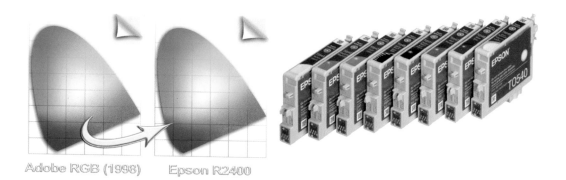

Adobe RGB (1998) Epson R2400

If you want to achieve optimum print quality at home it is recommended that you use a photo-quality printer (one with six or more inks), and that lets Photoshop manage the colors for the best results. A custom profile is only accurate so long as you continue to use the same ink and paper. Additional profiles will need to be created for every paper surface you would like to use. Printers come shipped with profiles, but these are of the 'one size fits all' variety, otherwise known as 'canned profiles'. For optimum quality, custom printer profiles need to be made for the unique characteristics of every printer (even if they are of the same brand and model number).

Note > Canned profiles for different paper stocks are also available on the web so check that you have the latest versions if you intend to proceed without making a custom profile.

PERFORMANCE TIP

In an attempt to make the first time not too memorable, for all the wrong reasons, check that your ink cartridges are not about to run out of ink and that you have a plentiful supply of good quality paper (same surface and same make). Refilling your ink cartridges with a no-name brand and using cheap paper is not recommended if you want to achieve absolute quality and consistency. I would recommend that you stick with the same brand of inks that came shipped with your printer and use the same manufacturer's paper until you have achieved your first successful workflow.

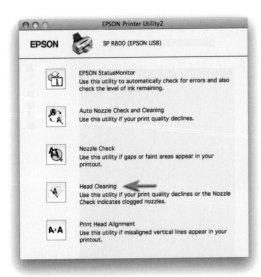

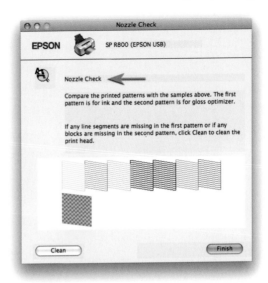

Important Note > Before proceeding to create a custom profile for your printer, check that all the ink nozzles are clean. Open your printer utility software and run a Nozzle Check. This will print out a pattern on plain paper so that you can check all of the inks are running cleanly. If one or more of the inks are not printing or some of the pattern is missing then proceed to select the option to clean the heads in the Utility software.

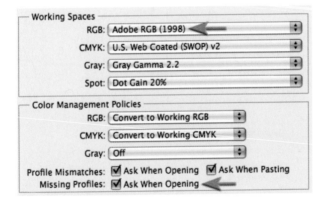

Step 4 – Select appropriate color setting

Select a 'working space' for Photoshop that is compatible with the range of colors that can be achieved with your inkjet printer using good quality 'photo paper'. The most suitable working space currently available is called 'Adobe RGB (1998)'. To implement this working space choose 'Color Settings' in Photoshop and set the workspace to 'Adobe RGB (1998)' from the RGB pull-down menu. In the 'Color Management Policies' section, select 'Convert to Working RGB' from the 'RGB' pull-down menu and check the 'Ask When Opening' boxes.

Note > Selecting North America Prepress 2 from the Settings menu in the Color Settings dialog will automatically adjust the RGB working space to Adobe RGB (1998).

Image Science Profile Target 2007 - RGB - Please do NOT resize or change the DPI!

A B C D E F G H I J K L M N O P Q R S T U V W X Y Z 2A 2B 2C 2D 2E 2F 2G 2H 2I 2J 2K 2L 2M

GretagMacbeth © 2005

Step 5 – Obtain a profile target

You can profile your printer, but the equipment is required for this step is a little expensive. You can, however, print out a test chart and mail it to a custom printer profile company that has the equipment and will make the profile for you. If this is the workflow you choose to follow download a profile target from the website of the company who will create your custom printer profile. The target print can be mailed back to the company and your profile can be emailed back to you once it has been created by analyzing the test print you created.

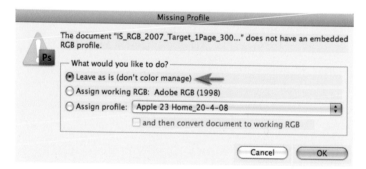

Step 6 – Open the profile target file in Photoshop

Open the target print and select 'Leave as is' in the 'Missing Profile' dialog box. If the file opens and no dialog box appears then close the file and check that you have changed the Color Settings as outlined in Step 4. The color swatches on the target print must remain unchanged by the color management mechanisms for this process to be effective.

Note > Do not attempt to print a profile target file or test chart using Photoshop Lightroom as Lightroom cannot leave a file 'as is', i.e. switch off the color management.

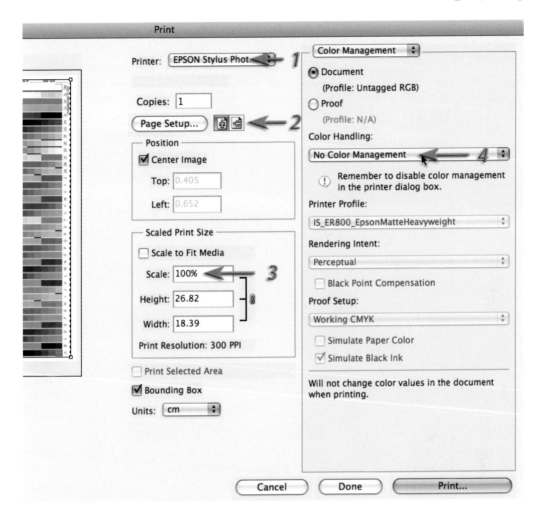

Step 7 – Adjust the print settings in Photoshop

When the target image is open in Photoshop proceed to 'File > Print'. In order to measure the unique characteristics of the printer the colors on the test chart must be printed without any color management, i.e. Photoshop must NOT change the RGB numbers, hence the recommendation to select No Color Management in this step.

1. Select your printer from the 'Printer' menu.
2. Click on the 'Page Setup' to choose the size of your printing paper (large enough to print the target image at 100%). **Note >** You can also rotate the image or rotate the paper orientation within the Page Setup dialog box.
3. Make sure that the scale is set to 100%. The patches **MUST** be output at 100%.
4. In the 'Color Management' section of the dialog box choose 'No Color Management' for the Color Handling option. The Source Space should read 'Untagged RGB' and there will be a reminder to switch off the color management in the Printer Preferences dialog which we will do in the next step.

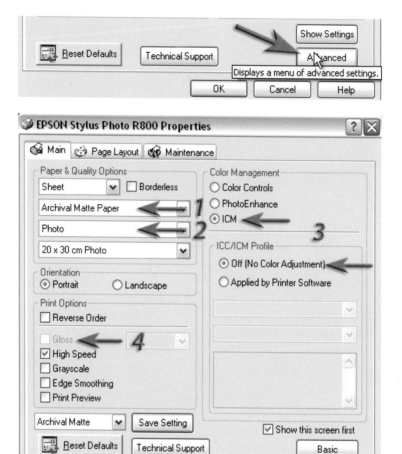

The printer driver of an Epson R800 – the layout and naming of the various options will vary between different makes and models of printers

Step 8 – Adjust the printer settings

Click on Printer Preferences in Photoshop's printer dialog box (in the Color Management section) and then choose the 'Advanced' options in your printer driver if available. In the printer driver dialog box choose the paper or media type (1), photo print quality (2) and switch off the color management (3), any Auto settings, a 'Gloss' option (4) if available and, for owners of Canon printers, make sure the 'Print Type' is set to 'NONE'. The precise wording for switching off the color management in the printer driver will vary depending on the make of the printer and the operating system you are using. When using an Epson or Canon printer you may see that color management is referred to as ICM or ICC. Other manufacturers may refer to letting the software (Photoshop) manage the color. When you print this target print, the colors are effectively printed in their raw state. In this way the lab that creates your profile can measure how the colors vary from one printer to another and they can then create a unique profile that best describes what your printer does with standard 'unmanaged' color.

Note > If in doubt consult your profile service provider for the precise settings you should use for your printer.

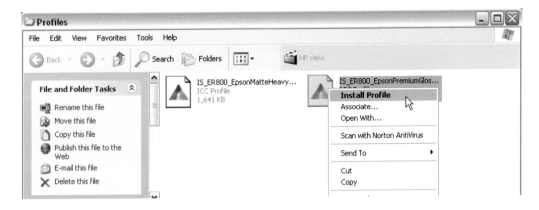

Step 9 – Create and install custom profile

Examine the target print to ensure that it is free from streaking (this may occur due to clogged printing heads) and if clean send this target print to the profiling company so that it can be measured using the more sophisticated and expensive profiling hardware that is required to complete this process. They will be able to send you the profile as an attachment to an email. If you are using a PC right-click the profile and choose Install, and Windows will install it in the correct location. If using a Mac you will need to locate the ColorSync folder on your hard drive (Library > ColorSync > Profiles) and copy the ICC profile to this location.

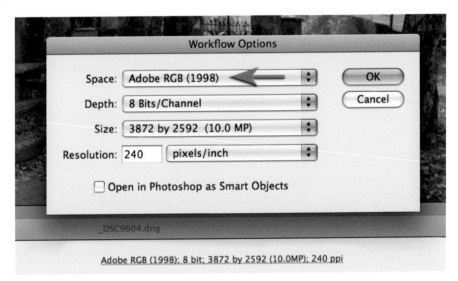

Step 10 – Tag images with the Adobe RGB profile

When you have installed your custom printer profile make sure that your images destined for print are tagged with the Adobe RGB profile. Select the Adobe RGB profile in the camera if possible when shooting in the JPEG file format (digital SLR cameras and many prosumer fixed-lens digicams allow the photographer to choose this setting). If capturing in the Raw file format you must click on the blue writing at the base of the ACR dialog box that will open the Workflow Options. Select Adobe RGB (1998) from the Space menu.

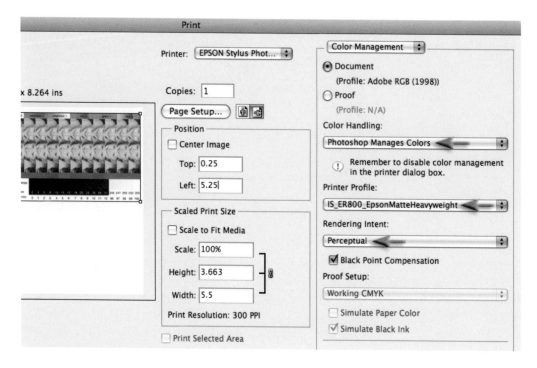

Step 11 – Test your color managed workflow

It is recommended that the first print you make using your custom profile is a test image – one that has a broad range of colors and tones (such as the one on the supporting DVD). A test image with skin tones can be very useful for testing the accuracy of your new print workflow. When you next open the 'Print' dialog box make sure you change the previous setting used to print the profile target from 'No Color Management' to **Photoshop Manages Colors**. Select your new custom profile from the Printer Profile menu and in the Rendering Intent options choose either 'Perceptual' or 'Relative Colorimetric'. Select 'Print'.

Note > All of the printer driver settings that were used to print your target print must now be duplicated with every other image to be printed using your custom profile.

Step 12 – Make printer presets

From the Printer Preferences menu select the same settings that were used to print the profile target (don't forget to ensure the color management is turned 'OFF'). Save a 'Preset' or 'Setting' for all of the printing options so that you only choose this one setting each time you revisit this dialog box. View your first print using bright daylight and you will discover, if you have followed these directions to the letter, that you have almost certainly found a solution to one of the mysteries of digital color photography – the search for predictable color.

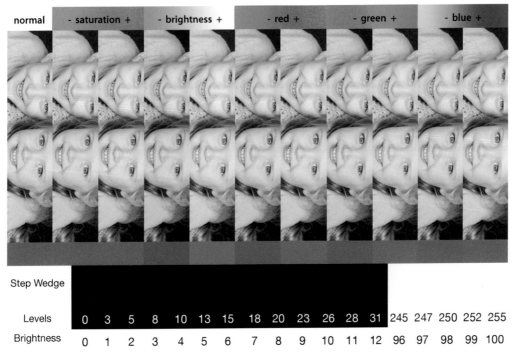

	normal	- saturation +	- brightness +	- red +	- green +	- blue +

Step Wedge																
Levels	0	3	5	8	10	13	15	18	20	23	26	28	31	245 247 250 252 255		
Brightness	0	1	2	3	4	5	6	7	8	9	10	11	12	96 97 98 99 100		

Use the test file on the supporting website to help you target the perfect color balance quickly and efficiently

Step 13 – Assessing the test print for accuracy

View the print using daylight (not direct sunlight) when the print is dry, and look for differences between the print and the screen image in terms of hue (color), saturation and brightness.

1. Check that the colors are saturated and printing without tracking marks or banding. If there is a problem with missing colors, tracking lines or saturation, clean the printer heads using the available option in the printer driver.
2. View any skin tones to assess the appropriate level of saturation.
3. View any gray tones to determine if there is a color cast present in the image. If these print as gray then no further color correction is required.

PERFORMANCE TIP

Any differences between the monitor and the print will usually now be restricted to the differences in color gamuts between RGB monitors and CMYK printers. The vast majority of colors are shared by both output devices but some of the very saturated primary colors on your monitor (red, green and blue) may appear slightly less saturated in print. Choose a printer with an inkset that uses additional primary inks if you want to achieve the maximum gamut from a printer.

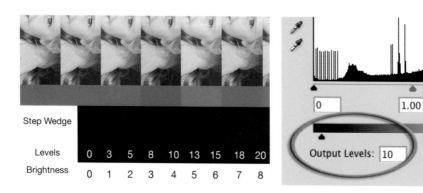

Step Wedge

Levels	0	3	5	8	10	13	15	18	20
Brightness	0	1	2	3	4	5	6	7	8

Step 14 – Preserving shadow detail

If the dark shadow detail that is visible on screen is printing as black without detail then you could try switching from the 'Relative Colorimetric' rendering intent to the 'Perceptual' rendering intent. If this does not resolve the problem then establish a Levels adjustment layer to resolve the problem in Photoshop. The bottom left-hand slider in the Levels dialog box should be moved to the right to reduce the amount of black ink being printed in the shadows (raise it to a value of no higher than 10 otherwise the darkest tones will start to appear gray). This should allow dark shadow detail to be visible in subsequent prints. This adjustment layer can be switched on for printing and switched off for viewing the image on screen.

Note > It is important to apply these Output level adjustments to an adjustment layer only as these specific adjustments apply only to the output device and media you are currently testing. You may need to create another adjustment layer for a different output device.

PERFORMANCE TIPS

Materials

Start by using the printer manufacturer's recommended ink and paper.
Use premium grade 'photo paper' for maximum quality.

Monitor

Position your monitor so that it is clear of reflections.
Let your monitor warm up for a while before judging image quality.
Calibrate your monitor using a calibration device.

Adobe

Set the Color Settings of the Adobe software to allow you to use the Adobe RGB profile.
Select 'Photoshop Manages Color'.
Use a six-ink (or more) inkjet printer or better for maximum quality.
Select the 'Media Type' in the Printer Software dialog box.
Select a high dpi setting (1440 dpi or greater) or 'Photo' quality setting.
Use a custom printer profile.

Proofing

Allow print to dry and use daylight to assess color accuracy of print.

Soft proofing

Although the image that appears on your monitor has been standardized (after the calibration process and the implementation of the Adobe RGB working space), the printed image from this standardized view would appear different if printed through a variety of different inkjet printers onto different paper surfaces or 'media types'. In Photoshop it is possible to further alter the visual appearance of the image on your monitor so that it more closely resembles how it will actually appear when printed by your specific make and model of inkjet printer on a particular paper surface. This process is called 'soft proofing'.

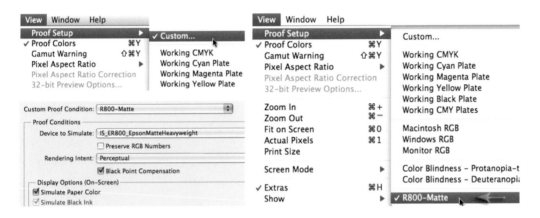

To set up the soft proof view go to View > Proof Setup > Custom. From the Profile menu select the profile of your printer and paper or 'media type'. Choose 'Perceptual' from the 'Intent' menu. Check the 'Use Black Point Compensation' and 'Paper White' boxes if you intend to remove all other white and black tones from your display when you view your image (this would include Photoshop's panels, menu and the desktop colors). The image colors will look gray or washed out if you don't take this step.

Save the soft proof settings so they can be accessed quickly the next time you need to soft proof to the same printer and media type. When you view your image with the soft proof preview the color and tonality will be modified to more closely resemble the output characteristics of your printer and choice of media. The image can now be edited with the soft proof preview on, to achieve the desired tonality and color that you would like to see in print. It is recommended that you edit in 'Full Screen Mode' to remove distracting colors on your desktop and use adjustment layers to modify and fine-tune the image on screen.

Printing using a professional laboratory

Professional photographic laboratory services are now expanding into the production of large and very large prints using the latest inkjet and piezo technology. Many are also capable of printing your digital files directly onto color photographic paper. In fact, outputting to color print paper via machines like the Durst Lambda and Fuji Frontier has quickly become the 'norm' for a lot of professional photographers. Adjustment of image files that print well on desktop inkjets so that they cater for the idiosyncrasies of these RA4 and large inkjet machines is an additional output skill that is really worth learning.

With improved quality, speed and competition in the area, the big players like Epson, Kodak, Durst, Fuji and Hewlett Packard are manufacturing units that are capable of producing images that are not only visually stunning, but also very, very big. Pictures up to 54 inches wide can be made on some of the latest machines, with larger images possible by splicing two or more panels together. A photographer can now walk into a bureau with a CD containing a favorite image and walk out the same day with a spliced polyester poster printed with fade-resistant, all-weather inks the size of a billboard. In addition to these dedicated bureau services, some professionals, whose day-to-day business revolves around the production of large prints, are actually investing in their own wide-format piezojet or inkjet machines. The increased quality of pigment-based dye systems together with the choice of different media, or substrates as they are referred to in the business, provides them with more imaging and texture choices than are available via the RA4 route.

Before you start

Getting the setup right is even more critical with large-format printing than when you are outputting to a desktop machine. A small mistake here can cause serious problems to both your 48 × 36 inch masterpiece as well as your wallet, so before you even turn on your computer, talk to a few professionals. Most output bureaus are happy to help prospective customers with advice and usually supply a series of guidelines that will help you set up your images to suit their printers. These instructions may be contained in a pack available with a calibration swatch over the counter, or might be downloadable from the company's website.

Some of the directions will be general and might seem a little obvious, others can be very specific and might require you to change the CMYK settings of your image-editing program so that your final files will match the ink and media response of the printer. Some companies will check that your image meets their requirements before printing, others will dump the unopened file directly to the printer's RIP assuming that all is well. So make sure that you are aware of the way the bureau works before making your first print.

General guidelines for professional labs

The following guidelines have been compiled from the suggestions of several output bureaus. They constitute a good overview but cannot be seen as a substitute for talking to your own lab directly.

1. Ensure that the image is orientated correctly. Some printers are set up to work with a portrait or vertical image by default; trying to print a landscape picture on these devices will result in areas of white space above and below the picture and the edges being cropped.

2. Make sure the image is the same proportion as the paper stock. This is best achieved by making an image with the canvas the exact size required and then pasting your picture into this space.

3. Don't use crop marks. Most printers will automatically mark where the print is to be cropped. Some bureaus will charge to remove your marks before printing.

4. Convert text to line or raster before submission. Some imaging and layout programs need the font files to be supplied together with the image at the time of printing. If the font is missing then the printer will automatically substitute a default typeface, which in most cases will not be a close match for the original. To avoid failing to supply a font needed, convert the type to line or raster before sending the image to the bureau.

5. Use the resolution suggested by the lab. Most output devices work best with an optimal resolution; large-format inkjet printers are no different. The lab technician will be able to give you details of the best resolution to supply your images in. Using a higher or lower setting than this will alter the size that your file prints so stick to what is recommended.

6. Keep file sizes under the RIP maximum. The bigger the file the longer it takes to print. Most bureaus base their costings on a maximum file size. You will need to pay extra if your image is bigger than this value.

7. Use the color management system recommended by the lab. In setting up you should ensure that you use the same color settings as the bureau. This may mean that you need to manually input set values for CMYK or use an ICC profile downloaded from the company's website.

Shell Wilkes

layers and channels

Serap Osman

essential skills

- Learn the creative potential of layers, adjustment layers, channels and layer masks.
- Develop skills and experience in the control and construction of digital montages.

Introduction

The traditional photograph contains all the picture elements in a single plane. Digital images captured by a camera or sourced from a scanner are similar in that they are also flat files. And for a lot of new digital photographers this is how their files remain – flat. All editing and enhancing work is conducted on the original picture but advanced techniques require things to be a little different.

Digital pictures are not always flat

Photoshop contains the ability to use layers with your pictures. This feature releases your images from having to keep all their information in a flat file. Different image parts, added text and certain enhancement tasks can all be kept on separate layers. The layers are kept in a stack and the image you see on screen in the work area is a composite of all the layers.

Sound confusing? Well try imagining, for example, that each of the image parts of a simple portrait photograph are stored on separate plastic sheets. These are your layers. The background sits at the bottom. The portrait is laid on top of the background and the text is placed on top. When viewed from above the solid part of each layer obscures the picture beneath. Whilst the picture parts are based on separate layers they can be moved, edited or enhanced independently of each other. If they are saved using a file format like Photoshop's PSD file (which is layer friendly) all the layers will be preserved and present next time the file is opened.

Layers and channels confusion

Another picture file feature that new users often confuse with layers is channels. The difference is best described as follows:

- Layers separate the image into picture, text, shapes and enhancement parts.
- Channels, on the other hand, separate the image into its primary base colors.

The Layers panel will display the layer stack with each part assembled on top of each other, whereas the Channels panel will show the photograph broken into its red, green and blue components (if it is an RGB image – but more on this later).

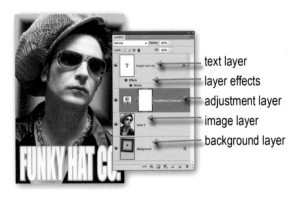

text layer
layer effects
adjustment layer
image layer
background layer

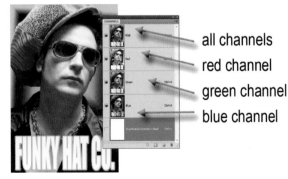

all channels
red channel
green channel
blue channel

Example image showing the layer components

Example image showing the channels

Layers overview

Being able to separate different components of a picture means that these pieces can be moved and edited independently. This is a big advantage compared to flat file editing, where the changes are permanently made part of the picture and can't be edited at a later date. A special file type is needed if these edit features are to be maintained after a layered image is saved and reopened. In Photoshop, the PSD, PDF and PSB formats support all layer types and maintain their editability. It is important to note that other common file formats such as standard JPEG and TIFF do not generally support these features (although JPEG2000 and TIFF saved via Photoshop CS2 can support layers). They flatten the image layers while saving the file, making it impossible to edit individual image parts later.

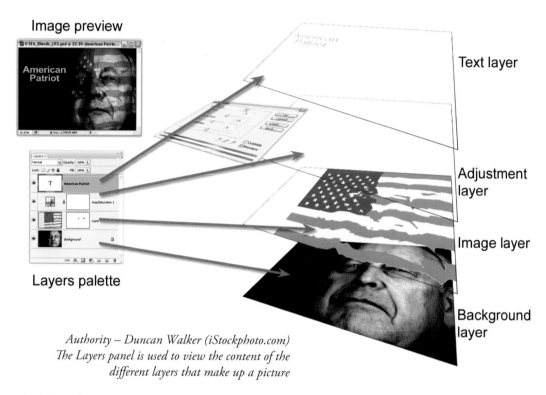

Image preview

Text layer

Adjustment layer

Image layer

Layers palette

Background layer

Authority – Duncan Walker (iStockphoto.com)
The Layers panel is used to view the content of the
different layers that make up a picture

Adding layers

When a picture is first downloaded from your digital camera or imported into Photoshop or Bridge it usually contains a single layer. It is a 'flat file'. By default the program classifies the picture as a background layer. You can add extra 'empty' layers to your picture by clicking the Create New Layer button at the bottom of the Layers dialog or choosing the Layer option from the New menu in the Layer heading (Layer > New > Layer). The new layer is positioned above the currently selected layer (highlighted in the Layers panel).

Some actions such as adding text with the Type Tool automatically or drawing a shape create a new layer for the content. This is also true when adding adjustment and fill layers to your image and when selecting, copying and pasting image parts.

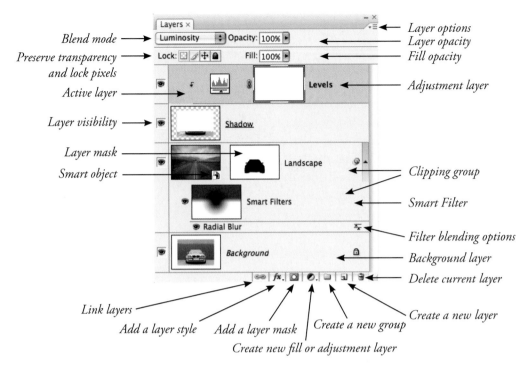

Blend mode → Luminosity Opacity: 100%
Preserve transparency and lock pixels → Lock: Fill: 100%
Active layer → Levels
Layer visibility → Shadow
Layer mask → Landscape
Smart object → Smart Filters
Radial Blur
Background

Layer options
Layer opacity
Fill opacity
Adjustment layer
Clipping group
Smart Filter
Filter blending options
Background layer
Delete current layer
Create a new layer

Link layers
Add a layer style Add a layer mask Create a new group
Create new fill or adjustment layer

Viewing layers

Photoshop's Layers panel displays all your layers and their settings in the one dialog box. If the panel isn't already on screen when opening the program, choose the option from the Window menu (Window > Layers). The individual layers are displayed, one on top of each other, in a 'layer stack'. The image is viewed from the top down through the layers. When looking at the picture on screen we see a preview of how the image looks when all the layers are combined. Each layer is represented by a thumbnail on the left and a name on the right. The size of the thumbnail can be changed, as can the name of the layer. By default each new layer is named sequentially (layer 1, layer 2, layer 3). This is fine when your image contains a few different picture parts, but for more complex illustrations it is helpful to rename the layers with titles that help to remind you of their content (portrait, sky, tree). Layers can be turned off by clicking the eye symbol on the far left of the layer so that it is no longer showing. This action removes the layer from view but not from the stack. You can turn the layer back on again by clicking the eye space.

Working with layers

To select the layer that you want to change you need to click on the layer. At this point the layer will change to a different color from the rest in the stack. This layer is now the 'selected layer' or 'active layer' and can be edited in isolation from the others that make up the picture. It is common for new users to experience the problem of trying to edit pixels on a layer that has not been selected. Always check the correct layer has been selected prior to editing a multi-layered image. Each layer in the same image must have the same resolution and image mode (a selection from one image that is imported into another image will take on the host image's resolution and image mode). Increasing the size of any selection will lead to 'interpolation', which will degrade its quality unless the layer is converted into a 'Smart Object' first.

Manipulating layers

Layers can be moved up and down the layer stack by click-hold-dragging. Moving a layer upwards will mean that its picture content may obscure more of the details in the layers below. Moving downwards progressively positions the layer's details further behind the picture parts of the layers above. In this way you can reposition the content of any layers (except background layers).

Two or more layers can be linked together so that when the content of one layer is moved the other details follow precisely. Simply multi-select the layers to link (hold down the Shift key and click onto each layer) and click the Link Layers button (chain icon) at the bottom of the panel. A chain symbol will appear on the right of the thumbnail to indicate that these layers are now linked. To unlink selected layers click on the Link Layers button again.

Unwanted layers can be deleted by dragging them to the trash icon at the bottom of the Layers panel or by selecting the layer and clicking the trash icon.

Layer styles

Layer styles or effects can be applied to the contents of any layer. Users can add effects by clicking on the 'Add a Layer Style' button at the bottom of the Layers panel (the 'fx' icon), by choosing Layer Style from the Layer menu, by clicking on the desired effect in the Styles panel or by dragging existing effects from one layer to another. The effects added are listed below the layer in the panel. You can turn effects on and off using the eye symbol and even edit effect settings by double-clicking on them in the panel.

Opacity

As well as layer styles, or effects, the opacity (how transparent a layer is) of each layer can be altered by dragging the opacity slider down from 100% to the desired level of translucency. The lower the number, the more detail from the layers below will show through. The opacity slider is located at the top of the Layers panel and changes the selected layer only.

Blending modes

On the left of the opacity control is a drop-down menu containing a range of blending modes. The default selection is 'normal', which means that the detail in upper layers obscures the layers beneath. Switching to a different blending mode will alter the way in which the layers interact.

Checking the 'preserve transparency' box confines any painting or editing to the areas containing pixels (transparent areas remain unaffected).

Layer shortcuts

1. To display Layers panel – Choose Windows > Layers.
2. To access layers options – Click settings icon in the upper right-hand corner of the Layers panel.
3. To change the size of thumbnails – Choose Panel Options from the Layers panel menu and select a thumbnail size.
4. To make a new layer – Choose Layer > New > Layer.
5. To create a new adjustment layer – Choose Layer > New Adjustment Layer and then select the layer type or click on the option in the Adjustment List in the new Adjustment panel.
6. To create a new layer group – Choose Layer > New > Layer Group.
7. To add a style to a layer – Select the layer and click on the Layer Styles button at the bottom of the panel.

Individual layers · Layers in a group

Layer groups

Layer groups are a collection of layers organized into a single 'folder'. Placing all the layers used to create a single picture part into a group makes these layers easier to manage and organize. Layers can be moved into the group by dragging them onto the group's heading. Layers in groups can have their stacking order (within the group) adjusted without ungrouping.

To create a layer group click on the New Group button at the bottom of the panel or choose Layer > New > Group or multi-select the layers to include in the group and press Ctrl/Cmd + G. In previous versions of Photoshop this feature was referred to as Layer Sets.

Layer masks

A '**layer mask**' is attached to a layer and controls which pixels are concealed or revealed on that layer. Masks provide a way of protecting areas of a picture from enhancement or editing changes. In this way masks are the opposite to selections, which restrict the changes to the area selected. Masks are standard grayscale images and because of this they can be painted, edited and erased just like other pictures. Masks are displayed as a separate thumbnail to the right of the main layer thumbnail in the Layers panel. The black portion of the mask thumbnail is the protected or transparent area and is opaque or shows the layer image without transparency. Grays, depending on the dark or lightness of the tone, will give varying amounts of transparency from partially transparent to almost opaque. Photoshop provides a variety of ways to create masks but one of the easiest is to use the special Quick Mask mode.

Layer types

Image layers: This is the most basic and common layer type containing any picture parts or image details. Background is a special type of image layer.

Text layers: Designed solely for text, these layers allow the user to edit and enhance the text after the layer has been made. It is possible to create '**editable text**' in Photoshop. If the text needs to be modified (font, style, spelling, color, etc.) the user can simply double-click the type layer. To apply filters to the contents of a text layer, it must be rasterized (Layer > Rasterize) first. This converts the text layer to a standard image layer and in this process the ability to edit the text is lost.

Shape layers: Shape layers are designed to hold the shapes created with Photoshop's drawing tools (Rectangle, Ellipse, Polygon, Line and Custom Shape). Like text layers the content of these layers is 'vector' based and therefore can be scaled upwards or downwards without loss of quality.

Smart Object layers: Smart Object layers are special layers that encapsulate another picture (either vector or pixel based). As the original picture content is always maintained any editing action such as transforms or filtering that is applied to a Smart Object layer is non-destructive. Pixel-based editing (painting, erasing, etc.) can't be performed on Smart Objects without first converting them to a normal image layer (Layer > Smart Objects > Rasterize). You create a Smart Object layer by either converting an existing image layer (Layer > Smart Objects > Convert to Smart Objects) or by opening the original file as a Smart Object (File > Open as a Smart Object) when commencing initial editing. When a filter is applied to a Smart Object layer it is termed a Smart Filter and appears below the Smart Object layer. Because the effects of a Smart Filter can be altered or removed after application, this type of filtering is non-destructive.

Smart Object layers are used for some non-destructive editing techniques as they contain and protect the original picture

3D Layers (Photoshop Extended only): The Extended edition of Photoshop also has the ability to open and work with three-dimensional architectural or design files. When Photoshop opens a 3D file it is placed on a separate layer where you can move, scale, change lighting and rendering of the 3D model. Editing of the 3D model can only occur in a 3D authoring program.

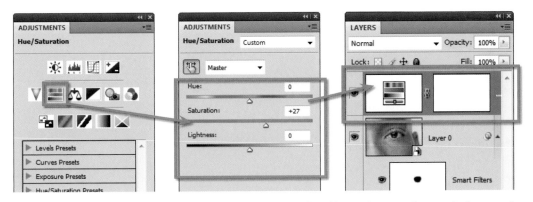

Selecting an Adjustment in the Adjustments pane automatically adds an adjustment layer to the layers stack

Adjustment layers: These layers alter the layers that are arranged below them in the stack. Adjustment layers act as a glass filter through which the lower layers are viewed. They allow image adjustments to be made without permanently modifying the original pixels (if the adjustment layer is removed, or the visibility of the layer is turned off, the pixels revert to their original value). You can use adjustment layers to perform many of the enhancement tasks that you would normally apply directly to an image layer without changing the image itself. In CS4 an adjustment layer is added automatically when clicking onto an Adjustment Type icon in the new Adjustment panel. This is a big change in adjustment layer workflow. Adjustment layers are always added to the stack with a linked layer mask.

Background layers: An image can only have one background layer. It is the bottom-most layer in the stack. No other layers can be moved beneath this layer. You cannot adjust this layer's opacity or its blending mode. You can convert background layers to standard image layers by double-clicking the layer in the Layers panel, setting your desired layer options in the dialog provided and then clicking OK.

Saving an image with layers

The file formats that support layers are Photoshop's native Photoshop document (PSD) format, PDF, JPEG2000, PSB and Photoshop TIFF. The layers in a picture must always be flattened if the file is to be saved as a standard JPEG. It is recommended that a PSD with its layers is always kept as an archived master copy – best practice would keep in progress archives as well as the final image. It is possible to quickly flatten a multi-layered image and save it as a JPEG or TIFF file by choosing File > Save As and then selecting the required file format from the pull-down menu.

Quick Masks, selections and alpha channels

Selections isolate parts of a picture. When first starting to use Photoshop it is easy to think of selections, masks and channels as all being completely separate program features, but in the reality of day-to-day image enhancement each of these tools is inextricably linked. As your skills develop most image-makers will develop their own preferred ways of working. Some use a workflow that is selection based, others switch between masking and selections and a third group concentrates all their efforts on creating masks only. No one way of working is right or wrong. In fact, many of the techniques advocated by the members of each group often provide a different approach to solving the same problem.

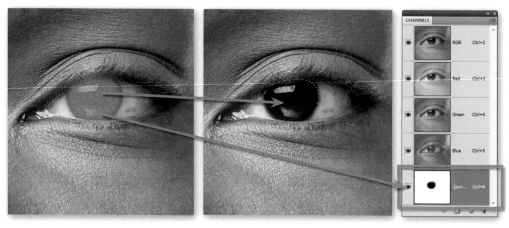

The masks created with the Quick Mask feature are stored as alpha channels which can be viewed and edited via the Channels panel. Switching from the Quick Mask mode changes the mask to a selection

Switching between Mask and Selection modes

You can switch between Mask and Selection (also called 'Standard') modes by clicking on the mode button positioned at the bottom of the toolbox. Any 'marching ants' indicating active selections will be converted to red shaded areas when selecting the Mask mode. Similarly active masks will be outlined with 'marching ants' when switching back to Selection mode.

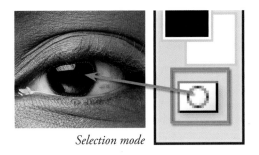

Selection mode

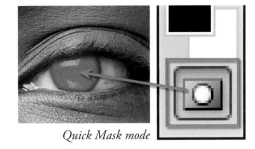

Quick Mask mode

Saving selections

Photoshop provides users with the option to save their carefully created selections using the Select > Save Selection option. In this way the selection can be reloaded at a later date in the same file via the Select > Load Selection feature, or even after the document has been closed and reopened. Though not immediately obvious to the new user, the selection is actually saved with the picture as a special alpha channel and this is where the primary link between selections and masks occurs. Masks too are stored as alpha channels in your picture documents.

Alpha channels are essentially grayscale pictures where the black section of the image indicates the area where changes can be made, the white portion represents protected areas and gray values allow proportional levels of change. Alpha channels can be viewed, selected and edited via the Channels panel.

When you save a selection you create a grayscale alpha channel. You can name the selection inside the Save Selection dialog

Quick definitions

Selections – A selection is an area of a picture that is isolated so that it can be edited or enhanced independently of the rest of the image. Selections are made with a range of Photoshop tools including the Marquee, Lasso and Magic Wand tools.

Masks – Masks also provide a means of restricting image changes to a section of the picture. Masks are created using standard painting tools whilst in the Quick Mask mode.

Alpha channels – Alpha channels are a special channel type that are separate to those used to define the base color of a picture such as Red, Green and Blue. Selections and masks are stored as alpha channels and can be viewed in the Channels panel. You can edit a selected alpha channel using painting and editing tools as well as filters.

149

Channels

As we have already seen, channels represent the way in which the base color in an image is represented. Most images that are created by digital cameras are made up of Red, Green and Blue (RGB) channels. In contrast, pictures that are destined for printing are created with Cyan, Magenta, Yellow and Black (CMYK) channels to match the printing inks. Sometimes the channels in an image are also referred to as the picture's 'color mode'.

Viewing channels

Many image-editing programs contain features designed for managing and viewing the color channels in your image. Photoshop uses a separate Channels panel (Window > Channels). Looking a little like the Layers panel, hence the source of much confusion, this panel breaks the full color picture into its various base color parts.

Changing color mode

Though most editing and enhancement work can be performed on the RGB file, sometimes the digital photographer may need to change the color mode of his or her file. There are a range of conversion options located under the Mode menu (Image > Mode) in Photoshop. When one of these options is selected your picture's color will be translated into the new set of channels. Changing the number of channels in an image also impacts on the file size of the picture. Four-channel CMYK images are bigger than three-channel RGB pictures, which in turn are roughly three times larger than single-channel grayscale photographs.

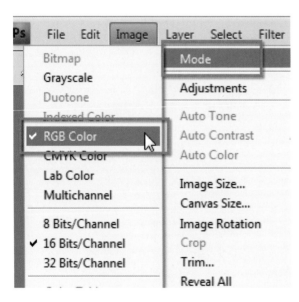

The type and number of color channels used to create the color in your pictures can be changed via the Mode option in the Image menu

When do I need to change channels?

For most image-editing and enhancement tasks RGB color mode is all you will ever need. Some high-quality and printing-specific techniques do require changing modes, but this is generally the field of the 'hardened' professional. A question often asked is 'Given that my inkjet printer uses CMYK inks, should I change my photograph to CMYK before printing?' Logic says yes, but practically speaking this type of conversion is best handled by your printer's driver software. Most modern desktop printers are optimized for RGB output even if their ink set is CMYK.

Channel types

RGB: This is the most common color mode. Consisting of Red, Green and Blue channels, most digital camera and scanner output is supplied in this mode.

CMYK: Designed to replicate the ink sets used to print magazines and newspapers, this mode is made from Cyan, Magenta, Yellow and Black (K) channels.

LAB: Consisting of Lightness, A color (green–red) and B color (blue–yellow) channels, this mode is used by professional photographers when they want to enhance the details of an image without altering the color. By selecting the L channel and then performing their changes only the image details are affected.

Grayscale: Consisting of a single black channel, this mode is used for monochrome pictures. Duo-, Tri- and Quad-tones are a special variation of grayscale images that include extra colors creating tinted monochromes.

Gray Mode

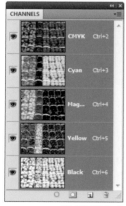

CMYK Mode

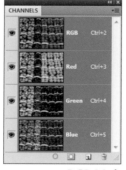

RGB Mode

LAB Mode

The most used color modes (channel types) are RGB, CMYK, LAB and Grayscale. Unless you are working in the publishing industry, or you want to use advanced image-editing techniques, you should keep your picture in RGB mode

Adjustment and filter layers and editing quality

As introduced earlier, adjustment layers act as filters that modify the hue, saturation and brightness of the pixels on the layer or layers beneath. Using an adjustment layer instead of the 'Adjustments' from the 'Image' menu allows the user to make multiple and consecutive image adjustments without permanently modifying the original pixel values.

Non-destructive image editing

The manipulation of image quality using '**adjustment layers**' and '**layer masks**' is often termed 'non-destructive'. Using adjustment layers to manipulate images is preferable to working directly and repeatedly on the pixels themselves. Using the 'Adjustments' from the 'Image' menu, or the manipulation tools from the toolbox (Dodge, Burn and Sponge Tools), directly on pixel layers can eventually lead to a degradation of image quality. If adjustment layers are used together with '**layer masks**' to limit their effect, the pixel values are physically changed only once when the image is flattened or the layers are merged. Retaining the integrity of your original file is essential for high-quality output.

Note > For the last couple of versions of Photoshop it has been possible to scale or 'transform' a layer or group of layers non-destructively by turning the layer, or layers, into a 'Smart Object'. In CS3 it became possible to apply filters (called Smart Filters) non-destructively to these Smart Objects and with CS4 we can also Skew, Distort and add Perspective effects interactively to a Smart Object.

Retaining quality

The evidence of a file that has been degraded can be observed by viewing its histogram. If the resulting histogram displays excessive spikes or missing levels there is a high risk that a smooth transition between tones and color will not be possible in the resulting print. A tell-tale sign of poor scanning and image editing is the effect of '**banding**' that can be clearly observed in the final print. This is where the transition between colors or tones is no longer smooth, but can be observed as a series of steps, or bands, of tone and/or color. To avoid this it is essential that you start with a good scan (a broad histogram without gaps) and limit the number of changes to the original pixel values.

Layer masks and editing adjustments

The use of 'layer masks' is an essential skill for professional image retouching. Together with the Selection Tools and 'adjustment layers' they form the key to effective and sophisticated image editing. A 'layer mask' can control which pixels are concealed or revealed on any image layer except the background layer. If the layer mask that has been used to conceal pixels is then discarded or switched off (Shift-click the layer mask thumbnail) the original pixels reappear. This non-destructive approach to retouching and photographic montage allows the user to make frequent changes. To attach a layer mask to any layer (except the background layer) simply click on the layer and then click on the 'Add layer mask' icon at the base of the Layers panel.

Photoshop CS4 contains a new Masks pane with controls for adjusting the density and feather of a layer mask. Also included are buttons for refining the mask using Mask Edge, Color Range and Invert features. Remember that painting or adding gradients to a mask will reveal or conceal the adjustment when used with Adjustment layers

A layer mask is automatically attached to every adjustment layer. The effects of an adjustment layer can be limited to a localized area of the image by simply clicking on the adjustment layer's associated mask thumbnail in the Layers panel and then painting out the adjustment selectively using any of the painting tools whilst working in the main image window. The opacity and tone of the foreground color in the toolbox will control whether the adjustment is reduced or eliminated in the localized area of the painting action. Painting with a darker tone will conceal more than when painting with a lighter tone or a dark tone with a reduced opacity.

A layer mask can be filled with black to conceal the effects of the adjustment layer. Painting with white in the layer mask will then reveal the adjustment in the localized area of the painting action. Alternatively the user can select the Gradient Tool and draw a gradient in the layer mask to selectively conceal a portion of the adjustment. To add additional gradients the user must select either the Multiply or Screen blend modes for the gradient in the Options bar.

Layer mask shortcuts

Disable/enable layer mask	Shift + click layer mask thumbnail
Preview contents of layer mask	Opt/Alt + click layer mask thumbnail
Preview layer mask and image	Opt/Alt + Shift + click layer mask thumbnail

Serap Osman

selections

Serap Osman

essential skills

- Develop skills in creating and modifying selections to isolate and mask image content.
- Develop skills using the following tools and features:
 - Selection Tools
 - Quick Mask, alpha channels and layer masks
 - Color Range and Extract filter
 - Pen Tool.

Introduction

One of the most skilled areas of digital retouching and manipulation is the ability to make accurate selections of pixels for repositioning, modifying or exporting to another image. This skill allows localized retouching and image enhancement. Photoshop provides several different tools that allow the user to select the area to be changed. Called the 'Selection' Tools, using these features will fast become a regular part of your editing and retouching process. Photoshop marks the boundaries of a selected area using a flashing dotted line sometimes called 'marching ants'. Obvious distortions of photographic originals are common in the media but so are images where the retouching and manipulations are subtle and not detectable. Nearly every image in the printed media is retouched to some extent. Selections are made for a number of reasons:

- Making an adjustment or modification to a localized area, e.g. color, contrast, etc.
- Defining a subject within the overall image to mask, move or replicate.
- Defining an area where an image or group of pixels will be inserted ('paste into').

Selection Tools overview

Photoshop groups the Selection Tools based on how they isolate picture parts. These categories are:

- The '**Marquee Tools**' are used to draw regular-shaped selections such as rectangles or ellipses around an area within the image.

- The '**Lasso Tools**' use a more freehand drawing approach and are used to draw a selection by defining the edge between a subject and its background.

- The '**Magic Wand**' and the '**Quick Selection**' Tools both create selections based on color and tone and are used to isolate groups of pixels by evaluating the similarity of the neighboring pixel values (hue, saturation and brightness) to the pixel that is selected.

Shape-based selections with the Marquee Tools

The Marquee Tools select by dragging with the mouse over the area required. Holding down the Shift key as you drag the selection will 'constrain' the selection to a square or circle rather than a rectangle or oval. Using the Alt (Windows) or Option (Mac) key will draw the selections from their centers. The Marquee Tools are great for isolating objects in your images that are regular in shape, but for less conventional shapes, you will need to use one of the Lasso Tools.

Selections based on shapes

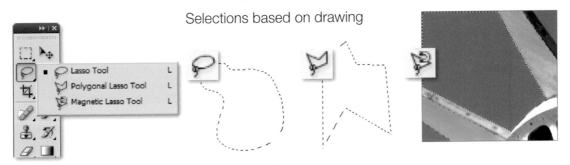

Selections based on drawing

Drawn selections using the Lasso Tools

Select by encircling or drawing around the area you wish to select. The standard Lasso Tool works like a pencil, allowing the user to draw freehand shapes for selections. A large screen and a mouse in good condition (or a graphics tablet) are required to use the Freehand Lasso Tool effectively. In contrast, the Polygonal Lasso Tool draws straight-edged lines between mouse-click points. Either of these features can be used to outline and select irregular-shaped image parts. A third tool, the Magnetic Lasso, helps with the drawing process by aligning the outline with the edge of objects automatically. It uses contrast in color and tone as a basis for determining the edge of an object. The accuracy of the 'magnetic' features of this tool is determined by three settings in the tool's Options bar. **Contrast** is the value that a pixel has to differ from its neighbor to be considered an edge, **Width** is the number of pixels either side of the pointer that are sampled in the edge determination process and **Frequency** is the distance between fastening points in the outline.

Double-clicking the Polygonal Lasso Tool or Magnetic Lasso Tool automatically completes the selection using a straight line between the last selected point and the first.

Note > Remember the Magnetic Lasso Tool requires a tonal or color difference between the object and its background in order to work effectively.

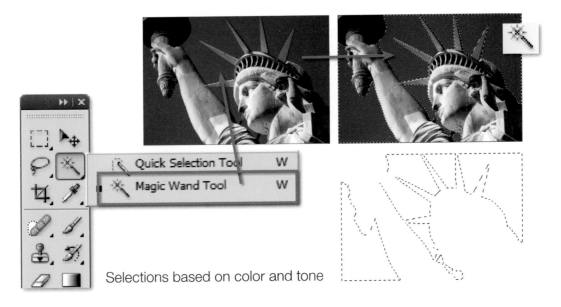

Selections based on color and tone

The Magic Wand

Unlike the Lasso and Marquee Tools the Magic Wand makes selections based on color and tone. It selects by relative pixel values. When the user clicks on an image with the Magic Wand Tool Photoshop searches the picture for pixels that have a similar color and tone. With large images this process can take a little time but the end result is a selection of all similar pixels across the whole picture.

Tolerance

How identical a pixel has to be to the original is determined by the **Tolerance** value in the Options bar. The higher the value, the less alike the two pixels need to be, whereas a lower setting will require a more exact match before a pixel is added to the selection. Turning on the **Contiguous** option will only include the pixels that are similar and adjacent to the original pixel in the selection.

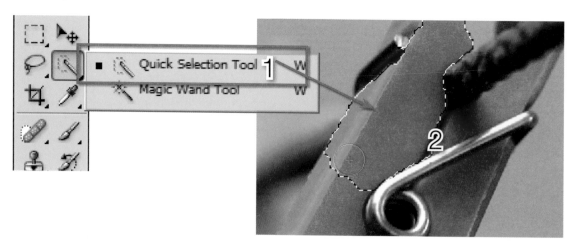

The new Quick Selection Tool is grouped with the Magic Wand in the toolbar (1). The feature creates intelligent selections as you paint over the picture surface (2). The tool's options bar contains settings for adding to and subtracting from existing selections (3), using the tool over multiple layers (4) as well as a button to display the new Refine Edge feature (5)

Quicker selections

Right from the very early days of Photoshop most users quickly recognized that being able to apply changes to just a portion of their images via selections was a very powerful way to work. It followed that the quality of their selective editing and enhancement activities was directly related to the quality of the selections they created. This was the start of our love/hate relationship with selection creation.

Over the years Adobe has provided us with a range of tools designed to help in this quest. Some, like the Magic Wand, are based on selecting pixels that are similar in tone and color; others, such as the Lasso and Marquee Tools, require you to draw around the subject to create the selection.

Introduced in CS3, there is now another tool which does both. Called the Quick Selection Tool, it is grouped with the Magic Wand in the toolbar. The tool is used by painting over the parts of the picture that you want to select. The selection outline will grow as you continue to paint. When you release the mouse button the tool will automatically refine the selection further.

Moving a selection

If the selection is not accurate it is possible to move the selection without moving any pixels. With the Selection Tool still active place the cursor inside your selection and drag the selection to reposition it. To move the pixels and the selection, use the Move Tool from the Tools panel.

To remove a selection

Go to Select > Deselect or use the shortcut 'Command/Ctrl + D' to deselect a selection.

Customizing your selections

Basic selections of standard, or regular-shaped, picture parts can be easily made with one simple step – just click and drag. But you will quickly realize that most selection scenarios are often a little more complex. For this reason the thoughtful people at Adobe have provided several ways of allowing you to modify your selections. The two most used methods provide the means to 'add to' or 'subtract from' existing selections. This, in conjunction with the range of Selection Tools offered by the program, gives the user the power to select even the most complex picture parts, often using more than one tool for the task. Skillful selecting takes practice and patience as well as the ability to choose which Selection Tool (or Tools) will work best for a given task. Photoshop provides two different methods to customize an existing selection.

Use the mode buttons located in a special portion of the tool's Options bar to start changing your selections. The default mode is 'New Selection', which means that each selection you make replaces the last. Once another option is selected the mode remains active for the duration of the selection session. This is true even when you switch Selection Tools.

The user can make a selection before creating the adjustment layer and then when the adjustment layer is created the selection is used to automatically create a mask.

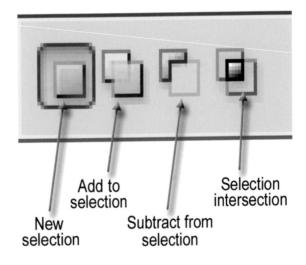

Add to selection

Selection intersection

New selection

Subtract from selection

Add to a selection

To add to an existing selection hold down the Shift key while selecting a new area. Notice that when the Shift key is held down the Selection Tool's cursor changes to include a '+' to indicate that you are in the 'add' mode. This addition mode works for all tools and you can change Selection Tools as needed to make further refinements.

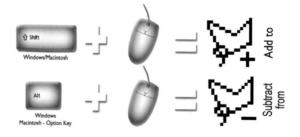

Keyboard shortcuts provide the fastest way to customize your selections

Subtract from a selection

To remove sections from an existing selection hold down the Alt key (Option – Macintosh) while selecting the part of the picture you do not wish to include in the selection. When in the subtract mode the cursor will change to include a '−'.

Selection intersection

In Photoshop often the quickest route to selection perfection is not the most direct route. When you are trying to isolate picture parts with complex edges it is sometimes quicker and easier to make two separate selections and then form the final selection based on their intersection. The fourth mode available as a button on the Selection Tool's Options bar is the Intersect mode. Though not used often, this mode provides you with the ability to define a selection based on the area in common between two different selections.

Inversing a selection

In a related technique, some users find it helpful to select what they don't want in a picture and then instruct Photoshop to select everything but this area. The Select > Inverse command inverts or reverses the current selection and is perfect for this approach. In this way foreground objects can be quickly selected in pictures with a smoothly graduated background of all one color (sky, snow or a wall space) by using the Magic Wand to select the background. Then the act of inversing the selection will isolate the foreground detail. Professionals who know that the foreground will be extracted from the picture's surrounds often shoot their subjects against an evenly lit background of a consistent color to facilitate the application of this technique.

Sometimes it is quicker to select the area that you don't want and then inverse the selection to produce the required results

Refining selections

As well as 'adding to' and 'subtracting from' existing selections, Photoshop contains several other options for refining the selections you make. Grouped under the Select menu, these features generally concentrate on adjusting the edge of the current selection. The options include:

Border – Choosing the Border option from the Modify menu displays a dialog where you can enter the width of the border in pixels (between 1 and 200). Clicking OK creates a border selection that frames the original selection.

Smooth – This option cleans up stray pixels that are left unselected after using the Magic Wand Tool. After choosing Modify enter a radius value to use for searching for stray pixels and then click OK.

Other options for modifying your selections can be found under the Select menu

Expand – After selecting Expand, enter the number of pixels that you want to increase the selection by and click OK. The original selection is increased in size. You can enter a pixel value between 1 and 100.

Contract – Selecting this option will reduce the size of the selection by the number of pixels entered into the dialog. You can enter a pixel value between 1 and 100.

Feather – The Feather command softens the transition between selected and non-selected areas.

Grow – The Grow feature increases the size of an existing selection by incorporating pixels of similar color and tone to those already in the selection. For a pixel to be included in the 'grown' selection it must be adjacent to the existing selection and fall within the current tolerance settings located in the options bar.

Similar – For a pixel to be included in the 'similar' selection it does not have to be adjacent to the existing selection but must fall within the current tolerance settings located in the options bar.

Refine Edge – To coincide with the release of the Quick Selection Tool in CS3, Adobe also created a new way of applying these refinements. The Refine Edge feature is accessed either via the button now present in all the Selection Tool options bars, or via Select > Refine Edge. The feature brings together five different controls for adjusting the edges of the selection (three of which existed previously as separate entries in the Select > Modify menu) with five selection edge preview options. Because of the preview options the feature makes what used to be a pretty hit and miss affair a lot easier to manage, with the ultimate result of the production of better selection edges for all.

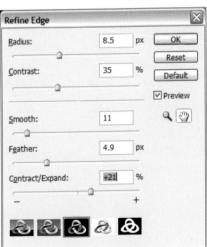

The Refine Edge dialog contains five sliders designed to customize your selection edges

New options

Two other options are available only in Refine Edge:

Radius – Use this slider to increase the quality of the edge in areas of soft transition with background pixels or where the subject's edge is finely detailed.

Contrast – Increase the contrast settings to sharpen soft selection edges.

Previewing edge refinements

The Preview mode buttons at the bottom of the Refine Edge dialog provide a range of different ways to view the selection on your picture.

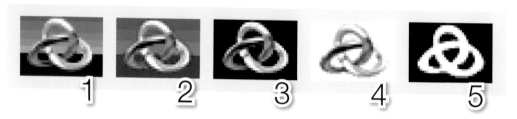

1) Provides a standard selection edge superimposed on the photo. 2) Previews the selection as a quick mask. 3) Previews the selection on a black background. 4) Previews the selection on a white background. 5) Previews the selection as a mask. Press the P key to turn off the preview of the current Refine Edge settings and the X key to temporarily display the full image view

Saving and loading selections

The selections you make remain active while the image is open and until a new selection is made, but what if you want to store all your hard work to use on another occasion? As we have already seen in the previous chapter Photoshop provides the option to save your selections/ masks as part of the picture file. Simply choose Select > Save Selection and the existing selection will be stored with the picture.

To display a selection saved with a picture, open the file and choose Load Selection from the Select menu. In the Load Selection dialog click on the Channel drop-down menu and choose the selection you wish to reinstate. Choose the mode with which the selection will be added to your picture from the Operation section of the dialog. Click OK to finish.

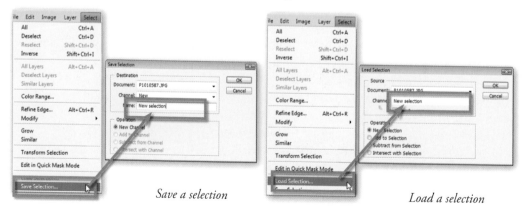

Save a selection *Load a selection*

Feather and anti-alias

The ability to create a composite image or '**photomontage**' that looks subtle, realistic and believable rests with whether or not the viewer is able to detect where one image starts and the other finishes. The edges of each selection can be modified so that it appears as if it belongs, or is related, to the surrounding pixels.

Options are available in Photoshop to alter the appearance of the edges of a selection. Edges can appear sharp or soft (a gradual transition between the selection and the background). The options to effect these changes are:

- Feather
- Anti-aliasing.

Feather

When this option is chosen the pixels at the edges of the selection are blurred. The edges are softer and less harsh. This blurring may either create a more realistic montage or cause loss of detail at the edge of the selection.

You can choose feathering for the Marquee or Lasso Tools as you use them by entering a value in the tool options box, or you can add feathering to an existing selection (Select > Feather). The feathering effect only becomes apparent when you move or paste the selection to a new area.

Anti-aliasing

When this option is chosen the jagged edges of a selection are softened. A more gradual transition between the edge pixels and the background pixels is created. Only the edge pixels are changed so no detail is lost. Anti-aliasing must be chosen before the selection is made (it cannot be added afterwards). It is usual to have the anti-alias option selected for most selections. The anti-alias option also needs to be considered when using type in image-editing software. The anti-alias option may be deselected to improve the appearance of small type to avoid the appearance of blurred text.

Better with a tablet

Many professionals prefer to work with a stylus and tablet when creating complex selections. All models change a tool's characteristics using pressure sensitivity with some including options such as intuitive motion as well.

Defringe and Matting

When a selection has been made using the anti-alias option some of the pixels surrounding the selection are included. If these surrounding pixels are darker, lighter or a different color to the selection a fringe or halo may be seen. From the Layers menu choose Matting > Defringe to replace the different fringe pixels with pixels of a similar hue, saturation or brightness found within the selection area.

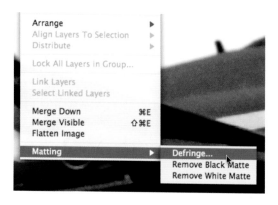

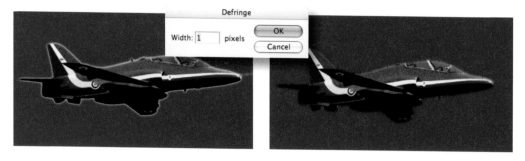

Fringe *Defringe*

The user may have to experiment with the most appropriate method of removing a fringe. The alternative options of Remove White Matte and Remove Black Matte may provide the user with a better result. If a noticeable fringe still persists it is possible to contract the selection prior to moving it using the Modify > Contract option from the Select menu.

Saving a selection as an alpha channel

Selections can be permanently stored as 'alpha channels'. The saved selections can be reloaded and/or modified even after the image has been closed and reopened. To save a selection as an alpha channel simply click the 'Save selection as channel' icon at the base of the Channels panel. To load a selection either drag the alpha channel to the 'Load channel as selection' icon in the Channels panel or Command/Ctrl-click the alpha channel.

It is possible to edit an alpha channel (and the resulting selection) by using the painting and editing tools. Painting with black will add to the alpha channel whilst painting with white will remove information. Painting with shades of gray will lower or increase the opacity of the alpha channel. The user can selectively soften a channel and resulting selection by applying a Gaussian Blur filter. Choose Blur > Gaussian Blur from the Filters menu.

Note > An image with saved selections (alpha channels) cannot be saved in the standard JPEG format. Use the PSD, PDF or TIFF formats or JPEG2000 if storage space is tight.

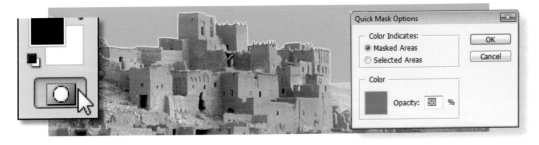

Quick Mask or Refine Edge

The problem with feathering and modifying selections using the Modify commands in the 'Select' menu is that the ants give very poor feedback about what is actually going on at the edge. Viewing the selection against a Matte color in the Refine Edge dialog box or as a 'Mask' in 'Quick Mask mode' allows you to view the quality and accuracy of your selection. Quick Mask allows the user to modify localized areas of the edge whilst Refine Edge works on the entire edge. Zoom in on an edge to take a closer look. Double-click the Quick Mask icon to change the mask color, opacity and to switch between 'Masked Areas' and 'Selected Areas'. If the mask is still falling short of the edge you can expand the selection by going to Filter > Other > Maximum. Choose a 1-pixel radius, select OK and the mask will shrink (expanding the selection). A 'Levels' adjustment in Quick Mask mode provides a 'one-stop shop' for editing the mask, giving you the luxury of a preview as with Refine Edge, but also gives you the advantage of localized editing.

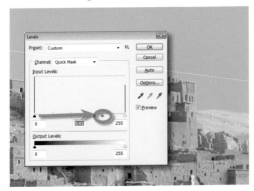
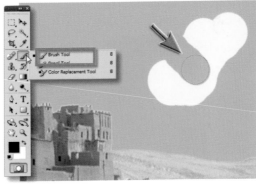

Using a 'Levels' adjustment (Image > Adjustments > Levels) in Quick Mask mode allows you to modify the edge quality if it is too soft and also reposition the edge so that it aligns closely with your subject. Make a selection of the edge using the Lasso Tool if you need to modify just a small portion of the Quick Mask. Dragging the shadow and highlight sliders in towards the center will reduce the softness of the mask whilst moving the midtone or 'Gamma' slider will move the edge itself. Unlike the Refine Edge dialog box you can paint in Quick Mask to refine localized areas of the selection.

Note > The selection must have been feathered prior to the application of the Levels adjustment for this to be effective.

Save the selection as an alpha channel. This will ensure that your work is stored permanently in the file. If the file is closed and reopened the selection can be reloaded. Finish off the job in hand by modifying or replacing the selected pixels. If the Quick Selection Tool or Magic Wand Tool is not working for you, try exploring the following alternatives.

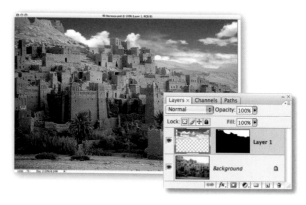

'Color Range'

The Quick Selection Tool may be the obvious tool for making a selection of a subject with a good color or tonal contrast, but Color Range can be utilized for making selections of similar color that are not contiguous. 'Color Range', from the Select menu, has been upgraded for CS4 and is useful for selecting subjects that are defined by a limited color range (sufficiently different from those of the background colors). The feature now contains Localized Color Clusters and Range options for better control over where the feature is put to work. Color Range is especially useful when the selection is to be used for a hue adjustment. Use a Marquee Tool (from the Tools panel) to limit the selection area before you start using the Color Range option.

Note > The Color Range option can misbehave sometimes. If the selection does not seem to be restricted to your sampled color press the Alt/Option key and click on the reset option or close the dialog box and re-enter.

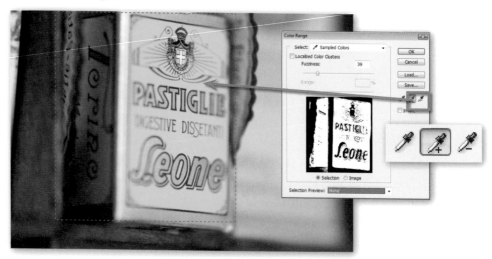

Use the 'Add to sample' eyedropper and drag the eyedropper over the subject area you wish to select. In the later stages you can choose a matte color to help the task of selection. Adjust the Fuzziness slider to perfect the selection. Very dark or light pixels can be left out of the selection if it is to be used for a hue adjustment only. The new dialog contains four options in the Selection Preview menu that will allow you to view the quality of the selection on the image to gain an idea of the selection's suitability for the job in hand.

166

The mask can be 'cleaned' using the Dust & Scratches filter and softened using a Gaussian Blur filter. A selection prepared by the 'Color Range' command is ideal for making a hue adjustment. It is also recommended to view the individual channels to see if the subject you are trying to isolate is separated from the surrounding information. If this is the case a duplicate channel can act as a starting point for a selection.

Channel masking

An extremely quick and effective method for selecting a subject with reasonable color contrast to the surrounding pixels is to use the information from one of the channels to create a mask and then to load this mask as a selection.

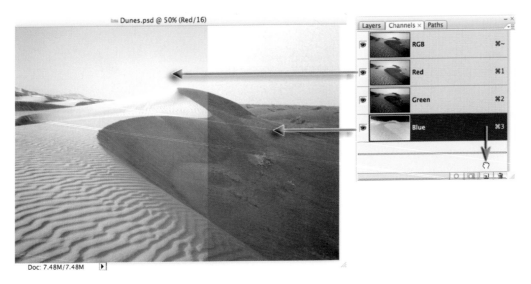

Click on each individual channel to see which channel offers the best contrast and then duplicate this channel by dragging it to the 'New Channel' icon.

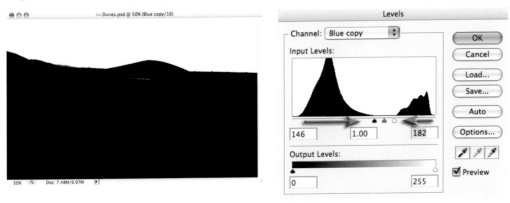

Apply a Levels adjustment to the duplicate channel to increase the contrast of the mask. Slide the shadow, midtone and highlight sliders until the required mask is achieved. The mask may still not be perfect but this can be modified using the painting tools.

Select the default settings for the foreground and background colors in the Tools panel, choose a paintbrush, set the opacity to 100% in the Options bar and then paint to perfect the mask. Zoom in to make sure there are no holes in the mask before moving on. To soften the edge of the mask, apply a small amount of Gaussian Blur.

Note > Switch on the master channel visibility or Shift-click the RGB master to view the channel copy as a mask together with the RGB image. This will give you a preview so that you can see how much blur to apply and if further modifications are required.

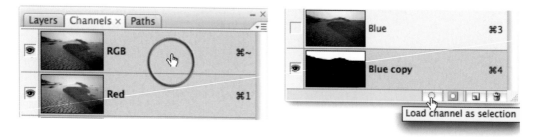

Click on the active duplicate channel or drag it to the 'Load channel as selection' icon. Click on the RGB master before returning to the Layers panel.

Channel masking may at first seem a little complex but it is surprisingly quick when the technique has been used a few times. This technique is very useful for photographers shooting products for catalogs and websites. A small amount of color contrast between the subject and background is all that is required to make a quick and effective mask.

Selections from paths

The Pen Tool is often used in the creation of sophisticated smooth-edged selections, but strictly speaking it is not one of the selection tools. The Pen Tool creates vector paths instead of selections; these, however, can be converted into selections that in turn can be used to extract or mask groups of pixels. The Pen Tool has an unfortunate reputation – neglected by most, considered an awkward tool by those who have made just a passing acquaintance, and revered by just a select few who have taken a little time to get to know 'the one who sits next to Mr Blobby' (custom shape icon) in the Tools panel. Who exactly is this little fellow with the 'ye olde' ink nib icon and the awkward working persona? The Pen Tool was drafted into Photoshop from Adobe Illustrator. Although graphic designers are quite adept at using this tool, many photographers the world over have been furiously waving magic wands and magnetic lassos at the megapixel army and putting graphics tablets on their shopping lists each year in an attempt to avoid recognizing the contribution that this unique tool has to offer.

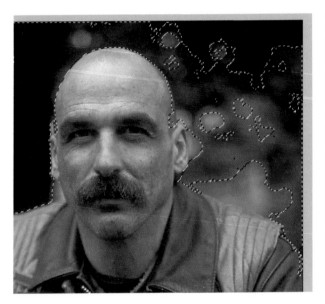

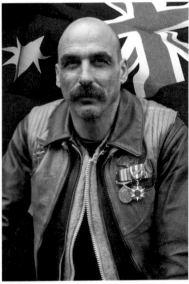

Not everything you can see with your eye can be selected easily with a selection technique based on color or tonal values. The resulting ragged selections can be fixed in Quick Mask mode, but sometimes not without a great deal of effort. The question then comes down to 'how much effort am I prepared to apply, and for how long?' Its about this time that many image editors decide to better acquaint themselves with the Pen Tool. Mastering the Pen Tool in order to harness a selection prowess known to few mortals is not something you can do in a hurry – it falls into a certain skill acquisition category, along with such things as teaching a puppy not to pee in the house, called time-based reward, i.e. investing your time over a short period of time will pay you dividends over a longer period of time. The creation of silky smooth curvaceous lines (called paths) that can then be converted into staggeringly smooth curvaceous selections makes the effort of learning the Pen Tool all worthwhile.

Basic drawing skills

Vector lines and shapes are constructed from geographical markers (anchor points) connected by lines or curves. Many photographers have looked with curiosity at the vector tools in Photoshop's Tools panel for years but have dismissed them as 'not for me'. The reason for this is that drawing vector lines with the Pen Tool for the inexperienced image editor is like reversing with a trailer for the inexperienced driver. It takes practice, and the practice can be initially frustrating.

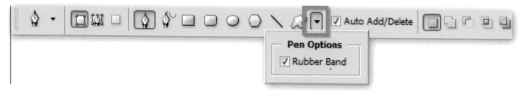

The pen can multi-task (just like most women and very few men that I know). The pen can draw a vector shape whilst filling it with a color and applying a layer style – all at the same time. Although tempting, this has nothing to do with selecting a bald man's head, so we must be sure to disarm this charming little function. We can also use the training wheels, otherwise known as the 'Rubber Band' option, by clicking on the menu options next to 'Mr Blobby'.

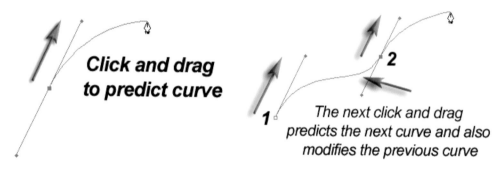

Click and drag to predict curve

1 **2** The next click and drag predicts the next curve and also modifies the previous curve

Basics Step 1 – Go to 'File > New' and create a new blank document. Choose 'White' as the 'Background Contents'. Size is not really important (no really – in this instance anything that can be zoomed to fill the screen will serve your purpose). Click on the Pen Tool (double-check the 'Paths' option, rather than the 'Shape layers' option, is selected in the Options bar) and then click and drag (hold down the mouse clicker as you drag your mouse) in the direction illustrated above. The little black square in the center of the radiating lines is called an anchor point. The lines extending either side of this anchor point are called direction lines, with a direction point on either end, and that thing waving around (courtesy of the Rubber Band option) is about to become the path with your very next click of the mouse.

Basics Step 2 – Make a second click and drag in the same direction. Notice how the dragging action modifies the shape of the previous curved line. Go to the 'Edit' menu and select 'Undo'. Try clicking a second time and dragging in a different direction. Undo a third time and this time drag the direction point a different distance from the anchor point. The thing you must take with you from this second step is that a curve (sometimes referred to as a Bézier curve) is both a product of the relative position of the two anchor points either side of the curve, and the direction and length of the two direction lines (the distance and direction of the dragging action).

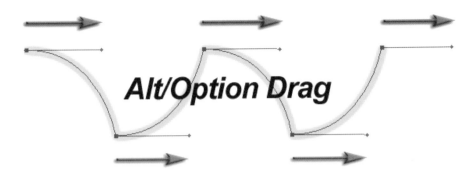

Basics Step 3 – Scenario 1: Let us imagine that the first click and drag action has resulted in a perfect curve; the second dragging action is not required to perfect the curve but instead upsets the shape of this perfect curve – so how do we stop this from happening? Answer: Hold down the Alt key (PC) or Option key (Mac) and then drag away from the second anchor point to predict the shape of the next curve. This use of the Alt/Option key cancels the first direction line that would otherwise influence the previous curve.

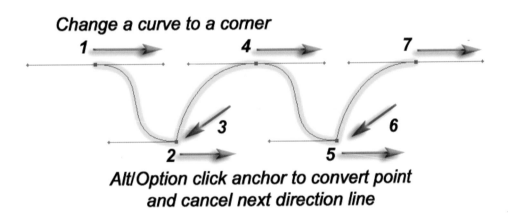

Scenario 2: Let us imagine that we have created the first perfect curve using two normal click and drag actions (no use of a modifier key). The direction lines that are perfecting the first curve are, however, unsuitable for the next curve – so how do we draw the next curve whilst preserving the appearance of the first curve? Answer: The last anchor point can be clicked whilst holding down the Alt/Option key. This action converts the smooth anchor point to a corner anchor point, deleting the second direction line. The next curved shape can then be created without the interference of an inappropriate direction line.

Note > The information that you need to take from this third step is that sometimes direction lines can upset adjacent curves. The technique of cancelling one of the direction lines using a modifier key makes a series of perfect curves possible. These two techniques are especially useful for converting smooth points into corner points on a path.

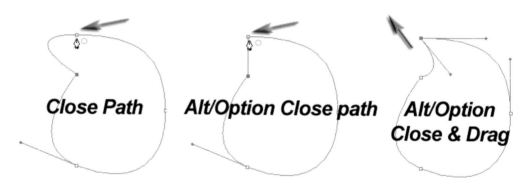

Basics Step 4 – Just a few more steps and we can go out to play. It is possible to change direction quickly on a path without cancelling a direction line. It is possible to alter the position of a direction line by moving the direction point (at the end of the line) independently of the direction line on the other side of the anchor point. To achieve this simply position the mouse cursor over the direction point and, again using the Alt/Option key, click and drag the direction point to a new position.

Close Path

Alt/Option Close path

Alt/Option Close & Drag

Basics Step 5 – If this path is going to be useful as a selection, it is important to return to the start point. Clicking on the start point will close the path. As you move the cursor over the start point the Pen Tool will be accompanied by a small circle to indicate that closure is about to occur. You will also notice that the final curve is influenced by the first direction line of the starting anchor point. Hold down the Alt/Option key when closing the path to cancel this first direction line. Alternatively, hold down the Alt/Option key and drag a new direction line to perfect the final curve.

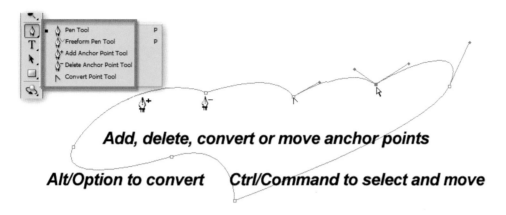

Add, delete, convert or move anchor points

Alt/Option to convert Ctrl/Command to select and move

Basics Step 6 – When a path has been closed it is possible to add, delete, convert or move any point. Although these additional tools are available in the Tools panel they can all be accessed without moving your mouse away from the path in progress. If the Auto Add/Delete box has been checked in the Options bar you simply have to move the Pen Tool to a section of the path and click to add an additional point (the pen cursor sprouts a plus symbol). If the Pen Tool is moved over an existing anchor point you can simply click to delete it. Holding down the Ctrl key (PC) or Command key (Mac) will enable you to access the Direct Selection Tool (this normally lives behind the Path Selection Tool). The Direct Selection Tool has a white arrow icon and can select and move a single anchor point (click and drag) or multiple points (by holding down the Shift key and clicking on subsequent points). The Path Selection Tool has to be selected from the Tools panel and is able to select the entire path.

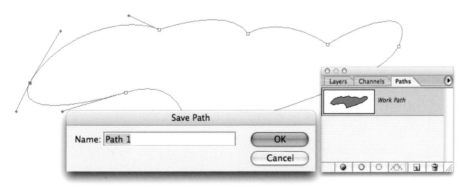

Basics Step 7 – The final step in the creation of a Path is to save it. All Paths, even Work Paths, are saved with the image file (PSD, PDF, PSB, JPEG or TIFF). If, however, a Work Path is not active (such as when the file is closed and reopened) and then the Pen Tool is inadvertently used to draw a new Path, any previous Work Path that was not saved is deleted.
Click on the Paths panel tab and then double-click the Work Path. This will bring up the option to save and name the Work Path and ensure that it cannot be deleted accidentally. To start editing an existing Path click on the Path in the Paths panel and then choose either the Direct Selection Tool or the Pen Tool in the Tools panel. Click near the Path with the Direct Selection Tool to view the handles and the Path.

Magdalena Bors

layer blends

American Patriot - Duncan P
Walker www.iStockphoto.com

essential skills

- Learn the practical applications of layer blend modes for image retouching and creative montage work.
- Develop skills using the the following techniques:
 - blend modes
 - layers and channels
 - layer masks.

Introduction

When an image, or part of an image, is placed on a separate layer above the background, creative decisions can be made as to how these layers interact with each other. Reducing the opacity of the top layer allows the underlying information to show through, but Photoshop has many other ways of mixing, combining or 'blending' the pixel values on different layers to achieve different visual outcomes. The different methods used by Photoshop to compare and adjust the hue, saturation and brightness of the pixels on the different layers are called 'blend modes'. Blend modes can be assigned to the painting tools from the Options bar but they are more commonly assigned to an entire layer when editing a multi-layered document. The layer blend modes are accessed from the 'blending mode' pull-down menu in the top left-hand corner of the Layers panel.

The major groupings

The blend modes are arranged in family groups of related effects or variations on a theme. Many users simply sample all the different blend modes until they achieve the effect they are looking for. This, however, can be a time-consuming operation and a little more understanding of what is actually happening can ease the task of choosing an appropriate blend mode for the job in hand. A few of the blend modes are commonly used in the routine compositing tasks, while others have very limited or specialized uses only. The five main groups of blend modes after Normal and Dissolve that are more commonly used for image-editing and montage work start with:

- Darken
- Lighten
- Overlay
- Difference
- Hue.

More blend modes than a photographer needs

There are 25 blend modes (counting 'Normal' as a mode) but photographers will usually only rely on less than half of these modes on a regular basis in their image retouching and montage projects. There are a few modes (such as Darker Color and Lighter Color) that offer the photographer with few if any practical uses. This chapter will focus on the 'essential' modes and skip over, or omit, the non-essential modes. The essential blend modes for photo-editing are:

- Normal
- Darken
- Multiply,
- Lighten
- Screen
- Overlay
- Soft Light
- Difference
- Luminosity
- Color

Opacity and Dissolve

At 100% opacity the pixels on the top layer obscure the pixels on the layers underneath. As the opacity is reduced the pixels underneath become visible. The Dissolve blend mode only works when the opacity of the layer is reduced. Random pixels are made transparent on the layer rather than reducing the transparency of all the pixels. The effect is very different to the reduced opacity of the 'Normal' blend mode and has commercial applications as a transition for fading one image into another, but the effect has very limited commercial applications for compositing and photomontage of stills image work.

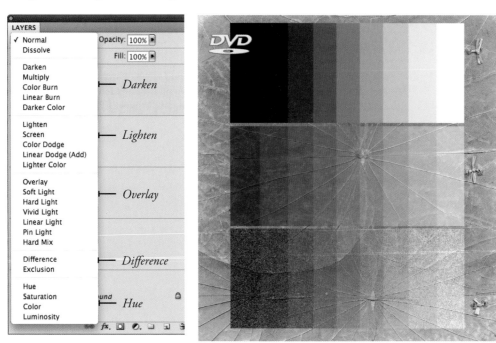

Image 02 Opacity. *The groups of blend modes are listed using the name of the dominant effect. The step wedge above shows 'Normal' at 100% and 50% opacity and the 'Dissolve' blend mode with the layer set to 50% opacity*

The 'Opacity' control for each layer, although not strictly considered as a blend mode, is an important element of any composite work. Some of the blend modes are quite 'aggressive' in their resulting effect if applied at 100% opacity. Experimenting with some blend modes at a reduced opacity will often provide the required result.

Shortcuts

The blend modes can be applied to layers using keyboard shortcuts (so long as a painting tool is not selected). Hold down the Shift key and press the '+' key to move down the list or the '−' key to move up the list. Alternatively, you can press the Alt/Option key and the Shift key and key in the letter code for a particular blend mode. If a tool in the painting group is selected (i.e. in use) the blend mode is applied to the tool rather than the layer. See Keyboard Shortcuts for more information. .

The 'Darken' group

It's not too hard to figure out what this group of blend modes have in common. Although Darken leads the grouping, Multiply is perhaps the most used blend mode in the group.

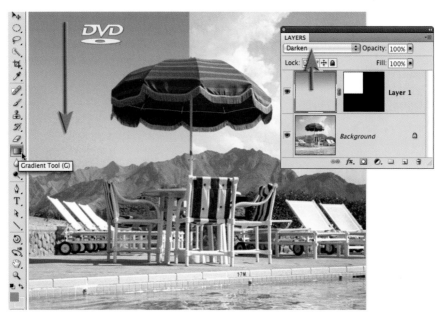

Image 03_Darken. *The Darken mode can replace existing highlights while ignoring darker tones*

Darken

When the top layer is set to Darken mode Photoshop displays the darker pixels, regardless of whether they are on the layer set to the Darken mode or on the underlying layers. Pixels on the layer with the blend mode applied that are lighter than the underlying pixels in the same location will no longer be visible. This mode is invaluable when retouching portraits or removing halos from around subjects due to masking errors (see Removing Shine from Skin or Project 6 – Smart Objects in the Advanced Retouching chapter).

Multiply is a useful blend mode when overall darkening is required

Multiply

The 'Multiply' blend mode belongs to the 'Darken' family grouping. The brightness values of the pixels on the blend layer and underlying layer are multiplied to create darker tones. Only values that are multiplied with white (level 255) stay the same.

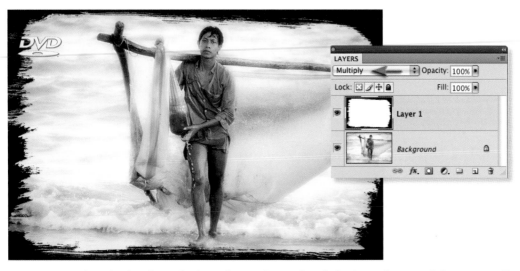

Image 04 Multiply. *The Multiply mode is used to apply a dark edge to the image (white is neutral)*

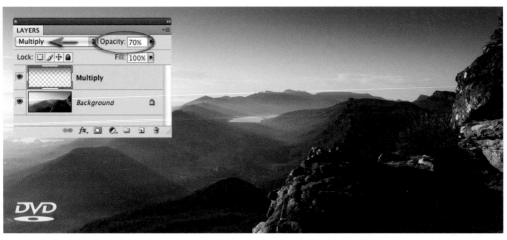

Image 05 Multiply. *The Multiply blend mode is used to darken the sky in this landscape image*

 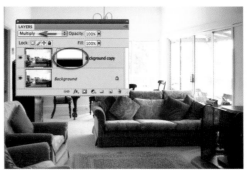

Image 06 Multiply. *The Multiply blend mode is used to darken the top half of the image. The layer is first duplicated and the Multiply mode set. A layer mask is added and a linear gradient in the layer mask shields the lower portion of the image from the effects of the blend mode*

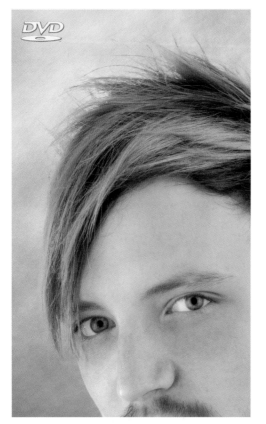

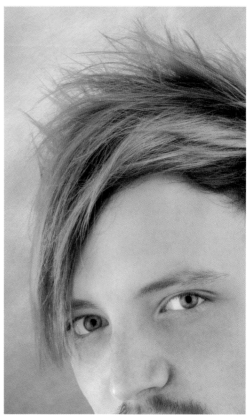

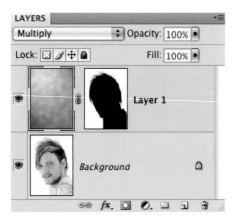

Image 07 Multiply. The Multiply blend mode is the secret to success when masking hair that was first captured against a white background. The new background layer and layer mask are positioned above the portrait and the layer is then set to the Multiply mode. Note the difference before and after the blend mode has been applied (see Montage Projects > Hair Extraction)

Image courtesy of Shari Gleeson

Color Burn, Linear Burn and Darker Color

Color Burn increases the underlying contrast while Linear Burn decreases the underlying brightness. These are difficult blend modes to find a use for at 100% opacity. Saturation can become excessive and overall brightness, now heavily influenced by the underlying color, can 'fill in' (become black). Darker Color is very similar to the Darken mode in that only the darker pixels remain visible. The difference between the two 'darkening' modes is how Photoshop assesses the brightness value – channel by channel (Darken) or combined channels (Darken Color).

The 'Lighten' group

The name of this group of blend modes is self-explanatory. If one of the modes in this group is applied to the top layer it usually results in a lighter outcome in some areas of the image. Although Lighten leads the grouping, Screen is perhaps the most used blend mode in the group.

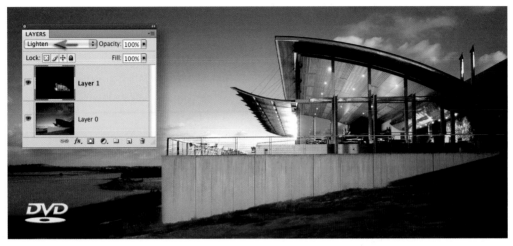

Image 08 Lighten. *Two exposures are combined to balance the bright ambient light and the comparatively dim interior lighting of a building. A second image is captured at night and placed on a layer above the daylight exposure. The layer is then set to the Lighten blend mode – original images by John Hay*

Lighten

When the top layer is set to Lighten mode Photoshop displays the lighter pixels, regardless of whether they are on the layer set to the Lighten mode or on the underlying layers. Pixels on the layer with the blend mode applied that are darker than the underlying pixels in the same location will no longer be visible. This blend mode is particularly useful for introducing highlights into the underexposed areas of an image. This technique can also be useful for replacing dark colored dust and scratches from light areas of continuous tone.

Image 9 Screen. *Screen is useful when overall lightening is required*

Screen

The 'Screen' blend mode belongs to the 'Lighten' family grouping. The 'inverse' brightness values of the pixels on the blend layer and underlying layers are multiplied to create lighter tones (a brightness value of 80% is multiplied as if it was a value of 20%). Only the underlying values that are screened with black (level 0) on the upper layer stay the same (see Project 5 in the Advanced Retouching chapter).

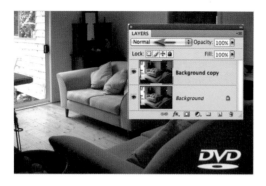 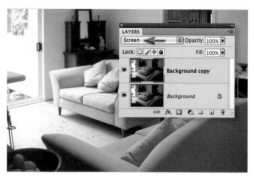

Image10. Screen. *A background layer is duplicated and a Screen blend mode is applied to lighten all levels*

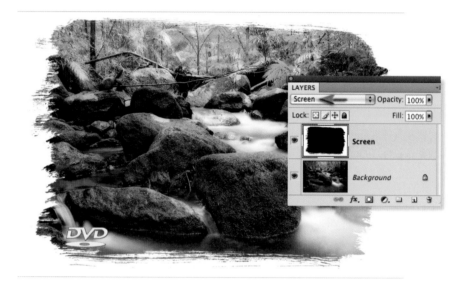

Image 11 Screen. *The Screen mode can be used to apply a white border around an image*

Blonde Goddess – Katja Govorushchenko (www.iStockphoto.com)

Image 12 Screen. *The Screen blend mode is useful when masking hair that was first captured against a black background (see Montage > Hair Extraction for more information about this technique)*

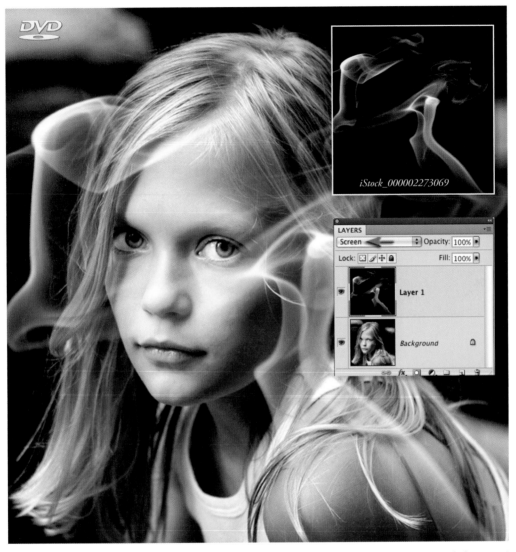

Girl by Shelly Perry (www.iStockphoto.com)

Image 13 Screen. *The Screen blend mode is particularly useful for quickly dropping in elements that were photographed against black background such as smoke, bubbles, splashing or spurting water and fireworks. For transparent elements the lighting is usually positioned to one side or behind the subject matter to create the best effect*

Color Dodge, Linear Dodge and Lighter Color

Color Dodge decreases the underlying contrast while Linear Dodge increases the underlying brightness. This again is a difficult blend mode to find a use for at 100% opacity. Saturation can become excessive and overall brightness, heavily influenced by the underlying color, can blow out (become white). Lighter Color is very similar to the Lighten mode in that only the lighter pixels remain visible. The difference between the two 'lightening' modes is how Photoshop assesses the brightness value – channel by channel (Lighten) or combined channels (Lighter Color).

The 'Overlay' group

This is perhaps the most useful group of blend modes for photomontage work.

Image 14 Overlay. *Applying the blend mode 'Overlay' to a texture or pattern layer will create an image where the form appears to be modeling the texture. Both the highlights and shadows of the underlying form are respected*

Image 15 Overlay. *The 'Overlay' blend mode is useful for overlaying textures over 3D form*

Overlay

The Overlay blend mode uses a combination of the Multiply and Screen blend modes while preserving the highlight and shadow tones of the underlying image. The Overlay mode multiplies or screens the colors, depending on whether the base color is darker or lighter than a midtone. The effect is extremely useful when overlaying a texture or color over a form modeled by light and shade. Excessive increases in saturation may become evident when overlaying white and black. The 'Soft' and 'Hard Light' blend modes produce variations on this overlay theme.

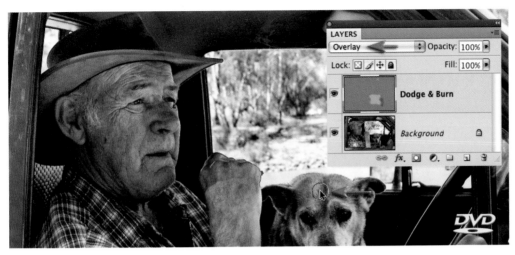

Image 16 Overlay. *A 50% Gray layer set to Overlay mode can be used to dodge and burn where increased localized contrast and saturation is required (such as dodging dark shadow tones)*

A layer filled with 50% Gray is invisible in Overlay and Soft Light mode and, as a result, is commonly used as a 'non-destructive' dodging and burning layer (see Project 3 in the Retouching chapter for a more in-depth look at this skill).

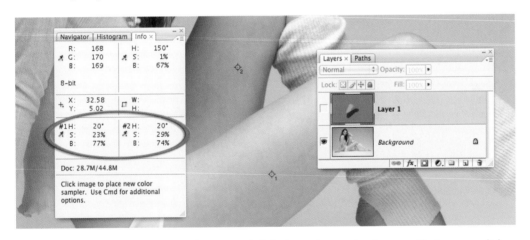

Image 17 Soft Light. *A 50% Gray layer set to Soft Light mode provides the most effective way to lighten or darken tones within an image. This is a more effective way than using Levels or Curves to change the luminance values. Using Levels or Curves to change localized luminance values always results in excessive shifts in Saturation and Hue values*

Soft and Hard Light – variations on a theme

The Soft and Hard Light blend modes are variations on the 'Overlay' theme. Photoshop describes the difference in terms of lighting (diffused or harsh spotlight). If the Overlay blend mode is causing highlights or shadows to become overly bright or dark or the increase in saturation is excessive then the Soft Light blend mode will often resolve the problem. The Hard Light, on the other hand, increases the contrast – but care must be taken when choosing this option as blending dark or light tones can tip the underlying tones to black (level 0) or white (255).

Difference and Exclusion

The Difference blend mode subtracts either the underlying color from the blend color or vice versa depending on which has the highest brightness value. This blend mode used to be useful for registering layers with the same content but this has now largely been replaced with the Auto-Align Layers for layers that are not Smart Objects. The Exclusion blend mode works in the same way except where the blend color is white. In this instance the underlying color is inverted.

Image 18 Difference. *The Difference mode is used to align two layers*

The Difference mode can also be used to create a 'solarized' or 'sabattier' effect. Duplicate the layer and go to Image > Adjustments > Invert and then apply the Difference blend mode to the copy layer.

Image 19 Difference. *Original image (Harmony) by Nicholas Monu (www.iStockphoto.com)*

Hue, Saturation and Color

The Hue and Color blend modes are predominantly used for toning or tinting images whilst the Saturation blend mode offers more limited applications. Saturation precedes Color in the Modes menu but is discussed after Hue and Saturation in this section due to their inherent similarities. See Project 1 in the Advanced Retouching chapter to see how the color mode is used to reintroduce some of the original color back into an image that has been converted to black and white.

Hue

The 'Hue' blend mode modifies the image by using the hue value of the blend layer and the saturation value of the underlying layer. As a result the blend layer is invisible if you apply this blend mode to a fully desaturated image. Opacity levels of the blend layer can be explored to achieve the desired outcome.

Color

The 'Color' blend mode is useful for toning desaturated or tinting colored images. The brightness value of the base color is blended with the hue and saturation of the blend color.

Image 20 Hue-Color. *Hue and Color blend modes*

Image 21 Hue

Note > Color fills can be used to tint or tone images by setting them to Hue or Color mode. Photoshop's Photo Filter layers perform a similar task but without the need to set the layer to the Hue or Color mode.

Saturation

The brightness or 'luminance' of the underlying pixels is retained but the saturation level is replaced with that of the blend layer's saturation level.

Note > This blend mode has limited uses for traditional toning effects but can be used to locally desaturate colored images. To work with this blend mode try creating a new empty layer. Then either fill a selection with any desaturated tone or paint with black or white at a reduced opacity to gradually remove the color from the underlying image.

Image 22 Saturation

Image 23 Saturation. *A Saturation layer is used to desaturate the underlying image*

Luminosity

Setting a layer to 'Luminosity' mode allows the Hue and Saturation values from the underlying layers to replace these on the Luminosity layer. The luminosity values within an RGB image have a number of very useful applications. The luminosity values can be extracted from an RGB image (from the Channels panel) and saved as an alpha channel, used as a layer mask or pasted as an independent layer above the background layer.

Image 24 Luminosity

Creating a luminance channel

1. In the Channels panel Command/Ctrl-click the master RGB channel to select the luminance values.
2. Hold down the Option/Alt key and click on the 'Save selection as channel' icon to create an alpha channel. In the New Channel dialog select the Masked Areas option and select OK.
3. Go to Select > Deselect.

A Curves adjustment layer can be switched to Luminosity mode to eliminate shifts in saturation when contrast is increased. The example above illustrates what happens when contrast is increased using a Curves layer in Luminance and Normal blend modes. Open up the file and try it!

Chris Neylon

filters

essential skills

- Apply filter effects to a picture.
- Use the Filter Gallery feature to apply several filters cumulatively.
- Use filters with text and shape layers.
- The 'Smart' way to apply filters.
- Filter a section of a picture.
- Paint with a filter effect.
- Install and use third party filters.

Filtering in Photoshop

Traditionally the term filter, when used in a photography context, referred to a small piece of plastic or glass that was screwed onto, or clipped in front of, the camera's lens. Placing the filter in the imaging path changed the way that the picture was recorded. During the height of their popularity there were literally hundreds of different filter types available for the creative photographer to use. The options ranged from those that simply changed the color of the scene, to graduated designs used for darkening skies to multi-faceted glass filters that split the image in many fragments. Even now when their popularity has waned most photographers still carry a polarizing filter, maybe a couple of color conversion filters and perhaps the odd graduated filter as well. But apart from these few examples, much of the creative work undertaken by in-front-of-camera filters is now handled by the digital filters that are shipped with your imaging program. These options, like the filters of old, are designed to change the way that your picture looks, but you will find that it is possible to create much more sophisticated effects with the digital versions than was ever possible before.

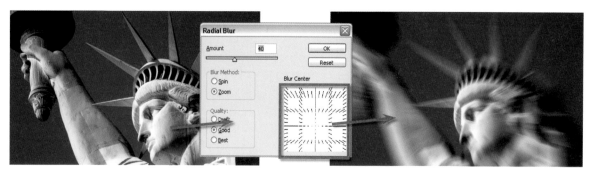

Statue of Liberty – Jeremy Edwards (www.iStockphoto.com)

Applying a filter is a simple process. After opening the image simply select the filter option from those listed under the Filter menu. This approach applies the effects of the filter to the whole of the photo, changing it forever. So be sure to keep a back up copy of the original picture (or a copy of the background layer) just in case you change your mind later. Better still, use the new Smart Filter option to apply your filter changes losslessly.

To get you started, I have included a variety of examples from the range that comes free with Photoshop that you will use most regularly. I have not shown Gaussian Blur or all the sharpening filters as these are covered in techniques elsewhere in the text, but I have tried to sample a variety that, to date, you might not have considered using.

If you are unimpressed by the results of your first digital filter foray, try changing some of the variables or mixing a filtered layer (using the layer's Blending Mode or Opacity controls) with an unfiltered version of the image. An effect that might seem outlandish at first glance could become usable after some simple adjustments of the in-built sliders contained in most filter dialog boxes or with some multiple layer variations.

The 'Smart' way to filter

The concept of non-destructive editing is the future of editing for photographers and is ever growing in popularity and acceptance. Now many dedicated amateurs are working like professionals by embracing ways of enhancing and editing that don't destroy or change the original pixels in the end result. Masking techniques, Adjustment Layers and the use of Smart Objects are the foundation technologies of many of these techniques. But try as we may some changes have just not been possible to apply non-destructively.

Filtering is one area in particular where this is the case. For example, applying a sharpening filter to a picture irreversibly changes the pixels in the photo forever. For this reason many of us have been applying such filters to copies of our original document whilst all the time dreaming of a better way. Well the better way arrived in CS3 which included for the first time a new filtering option called Smart Filters and yes, you guessed it, this technology allowed users to apply a filter to an image non-destructively. Cool!

Based around the Smart Object technology first introduced into Photoshop in CS2, applying a Smart Filter is a two-step process. First the image layer needs to be converted to a Smart Object. This can be done via the new entry in the Filter menu, Convert for Smart Filters, or by selecting the image layer and then choosing Layer > Smart Objects > Convert to Smart Objects. Next pick the filter you want to apply and adjust the settings as you would normally before clicking OK.

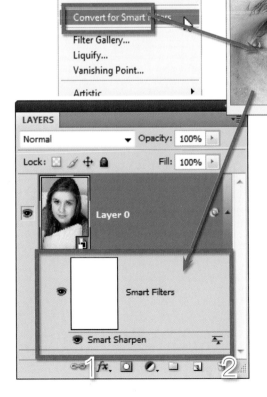

Applying Smart Filters

Applying a filter to a Smart Object layer will automatically create a Smart Filter entry in the Layers panel. Multiple filters with different settings can be added to a single Smart Object layer. The settings for any Smart Filter can be adjusted by double-clicking the filter's name (1) in the Layers panel. The blending mode of the Smart Filter can be changed by double-clicking the settings icon (2) at the right end of the entry. This changes the way that the filter is applied to the image. To apply a filter to several layers, convert the multi-selected layers to a Smart Object first and then filter.

Smart Filters are added as an extra entry beneath the Smart Object in the Layers panel. The entry contains both a mask as well as a separate section for the filter entry and its associated settings. Like Adjustment Layers, you can change the setting of a Smart Filter at any time by double-clicking the filter's name in the Layers panel. The blending mode of the filter is adjusted by double-clicking the settings icon at the right end of the filter entry.

The Smart Filter mask can be edited to alter where the filter effects are applied to the photo. In this release multiple Smart Filters can be added to a photo but they all must use the one, common mask.

Finally, with the Smart Filter technology we have a way to apply such things as sharpness or texture non-destructively.

Sharpness applied locally using a masked Smart Object

Masking Smart Filters

You can easily localize the effects of a Smart Filter by painting directly onto the mask associated with the entry. Here the mask thumbnail was selected first and then inverted using the Image > Adjust > Inverse option. Keep in mind that black sections of a mask do not apply the filter to the picture so inverting the thumbnail basically removes all filtering effects from the image. Next white was selected as the foreground color and the Brush Tool chosen. The opacity of the tool was reduced and with the mask thumbnail still selected, the areas to be sharpened are then painted in.

The Filter Gallery

Most Photoshop filters are applied using the Filter Gallery feature. Designed to allow the user to apply several different filters to a single image, it can also be used to apply the same filter several times. The dialog consists of a preview area, a collection of filters that can be used with the feature, a settings area with sliders to control the filter's effect and a list of filters that are currently being applied to the image. The gallery is faster and provides previews that are much larger than those contained in individual filter dialogs.

Filters are arranged in the sequence that they are applied. Filters can be moved to a different spot in the sequence by click-dragging up or down the stack. Click the 'eye' icon to hide the effect of the selected filter from preview. Filters can be deleted from the list by dragging them to the dustbin icon at the bottom of the dialog.

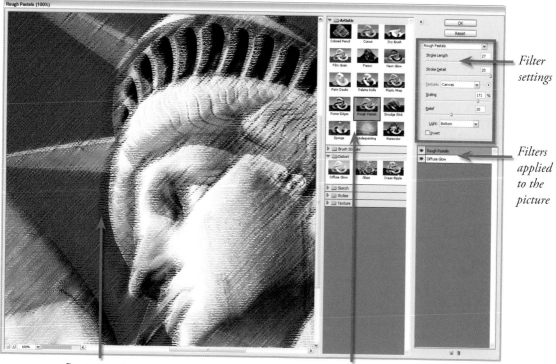

Filter settings

Filters applied to the picture

Preview area

Gallery filters

Filters that can't be used with the Filter Gallery feature are either applied directly to the picture with no user settings or make use of a filter preview and settings dialog specific to that particular filter, and they generally cannot be used on 16-bit images.

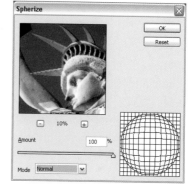

Fade Filter command

The opacity, or strength, of a standard filter effect can be controlled by selecting the Edit > Fade command when selected directly after the filter is applied. With a value of 0% the filter changes are not applied at all, whereas a setting of 100% will apply the changes fully. As well as controlling opacity the Fade dialog also provides the option to select a different blend mode for the filter changes. Note that the actual entry for the Fade command will change depending on the last filter applied and this option is not available when using Smart Filters.

Note > When using Smart Filters you can change the Blend Mode and filter amount (use the Opacity slider) via the Blending Options dialog. This is displayed by double-clicking the settings icon on the right of the filter entry in the Layers panel.

Improving filter performance

A lot of filters make changes to the majority of the pixels in a picture. This level of activity can take considerable time, especially when working with high-resolution pictures or underpowered computers. Use the following tips to increase the performance of applying such filters:

- Free up memory by using the Edit > Purge command before filtering.
- Allocate more memory to Photoshop via the Edit > Preferences > Performance option before filtering.
- Try out the filter effect on a small selection before applying the filter to the whole picture.
- Apply the filter to individual channels separately rather than the composite image.

Installing and using third party filters

Ever since the early versions of Photoshop Adobe provided the opportunity for third party developers to create small pieces of specialist software that could plug into Photoshop. The modular format of the software means that Adobe and other software manufacturers can easily create extra filters that can be added to the program at any time. In fact, some of the plug-ins that have been released over the years have became so popular that Adobe themselves incorporated their functions into successive versions of Photoshop. This is how the Drop Shadow layer effect came into being.

Most plug-ins register themselves as extra options in the Filter menu where they can be accessed just like any other Photoshop feature. The Digital SHO filter from Applied Science Fiction is an example of such plug-in technology. Designed to automatically balance the contrast and enhance the shadow detail in digital photographs, when installed it becomes part of a suite of filters supplied by the company that are attached to the Filter menu (see above). Other filters like those supplied by Pixel Genius Suite are automation filters and are therefore placed in the Automate folder.

Filtering a shape or text (vector) layer

Filters only work with bitmap or pixel-based layers and pictures. As text, vector masks and custom shape layers are all created with vector graphics (non-pixel graphics), these layers need to be converted to bitmap (pixel-based picture) before a filter effect can be applied to them. Photoshop uses a Rasterize function to make this conversion. Simply select the text or shape layer and then choose the Layer > Rasterize option. Alternatively, if you inadvertently try to filter a vector layer Photoshop will display a warning dialog that notifies you that the layer needs to be converted before filtering and offers to make the conversion before proceeding.

Note > Especially in the case of text, you may want to create a copy of the vector layer as a backup, to avoid the need to recreate the layer if the text layer needs to be edited again later.

The great filter round-up

The filter examples on the next few pages will give you an idea of how this type of technology can be used to enhance, change and alter your photos. Keep in mind that there are many more filters that ship with Photoshop or are available online. In fact, for the first time, CS4 includes an extra option in the Filter menu (Filter > Browse Filters Online) that allows you to search for other Photoshop filters on the web.

Liquify filter

The Liquify filter is a very powerful tool for warping and transforming your pictures. The feature contains its own sophisticated dialog box complete with a preview area and no less than ten different tools that can be used to twist, warp, push, pull and reflect your pictures with such ease that it is almost as if they were made of silly putty. In CS3 and CS4 the filter also works with 16-bit images but not Smart Objects. The effects obtained with this feature can be subtle or extreme depending on how the changes are applied. Stylus and tablet users have extra options and control based on pen pressure.

Liquify works by projecting the picture onto a grid or mesh. In an unaltered state, the grid is completely regular; when liquifying a photo the grid lines and spaces are intentionally distorted, which in turn causes the picture to distort. As the mesh used to liquify a photo can be saved and reloaded, the distortion effects created in one picture can also be applied to an entirely different image.

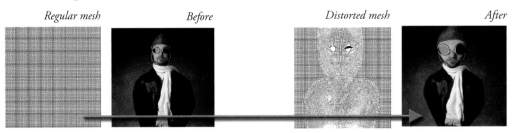

Regular mesh *Before* *Distorted mesh* *After*

The tools contained in the filter's toolbox are used to manipulate the underlying mesh and therefore distort the picture. Areas of the picture can be isolated from changes by applying a Freeze Mask to the picture part with the Freeze Mask Tool. While working inside the filter dialog, it is possible to selectively reverse any changes made to the photo by applying the Reconstruct Tool. When applied to the surface of the image the distorted picture parts are gradually altered back to their original state (the mesh is returned to its regular form). Like the other tool options in the filter, the size of the area affected by the tool is based on the Brush Size setting and the strength of the change is determined by the Brush Pressure value.

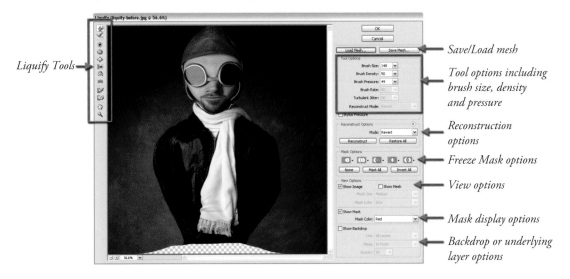

Liquify Tools

Save/Load mesh

Tool options including brush size, density and pressure

Reconstruction options

Freeze Mask options

View options

Mask display options

Backdrop or underlying layer options

Usage summary

1. Open an example image and then the Liquify filter (Filter > Liquify). The dialog opens with a preview image in the center, tools to the left and tool options to the right. The Size, Pressure, Rate and Jitter options control the strength and look of the changes, whereas the individual tools alter the type of distortion applied. In order to create a caricature of the example picture we will exaggerate the perspective of the figure. Select the Pucker Tool and increase the size of the Brush to cover the entire bottom of the subject. Click to squeeze inwards the lower part of the subject.

2. Now select the Bloat Tool and place it over the head; click to expand this area. If you are unhappy with any changes you can use the keyboard shortcuts for Edit > Undo (Ctrl + Z) to remove the last changes. Use a smaller brush size to bloat the goggles.
3. To finish the caricature switch to the Forward Warp Tool and push in the cheek areas. You can also use this tool to drag down the chin and lift the cheekbones.
4. The picture can be selectively restored at any point by choosing the Reconstruct Tool and painting over the changed area. Click OK to apply the distortion changes.

Liquify tools

 Forward Warp Tool – used to push pixels in the direction you drag the cursor across the picture surface.

 Reconstruct Tool – restores the picture and mesh back to its original appearance before any distortion was applied.

 Twirl Clockwise Tool – used for rotating pixels in a clockwise direction. Use with the Alt key to twirl in an anticlockwise direction.

 Pucker Tool – designed to suck or pinch the pixels towards the center of the brush.

 Bloat Tool – balloons the pixels away from the center of the brush towards the outside edges.

 Push Left Tool – used to move the pixels to the left or to the right (Alt-drag) of the drag.

 Mirror Tool – used to copy and reflect the pixels perpendicular to the direction of the stroke. Use Alt-drag to reflect the pixels in the opposite direction.

 Turbulence Tool – used for creating clouds, fire and waves by smoothly scrambling pixels.

 Freeze Mask Tool – adds a mask that protects the masked area from liquify changes.

 Thaw Mask Tool – acts as an eraser for the Freeze Mask Tool.

Before

After

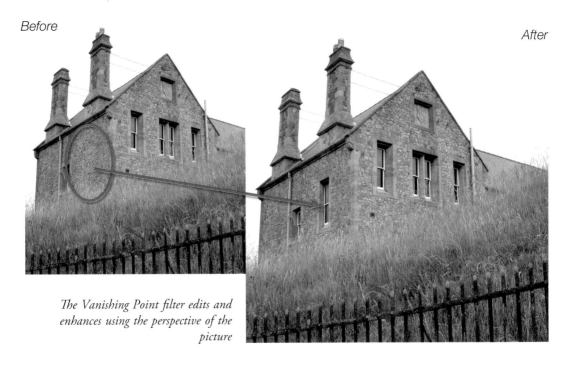

The Vanishing Point filter edits and enhances using the perspective of the picture

Vanishing Point

The Vanishing Point filter was first introduced in CS2 as an addition to the specialist filter line-up that includes Extract, Lens Blur and Liquify. Like the others, the feature has its own dialog complete with preview image, toolbox and options bar. The filter allows the user to copy and paste and even Clone Stamp portions of a picture whilst maintaining the perspective of the original scene. The filter evolved in CS3 so that it could be used in many more situations as that version allowed perspective plans to be linked at any angle (rather than just 90° as was the case in CS2). Vanishing Point cannot be used in conjunction with Smart Objects. Using the filter is a two-step process:

Step 1: Define perspective planes

To start, you must define the perspective planes in the photo. This is achieved by selecting the Create Plane Tool and marking each of the four corners of the rectangular-shaped feature that sits in perspective on the plane. A blue grid means that it is correct perspective, yellow that it is borderline, and red that it is mathematically impossible. In the example, the four corners of a window were used to define the plane of the building's front face. Next, a second plane that is linked to the first at an edge is dragged onto the surface of the left side wall.

Step 2: Copy and paste or stamp

With the planes established the Marquee Tool can be used to select image parts which can be copied, pasted and then dragged in perspective around an individual plane and even onto another linked plane. All the time the perspective of the copy will alter to suit the plane it is positioned on. The feature's Stamp Tool operates like a standard stamp tool except that the copied section is transformed to account for the perspective of the plane when it is applied to the base picture.

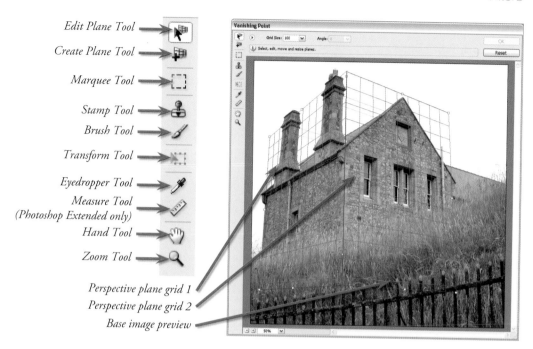

Edit Plane Tool
Create Plane Tool
Marquee Tool
Stamp Tool
Brush Tool
Transform Tool
Eyedropper Tool
Measure Tool
(Photoshop Extended only)
Hand Tool
Zoom Tool

Perspective plane grid 1
Perspective plane grid 2
Base image preview

Usage summary

1. Create a new layer above the image layer to be edited (Layer > New > Layer) and then choose the Vanishing Point filter from the Filter menu.

2. Select the Create Plane Tool and click on the top left corner of a rectangle that sits on the plane you wish to define. Locate and click on the top right, bottom right and bottom left corners. If the plane has been defined correctly the corner selection box will change to a perspective plane grid. In the example, the front face of the building was defined first.

3. To create a second, linked, plane, Ctrl-click the middle handle of the existing plane and drag away from the edge. The left side of the building was defined using the second plane.

4. To copy the window from the building's front face, select the Marquee Tool first, set a small feather value to soften the edges and then outline the window to be copied. Choose Ctrl/Cmd + C (to copy) and then Ctrl/Cmd + V (to paste). This pastes a copy of the window in the same position as the original marquee selection.

5. Click-drag the copy from the front face around to the side plane. The window (copied selection) will automatically snap to the new perspective plane and will reduce in size as it is moved further back in the plane. Position the window on the wall surface and choose Heal > Luminance from the Marquee options bar.

6. Press 'T' to enter the Transform mode and select Flip from the option bar to reorientate the window so that the inside edge of the framework matches the other openings on the wall. Click OK to complete the process.

Vanishing Point tips

- Use the Edit Plane Tool to click and drag the corners of the grid if grid lines do not match up with the edges of the picture parts that are sitting on the perspective plane.
- In order to copy and paste in full perspective the source plane and destination plane must be joined by a series of linked perspective planes.
- Use the Heal option to help match tones of the copied parts and their new locations.
- Grids can be output as layers, are 16-bit capable, text can be pasted into a grid and are auto-saved as part of the PSD file format.

Vanishing Point goes askew

When the Vanishing Point filter first appeared in Photoshop CS2 there were many admirers of its power to manipulate objects in three-dimensional space but comparatively few people who could find a use for it in their day-to-day workflows. One reason for this lack of popularity was that the feature assumed that all adjoining perspective planes met at a 90° angle. This is fine for buildings and boxes but is limited when it comes to a good many other surfaces.

The version of Vanishing Point that appears in both CS3 and CS4 can create perspective-based planes at almost any angle, making the feature much more usable in a variety of everyday images.

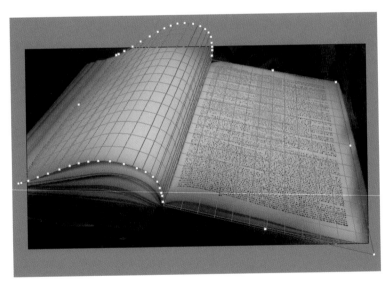

Vanishing Point 2.0 provides the ability to create perspective planes that join at angles other than 90°. In this example, the curve of the page was recreated with a series of small angled planes

Usage summary

1. In the example image some text (or an image) needed to be added to the blank page on the left-hand side of the book. The text was photographed from another part of the book, the file opened in Photoshop and then copied to memory (Ctrl/Cmd + A, Ctrl/Cmd + C).
2. Next the book picture was opened into the Vanishing Point filter (Filter > Vanishing Point). To start, a new plane was created on the right side of the book using the edge of the text as a guide. The Create Plane Tool was selected and then the four corners of the plane dragged out to align with the edges of the text.

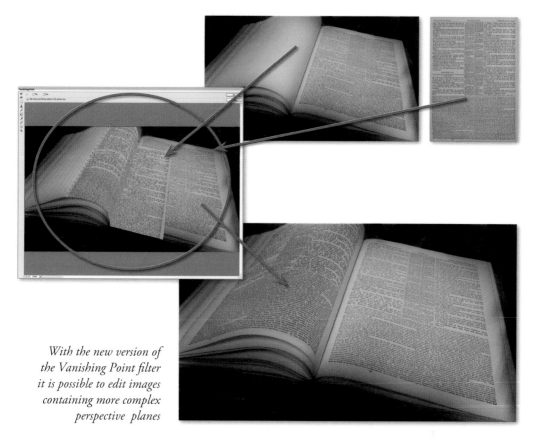

With the new version of the Vanishing Point filter it is possible to edit images containing more complex perspective planes

3. Once the plane is created the tool reverts to the Edit Plane mode for fine-tuning. The corners of the plane were then adjusted so that it extended to the edges of the page and, more importantly, the spine of the book.

4. To create a linked plane for the other side of the book, the Create Plane Tool was chosen a second time (or you could hold down the Ctrl/Cmd key whilst in Edit Plane mode) and a new plane was dragged from the center handle on the edge of the existing plane.

5. Next the new Angle slider in the top of the dialog was used to rotate the plane so that it ran along the face of the curved page.

6. Using the page edge as a guide, add a series of small linked planes to the picture. Each need to be rotated and realigned to duplicate the perspective of the surface of the page.

7. Next the copied text was pasted (Ctrl/Cmd + V) into the Vanishing Point workspace and dragged to the first perspective plane.

8. The size of the text was then adjusted in the Transform mode (press T to enter) by click-dragging the corners of the marquee around the text before dragging into position on the curved page.

Blur filters

The Blur filters are designed to add a degree of softness to the photo. The most basic filters in this group are the Blur and Blur More options. These apply a set level of blur to your picture quickly and easily. For a more sophisticated and controllable Blur filter try Gaussian Blur or the new Box, Shape, Smart and Surface Blur versions. They all contain controls that alter the style and strength of the effect.

| Average |
| Blur |
| Blur More |
| Box Blur... |
| Gaussian Blur... |
| Lens Blur... |
| Motion Blur... |
| Radial Blur... |
| Shape Blur... |
| Smart Blur... |
| Surface Blur... |

The Lens Blur filter

One popular application for the Blur filters is to recreate a shallow focus photo where the main subject is sharp and the rest of the picture is unsharp. By selecting the areas to blur and then applying a filter you can create a crude shallow focus result. This approach does create a simple in-focus and out-of-focus effect but it would be hard to say that the results are totally convincing. To achieve a depth of field (DOF) effect that is more realistic and believable, the basic idea of this technique needs to be coupled with the Lens Blur filter.

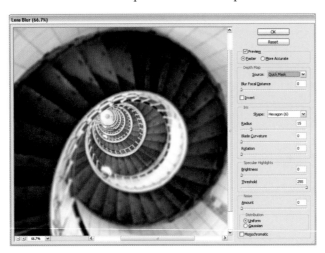

*Spiral Staircase by Bart Broek
(www.iStockphoto.com)*

Photoshop's Lens Blur filter is a dedicated feature designed to create realistic DOF effects in your pictures. From CS2 onwards the feature is 16-bit capable

If realism is your goal then it is necessary to look a little closer at how camera-based DOF works and, more importantly, how it appears in our images. Imagine an image shot with a long lens using a large aperture. The main subject situated midway into the image is pin sharp. Upon examination it is possible to see that those picture elements closest to the main subject are not as 'unsharp' as those further away. In effect the greater the distance from the point of focus, the more blurry the picture elements become.

This fact, simple though it is, is the key to a more realistic digital DOF effect. The application of a simple one-step blurring process does not reflect what happens with traditional camera-based techniques. The Lens Blur filter (Filter > Blur > Lens Blur) is designed specifically to help replicate this gradual change in sharpness. The filter uses selections or masks created before entering the feature to determine which parts of the picture will be blurred and which areas will remain sharp. In addition, if you use a mask that contains areas of graduated gray (rather than just black and white) the filter will adjust the degree of sharpness according to the level of gray in the mask.

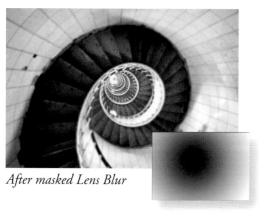

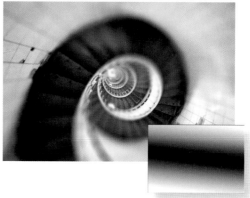

After masked Lens Blur

Mask

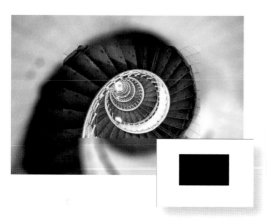

The Lens Blur filter uses a mask or selection to determine which parts of the picture will remain sharp and which areas will be blurred. In addition, the level of sharpness is directly related to the density of the mask. Graduated masks will produce graduated sharpness similar to that found in photographs with camera-based shallow DOF techniques

Lens Blur filter options

Preview – Faster to generate quicker previews. More accurate to display the final version of the image.

Depth Map Source – Select the mask or selection that you will use for the filter from the drop-down list.

Invert – Select this option to inverse the alpha channel mask or selection.

Iris Shape – Determines the way the blur appears. Iris shapes are controlled by the number of blades they contain.

Gaussian or Uniform – Select one of these options to add noise to the picture to disguise the smoothing and loss of picture grain that is a by-product of applying the Lens Blur filter.

Distort filters

Diffuse Glow...
Displace...
Glass...
Lens Correction...
Ocean Ripple...
Pinch...
Polar Coordinates...
Ripple...
Shear...
Spherize...
Twirl...
Wave...
ZigZag...

The Distort filters push, pull and twist the pixels within your pictures. Unlike other filter options, which recreate the image using different drawing or painting styles, the Distort filters deform the original image. The controls included are used to alter the strength of the distortion, sometimes the direction and often how to handle any areas of the image that are left blank by the filter's action. Generally the filters in this group are not applied via the Filter Gallery dialog but rather have their own specific dialog containing both controls and preview.

Distort filters in action – Correcting lens distortion

Photoshop also contains a sophisticated Lens Correction filter (Filter > Distort > Lens Correction). The feature is specifically designed to correct the imaging problems that can occur when shooting with different lenses. Apart from correcting barrel and pincushion distortion, the filter can also fix the color fringing (color outlines around subject edges) and vignetting (darkening of the corners) problems that can also occur as a result of poor lens construction. Controls for changing the perspective of the picture (great for eliminating the issue of converging verticals) as well as how to handle the vacant areas of the canvas that are created after distortion correction are also included.

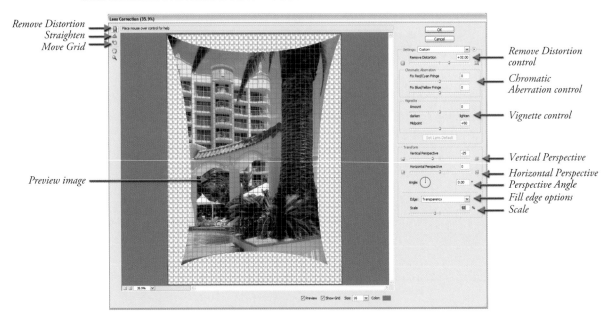

The symptoms of lens distortion

Barrel distortion is usually associated with images that are photographed with extreme wide-angle lenses. The characteristics of barrel distortion are straight lines that appear near the edge of the frame are bent, the whole image appears to be spherical or curved outward and objects that are close to the camera appear grossly distorted. The opposite effect is pincushion distortion, which can be created with some telephoto lenses. Rather than bulging the image seems to recede into the background and straight lines that appear near the edge of the frame are bent inwards.

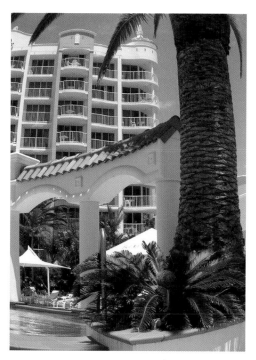 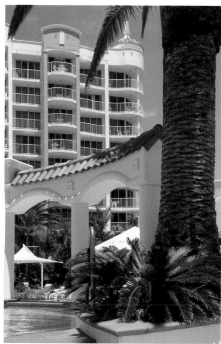

Correcting distortion and perspective

The example image was photographed with a wide-angle lens attached to a digital camera. It displays both barrel distortion and converging verticals that are in need of correction.

1. With the example open select Filter > Distort > Lens Correction. Zoom in or out using the Zoom control at the bottom left of the dialog and drag the grid with the Move Grid Tool, to a position where it can be easily used to line up a straight edge in the photo.

2. Adjust the Remove Distortion slider to the right to correct the barrel effects in the picture. Your aim is to straighten the curved edges of what should be straight picture parts.

3. Now concentrate on correcting the converging verticals. Move the Vertical Perspective option to the left to stretch the details at the top of the photo apart and condense the lower sections. Again aim to align straight and parallel picture parts with the grid lines.

4. If the image is suffering from darkened edges select the Vignetting control and lighten the corners by moving the Amount slider to the right and adjust the percentage of the picture that this control affects with the Midpoint control.

5. Zoom in to at least 600% to check for chromatic aberration problems and use the Fix Red/ Cyan Fringe or Fix Blue/Yellow Fringe controls to reduce the appearance of color edges. Click OK to apply the correction settings. Crop the 'fish tail' edges of the corrected photo to complete.

Noise filters

The Noise filters group contains tools that are used for either adding noise (randomly colored pixels) to, or reducing the existing noise in, a photo. Dust & Scratches is designed to automatically hide picture faults such as hairs or scratches in scanned photos. Despeckle, Median and the new Reduce Noise filter remove or hide the noise associated with high ISO pictures and the Add Noise filter is used to create and add noise to photos.

All the filters in this group, except Despeckle, are applied via their own filter dialog.

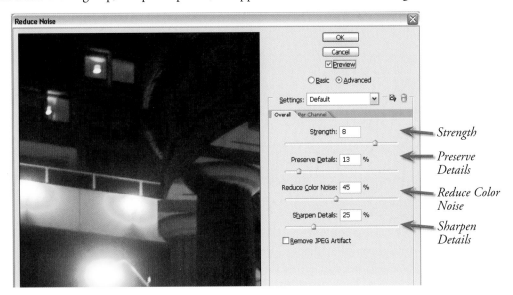

Strength

Preserve Details

Reduce Color Noise

Sharpen Details

The Reduce Noise filter

The feature includes a preview window, a Strength slider, a Preserve Details control and a Reduce Color Noise slider. As with the Dust & Scratches filter you need to be careful when using this filter to ensure that you balance removing noise while also retaining detail.

The best way to guarantee this is to set your Strength setting first, ensuring that you check the results in highlights, midtone and shadow areas. Next gradually increase the Preserve Details value until you reach the point where the level of noise that is being reintroduced into the picture is noticeable and then back off the control slightly (make the setting a lower number). For photographs with a high level of color noise (random speckles of color in an area that should be a smooth flat tone) you will need to adjust this slider at the same time as you are playing with the Strength control.

When the Advanced mode is selected the noise reduction effect can be applied to each channel (Red, Green, Blue) individually. This filter also works in 16-bit mode and contains saveable/loadable settings. There is also a special option for removal of JPEG artifacts. One of the side effects of saving space by compressing files using the JPEG format is the creation of box-like patterns in your pictures. These patterns or artifacts are particularly noticeable in images that have been saved with maximum compression settings. With the Remove JPEG Artifact option selected in the Reduce Noise dialog, Photoshop attempts to smooth out or camouflage the box-like pattern created by the overcompression. The feature does an admirable job but the results are never as good as if a lower compression rate was used initially.

Per Channel mode (Advanced section)

The Per Channel option provides the ability to adjust the noise reduction independently for each of the Red, Green and Blue channels. This allows the user to customize the filter for the channel(s) that have the most noise. The **Strength** setting controls the amount of Luminance or non-color noise reduction applied to each channel. The **Preserve Details** slider maintains the appearance of edge details at the cost of lowering the noise reduction effect. The best results balance both these options for each channel.

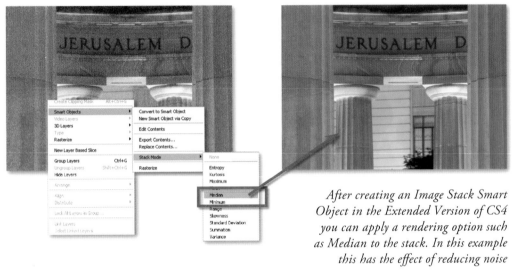

After creating an Image Stack Smart Object in the Extended Version of CS4 you can apply a rendering option such as Median to the stack. In this example this has the effect of reducing noise

Reducing noise with Image Stacks

Another way to reduce noise is to take a series of images of the same scene in quick succession and then use the combined information from all the photos to produce a new, less noisy, composite picture. The process of achieving this outcome became possible in Photoshop CS3 Extended as Adobe introduced the concept of Image Stacks as well as the ability to apply functions, such as the Median command, to these stacks. The process involves layering the sequential source images in a single document, applying the Auto-Align option (to ensure registration) and then converting the layers into Smart Object. Once in this Image Stack form it is possible to select one of a range of rendering options from those listed in the Layer > Smart Objects > Stack Mode menu. These options manage how the content of each of the layers will interact with each other.

In the noise reduction technique shown here the Median command creates the composite result by retaining only those image parts that appear (in the same spot) in more than 50% of the frames (layers). As noise tends to be pretty random, its position, color and tone change from one frame to the next and so are removed from the rendered photo, leaving just the good stuff – the picture itself.

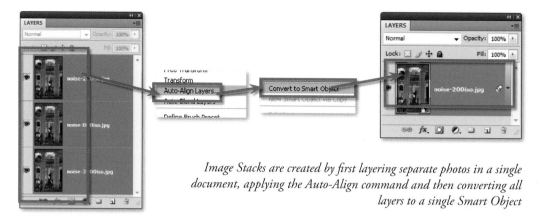

Image Stacks are created by first layering separate photos in a single document, applying the Auto-Align command and then converting all layers to a single Smart Object

In another example of how this technology can be used, in order to remove tourists from in front of your favorite statue there is no need to wait until they have all gone home, instead simply capture multiple pictures of the monument, group them together in an Image Stack and apply the Median function to the group. Hey presto, tourists be gone!

Using Image Stacks to remove noise in Photoshop Extended

1. Reducing noise using this technique is a multi-step affair that starts at the time of capture. If you are confronted with a scene where it is essential that you use either a long exposure or high ISO setting (or both) then you can be pretty sure that your resultant images will contain some noise. So in these circumstances shoot several photos of the same scene. For best results maintain the same camera settings and camera position throughout the whole sequence.
2. Next open all photos into Photoshop and drag each picture onto a single document, creating a multi-layer file containing all the photos in the sequence.
3. Multi-select all the layers and choose the Auto-Align option (Auto Projection) from the Edit menu. Photoshop will arrange all the layers so that the content is registered.
4. With the multiple layers still selected choose Layer > Smart Object > Convert to Smart Object. This places all the layers in a single Smart Object.
5. The last step in the process is to select the Smart Object layer and then choose how you want to render the composite image. Do this by selecting one of the options from the Layer > Smart Object > Stack Mode menu. To reduce noise we choose the Median entry.

Sharpen filters

Photoshop provides a variety of sharpening filters designed to increase the clarity of digital photographs. The options are listed in the Filter > Sharpen menu and include the Sharpen, Sharpen Edges, Sharpen More, Unsharp Mask filters as well as the new Smart Sharpen option. Digital sharpening techniques are based on increasing the contrast between adjacent pixels in

the image. When viewed from a distance, this change makes the picture appear sharper. The Sharpen and Sharpen More filters are designed to apply basic sharpening to the whole of the image and the only difference between the two is that Sharpen More increases the strength of the sharpening effect.

One of the problems with sharpening is that sometimes the effect is detrimental to the image, causing areas of subtle color or tonal change to become coarse and pixelated. These problems are most noticeable in image parts such as skin tones and smoothly graded skies. To help solve this issue, Adobe included the Sharpen Edges filter, which concentrates the sharpening effects on the edges of objects only. Use this filter when you want to stop the effect being applied to smooth image parts.

Customizing your sharpening

Out of all the sharpening options in Photoshop the Smart Sharpen and Unsharp Mask filters provide the greatest control over the sharpening process by giving the user a variety of slider controls that alter the way the effect is applied to their pictures. Both filters contain Amount and Radius controls. The Unsharp Mask filter includes a Threshold slider and the Smart filter contains controls for adjusting sharpness in Shadows and Highlights independently (in Advanced mode) as well as a Removal option for ridding images or specific blur types (Gaussian, Motion or Lens Blur).

Sharpening controls

The **Amount slider** controls the strength of the sharpening effect. Larger numbers will produce more pronounced results, whereas smaller values will create more subtle effects.

The **Radius slider** value determines the number of pixels around the edge that are affected by the sharpening. A low value only sharpens edge pixels. High settings can produce noticeable halo effects around your picture so start with a low value first.

The **Threshold slider** is used to determine how different the pixels must be before they are considered an edge and therefore sharpened.

The **Remove** setting locates and attempts to neutralize different blur types.

The **Shadow and Highlight** tabs contain options for adjusting the sharpening effects in these tonal areas.

Texture filters

The Texture filter group provides a range of ways of adding texture to your photos. Most of the filters apply a single texture type and include controls for varying the strength and style of the effect, but the Texturizer filter adds to these possibilities by allowing users to add textures they create themselves to a photo.

All filters in this group are applied via the Filter Gallery dialog.

The Texturizer filter

When applying the Texturizer filter the picture is changed to give the appearance that the photo has been printed onto the surface of the texture. The Scaling and Relief sliders control the strength and visual dominance of the texture, while the Light Direction menu alters the highlight and shadow areas. Different surface types are available from the Texture drop-down menu. The feature also contains the option to add your own files and have these used as the texture that is applied by the filter to the image.

Making your own textures

Any Photoshop file (.PSD) can be loaded as a new texture via the Load Texture option in the side-arrow menu, top right of the Texturizer dialog. Simply shoot, scan or design a texture image and save as a Photoshop file (.PSD).

Other filters

The filters grouped together under the Other heading include the Custom filter, which is used for creating you own filter effects (see opposite page), the edge-finding High Pass filter, the Offset filter that shifts picture pixels by a set amount, and the Maximum and Minimum filters, which are most often used for modifying masks.

Filters in this group are not applied via the Filter Gallery dialog but rather have their own specific dialog containing both controls and preview.

Sharpening with the High Pass filter

The High Pass filter isolates the edges in a picture and then converts the rest of the picture to mid gray. The filter locates the edge areas by searching for areas of high contrast or color change. The filter can be used to add contrast and sharpening to a photo.

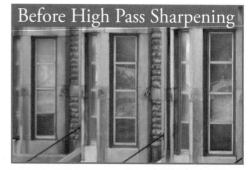

Before High Pass Sharpening

1. To start, make a copy of the picture layer that you want to sharpen, then filter the copied layer with the High Pass filter. Adjust the Radius so that you isolate the edges of the image only against the gray background.

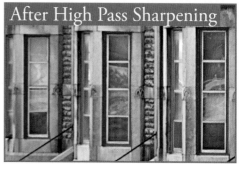

After High Pass Sharpening

2. Next select the filtered layer and switch the blend mode to Hard Light.
3. Finally, adjust the opacity of this layer to govern the level of sharpening being applied to the picture layer.

The ten commandments for filter usage

1. *Subtlety is everything.* The effect should support your image not overpower it.

2. *Try one filter at a time.* Applying multiple filters to an image can be confusing.

3. *View at full size.* Make sure that you view the effect at full size (100%) when deciding on filter settings.

4. *Filter a channel.* For a change try applying a filter to one channel only – Red, Green or Blue.

5. *Print to check effect.* If the image is to be viewed as a print, double-check the effect when printed before making final decisions about filter variables.

6. *Fade strong effects.* If the effect is too strong try fading it. Use the 'Fade' selection under the 'Filter' menu.

7. *Experiment.* Try a range of settings before making your final selection.

8. *Mask then filter.* Apply a gradient mask to an image and then use the filter. In this way you can control what parts of the image are affected.

9. *Try different effects on different layers.* If you want to combine the effects of different filters try copying the base image to different layers and applying a different filter to each. Combine effects by adjusting the opacity of each layer.

10. *Did I say that subtlety is everything?*

Filter DIY

Can't find exactly what you are looking for in the hundreds of filters that are either supplied with Photoshop or are available for download from the Net? I could say that you're not really trying, but then again some people have a compulsion to 'do it for themselves'. Well, all is not lost. Photoshop provides you with the opportunity to create your own filtration effects by using its Filter > Other > Custom option.

By adding a sequence of positive/negative numbers into the 25 variable boxes provided you can construct your own filter effect. Add to this the options of playing with the 'Scale' and 'Offset' of the results and I can guarantee hours of fun. Best of all your labors can be saved to use again when your specialist customized touch is needed.

Chris Neylon

retouching projects

photoshop photoshop photoshop photoshop photoshop photoshop phot

Mark Galer

essential skills

- Develop skills using layers, adjustment layers, channels and layer masks.
- Retouch and enhance images using the following techniques and tools:
 - Lens Correction Filter and Warp
 - Adjustment layers and layer masks
 - Target tones
 - Healing Brush, Clone Stamp Tool and Stamp Tool
 - Shadow/Highlight adjustment
 - High Pass, Unsharp Mask and Smart Sharpen.

Adjustment layers – Project 1

Image adjustments can be applied directly to the image from the Image menu or as non-destructive adjustment layers from the Layers panel. The advantage of using adjustment layers is that they can be re-edited an infinite number of times without causing any degradation to the image data and the adjustments can be applied to localized areas rather than globally by masking their effects using the adjustment layer mask that is attached to every adjustment layer. This project takes a look at the major adjustment layers used most frequently by photographers.

The Yarra river from the Princes bridge, Melbourne

Many of the adjustments applied in this project can also be applied in Adobe Camera Raw. If the adjustments are made in the main editing space of CS4 then it is essential to apply these adjustments non-destructively using adjustment layers to retain maximum quality of the final outcome. Many of the adjustments made to optimize or enhance an image are relatively subjective (no two people would use exactly the same settings in each of the adjustments – in fact, the same person may create different versions from the same image file depending on their mood or creative objectives on any particular day). The famous photographer Ansel Adams often compared photography with music. He likened the original film negative to the sheet of music and the print created from the negative in the darkroom to the musical performance from the sheet music. The digital file has now replaced the film negative and Photoshop is now the digital darkroom. The essential skills to master are to be able to previsualize the final outcome and be able to exercise control over Photoshop's tools to be able to realize this outcome.

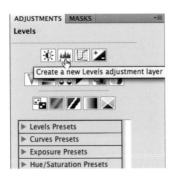
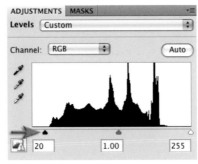

1. Open the R1 support image (R1_Adjustment_Layers.tif) from the DVD and open the Adjustments panel. Click on the 'Create a new Levels adjustment layer' icon. The Levels adjustment feature will allow us to optimize the dynamic range of the image to ensure the image uses the full tonal range between black and white. The graph that appears in the Levels dialog box is called a histogram and is an indication of how many pixels there are at each level of brightness in this image. Level 0 on the left is absolute black and level 255 on the right is absolute white. The three sliders directly underneath the histogram (from left to right) are called the Input Shadow slider, the Gamma slider and the Input Highlight slider. The image you have opened has not been optimized in Adobe Camera Raw; the Input Shadow slider needs to be adjusted in order to expand the contrast.

Note > It is recommended that you go to Preferences > Interface and uncheck the Auto Collapse Iconic Panels checkbox in the Panels & Documents section of the dialog so that the Adjustments panel always stays open during the following steps.

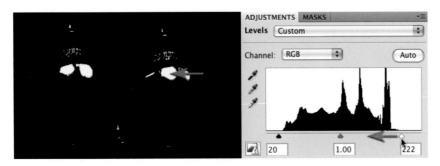

The Shadow and Highlight sliders need to be moved a precise distance to give the best possible result. The goal is to expand the contrast without losing any detail in either the shadows or the highlights. A loss of detail is called 'clipping' and should be avoided if possible. Hold down the Alt key (PC) or Option key (Mac) and drag the Highlight slider slowly to the left. The image window will momentarily appear black (this is called a Threshold view). As you drag the slider underneath the start of the histogram you will notice more and more white areas appearing in the image (this is an indication of when clipping is occurring). Still holding down the Alt/Option key move the slider back to the right until there are no large patches of white remaining (the street lights should not have any large areas of clipping). Some minor clipping is inevitable when the light source is reflected off any shiny surfaces in the image (these are called specular highlights). The highlight slider can only be moved one or two levels in this image before clipping occurs.

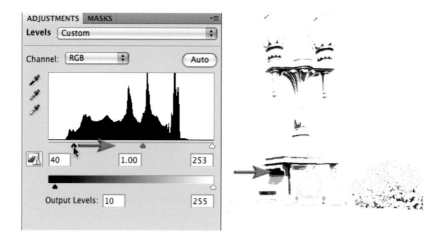

Repeat the process in the previous step using the Shadow slider. When holding down the Alt/ Option key move the slider until only thin lines appear in the image window. Any large areas of clipping should be avoided unless there is an absence of a surface in the image, e.g. the entrance to a cave or an open door to an unlit room. The Gamma slider underneath the center of the histogram can be moved to the left or the right to lighten or darken the image. We will, however, perform this adjustment using an alternative adjustment feature.

Note > If the major clipping is evident before the sliders are moved this is an indication that the original image was either underexposed or overexposed in the camera. This is not something that can be corrected in Photoshop unless another image with a different exposure was also captured (see HDR).

$2.$ Click on the arrow in the bottom left-hand corner of the panel to return to the adjustment list and then select Brightness/Contrast. This adjustment feature was seldom used by professional photographers prior to the release of Photoshop CS3 due to its destructive nature (without great care shadow and/or highlight detail quickly became clipped). In the dialog box make sure the legacy box is NOT checked to avoid the old destructive behavior of this adjustment feature. Raise both the Brightness and Contrast sliders until the required tonality is achieved. Unlike the Levels adjustment this is a fairly subjective adjustment so there are no specific settings that should be used.

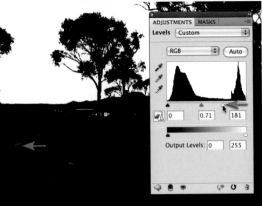

Localized levels

Sometimes when the levels are optimized for the entire image a portion of the image still appears flat. A close examination of the image used in this illustration (also on the DVD) will reveal that the range of levels on the right of the histogram belong only to the sky. None of the highlights in the foreground have been rendered higher than level 200, even after the Highlight slider has been adjusted. Greater contrast can be achieved if the user ignores the sky when setting the Highlight levels slider and then masks the sky later by painting into the layer mask to restore the tonality to this area of the image (preventing the highlights in the sky from becoming clipped by the adjustment). In this example a black/white gradient has been applied to the upper portion of the layer mask.

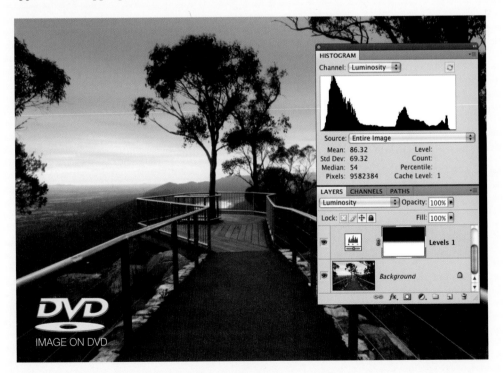

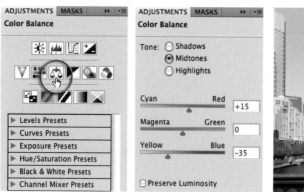

3. From the Adjustments panel select a Color Balance adjustment. The Color Balance dialog box allows color adjustments based around the primary and secondary colors. Theoretically it should be possible to achieve any color correction using just two of the three sliders. The image currently has a blue/cyan color cast so the top Cyan/Red slider needs to be moved to the right and the bottom Yellow/Blue slider needs to be moved to the left.

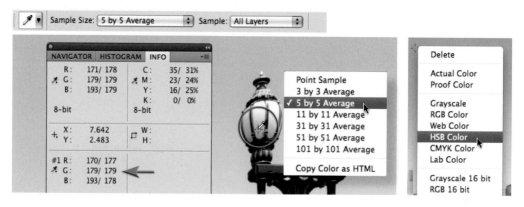

Quick and accurate color corrections can be difficult to achieve for newcomers to digital image editing without some guidance from the Info panel. The user should attempt to identify a tone in the image that should appear gray (where the levels in the Red, Green and Blue channels are mixed in equal proportions). Move the mouse cursor into the image window and position the eyedropper over the shaded white areas of the street lamps. Observe the RGB readings in the Info panel. Right-click with your mouse to set the eyedropper to a '5 by 5 Average' so that you obtain a representative sample rather than the value of a single pixel. The information in the Info panel should now guide you as to which sliders to move, and in which direction, e.g. if the Red reading is lower than the other two readings move the slider in the Color Balance panel towards Red to increase its value. Hold down the Shift key and the Alt/Option key and click to set a color sampler target. Move the sliders until all three numbers are equal. Select OK when you are happy with the Color Balance.

Note > The readout of a color sample in the Info panel can be changed by first selecting the Color Sampler Tool and then right-clicking on the color sample target to reveal the context menu. Changing the readout to HSB will help in assessing Brightness values.

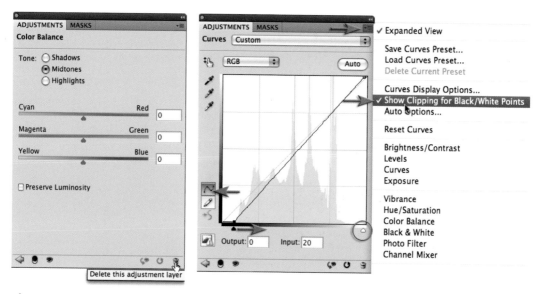

4. Perhaps the most powerful of all of the other adjustment features is Curves. To demonstrate this control we will delete all three adjustments by either clicking three times on the trash can in the bottom right-hand corner of the Adjustments panel or by dragging the three adjustment layers to the trash can in the Layers panel. Select a Curves adjustment from the Adjustments panel. The diagonal line appears above a histogram. There is an adjustment point in the bottom left-hand corner and another in the top right-hand corner of the histogram window (equivalent to the Shadow and Highlight sliders in the Levels dialog box). The power of Curves comes in the ability to add additional points by clicking anywhere along the line to control specific areas of the histogram (we are not limited to just three sliders as with levels). Select the Show Clipping for Black/White Points option from the panel menu and then set the black and white points using the sliders underneath the histogram (alternatively you can hold down the Alt/Option key as you drag the black or white input sliders underneath the histogram to preview clipping). This adjustment sets the dynamic range of the image in the same way that we performed the task using the Levels dialog box in Step 1.

5. Click on the diagonal line about three-quarters of the way towards the top and drag the adjustment point higher in the window to brighten the highlights of the image. Now click halfway along the line and modify the midtone values with the image. Click one-quarter of the way along the line and drag the adjustment point to modify the shadow tones within the image. As the line gets steeper in the middle of the histogram the contrast of the image will increase. This performs the same task as the Brightness/Contrast adjustment but with a greater degree of control.

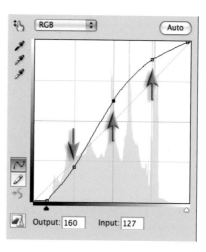

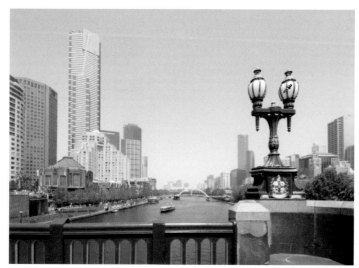
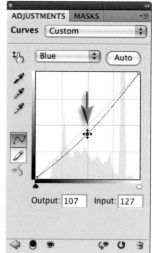

6. We can color correct the image in Curves in two different ways. We can use the individual channels in the Curves dialog box to balance the numbers. Select the Blue channel from the Channel menu in the Curves dialog box and then click to place an adjustment point halfway along the curve. Drag the adjustment point down to reduce the blue, observing the channel information in the Info panel. Repeat the process using the Red channel but this time raise the curve to increase the red values. The second alternative offers a more automated approach.

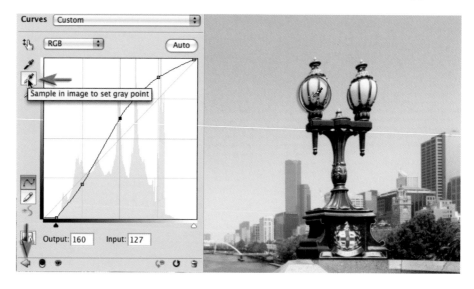

The quick alternative for color correction is to click on the center eyedropper on the side of the histogram window. If you leave the cursor over this icon momentarily you will see the advice 'Sample in image to set gray point'. Move your mouse cursor out into the image window and locate the Color Sample target you created in Step 3. Click on this target to color balance your image. If you use the eyedropper tool and look in the Info palette you will see the point you clicked to set the gray point now has equal RGB values. Click on the arrow in the bottom left-hand corner of the panel to return to the adjustments list.

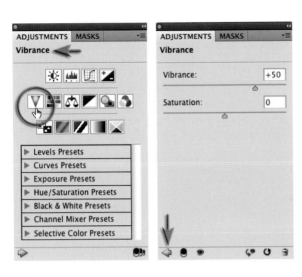

7. We have adjusted the hue and brightness of the pixels in this image but we have not yet had any control over the vibrance or saturation of the colors. An overall increase in saturation has occurred since we started editing this image due to the fact that we have increased the contrast (saturation increases as contrast increases). We need to add a Vibrance adjustment in order to have precise control over this element of the corrective process. Move the Vibrance slider (less destructive than the Saturation slider) until the colors appear richer but realistic (a subjective decision). As the saturation increases the image appears to be sunnier. Click on the arrow in the bottom left-hand corner of the panel to return to the adjustments list.

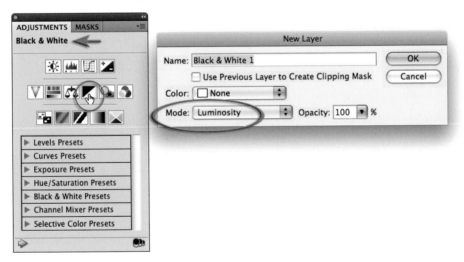

8. We are now going to look at how we can make some localized adjustments that target a single color or affect just a selected area of the image. The first localized adjustment will make the blue sky darker. Hold down the Alt/Option key and from the adjustments list choose Black & White. In the New Layer dialog box that opens (a result of holding down the Alt/ Option key) select Luminosity as the mode. A Black & White adjustment in Luminosity mode will allow us to adjust the luminance or brightness values of each color without affecting the saturation or vibrance of the color.

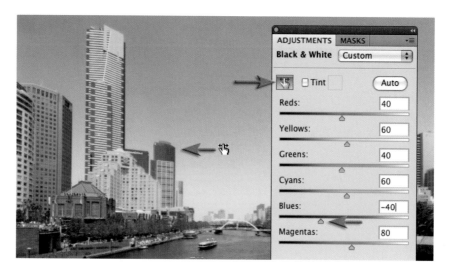

9. Click on the scrubby slider icon in the Black & White panel and move the cursor into the image window. Click low in the sky and drag in the image to modify the blues (clicking higher in the sky will target the Cyans). Dragging left will darken the color. When darkening Blues or Cyans using this technique it is recommended to proceed with caution as image artifacts may appear (noise and banding) with aggressive adjustments. These artifacts will be slightly less problematic when editing a 16 Bits/Channel image.

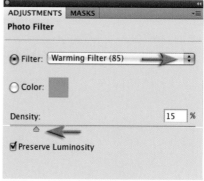

10. The color corrections that were carried out in Steps 3 and 6 render neutral colors completely neutral. It is sometimes a requirement that colors are not neutral at all, but rendered cool or warm depending on the mood that is required, e.g. the cool tones of winter or the warm tones of summer. With this in mind Photoshop gives us another way of adjusting the color of our images. The adjustment feature called Photo Filter has less control than Curves, or even Color Balance, but it has similarities with the way some photographers have traditionally used filters to adjust color at the time of capture. A warming or cooling filter can be selected (the numbers refer to glass filter equivalents that were attached directly to the camera lens) and the strength of the effect is controlled by the Density slider. To give this image a late afternoon feel (the image was actually captured just before noon) select an 85 Warming filter and set the density to 15%. Click on the arrow in the bottom left-hand corner of the panel to return to the adjustments list.

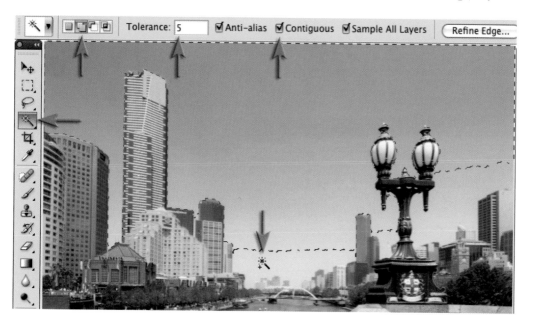

11. The effects of the Photo Filter are, at the moment, global but the warming effect of this adjustment can be removed from the sky by masking the adjustment in this area. To remove the effect from the sky we could simply paint over the sky with the Brush Tool with black as the foreground color or make a selection and fill it with black (when an adjustment layer is active, painting with black will mask an adjustment and not paint with black pixels that are visible). Make a selection of the sky using the Magic Wand Tool. Click in the upper portion of the sky using the default Tolerance of 32 in the Options bar. Select the 'Add to selection' icon in the Options bar and lower the Tolerance below 10 to select the sky close to the horizon line (edges with lower contrast require a lower Tolerance setting). If the selection invades the buildings choose Undo from the Edit menu, lower the Tolerance and try again.

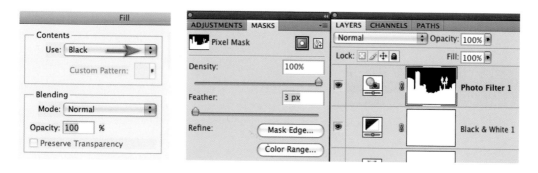

12. With the active selection go to the Edit menu and choose 'Fill'. In the Fill dialog box choose Black from the Use menu. Select OK to fill the selection with black. Note how the layer mask in the Layers panel and Mask panel indicates which parts of the image are being shielded from the adjustment. In Photoshop CS4 we can now reduce the Density of the mask to allow some of the adjustment to feed through to the masked area.

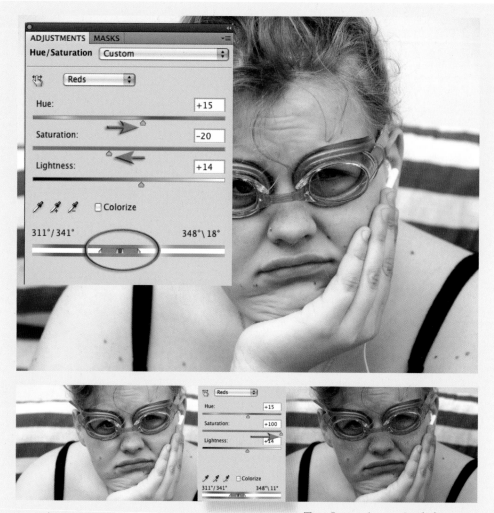

Tina Lorien (www.iStockphoto.com)

Adjusting narrow ranges of color

The Hue/Saturation adjustment can target a very narrow range of color values and then adjust them to match other colors within the image. In the example above the sunburn is targeted and then matched with the surrounding skin colors. To achieve this level of control the user must first select the broad color range that the color belongs to from the Edit menu inside the Hue/Saturation panel, e.g. reds, yellows, greens, cyans, etc. By clicking and dragging the sliders that sit between the two color ramps (at the base of the dialog box) closer together, or by using the 'Add to Sample' or 'Subtract from Sample' eyedroppers, the precise colors can be targeted. Moving the Saturation slider temporarily to −100 or +100 can help determine when the target colors have been isolated from their neighboring colors of a similar hue. When this has been achieved the Saturation slider is returned to 0 before moving the Hue slider to achieve the required match. Some fine-tuning using the Saturation and Lightness sliders will usually be required before the match is perfect.

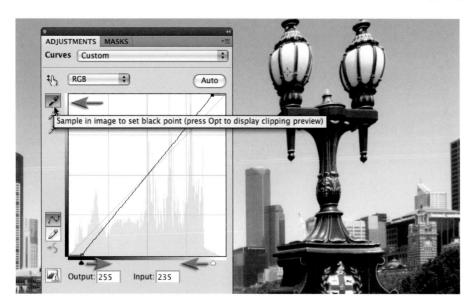

13. In order to optimize the image for print it is useful to assign two more color sample targets to the image. From the adjustments list choose Curves to place a new adjustment layer at the top of the layer stack (CS4 allows us to drag a new adjustment layer to a different position in the layers stack without exiting the adjustment dialog – one aspect of the new non-modal behavior). Drag the black and white sliders under the histogram in slightly (to a point where clipping is visible). Click on the 'Sample in image to set black point' icon in the Curves panel.

14. Drag the Info panel out into the main working space in order to prevent the Adjustments panel from closing each time we set a color sample target. Hold down the Alt/Option key as you move your cursor into the image window to observe where the shadows are clipping. In addition to the Alt/Option hold down the Shift key to activate the color sample eyedropper. Click on one of the shadows to set a target in the Info panel.

15. Click on the 'Sample in image to set white point' icon in the Curves panel, move into the image window, hold down the Alt/Option and Shift keys and click on a clipped highlight to set another color sample in the Info panel. Now that you have located and sampled the darkest shadow tones and the brightest highlights with detail in the image you can reset the curves to the adjustment defaults, i.e. cancel the current changes. This will now put you in a position where you can use this curves adjustment to optimize the shadows and highlights for printing using the information from the Info panel.

16. Take a look at the RGB numbers of the shadow and highlight color sample targets in the Info panel and consider whether these will be suitable for your intended output device. If the highlights are too bright or the shadows are too dark then they will not print with detail. In the example above the black point is selected in the Curves panel (level 0) and the output value is raised to level 10. This can be achieved by typing 10 in the Output field or dragging the black point higher on the curve. The color sample levels in the Info panel now reflect these changes, with a reading of approximately level 15 for the #2 color sample target. A similar step can be taken to preserve highlight detail (lowering the brightness of the highlights) if required. This procedure lowers the contrast to ensure highlights and shadows print with full detail. The visibility of this final adjustment can be switched off when the image is being viewed on screen. Rename the layer 'printer targets' (double-click the layer name in the Layers panel) for future reference.

Correcting perspective – Project 2

Many photographers prematurely jump to the conclusion that Photoshop is solely a tool for distorting reality or fabricating an alternative reality (the expression 'it's been photoshopped' still has negative connotations for some photographers). Although this may be the case in some instances Photoshop can, however, be used as a tool to correct the distortions introduced by the camera and lens and return an image back to how we remember the original subject or location, rather than how the camera interpreted it.

The Shrine of Remembrance, Melbourne – Nikon D200, Nikkor 12–24 mm 1:4 G ED @ 12 mm

Wide-angle lenses are an essential tool for the commercial photographer but they can introduce an unnatural and unnerving sense of perspective. In the natural landscape this exaggerated perspective may go unnoticed but when the photographer is in the urban environment and the photographer has to tilt the camera up in order to frame the shot, the verticals will lean inwards – sometimes to an alarming extent. Architectural photographers may go into this environment equipped with specialized equipment such as shift lenses and large-format cameras (some even take their own ladders). This specialized equipment allows the photographer to frame the view they need without tilting the camera from the horizontal axis. There is, however, a post-production answer that allows the photographer to create a more natural sense of perspective. This first project focuses its attention on correcting rather than distorting images and will look at perspective correction and chromatic aberration (the misalignment of colors commonly found in the corners of an image).

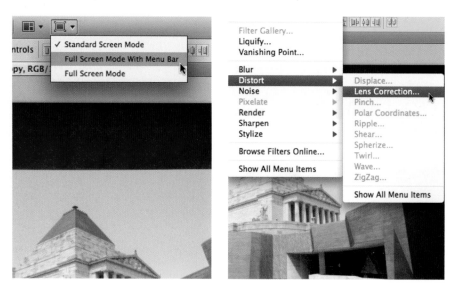

1. Open the project image from the supporting DVD (R2_Correcting_Perspective.tif). Start the process by selecting an appropriate screen mode in the Options bar. Choosing the 'Full Screen Mode With Menu Bar' option will allow you to reposition the image anywhere on your screen by holding down the Spacebar and dragging the image. This will be useful as we access the edges and corners of the image. To create a backup layer, drag the Background layer in the Layers panel to the New Layer icon at the base of the panel to duplicate it (alternatively you can use the keyboard shortcut Ctrl + J (PC) or Command + J (Mac)). Select Filter > Distort > Lens Correction to open the Lens Correction dialog box.

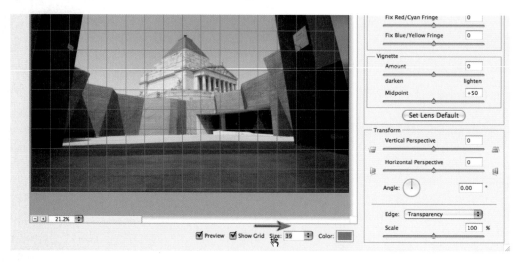

2. At the base of the Lens Correction dialog box make sure the Show Grid option is checked. Move your mouse cursor over the word 'Size' to the right of this checkbox. You should notice two arrows appear from the hand icon that indicate you can change the value in the field to the right (this tool for changing values in any numerical field is called a scrubby slider). If you now click and drag to the right the size of the grid will increase. Set the value to around 40.

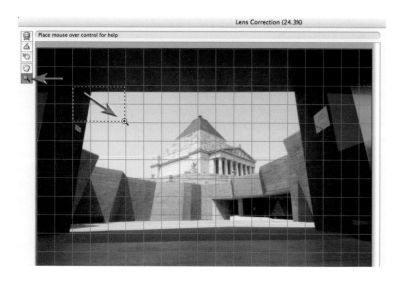

3. To check for chromatic aberration (color fringing as a result of misalignment of color channels) we will need to zoom in to 100% or 200% and view the edge detail in the corners of the image. Click on the Zoom Tool in the upper left-hand corner of the dialog box or use the keyboard shortcut Ctrl + Spacebar (PC) or Command + Spacebar (Mac) to access the Zoom Tool and then click and drag to target a zoom area in the upper left-hand corner of the image (where the dominant vertical line meets the dominant horizontal line). Click on the tab to the right of the magnification size (underneath the image in the Lens Correction dialog box) and select 200% from the menu of sizes. This will ensure that we get an accurate view of any chromatic aberration present in this image.

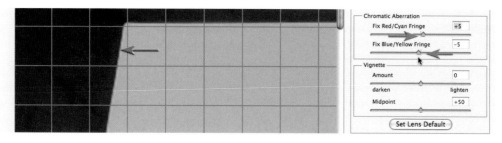

4. The chromatic aberration, if present, can be seen as a fringe running alongside the edges of lines within the corners of the image. The amount of aberration visible depends on the camera and lens used to capture the image and also, to a large extent, on the size of the reproduction of the image. By slowly moving the Red/Cyan Fringe and Blue/Yellow Fringe sliders it should be possible to greatly reduce the width of the color fringing, if not eliminate it altogether.

Note > As well as chromatic aberration some lenses will produce noticeable darkening in the corners (especially at wide apertures). These overly dark corners can be removed using the Vignette slider. The Set Lens Default option is able to record these settings and apply them to subsequent images taken with the same lens. This feature is most useful where the chromatic aberration and vignetting do not vary as a result of zooming to a different focal length or by using a different aperture.

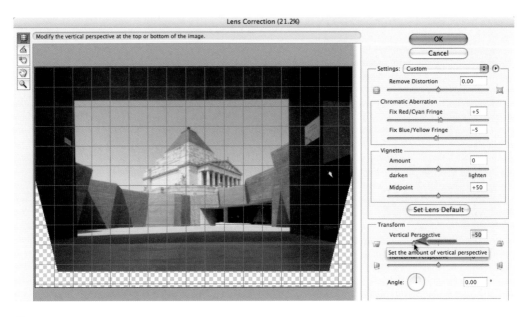

5. Now that the chromatic aberration is under control we can move on to the Transform section of the dialog box. Zoom out or select Fit in View. The controls found in this section are not recorded as part of the Lens Default Setting, as the corrections required are variable for each image depending on the angle of the camera to the subject matter. In this image the Vertical Perspective slider is moved to the left (between −45 and −50) so that the verticals align with the grid lines that overlay this image. With a numerical field highlighted you can use the up or down keyboard arrow keys to nudge a precise adjustment. Hold down the Shift key as you press an arrow key to increase or decrease the value in units of 10.

Note > There is a limit to the amount of correction that can be undertaken before some shapes within the subject become misshapen. Where the converging verticals are very pronounced it is sometimes only possible to reduce the distortion rather than remove the converging verticals altogether. It is worth remembering that verticals converge even when using standard focal length lenses.

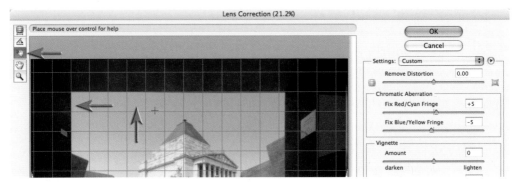

6. For an accurate assessment of the degree of correction you should click the Move Grid Tool and click and drag the grid so that it aligns with edges within the image that are meant to be vertical and horizontal.

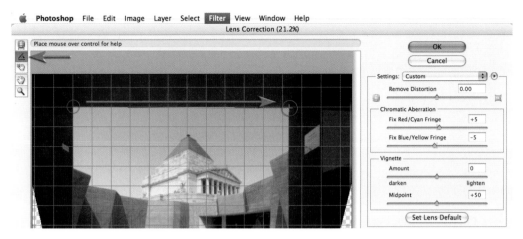

7. Use the Straighten Tool if the image appears slightly crooked when compared to the grid lines. Click on the tool in the upper left-hand corner of the dialog box and then click and drag along either a vertical or horizontal line. Let go of the mouse clicker when you get to the other end of the straight line to automatically straighten the image.

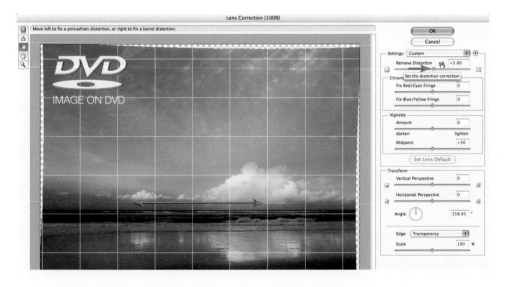

Pincushion distortion and barrel distortion

If the vertical or horizontal lines with the image appear to be curved rather than straight this is an indication that either 'barrel distortion' or 'pincushion distortion' is present within the image as a result of the lens that has been used. The slider to correct this distortion appears at the top of the control panel but is sometimes best implemented after the image has first been straightened and the vertical perspective corrected. The image used in the illustration above is a typical example where the horizon line curves excessively. After first straightening the image a small amount of barrel distortion is corrected. Pincushion distortion can be found in some images where a long telephoto lens has been used to capture the image. The image used in this illustration can also be found on the supporting DVD.

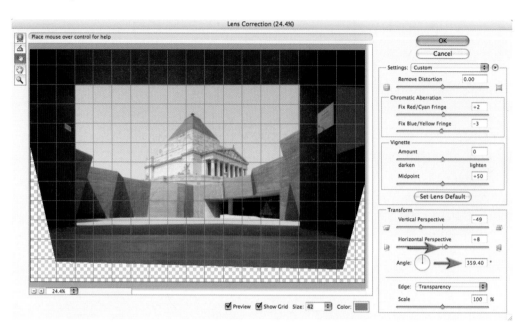

8. As a result of being slightly off-center when photographed it will be impossible to align both the horizontals and verticals that frame the sky without one further adjustment. Moving the Horizontal Perspective slider slightly to the right will ensure this entrance aligns to the grid lines. You may need to revisit some of the sliders a second time to perfect the alignment.

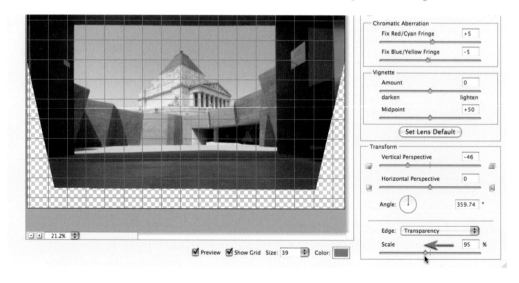

9. Scale the image down slightly using the slider in the bottom right-hand corner of the dialog box if quality rather than pixel quantity is the priority. The large correction required in this project will lead to a softening of image detail unless the scale is reduced to approximately 95%. As this is a 10-megapixel image there should be enough pixels (even at the reduced scale) to meet the final image requirements. Select OK to apply the changes and pass the corrected image back to the main Photoshop workspace.

10. After the Lens Correction filter has been applied it is still possible to fine-tune the correction in Photoshop's main workspace. Choose 'Rulers' from the View menu and then use the keyboard shortcut Ctrl + T (PC) or Command + T (Mac) to access the Free Transform command. Some images appear squashed after perspective correction so dragging the center handle of the transform bounding box either up or down can restore a more natural appearance to the image. The Transform command can correct lines that were not possible using the Lens Correction filter.

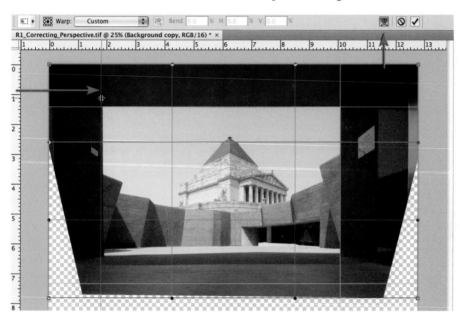

Click and drag a guide from the vertical rule to each side of the entrance. Click on the top rule and drag in a guide to the top of the entrance. Drag a fourth guide to the lower portion of the image and align it with either end of the horizontal line on the concrete slab. You will notice how these lines in the lower portion of the image appear curved, even though the horizontal line in the top portion of the image appears comparatively straight. This is not something that the barrel distortion slider in the Lens Correction filter could compensate for (the uneven distortion is due to the fact that the horizontal lines near the base of the image are closer to the camera lens than the horizontal lines in the upper portion of the image, and have therefore been subject to a greater degree of barrel distortion). Click on the Warp icon in the Options bar and then move your mouse cursor over one of the curved lines in the central lower portion of the image. Click and drag gently upwards until the curved lines align with the guide you dragged into the image. Hit the Return/Enter key to accept the warp when everything is aligned. You can either hide or delete the guides by going to View > Show > Guides or View > Clear Guides.

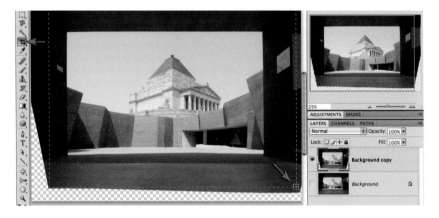

11. Switch off the visibility of the background layer so that you can see the part of the image that is now surplus to requirements. Select the Crop Tool and drag a cropping marquee around the picture area to be retained. Enter the crop dimensions and resolution in the Options bar if you are already aware of the final image requirements. Hit the Enter/Return key to apply the crop.

Move your cursor over the background layer and then right-click (PC) or Command-click (Mac) on the layer to open the context-sensitive menu. This menu will give you the option to flatten the image if you are now happy with the corrections. Select OK if you are presented with a warning dialog box asking you whether you want to discard the hidden layers.

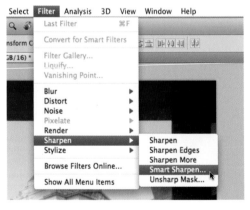

12. To complete the project we need to sharpen this image as it has not been sharpened in-camera or in ACR (Adobe Camera Raw). This sharpening is considered to be part of a normal corrective process that must be performed either in-camera or in post-production to all images. The Smart Sharpen filter and the Unsharp Mask filter offer greater control than sharpening in either the camera or in ACR. Since CS3 we are now able to apply filters non-destructively by first converting the layer for Smart Filters (Filter > Convert for Smart Filters). After converting the layer for Smart Filters (the layer is now known as a Smart Object) choose Filter > Sharpen > Smart Sharpen. We can use any filter on a Smart Object, not just the ones that have smart in their name.

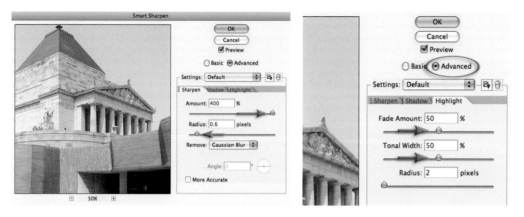

13. Images appear sharper when the contrast is raised at the edges within the image. In the Smart Sharpen dialog box we can control the amount of contrast by raising the Amount slider. Choose a generous amount of between 100% and 500%. The width either side of the edge where contrast is raised is controlled by the Radius slider. Choose a setting lower than 1.5 pixels. You should see a good overall improvement in sharpness using these settings. There is one unpleasant artifact that you may notice as a result of this sharpening process. If you click in the main image window where the roof of the war memorial meets the sky you may notice a halo appears at the edge. This halo can be reduced by clicking on the Advanced radio button and then clicking on the Highlight tab. Increase the Fade Amount and Tonal Width sliders to 50% to reduce the halo significantly. Click OK to apply these settings.

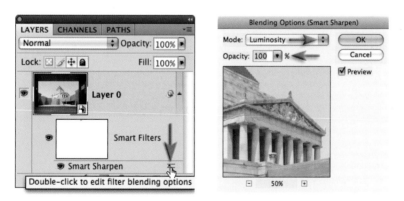

14. Double-click on the name of the filter in the Layers panel to reopen the Smart Sharpen dialog box to modify the settings if required. Double-click on the Blending Options icon to the right of the filter name to open the Blending Options dialog box. Change the mode to Luminosity in order to reduce the risk of any additional color fringing as a result of the sharpening process (saturation is a by-product of contrast) and lower the opacity of the filter if required. Lowering the opacity will reduce the effect of the filter but give you the flexibility to optimize the amount of sharpening for different paper surfaces. Matte paper may require an increase in the filter opacity while outputting to glossy paper may require the opacity to be lowered further.

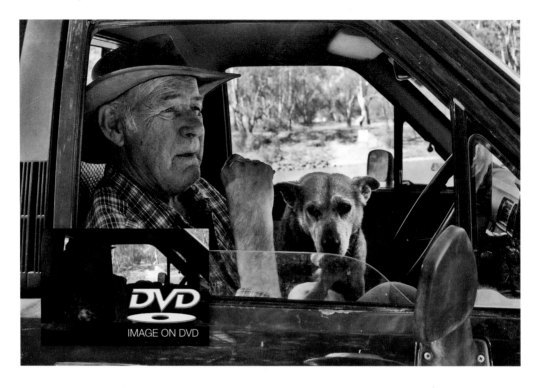

IMAGE ON DVD

Shadow/Highlight – Project 3

The Shadow/Highlight adjustment feature is one of the most useful and powerful of all the adjustment features, but it has never been available as an adjustment layer. The adjustment can, however, be applied as a Smart Filter (even though the adjustment does not live in the Filter menu). The strength of this adjustment feature lies in its ability to quickly, and gently, render shadow tones that are too dark to print lighter. The adjustment feature can also rescue shadows or highlights while adding localized contrast to these tonal regions. The Curves adjustment feature is unable to compete with the Shadow/Highlight's ability to inject localized contrast into the modified tonal areas. For shadow recovery this adjustment feature is a little like a post-production version of fill flash.

This project uses an image where the shadow tones have been greatly underexposed in-camera (in order to preserve the highlight tones outside of the car window). Although the final quality of these rescued shadow tones will never be as good as if the exposure had been raised in-camera, the project does illustrate the usefulness of this adjustment feature, especially where the photographer is unwilling or unable to add additional lighting to the image at the time of capture. When opening up shadow tones to this extent the photographer needs to be aware of possible problems with noise and/or tonal banding (steps of tone rather than smooth transitions). This project will also explore the use of localized color corrections and localized tonal corrections using a 'Dodge and Burn' layer (instead of using the Dodge and Burn Tools from the Tools panel directly to an image layer). The project will utilize adjustment layers and Smart Filters (avoiding working on the pixels themselves) to achieve the goal of editing non-destructively.

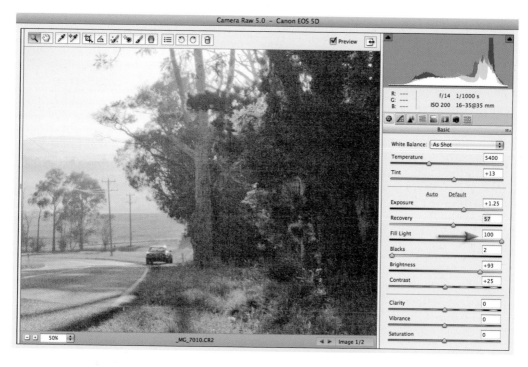

Underexposure – the Achilles heel of digital exposure

Shadows in digital images contain low-quality data and the shadows of most digital images cannot be rescued to the extent seen in this project (an image captured at 100 ISO on a Sony CCD sensor). Shadows information will tend to be superior if the image is captured at low ISO on a large 14- or 16-bit image sensor. The illustration above shows the poor quality of underexposed shadow information captured on a full frame 35 mm CMOS sensor at 200 ISO.

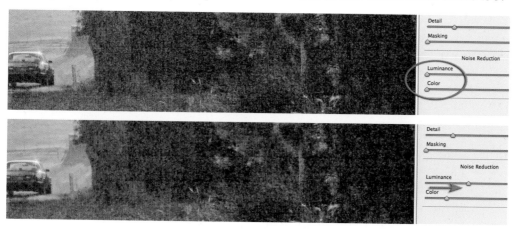

In Adobe Camera Raw the noise can be reduced by raising the Color and Luminance Noise Reduction sliders. The effects of these sliders in ACR can only be viewed at magnifications of 100% and above. Ideally the photographer should raise the exposure at the time of capture to avoid underexposure (see Adobe Camera Raw) or capture multiple exposures (see HDR).

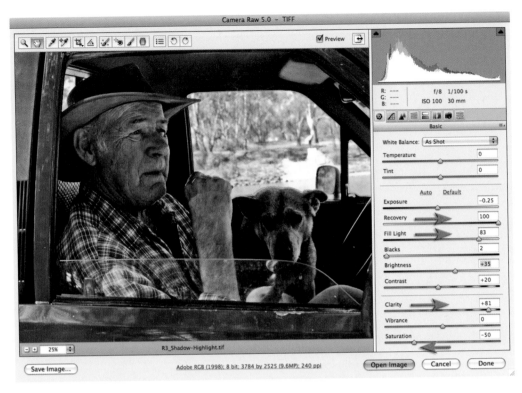

Quick adjustments using Adobe Camera Raw

Adobe Camera Raw can offer fast and convenient control over tones that need adjustment, without the need for extended editing procedures in the main editing space. Using the Fill Light and Recovery sliders in Adobe Camera Raw the user can lighten the deep shadows and recover the bright highlight tones in this image. Localized contrast can be increased using the Clarity slider and finally the excessive saturation that results from these adjustments is put back in check by lowering the Saturation slider. The convenience and speed, however, come at a price – quality and control. Give this technique a go using the R3-Shadows.DNG file on the supporting DVD.

The example on the left is a close-up view (the top of the dog's head) taken from the image edited in Adobe Camera Raw (ACR). Notice the dark line surrounding the window frame and the top of the fur – an artifact from the aggressive editing procedure in ACR. On the right is the same image edited in the main editing space using the Shadow/Highlight adjustment.

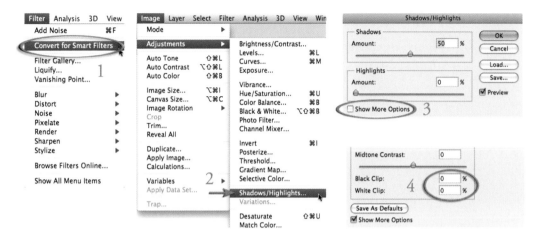

1. Open the R3-Shadows.tif file from the supporting DVD. To prepare the image for the Shadow/Highlight adjustment we need to convert the background layer for Smart Filters (Filter > Convert for Smart Filters) and then select Shadows/Highlights from Image > Adjustments > Shadows/Highlights. When the Shadows/Highlights dialog box opens check the 'Show More Options' box to expand the dialog box. Enter 0 in the Black Clip and White Clip fields at the base of the dialog box so that the white and black points are left untouched. The Levels of the project image have already been set, i.e. black and white points have already been set for this image.

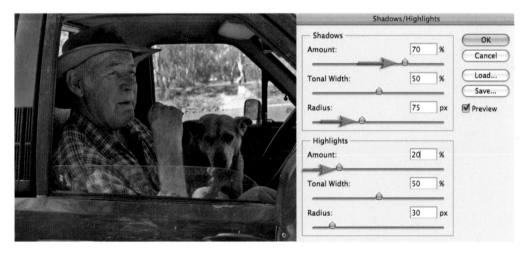

2. Raise the Amount slider in the Shadows section of the dialog box to around 70% to lighten the shadows. Leave the Tonal Width slider at 50% so that any tones darker than level 128 will come under the influence of the Amount slider above. The Radius slider controls the localized contrast in these shadows. If this slider is moved to the left or right you should notice how the contrast or lighting in these shadows appears to change. The precise value for this slider is very subjective and is determined only by the appearance of the shadow tones. In this project the Radius slider is raised to create the best appearance in the skin tones on the man's face. In the Highlights section of the dialog box the Amount slider is raised to lower the brightness of the tones outside the window. Beware of haloes surrounding the dark tones when using this adjustment.

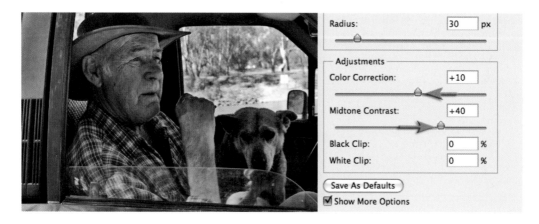

3. Additional contrast can be introduced into the shadow tones by raising the Midtone Contrast slider in the Adjustments section of the dialog box. The Amount slider in the Shadows section of the dialog box should then be raised to +90% to compensate for the tones being rendered darker. As the contrast increases in these midtones the Color Correction slider should be reduced to +10 in order to protect the midtones from excessive saturation. Select OK to apply these Shadow/Highlight changes.

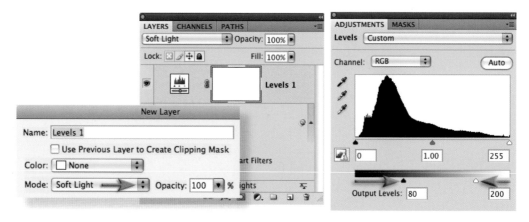

4. Blending modes can also be used to increase contrast. Hold down the Alt/Option key as you select a Levels adjustment layer from the Adjustments panel. Set the mode of this adjustment layer to Soft Light in the new layer dialog and select OK. The increased contrast is a result of the blend mode and not any changes you have made in the adjustment layer dialog box. To restrict the increase in contrast to just the midtones drag both of the output sliders in the Levels dialog towards the center of the gray ramp. In this project I have used the output values of 80 and 200 but the precise values have to be fine-tuned for each image you apply this technique to. Change the blend mode of this adjustment layer to Overlay to increase the contrast even further.

Note > Holding down the Option/Alt key as you select a new adjustment layer will open the New Layer dialog box. This dialog box will allow you to set the blend mode of the adjustment layer before the adjustment layer becomes active.

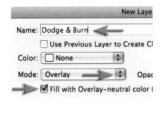
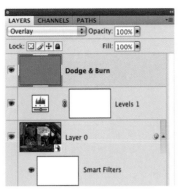

5. Blend modes can be utilized to modify the tonality of the image in other ways. The Dodge and Burn Tools in the Tools panel cannot be used on a layer that has been converted for Smart Filters. Instead of using these tools we can create a non-destructive Dodge and Burn layer. Hold down the Option/Alt key and click on the New Layer icon. In the New Layer dialog box choose Overlay as the mode and check the 'Fill with Overlay-neutral color (50% gray)' checkbox. Continue the practice of naming the layers, e.g. 'Dodge & Burn' instead of the default 'Layer 1' (this will help us remember what each of the layers is contributing to the final appearance of the image). Select OK to create the new layer. 50% gray in Overlay mode has no effect on the underlying pixels (pixels on this layer are effectively invisible when 50% gray). It is only when you lighten or darken pixels on this layer that you will be able to see any difference to the underlying pixels. Select the Brush Tool from the Tools panel and White as the foreground color. Choose a soft-edged brush with an Opacity of 20% from the Options bar. Paint any dark areas that need to be made lighter. Paint over the dog several times until the lightness is balanced with the rest of the image.

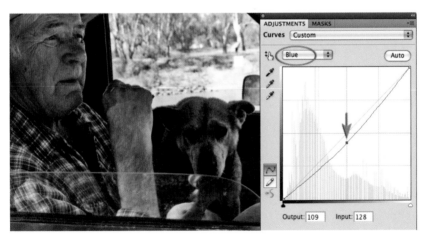

6. Although the dog is now lighter in tones the color will need correcting in this region. Create a new Curves adjustment layer. Select the Blue channel in the Curves dialog box and pull the curve down slightly to increase the yellow in the image. Concentrate your attentions only on the dog as the rest of the image will be masked later. Now go to the Red channel and raise the curve slightly until you have achieved some warmer colors in the coat of the dog. Select OK to apply these changes.

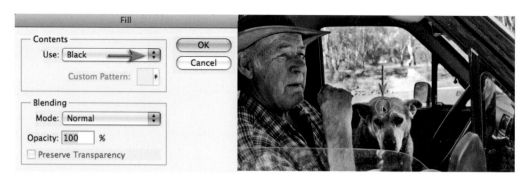

7. From the Edit menu choose Fill and from the Contents section in the Fill dialog box choose Black and then select OK. The keyboard shortcut for filling with the background color (the default color when a mask is selected) is Command + Delete (Mac) or Ctrl + Backspace (PC). The color adjustment has now been totally masked by the fill color. Choose the Brush Tool from the Tools panel and choose White as the foreground color. Select a soft-edged brush and set the Opacity to 50%. Painting over the dog will erase some of the fill color and slowly reveal the color correction that is required to achieve the correct color balance.

Note > If streaks appear where the brush strokes overlap you can either paint in a continuous action with a higher opacity or many times with a very low opacity.

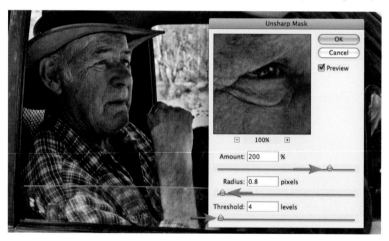

8. To complete the project you should zoom in to 100% and assess the noise and sharpness levels of the image. The initial underexposure and the subsequent extensive tonal rescue will leave an image where the overall quality has been compromised when compared to an image where the exposure had been optimized for the shadows at the expense of the highlights. Some noise reduction may be required to the image (go to Filter > Noise > Reduce Noise) before sharpening takes place (these can be applied as Smart Filters to the base layer – the layer that was converted for Smart Filters) so that the non-image artifacts are not exaggerated excessively. My preference for sharpening would be for the Unsharp Mask rather than Smart Sharpen in this instance. Raising the Threshold slider in the Unsharp Mask dialog box will restrict the sharpening to just the major tonal differences, thus reducing the grainy effect when compared to sharpening carried out by the Smart Sharpen filter.

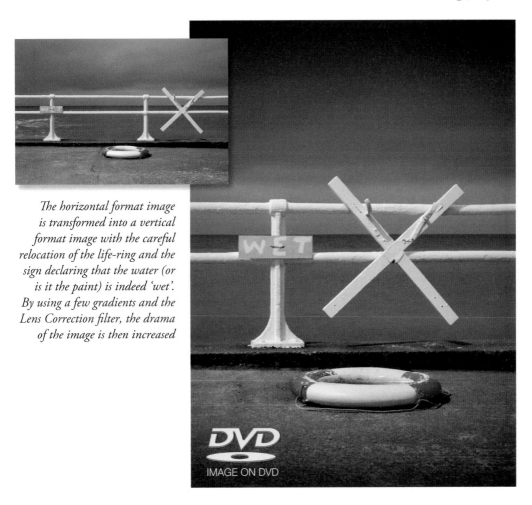

The horizontal format image is transformed into a vertical format image with the careful relocation of the life-ring and the sign declaring that the water (or is it the paint) is indeed 'wet'. By using a few gradients and the Lens Correction filter, the drama of the image is then increased

Clone and stamp – Project 4

It has become a common retouching task in image editing to move, remove or replace details within an image to fine-tune the composition or clean the image area so everything is in its right place and there is no superfluous detail to detract from the composition or distract the viewer's attention. Beginning in Photoshop CS3 a new panel called Clone Source appeared. This enables a more controlled approach to copying pixels and painting them into a new location or into a new image. There is also a Stamp Tool in the Vanishing Point dialog box that offers additional features not found in the main workspace of Photoshop. Many photographers never seem to find an appropriate image that requires them to 'edit in perspective' in Vanishing Point and have therefore overlooked the performance features of the Stamp Tool in this editing space.

Vanishing Point may be a highly specialized editing space but the Stamp Tool that resides here can be used for a broader range of retouching activities that have no clearly defined perspective at all. This project is divided into two parts – the first part deals with the features of the Clone Stamp Tool and the Stamp Tool found in Vanishing Point, while Part 2 looks at image enhancement using gradients and the creation of a vignette in the Lens Correction filter.

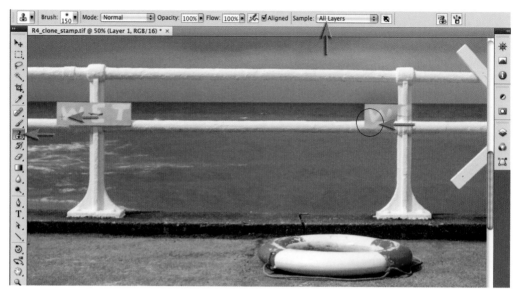

Part 1 – Clone and stamp

1. A new feature for the Clone Stamp Tool in Photoshop CS4 is the ability to see a preview of what you are cloning to enable precise alignment without having to use the Clone Source panel that was introduced with CS3. Open the supporting image (R4_clone_stamp.tif) and click on the New Layer icon in the Layers panel to create an empty new layer. Click on the Clone Stamp Tool in the Tools panel. Choose a small soft-edged brush from the Options bar and set the Clone Stamp Tool Opacity to 100%. Choose All Layers from the 'Sample' options. Hold down the Option/Alt key and click on the top of the Wet sign where it meets the horizon. Move the mouse cursor over to the right side of the image and align the horizon line and side of the white pole before you click to paint or clone the sign into position. Although it is now easier to achieve precise alignment between the cloned pixel and the background layer the lack of a healing option makes it difficult to achieve a seamless result (the ocean and sky are slightly different tones).

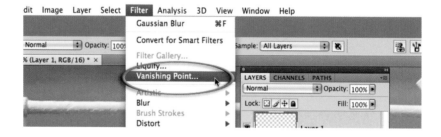

2. Discard Layer 1 in the Layers panel by dragging it to the trash can icon at the base of the Layers panel. Create another new empty layer by clicking on the New Layer icon. All of the modifications will be stamped into this layer, leaving the background layer unaffected. Go to the Filter menu and choose 'Vanishing Point'. Be prepared for a short wait while Photoshop opens the image into the Vanishing Point dialog box.

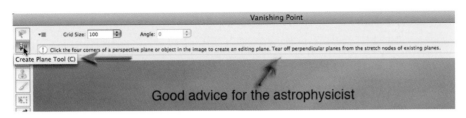

Good advice for the astrophysicist

3. When the dialog box opens, Vanishing Point tries to be really helpful by giving you advice as to what to do next – sound advice that we will now ignore (unless of course you would like to 'tear off your perpendicular planes from the stretch nodes of existing planes'). What I would like you to do instead is to simply double-click the second icon from the top in the left-hand corner of the dialog box (the Create Plane Tool). This completely ignores Adobe's invitation to locate any planes of perspective (parallel lines that converge as they recede into the distance – a particularly rare animal in natural landscape and portrait photography) and instead just drops a nice blue grid over your entire image. This blue grid serves absolutely no purpose in this project – but is of course an essential step before Adobe will allow us to utilize the Stamp Tool.

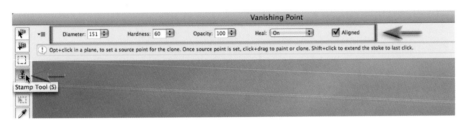

4. Now select the Stamp Tool in the Vanishing Point dialog box. Set the Opacity of the tool to 100% and switch the Heal option to 'On' or 'Luminosity'. Reduce the Hardness of the brush to around 60 and then increase the Diameter of the brush to around 150.

Note > If the complex process of creating the 'planes of perspective' on your first visit to Vanishing Point seemed more trouble than it is was worth then you probably missed the significant difference between the seemingly identical Stamp Tool in Vanishing Point and the our old friend that resides in the Tools panel of the main editing space. On closer inspection they are not the same animal at all, for when you choose a brush size and hardness for the Stamp Tool in Vanishing Point and then choose a source point for the pixels you wish to clone (copy and paint to another area in the image) the brush displays the pixels that you will paint with rather than an overlay. The essential ingredient that enables us to achieve success when using the Stamp Tool is the fact that it adopts the behavior of the healing brush. The luminosity or healing options in the Options bar within the dialog box enable the cloned pixels to achieve a seamless blend with the surrounding pixels. This is achieved when the tool draws in the hue and luminosity values of the surrounding pixels (or just the luminosity values as is the case with the Luminosity option) into the feathered edge of the brush you are using. The softer the brush the broader the area of healing that occurs, but this may also increase the risk of drawing in adjacent values of an inappropriate value. Care must be taken to adapt the brush size and hardness to the area you are cloning into.

5. Alt/Option-click on the horizon line where it meets the upright pole, just above the sign 'wet', to select a source point for the pixels you wish to clone. Now move over to the vertical pole on the right side of the image and click on the similar intersection point where the horizon line meets the pole. Hold down the mouse clicker as you paint; stamp or clone just enough pixels to reveal the sign and its shadow into its new location.

Note > Choosing a precise intersection of horizontal and vertical lines as your initial source point is critical when attempting to clone pixels into another area of the image that shares these strong geometric lines.

6. Turn your attention to cloning the life-ring when the sign has been relocated. To prevent the horizontal edge above the life-ring being cloned out of alignment it will be necessary to reduce the size of the brush and increase its hardness to 80%.

7. Increase the size of the brush and decrease the hardness once again before selecting a new source point from the foreground concrete to the left of the life-ring. Proceed to remove the original life-ring from the image. If the left side of the original life-ring starts to reappear when attempting to remove the life-ring try selecting a source point further over to the left side of the image. When the original life-ring has been successfully removed click OK to apply the changes made by the Stamp Tool. You will notice that all of your changes now appear in the new layer you created before using Vanishing Point and can be removed if you are not entirely happy by simply switching off the layer visibility.

8. With the changes isolated to their own layer you have the option to erase or mask just a few of the changes that are not entirely convincing. In this image when the white pole and horizon line are aligned there is a small amount of alignment error just to the left of the sign. This can be masked by clicking on the 'Add layer mask' icon in the Layers panel and masking the error using the Brush Tool. Choose black as the foreground color and set the Opacity in the Options bar to 100%. Paint with a small brush to mask the alignment error.

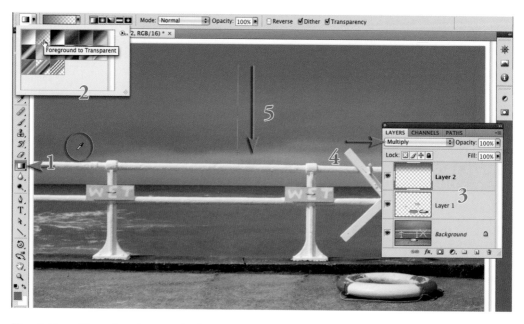

Part 2 – Gradients and vignettes

$9.$ Select the Gradient Tool from the Tools panel and choose the Foreground Transparent and Linear gradient options from the Options bar. Hold down the Alt key and sample an area of the blue cloud cover to select this as your foreground color.

Note > If you intend to sample colors when working with multi-layered files you should ensure the following settings are in place. Select the Eyedropper Tool and select a 5 x 5 average and the All Layers option in the Options bar. You will now be able to hold down the Alt/Option key and click to sample a color, without first checking to see what layer you are on or selecting the Eyedropper Tool. It is also important to ensure you do not have a layer mask selected when you try to sample a color.

Before creating your gradient add a new layer by clicking on the 'Create a new layer' icon in the Layers panel and set the blend mode of this layer to Multiply. Now proceed to drag a gradient from the top of the image to a position just above the top railing. Holding down the Shift key as you drag the gradient will ensure the gradient is constrained to a perfect vertical.

Choosing a blend mode for a gradient

The Multiply blend mode is a darkening mode that will darken the sky even though you have sampled a color of the same brightness value that is in the existing sky. Selecting the blend mode in the Options bar, however, will not darken the sky unless the gradient is applied to a layer with pixels, e.g. the background layer. The blend mode in this project must be applied to the empty new layer for the darkening process to take effect and not the Options bar. If you want to darken the sky after the initial gradient has been applied then the Multiply blend mode can be selected in the Options bar and a second gradient using the same foreground color can be applied. The Multiply blend mode selected in the Options bar will now take effect on the pixels in this layer from the first gradient.

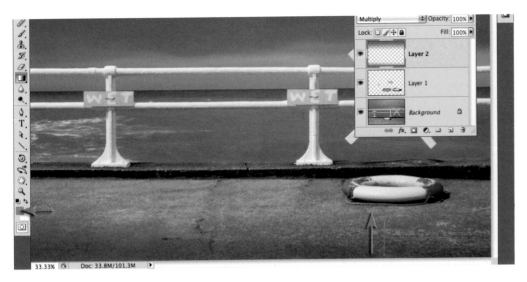

10. Sample a new color from the concrete in the foreground and add a second gradient into this layer to darken the foreground.

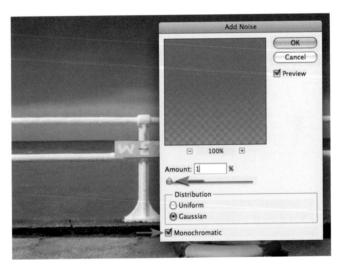

11. If you would like to reduce the effect of this second gradient without altering the effect of the first gradient you can proceed directly to the Edit menu and choose 'Fade Gradient'. To prevent any banding (visible steps of tone) appearing in the area of the gradient it is advisable to add a small amount of noise to this gradient layer. Go to the Filter menu and choose Add Noise from the Noise submenu: 1 or 2% noise using the Gaussian and Monochromatic options selected will usually prevent any banding issues on screen or in print.

Note > The Fade option is available for any filter or painting tool that you may have used but it is only available if it is the first step you take after the filter or painting action has been applied. Even the act of deselecting a selection will render the Fade option unavailable.

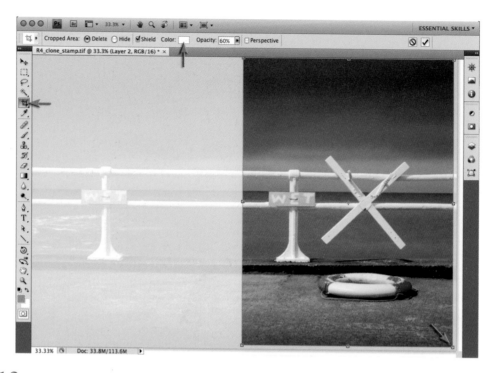

12. Duplicate your master PSD file (Image > Duplicate) and then crop your image to its new vertical format (duplicating the file will ensure you still have a record of the horizontal file after cropping). When cropping I prefer to switch my shield color in the Options bar to white and reduce the opacity to 50% (you can take this action only after you have first dragged out a crop marquee). I find this gives me a better idea of the new composition when cropping rather than using the default option of Black at 75% opacity.

13. Create a new layer, fill it with white (Edit > Fill) and set the blend mode of the layer to Multiply. Now choose 'Lens Correction' from the Distort submenu. The vignette option in Lens Correction is designed to eliminate vignetting that may occur with some wide-angle lenses while shooting at wide apertures, but it is equally adept at adding vignettes for creative purposes.

Note > White is a neutral color in Multiply mode so the effects of this layer will be invisible until we darken the corners.

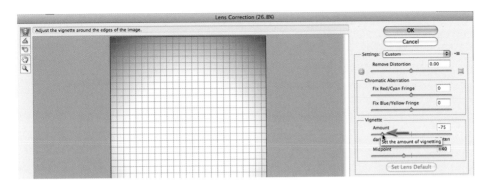

14. Reduce the Amount and Midpoint sliders in the Lens Correction dialog box to create the vignette you are looking for. Click OK when you are done. An advantage to using the Lens Correction filter to add a vignette as opposed to other techniques is that this process can be included as part of an automated 'action' that can be applied on a range of different resolution files, i.e. it requires no radius value for either a feather or mask.

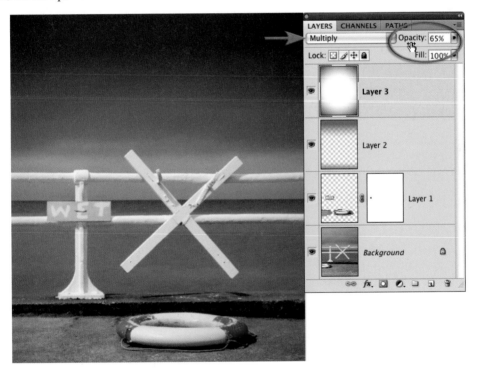

15. Reduce the opacity of the vignette layer until you strike the appropriate amount of drama in the image and then you are pretty much done. You will probably want to complete the project by merging all of the visible elements of the project to a new layer (hold down the Ctrl + Alt + Shift keys and then type the letter E) and then applying the Unsharp Mask or Smart Sharpen filter.

Note > Converting the background layer to a Smart Object and applying the sharpening as a Smart Filter will not sharpen the sign and life-ring, which have been placed on another layer.

IMAGE ON DVD

Clone or Heal

When cleaning an image of superfluous detail the question often arises as to which is the best tool for the job. When working in broad areas of texture to remove small blemishes the Spot Healing Brush Tool is hard to beat for speed and ease of use. As the areas requiring removal get larger, switching to the Healing Brush and nominating a texture avoids the errors that occur when using the Spot Healing Brush for this task. The limitations of the Healing Brush (and Spot Healing Brush) become apparent when working up against tones or colors that are markedly different to the area being cleaned. The Healing process draws luminance and color values from the surrounding area and when these colors are very different they contaminate the area to be healed. Problems can often be avoided in these instances by either using a harder brush or making a selection that excludes the neighboring tones that are different. When working up against a sharp edge even these actions may not be enough to avoid contamination – this is the time to switch to the Clone Stamp Tool. A selection will help to contain the repair while the Clone Source panel or Stamp Tool in Vanishing Point will help to align edges so that the repair is seamless.

Advanced sharpening techniques – Project 5

Most, if not all, digital images require sharpening – even if shot on a state-of-the-art digital mega-resolution SLR with pin-sharp focusing. Most cameras or scanners can sharpen as the image is captured but the highest quality sharpening is to be found in the image-editing software. Sharpening in the image-editing software will allow you to select the precise amount of sharpening and the areas of the image that require sharpening most. When you are sharpening for the screen, it is very much a case of 'what you see is what you get'. For images destined for print, however, the monitor preview is just that – a preview. The actual amount of sharpening required for optimum image quality is usually a little more than looks comfortable on screen – especially when using a TFT monitor (flat panel).

IMAGE ON DVD

The basic concept of sharpening is to send the Unsharp Mask filter or Smart Sharpen filter on a 'seek and manipulate' mission. These filters are programmed to make the pixels on the lighter side of any edge they find lighter still, and the pixels on the darker side of the edge darker. Think of it as a localized contrast control. Too much and people in your images start to look radioactive (they glow), not enough and the viewers of your images start reaching for the reading glasses they might not own. The best sharpening techniques to use with sharpening filters are those that prioritize the important areas for sharpening and leave the smoother areas of the image well alone, e.g. sharpening the eyes of a portrait but avoiding the skin texture. These advanced techniques are essential when sharpening images that have been scanned from film or have excessive noise, neither of which will benefit from a simple application of the Unsharp Mask filter. So let the project begin.

Note > If you have any sharpening options in your capture device it is important to switch them off or set them to minimum or low (if using Camera Raw set the sharpening amount to 0). The sharpening features found in most capture devices are often very crude when compared to the following technique. It is also not advisable to sharpen images that have been saved as JPEG files using high compression/low quality settings. The sharpening process that follows should also come at the end of the editing process, i.e. adjust the color and tonality of the image before starting this advanced sharpening technique. Reduce the levels of sharpening later if it proves too much.

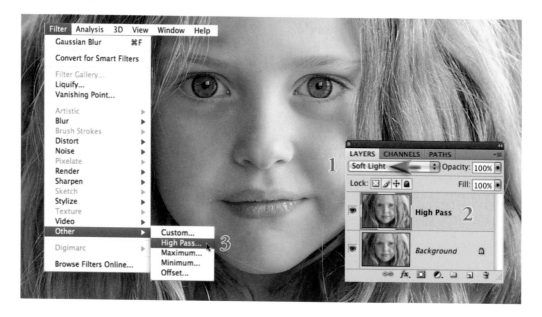

Technique 1 – High Pass

1. Open the project image (R5_Sharpen-crop.tif). Duplicate the background layer and set the blend mode to Soft Light from the blend modes menu in the Layers panel. Change the name of this layer to High Pass. Go to Filter > Other > High Pass.

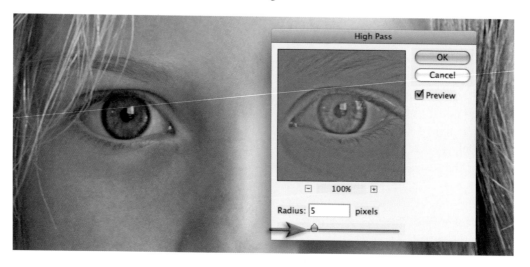

2. Choose a 5.0 pixels Radius for this project. A pixel Radius between 1.0 and 5.0 would be considered normal if you were not going to proceed beyond Step 4 in this project.

Note > Use lower Radius values when printing to Gloss paper and higher values if printing to Matte paper. To adjust the level of sharpening later you can either lower the opacity of the High Pass layer (to decrease the amount of sharpening) or set the blend mode of the 'High Pass' layer to 'Overlay' or 'Hard Light' (to increase the level of sharpening).

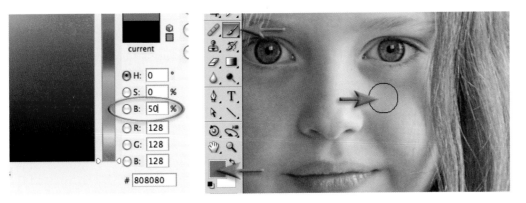

3. Click on the foreground color swatch in the Tools panel to open the Color Picker. Enter 0 in the Hue and Saturation fields and 50% in the Brightness field to choose a midtone gray. Select OK. Paint the High Pass layer to remove any sharpening that is not required, e.g. skin tones, skies, etc. Zoom in to 100 or 200% to obtain a clear view of the skin detail. This technique is especially useful for limiting the visual appearance of noise or film grain. Turn off the background layer momentarily to observe any areas you may have missed.

Detail from a portrait captured on a Nikon D1x. The Raw image was processed with 15% sharpening. First test has no subsequent sharpening. Second test uses a High Pass layer (3 pixel radius) in Soft Light mode. Third test has had the blend mode of the High Pass layer changed to Overlay mode. Fourth test has sharpening via a localized Unsharp Mask (100%) in Luminosity mode. The Opacity slider could be used to fine-tune the preferred sharpening routine

4. Remember at this point the settings you have selected are being viewed on a monitor as a preview of the actual print. To complete the process it is important to print the image and then decide whether the image could stand additional sharpening or whether the amount used was excessive. If the settings are excessive you can choose to lower the opacity of the 'High Pass' layer.

Saturation and sharpening

Most techniques to increase the contrast of an image will also have a knock-on effect of increasing color saturation. As the High Pass and Unsharp Mask filters both increase local contrast there is an additional technique if this increased color saturation becomes problematic. You may not notice this in general image editing, but if you become aware of color fringing after applying the High Pass technique you should consider the following technique to limit its effects.

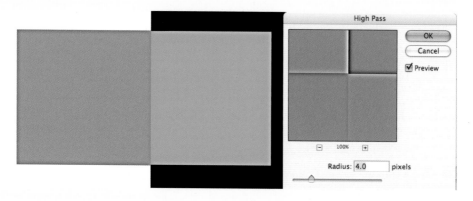

Technique 2 – Unsharp Mask/Smart Sharpen

The second technique is a continuation of the first technique and is intended to address the issues of increased saturation leading to the effect of color fringing. If we stamp the visible layers to a new layer (hold down the Command, Option and Shift keys on a Mac or Ctrl, Alt and Shift keys on a PC and then press the letter E on the keyboard) and set the mode of this layer to Luminosity, the effects of saturation are removed from the contrast equation when we sharpen. This second technique looks at how the benefits of localized sharpening and Luminosity sharpening can be combined.

5. Change the blend mode of the High Pass layer back to Normal mode. Then apply a Threshold adjustment to the High Pass layer. Go to Image > Adjustments > Threshold.

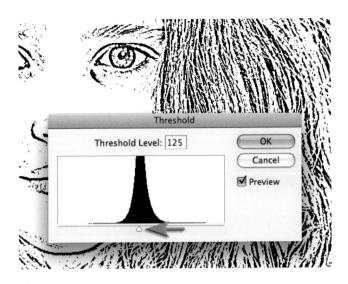

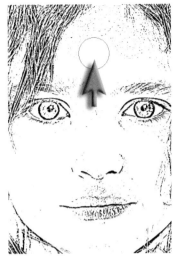

6. Drag the slider just below the histogram to isolate the edges that require sharpening. The goal of moving these sliders is to render all of those areas you do not want to sharpen white. Select 'OK' when you are done. Paint out, with a white brush, any black pixel areas that you do not want sharpened, e.g. in the portrait used in this example any pixels remaining in the skin away from the eyes, mouth and nose were painted over using the Paintbrush Tool with white selected as the foreground color.

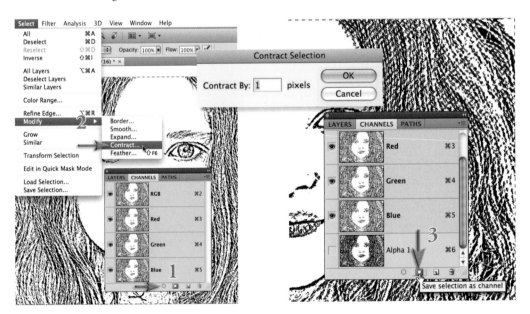

7. Go to the Channels panel and either Ctrl-click (PC) or Command-click (Mac) the RGB thumbnail or click on the 'Load channel as selection' icon from the base of the Channels panel to load the edge detail as a selection. Go to Select > Modify > Contract. Enter 1 pixel in the Contract dialog box and select OK. Click on the 'Save selection as channel' icon at the base of the Channels panel to save this modified selection as a channel. Go to Select > Deselect.

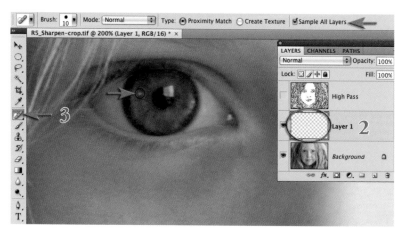

8. Switch off the visibility of the High Pass layer. Click on the 'Create a new layer' icon at the base of the Layers panel and then select the Spot Healing Brush Tool in the Tools panel. Select Sample All Layers in the Options bar and then spot any minor defects you can find in the image, e.g. there is a light spot in each eye that can be removed.

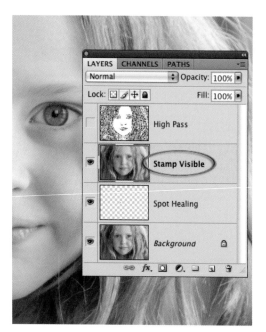

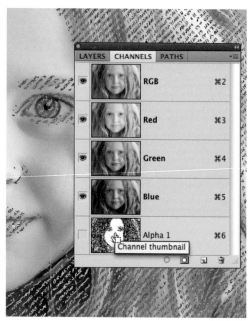

9. When your editing of the file is complete and you are ready for sharpening, stamp the visible elements to a new layer by holding down the Command, Option and Shift keys on a Mac or Ctrl, Alt and Shift keys on a PC and then pressing the letter E on the keyboard. This layer contains the combined elements from the layers below. Go to the Channels panel and load the Alpha channel you saved in Step 7 as a selection (drag the Alpha channel to the Load channel as selection icon or hold down the Command/Ctrl key and click on the Alpha channel. Make sure the Master RGB channel is the active component before returning to the Layers panel.

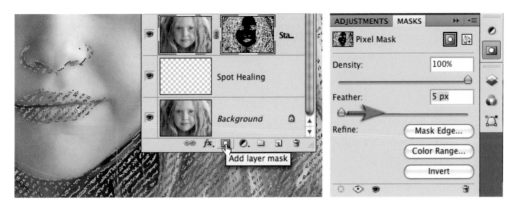

10. With the selection active hold down the Alt/Option key and click on the 'Add layer mask' icon. In the Masks panel increase the Feather of the mask to 5 pixels to soften the hard edges.

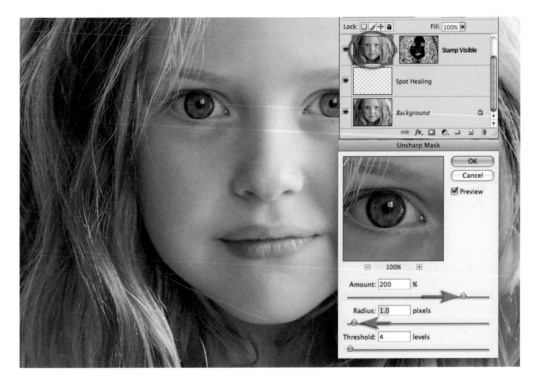

11. Now click on the image thumbnail rather than the layer mask in the Layers panel to make this the active component. Ensure the image is zoomed in to 100% for a small image or 50% for a larger print resolution image (200–300 ppi). Go to 'Filter > Sharpen > Smart Sharpen or Unsharp Mask'. Adjust the 'Amount' slider to between 100 and 300%. This controls how much darker or lighter the pixels at the edges are rendered. Choose an amount slightly more than looks comfortable on screen if the image is destined for print rather than screen. The Radius should be kept low, around 0.5 to 1.5 pixels. The mask protects the skin from the sharpening process but the Threshold can be raised to 3 or 4 to keep any noise in the image appearing soft.

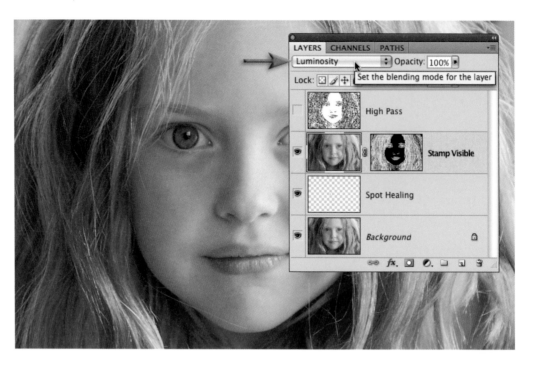

12. Change the blend mode of the sharpening layer (the Stamp Visible) to Luminosity mode. Luminosity mode will restrict the contrast changes to brightness only, and will remove any changes in saturation that have occurred due to the use of the Unsharp Mask. The changes are often very subtle but this technique is recommended for all images and is a fast alternative to a technique that advocates changing the mode of the image to Lab and then sharpening the L channel only (L for Luminosity).

Darkened edge exhibits increased saturation prior to changing the blend mode to Luminosity

The illustration above is a magnified view of the effects of changing the blend to Luminosity. These two cutting-edge sharpening techniques are capable of producing razor-sharp images that will really put the finishing touches to a folio-quality image.

Original photography by Scott Hirko

Replace color and tone – Project 6

This project will change the background color of a studio image and change target colors of the subject itself. The essential skill in this project is how to handle the shadows in the process. The preservation of the original shadows when the background color changes or the subject gets transported to a new location is one of the most essential ingredients for creating a realistic montage. The quickest way to destroy the dimensional illusion of the montage is to have conflicting light sources and shadows. Graphic designers all too often resort to recreating a shadow from scratch rather than preserving the original shadow, thereby creating a graphic, rather than a photographic, effect. When capturing a subject for a montage project try to capture all of the shadow on a smooth textured surface or on a surface with a similar texture to the new location. It is difficult to light a white backdrop so that it is white rather than gray but as shadows are always darker than the backdrop tone they can be separated quite easily if you know the technique to achieve this. The primary skills we will utilize in this tutorial are the controlled clipping of tones using Levels, the Hue/Saturation adjustment feature, duplicating and inverting layer masks, and a few blend modes thrown in.

Note > The studio backdrop does not have to be white in order to isolate the shadow from the surrounding background. Subjects are often photographed against a blue or green screen (chroma blue or chroma green) for video compositing but this can prove problematic when replacing backgrounds using Photoshop if the blue or background is not lit correctly.

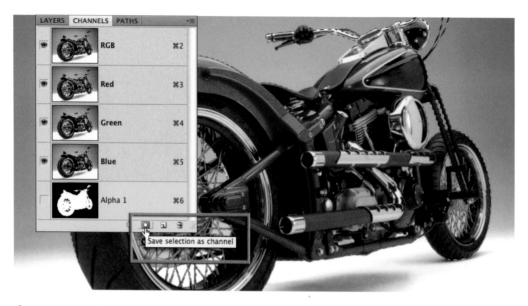

1. Make a selection of the studio background surrounding the bike using the skills learnt in the Selections chapter. The selection can be created using a range of selection tools but if you are using the Pen Tool or Magic Wand as one of the selection tools you will need to use the other selection tools with a feather radius set to zero. When the selection is complete click on the 'Save selection as channel' icon at the base of the Channels panel. Alternatively use the saved selection that is available with the TIFF file on the DVD. The saved selection has had a 1-pixel feather applied to soften the edge of the mask.

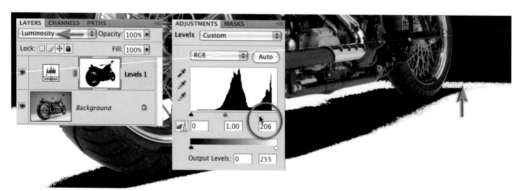

2. With the selection still active (Ctrl- or Command-click the alpha channel in the Channels panel if the selection is **NOT** active) choose Levels from the Adjustments panel and set the mode of the resulting Adjustment layer in the Layers panel to Luminosity*. In the Layers dialog hold down the Alt key (PC) or Option key (Mac) and drag the white highlights slider underneath the histogram to clip the tones surrounding the shadow under the bike to white (255). As soon as the shadow becomes an island stop dragging the highlight slider. We can clip the rest of the tones behind the bike to white using the technique outlined in the next step.

***Note > The Luminosity mode will protect the existing saturation levels on the underlying layer when we make the following adjustment.**

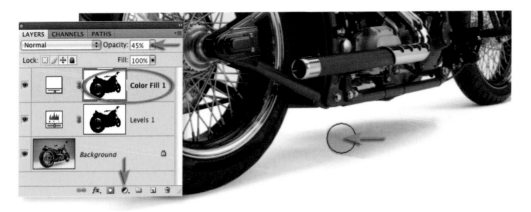

3. Hold down the Ctrl key (PC) or Command key (Mac) and click on the layer mask thumbnail to load the mask as a selection. Click on the 'Create new fill or adjustment layer' icon at the base of the Layers panel and choose 'Solid color'. Enter 255 in all three of the RGB fields in the Pick a Solid Color dialog (Color Picker) and select OK. Lower the opacity of the Color Fill adjustment layer to around 50% so that you can see the shadows on the underlying layer. Choose the Brush Tool and select black as the foreground color and then in the Color Fill layer mask paint over the faint shadows under the bike (including their soft edges). Be careful not to paint over any areas of the studio backdrop that were not rendered 255 by the Levels adjustment layer. When the painting is complete return the opacity of the layer back to 100%. The shadows should now appear natural with soft edges and the rest of the backdrop is white.

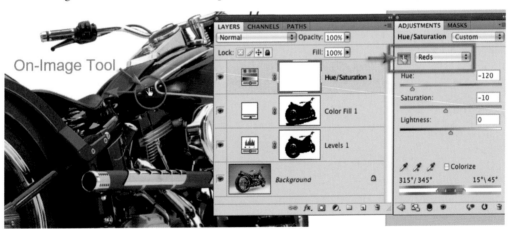

4. You can change the color of the paintwork quickly by selecting a Hue/Saturation adjustment layer from the Adjustments panel. Select Reds in the Edit menu and then move the Hue slider to –120 or just select the on-image tool, hold down the Ctrl key (PC) or Command key (Mac) and click on the paintwork and drag left. Lower the Saturation by dragging left without holding down the modifier key (Ctrl/Command key). As the center of the wheels are very close to red you may also notice these changing color along with the bright red paintwork. This will be corrected in the next step.

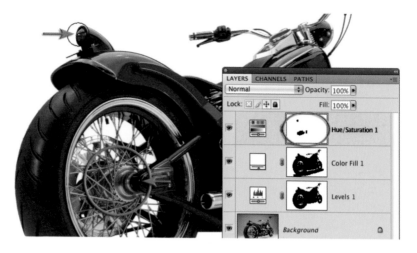

5. The observant among you will have noticed that we now have a blue tail-light and discolored wheels. This can be quickly restored to the original color by selecting the Brush Tool from the Tools palette, choosing black as the foreground color (press D on the keyboard) and then painting over the tail-light and the center of each wheel to mask the adjustment in this area.

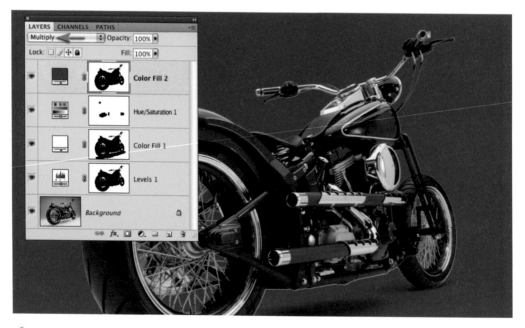

6. The following step shows us how we can change the color of the background and yet still retain the original shadows. This is a useful technique that allows us to preview how the subject will appear if placed against a darker background in a montage or composite image (see the Montage Projects chapter). Load the Levels adjustment, mask as a selection and then create another Color Fill (Solid Color) adjustment layer and this time choose a darker color from the Color Picker. In the illustration above the color is around 40% Brightness and Saturation. The mode of the adjustment layer has to be set to Multiply in order to preserve the original shadows.

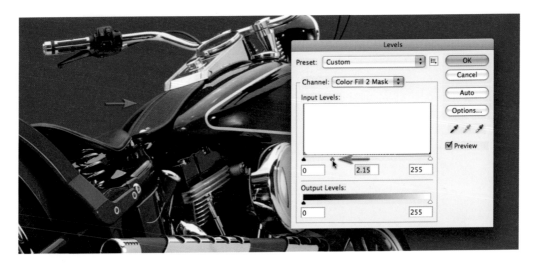

7. A white line will appear around the motorcycle after applying this second Color Fill adjustment layer. If we shrink or choke the Color Fill mask this will allow the fill color to replace this white line. Go to Image > Adjustments > Levels and drag the center gamma slider beneath the histogram to the left. This adjustment can also be achieved using the Expand/Contract slider in the Refine Edge dialog (Select > Refine Edge).

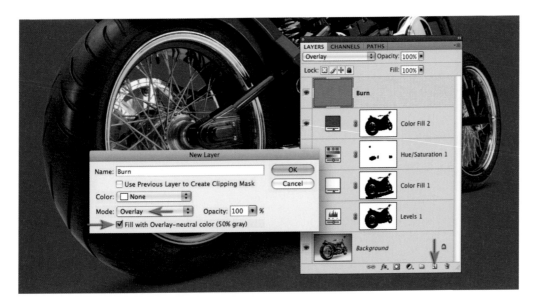

8. Some parts of the bike will now appear too light as they were collecting some light reflected from the original white backdrop. We can create a layer to darken areas of the underlying image. Holding down the Alt key (PC) or Option key (Mac) click on the 'Create a new layer' icon at the base of the Layers palette. In the New Layer dialog box set the Mode to Overlay and check the 'Fill with Overlay-neutral color (50% gray)' option. Name the layer Burn and select OK to create this new layer.

9. Hold down the Alt key (PC) or Option key (Mac) and drag the layer mask from the Levels 2 layer to the 'Burn' layer to duplicate it. Use the keyboard shortcut (Ctrl + I for PC or Command + I for Mac) to invert the mask. Select the layer thumbnail rather than the Layer mask thumbnail (when selected it will have a second line running around the thumbnail icon). Select the Brush Tool from the Tools palette and Black as the foreground color (press the letter D key on the keyboard). Choose a large soft-edged brush and set the Opacity between 10 and 20% in the Options bar. Paint the underside of the tires and the bike darker so that the effect is consistent with the new background tone. If you should lighten the fill color or place the bike against a background with a lighter tone in a composite image the opacity of this burn layer can be adjusted.

10. The easiest way to transplant all of these layers into another image when we come to create a montage is to create a group from these layers. The first step is to double-click the background layer and select OK in the New Layer dialog. Now select Layer 0 and hold down the Shift key as you select the top layer (the Burn layer) so that all layers are selected. Use the keyboard shortcut Ctrl + G (PC) or Command + G (Mac) to load the layers into the group.

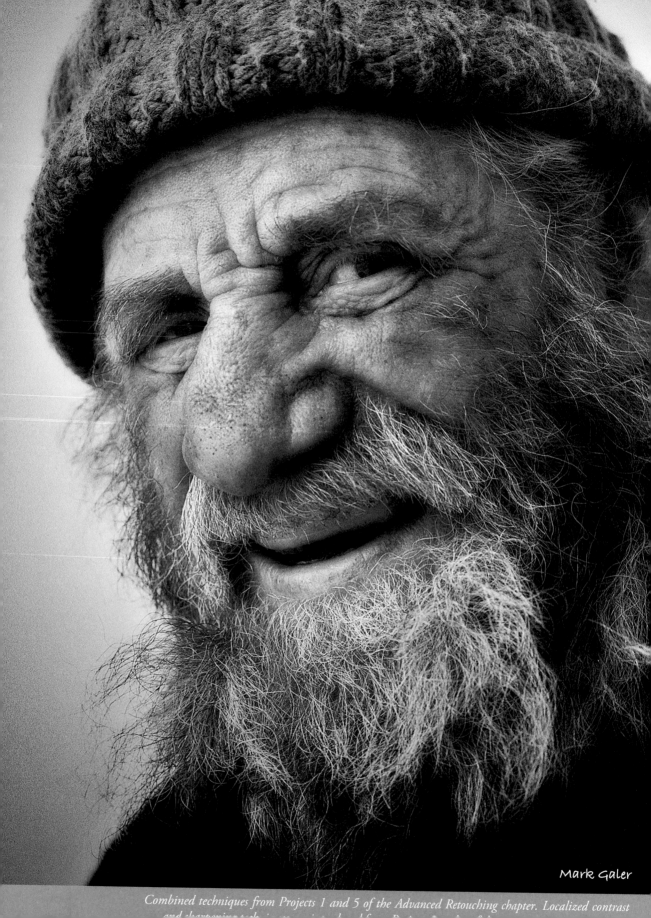

Mark Galer

Combined techniques from Projects 1 and 5 of the Advanced Retouching chapter. Localized contrast

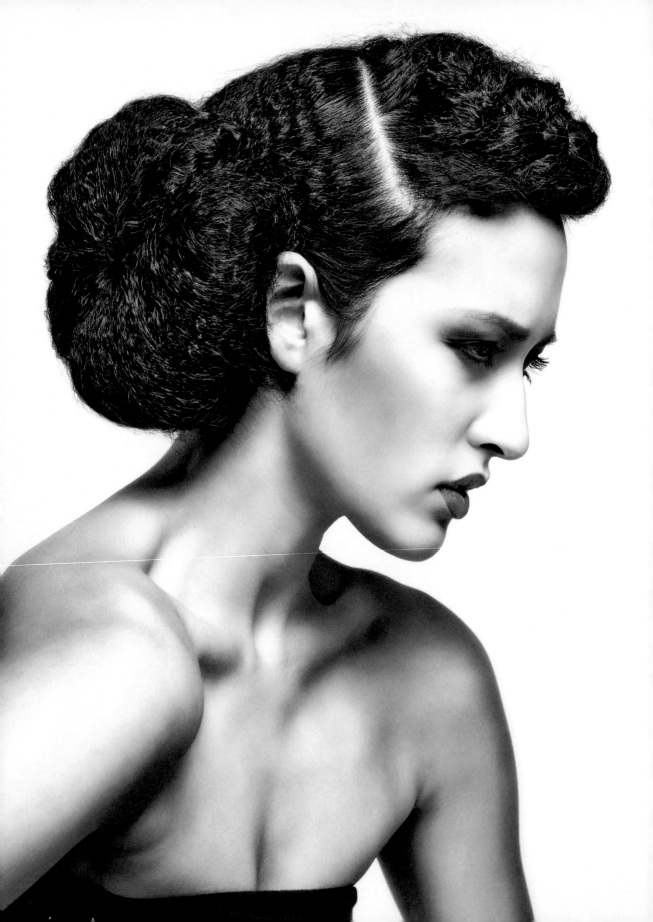

advanced retouching

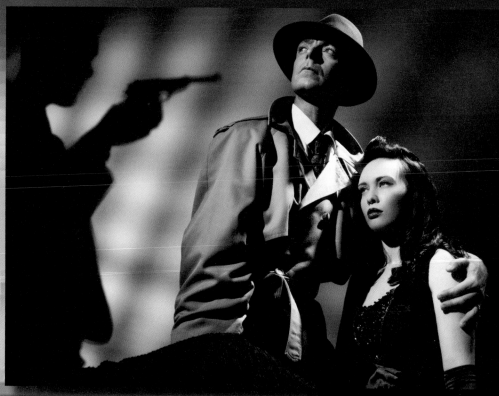

Morten Haugen

essential skills

- Create a monochrome or black and white image from an RGB master.
- Create a toned image using a 'Gradient Map'.
- Create an image with reduced depth of field.
- Use Smart Objects to balance the lighting within a scene.
- Use professional techniques to enhance the facial features of a portrait image.
- Create smooth tone and exaggerate midtone contrast to create a signature style.

Black and white – Project 1

When color film arrived over half a century ago the pundits who presumed that black and white film would die a quick death were surprisingly mistaken. Color is all very nice but sometimes the rich tonal qualities that we can see in the work of the photographic artists are something certainly to be savored. Can you imagine an Ansel Adams masterpiece in color? If you can – read no further.

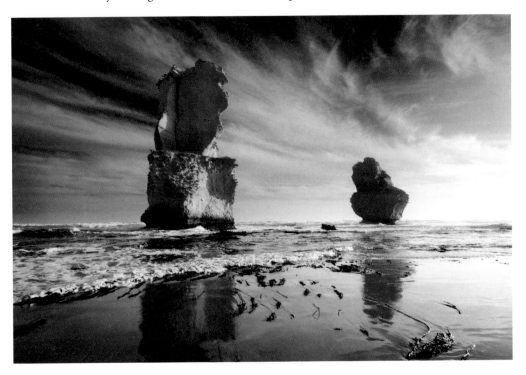

Creating fabulous black and white photographs from your color images is a little more complicated than hitting the 'Convert to Grayscale mode' or 'Desaturate' buttons in your image-editing software (or worse still, your camera). Ask any professional photographer who has been raised on the medium and you will discover that crafting tonally rich images requires both a carefully chosen color filter during the capture stage and some dodging and burning in the darkroom. Color filters for black and white? Now there is an interesting concept! Well as strange as it may seem, screwing on a color filter for capturing images on black and white film has traditionally been an essential ingredient in the recipe for success. The most popular color filter in the black and white photographer's kit-bag, that is used for the most dramatic effect, is the 'red filter'. The effect of the red filter is to lighten all things that are red and darken all things that are not red in the original scene. The result is a print with considerable tonal differences compared to an image shot without a filter. Is this a big deal? Well yes it is – blue skies are darkened and skin blemishes are lightened. That's a winning combination for most landscape and portrait photographers wanting to create black and white masterpieces.

Note > The more conservative photographers of old (those not big on drama) would typically invest in a yellow or orange filter rather than the 'full-on' effects that the red filter offers.

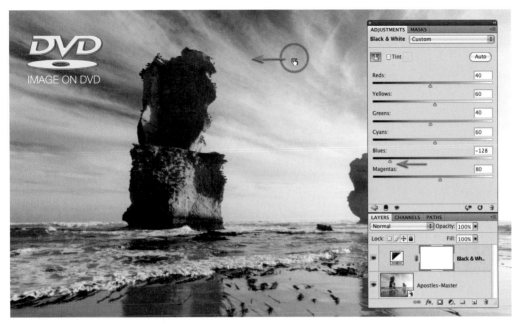

The Black & White adjustment offers a quick and controlled method for controlling tonality – just click in the main image window and drag left or right to darken or lighten the tonal value of this color range

Traditional Black and White

Now just before you run out to purchase your red filter and 'Grayscale image sensor' you should be reminded that neither is required by the digital photographer with access to Photoshop. Shooting digitally in RGB (red, green, blue) means that you have already shot the same image using the three different filters. If you were to selectively favor the goodies in the red channel, above those to be found in the green or blue channels, you would, in effect, be creating a Grayscale image that would appear as if it had been shot using the red filter from the 'good old days'. You can see the different tonal information by using the 'Channels panel' to view the individual channels (turn off the visibility of all but one channel). Then you can selectively control the information using the Black & White adjustment layer feature.

Black & White adjustment in Photoshop

The Black & White adjustment feature is now the easiest and most versatile way to convert images to black and white. No more juggling sliders in Channel Mixer to prevent clipping. The adjustment feature is a breeze to use and very versatile. You can use the color sliders if you like or simply click on a color within the image window and drag to the right to make the color lighter, or to the left to make it darker. How easy is that! In fact, this technique is so easy to use it hardly warrants a project to master the technique. The adjustment feature does, however, have its limitations. Dragging the sliders to their extreme values in the Black & White adjustment feature can introduce image artifacts and haloes around adjusted colors and the image adjustment feature has no contrast adjustment within the dialog box. Total control over tonality still requires some additional and essential skills using the information from the individual channels in conjunction with the contrast blend modes such as Overlay and Soft Light. The skill of controlled black and white conversions is a foundation for most of the color toning projects that follow.

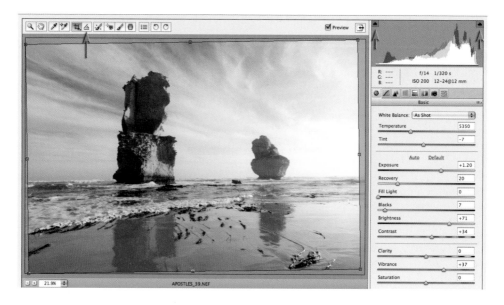

1. Optimize the project file in Adobe Camera Raw making sure that there is no clipping in either the shadows or highlights. Hold down the Alt/Option key as you drag the Blacks and Exposure sliders to set the Black and White points in the image. The Recovery slider has been raised to allow the Exposure slider to be raised to +1.20. The project image also has to be straightened using the Straighten Tool before it is opened in the main editing space.

Note > It is possible to render the image as a Grayscale image in the HSL/Grayscale tab of the ACR dialog box. It is also possible, using the Grayscale Mix sliders, to brighten the rocks by raising the Yellows slider and darken the sky by lowering the Blues slider. You may notice, however, that such an aggressive adjustment introduces both noise and haloes. The haloes around the edges of the rocks (the transition between the darkened blues and lightened yellows) are most noticeable when viewed at 100%. This is where a manual conversion to Grayscale in the main editing space can provide the user with superior results.

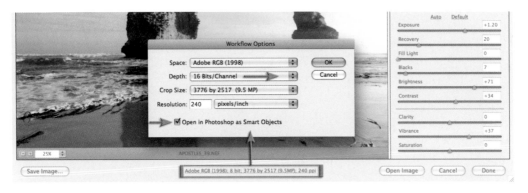

2. Open the project file into Adobe Camera Raw and set the Workflow Options to 16 Bits/Channel and check the Open in Photoshop as Smart Objects preference. Select OK and click on the Open Object button (formerly the Open Image button). This will ensure we embed the Raw file into the project file and allow us to make large changes in tonality and reduce the risk of introducing image artifacts and banding into the edited image.

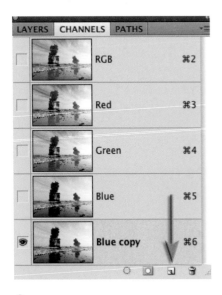

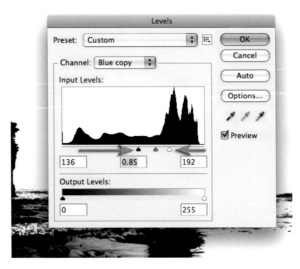

3. Open the Channels panel and click on the Blue channel thumbnail (not the visibility icon). Note how this channel offers the best contrast between the sky and the rocks (blue sky will be lighter in the Blue channel and opposite colors, such as the yellow rocks, will be darker in the Blue channel). We can use this channel to create a quick and effective mask for this project. This mask will allow us to work on the sky and the foreground separately to achieve optimum tonality and contrast in both areas. This technique is called channel masking and is a commonly used advanced technique for professional retouchers to save time. Drag the Blue channel to the New Channel icon to copy it. From the Image > Adjustments submenu choose 'Levels'. Drag the shadow slider in the Levels dialog box to the right until the dark rocks are mostly black. Drag the highlight slider to the left until the sky is mostly white (you should be left with a few gray clouds). Click OK to apply the adjustment. Although not perfect, this mask can be optimized in the next step.

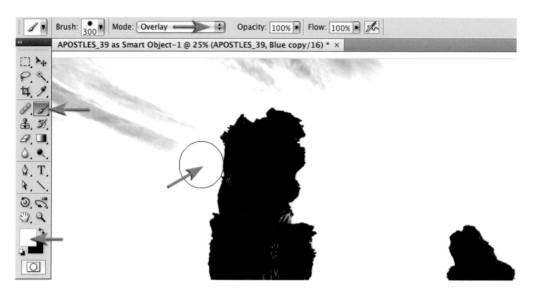

4. Painting in Photoshop is not everybody's flavor of the month. There is, however, a clever brush technique when masking that makes it a far less painful procedure. Switch the blend mode of the Brush Tool to 'Overlay' in the Options bar and set the foreground color to white. When you paint over the clouds with a white brush in Overlay mode all the gray tones are progressively rendered lighter. The magic of the Overlay mode lies in the fact that white has little or no effect on the darkest tones and black has little or no effect on the lightest tones. Switching the foreground color to black and painting over the dark gray tones on the rocks will help to expand the contrast of the Alpha channel.

Switch the mode of the brush back to Normal for final clean-up work in the sky (away from the edges of the rocks). There is no need to work on the water or beach at this stage. Zoom in to 100% (Actual Pixels) and check the mask for any holes in the rocks that need painting with black.

5. Go to the Channels panel and click on the Red channel thumbnail (not the visibility icon). This channel offers the best contrast in the sky. To copy the Red copy channel to the clipboard, choose All from the Select menu (Ctrl/Command + A) and then Copy from the Edit menu (Ctrl/Command + C). Click on the RGB channel and then go to the Layers panel and create a new layer by choosing Paste from the Edit menu (Ctrl/Command + V).

6. From the Image > Adjustments menu choose Levels. Hold down the Alt/Option key as you drag the black slider to the right. Stop moving the slider only when you see the darker areas of the sky clipping. Move the slider back a little until no clipping is visible in the sky. Drag the central gamma slider underneath the histogram to the left to brighten the sky. You have now expanded the contrast of the sky to the maximum possible before clipping occurs. The tonality of the beach and rocks will be used from the underlying Smart Object and will not be damaged by this step.

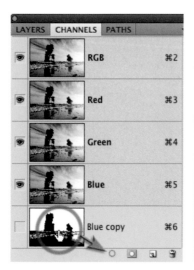

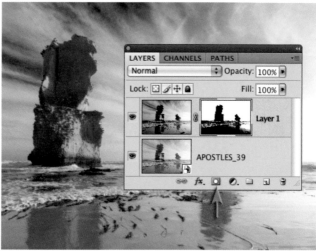

7. Drag the Blue copy channel to the 'Load channel as selection' icon at the base of the Channels panel to load the channel as a selection. The keyboard shortcut to load a channel as a selection is to hold down the Command key on a Mac or the Ctrl key on a PC and click on the channel thumbnail. Click on Layer 1 (the information from your Red channel) to make sure it is the active layer. Click on the 'Add layer mask' icon at the base of the Layers panel. The mask will require further work to ensure the modified sky is seamless and the immediate foreground (waves and sand) does not appear a little strange.

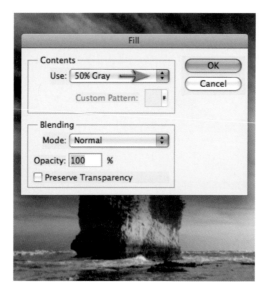

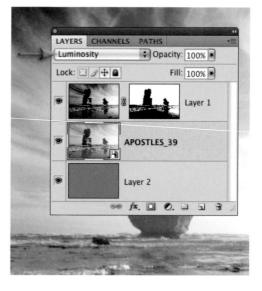

8. Click on the 'Create a new layer' icon to create a new empty layer. From the Edit menu choose Fill and then select 50% Gray from the contents menu of the Fill dialog box before selecting OK. Drag the gray layer beneath the Smart Object and change the blend mode of the smart object (the Apostles layer) to Luminosity. This blend mode will allow only the Luminance values to be visible and is a non-destructive way of removing the color from view.

9. Click on the layer mask thumbnail on Layer 2 to make it active and then go to Filter > Blur > Gaussian Blur and apply a 1-pixel blur to soften the edge of the mask a little. Select OK and then zoom in and take a close look around the edges of the rocks. If you notice a halo around any section select that portion using the Lasso Tool. Go to Image > Adjustments > Levels. Drag the central gamma slider underneath the histogram to the left to reduce the width of the halo.

10. Haloes around edges can be removed or substantially reduced using the technique in the previous step. Sometimes, however, an additional step may be required to remove the halo completely. Create an empty new layer by clicking on the 'Create a new layer' icon. Set the mode of the layer to Darken and select the Clone Stamp Tool in the Tools panel. Make sure All Layers is selected in the Options bar, hold down the Alt/Option key and click to select a clone source point just next to the lighter edge. Next, so that you can keep track of what each layer is doing, double-click on the layer names you have created to rename the layers, e.g. Layer 1 can be renamed 'Sky' and Layer 2 can be renamed 'Darken edge'.

11. As we only require the tonality of the sky on this layer we will need to mask the water and beach using the Gradient Tool from the Tools panel. Choose the Black, White gradient and the Linear options and set the Opacity to 100% in the Options bar. Set the mode to Multiply to add information rather than replace information in the layer mask. Make sure the sky layer mask is selected then drag a short gradient from just below the horizon line to just above the horizon line to mask the foreground.

Note > An alternative to the Black, White gradient in Multiply mode is to set the Foreground color to Black and then use the Foreground to Transparent gradient in Normal mode.

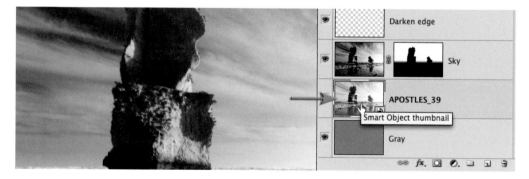

12. This step will add contrast to the waves and beach to match the expanded contrast in the sky. We can do this in one of two ways. The first way is to double-click the Smart Object thumbnail and increase the Contrast and Clarity in the Adobe Camera Raw dialog box. Click Done in ACR to close the dialog box and update the Smart Object.

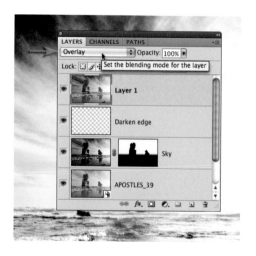

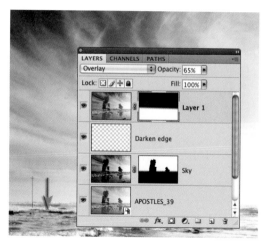

Alternatively we can choose Select > All, then Edit > Copy Merged and then Edit > Paste. These three commands can be combined into a single command which is commonly referred to as Stamp Visible by professional retouchers. This command has an unlisted shortcut which is to hit the letter E while holding down the Ctrl + Alt + Shift keys (PC) or Command + Option + Shift keys (Mac). This will create a copy of what you see on the screen and paste it as a new layer. Switch the blend mode of this layer to Overlay and then add a layer mask. Add a short Black to White gradient to this mask from just above the horizon line to just below the horizon line.

Note > Toggle the layer visibility on and off to see the actual effect this has on the image.

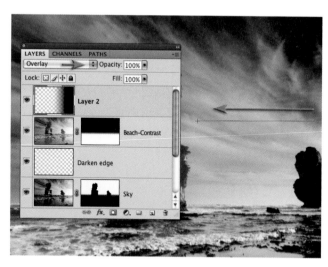

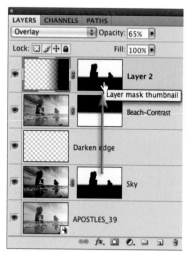

13. This step will darken the sky on the right side of the image. Click on the New Layer icon at the base of the Layers panel and set the mode to Overlay. Choose Black as the Foreground color and select a Foreground to Transparent gradient. Drag a gradient from the right side of the image to a position just short of the larger dominant rock in the sea. Hold down the Alt/Option key and drag a copy of the layer mask on the Sky layer to the Gradient layer. Lower the opacity of the Gradient layer to reduce the effect and create a balance of sky tones within the image.

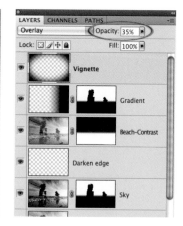

14. This step will create a subtle vignette that is designed to darken the corners without darkening the brighter highlights of the image. Add another new layer and set the mode to Overlay. Select the Elliptical Marquee Tool from the Tools panel (behind the Rectangular Marquee Tool). Drag a selection from the top-left corner to the bottom-right corner of the image. Choose Inverse from the Select menu. Press the Q key to turn this selection into a 'Quick Mask'. Go to Filter > Blur > Gaussian Blur and apply a 200-pixel blur to this mask. Press Q on the keyboard to return to the selection. Be sure the foreground color is set to black and fill the selection with black using the keyboard shortcut Alt + Backspace (PC) or Option + Delete (Mac). Lower the opacity of the layer to around 35%. Finally, don't forget to choose Select > Deselect before going on to the next step.

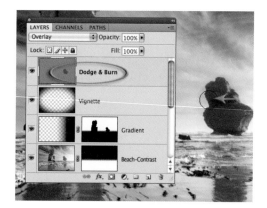
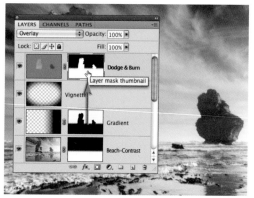

15. Create a 'Dodge & Burn' layer (create a new layer and fill with 50% gray and then set the mode to Overlay). Select the Brush Tool from the Tools panel and then choose a soft-edged brush, Opacity 10% and Normal mode from the Options bar. Set the foreground color to white to dodge or black to burn, then paint over the rock on the right to darken and increase its localized contrast. Paint several times until you are happy with the effect. It does not matter if the brushwork spills into the background sky, because we will apply a layer mask to hide any spill. Hold down the Alt/Option key and drag the layer mask from the Gradient layer to the Dodge & Burn layer. Holding down the Alt/Option key will copy the mask. Invert this mask using the Invert shortcut Ctrl + I (PC) or Command + I (Mac).

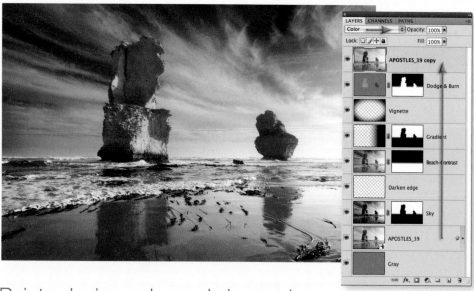

Reintroducing color and sharpening

The original color can be reintroduced in a way that preserves the tonal values we have just created. Copy the Apostles layer by holding down the Alt/Option key and dragging it to the top of the Layers stack. Right-click on the layer thumbnail and choose Rasterize if you need to reduce the overall files size and then change the mode of this copy layer to Color. Adjust the opacity until an appropriate balance between tonality and color is achieved. This Color layer does not affect the underlying luminance values that we have created in the previous steps.

Note > The ability to modify color and tonality separately and then reunite them later in the editing process can be a powerful technique for creating information-rich images where luminance values have the priority over color values.

All of the detail in this project is on the first Smart Object above the gray layer. To sharpen this project for printing apply the Unsharp Mask filter. Raising the Threshold slider in the Unsharp Mask dialog box to 3 or 4 will prevent image artifacts from being sharpened. The sky and gradients will not be sharpened using this procedure. As the layer is a Smart Object the filter will automatically be applied as a Smart Filter, allowing subsequent adjustments to the sharpening settings.

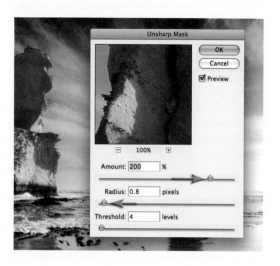

Gaussian Blur and toning – Project 2

Burning, toning, split-grade printing and printing through your mother's silk stockings are just some of the wonderful, weird and positively wacky techniques used by the traditional masters of the darkroom waiting to be exposed in this tantalizing digital tutorial designed to pump up the mood and ambience of the flat and downright dull.

Seeing red and feeling blue

It probably comes as no small surprise that 'color' injects images with mood and emotional impact. Photographers, however, frequently work on images that are devoid of color because of the tonal control they are able to achieve in traditional processing and printing techniques. Toning the resulting 'black and white' images keeps the emphasis on the play of light and shade but lets the introduced colors influence the final mood. With the increased sophistication and control that digital image-editing software affords us, we can now explore the 'twilight zone' between color and black and white as never before. The original image has the potential to be more dramatic and carry greater emotional impact through the controlled use of tone and color.

The tonality of the tutorial image will be given a split personality. The shadows will be gently blurred to add depth and character while the highlights will be lifted and left with full detail for emphasis and focus. Selected colors will then be mapped to the new tonality to establish the final mood.

1. Open the project image from the support DVD. Although the Levels have already been optimized for this file the tonality will be adjusted extensively during the following steps. Although none of the steps will cause any of the tones to become clipped in the master image file, some of the shadow tones may need extensive recovery so that they will print with detail. It is recommended that you leave the Histogram panel open for the duration of the project to monitor these tones as you work. The Histogram panel is set to RGB in Expanded View.

2. This step will create a black and white layer with good contrast above the background layer. Select the Red channel in the Channels panel. Go to Select > All and then Edit > Copy. Select the RGB channel and then open the Layers panel and choose 'Paste' from the Edit menu. The information from the Red channel will now appear in its own layer above the background layer. Choose 'Apply Image' from the Image menu and choose 'Overlay' from the Blending options in the Apply Image dialog box. Lower the Opacity to 60% and select 'OK'.

3. Use a Levels 'adjustment layer' to adjust the tonality of this layer. Click the icon of two overlapping circles that will clip the adjustment to the layer below (the adjustment will not affect the background layer). Drag the highlight slider to the left until the highlight tones in the sky disappear (hold down the Alt/Option key to be sure these tones are clipped to 255). Move the 'gamma' slider (the one in the middle) until you achieve good contrast in the shadows of the image.

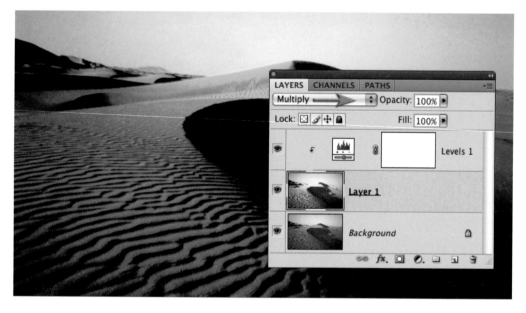

4. In the Layers panel select Layer 1 (not the adjustment layer) and switch the 'mode' of the layer to 'Multiply' to blend these modified shadow tones back into the color image. The image will appear excessively dark but will be corrected in Step 6.

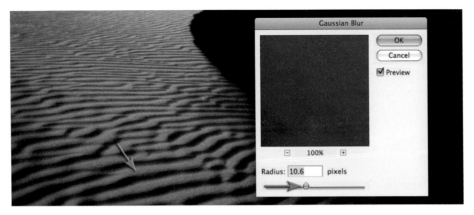

5. With the Layer 1 still selected go to Filter menu and choose Convert for Smart Filters. Then go to 'Filter > Blur > Gaussian Blur' and increase the 'Radius' (a 10-pixel radius using the project image) to spread and soften the shadow tones. With the Preview on you will be able to see the effect as you raise the amount of blur. Go to 'View > Zoom In' to take a closer look at the effect you are creating. There is no single amount of blur that will suit all images so experiment with alternate values when using images where the size and shape of the shadows are different.

Note > This effect emulates an old darkroom technique using a silk stocking placed over the enlarger lens (applied to only the high-contrast part of a split-grade printing technique made famous by Max Ferguson).

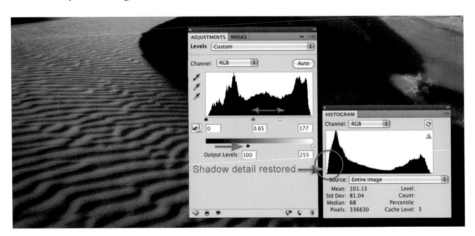

6. Open the Histogram panel and observe how the shadow tones have become compressed towards Level 0. We need to open up these shadow tones to ensure they print with detail. Select the Levels adjustment that you created earlier (note how the histogram only reflects the tones present in the layer it is clipped with and not the overall image). Drag the shadows Output slider to the right (see the illustration to ensure you have the correct slider) to lighten the shadows. Readjust the gamma slider and the highlights slider to achieve the maximum blur effect over all of the sand ripples in the foreground. Moving the highlight slider can introduce gray tones back into the sky but this can be removed with another adjustment layer and an adjustment mask in the next step.

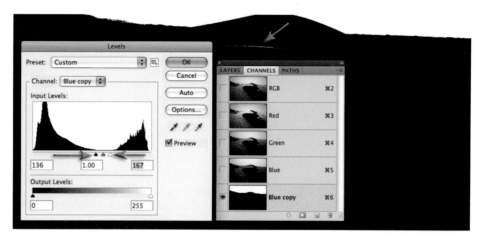

7. The second adjustment layer required to remove the gray tones from the sky will require a layer mask to limit the effects to the sky. To start this process hold down the Alt/Option key and click on the visibility icon of the background layer to switch all the other layers off. Go to the Channels panel and drag the Blue channel to the New Channel icon to create a Blue copy channel (this channel has the most contrast between the sand and the sky). Go to Image > Adjustments > Levels (you cannot apply an adjustment layer to an Alpha channel). Move the shadows slider in the Levels dialog box to clip all of the dark tones to black and move the highlight slider to the left to clip all of the sky tones to white.

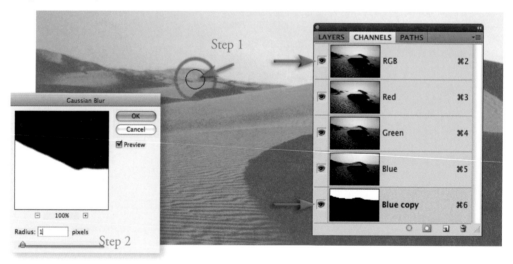

8. Fine-tune the mask by switching on the visibility of the RGB master channel. You should now see the Blue copy channel as a mask over the RGB image (remember you can change your mask color to a green to contrast better with the dunes by double-clicking on the Blue copy channel thumbnail). Make sure the Blue copy channel is the active channel, use a hard-edged brush with the foreground color set to black and then paint any areas missed by the channel masking process; make sure the brush opacity is set to 100%. Apply a 1-pixel Gaussian Blur to the finished mask. Click on the RGB channel thumbnail (not the visibility icon) to deselect the Blue copy channel and then switch off the visibility of the Blue copy channel.

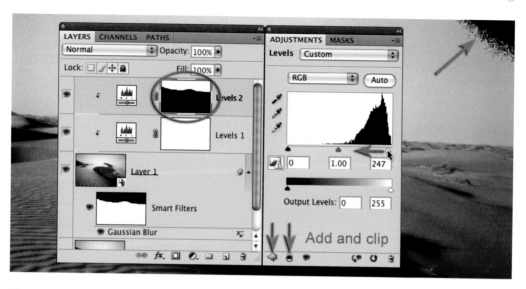

9. Load the channel mask as a selection by holding down the Ctrl key (PC) or Command key (Mac) and clicking on the Blue copy thumbnail. Switch to the Layers panel and from the Adjustments panel choose another Levels adjustment and clip this to the layer below (use the icons in the lower right-hand corner of the Adjustments panel to return to the Adjustments list and then clip the second Levels adjustment layer). The selection will become a mask and limit the adjustments to the sky. Hold down the Alt/Option key and slide the highlight slider to the left until the sky is clipped to 255.

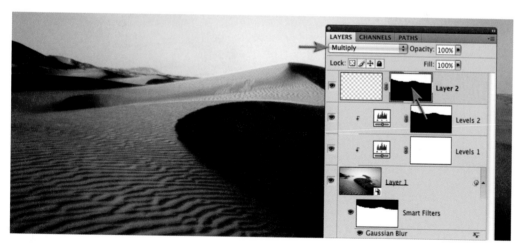

10. Bright areas of tone within the image can be distracting if they are not the focal point of the image. It is common to 'burn' skies darker so that they do not detract the viewer's attention from the main focal point of the image. In the project image the overly bright sky detracts from the beautiful sweep of the dominant sand dune. Create a new layer for a gradient by clicking on the 'Create a new layer' icon in the Layers panel and switch the blend mode to Multiply. Hold down the Alt/Option key and drag the adjustment layer mask from Levels 2 adjustment layer onto the new layer to copy it.

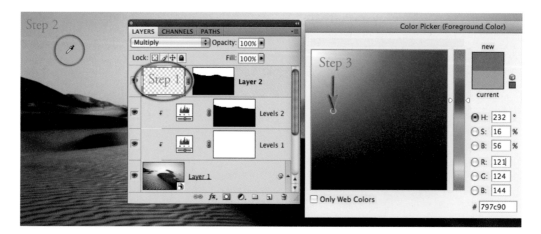

11. Make the image thumbnail, rather than the mask thumbnail, the active component of the layer. Select the Gradient Tool from the Tools panel. Click on the foreground color swatch in the Tools panel to open the Color Picker. Move your mouse cursor into the image and click on a deep blue from the sky within the image. Make the color that you selected darker by moving the sample circle in the Color Picker lower and then select OK.

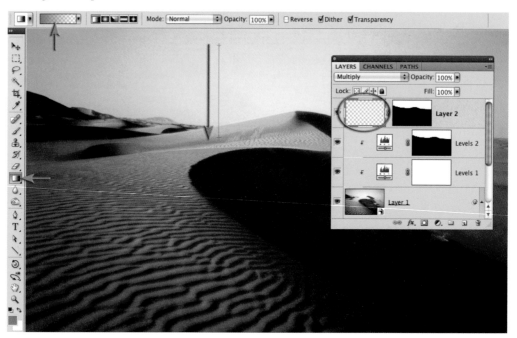

12. In the Options bar select the 'Foreground to Transparent' and 'Linear Gradient' options (make sure that Reverse is not checked). Drag a gradient from the top of the image to just below the horizon line to darken the sky. Holding down the Shift key as you drag constrains the gradient, keeping it absolutely vertical. Go to Filter > Noise > Add Noise. Check the Monochromatic option and adjust the Amount slider to a value between 1 and 2%. Adding noise will help to reduce any banding (stepping of tone) that may occur as a result of using the Gradient Tool.

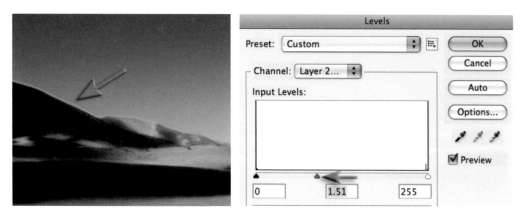

13. Zoom in and take a look at the edge where the sky meets the sand dunes. If you notice a small halo this can be corrected by making adjustments to the layer mask. Click on the layer mask thumbnail and from the Image > Adjustments menu choose 'Levels'. Moving the gamma slider will realign the edge precisely with the edge of the sand dunes. Moving the shadow and highlight sliders in the Levels dialog box will render the edge of the mask less soft.

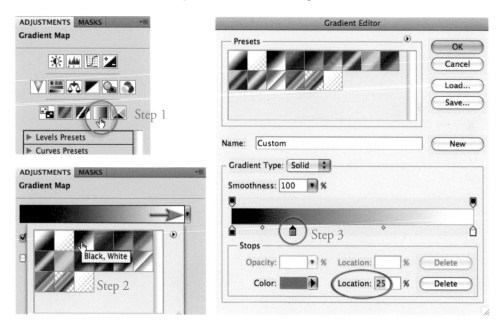

14. To introduce alternative colors into the image we can use a Gradient Map adjustment layer. Click the down arrow and in the dialog box choose the 'Black, White' gradient from the gradient dialog presets (this will remap the colors to a full tonal range black and white image), check the Dither option in the Gradient Map dialog box (to help to reduce banding) and then click on the gradient strip in the gradient dialog to open the 'Gradient Editor' dialog. Click underneath the gradient ramp to add a color stop. Move the stop to a location of 25%. Click on the mini color swatch at the bottom of this dialog box to change the color of this stop. The Select Stop Color dialog box (Color Picker) will open.

15. Choose a cool color with a brightness value of 35% to give character to the shadow tones. Choosing desaturated colors (25% or less) will help to keep the effects subtle so the tonal qualities of the image are not suppressed by overly vibrant colors. If color rather than tone is to take center stage then saturation levels of the color stops can be increased beyond 25%. Select OK to return to the Gradient Editor dialog box. Create another stop by clicking underneath the gradient ramp in the Gradient Editor dialog box and move it to a location that reads approximately 70%. This time try choosing a bright warm color with a brightness value of 90% to contrast with the blue chosen previously.

16. Fine-tune the tonality and color distribution in the image by moving each slider to the left or right to either darken or lighten this range of tones. In this project image the highlight and shadow tones are lightened by moving both stops slightly to the left. Note how the colors you have chosen are remapped to the tones as they change in brightness, i.e. as the shadow tones are made lighter they also become warmer.

17. Add a third midtone color stop if required halfway between the shadow and highlight stops. In this project image I have chosen a cool Cyan color of only 10% saturation. Drag this color stop and observe how the highlight or shadow tones can be pushed back or drawn into the adjacent tones, e.g. moving the midtone color stop to the left will let the highlight color flow through to some of the ridges in the sand ripples.

Note > Be careful not to drag any of the sliders too close together as this will cause banding in the image. Once you have created the perfect gradient you can give it a name and save it by clicking on the 'New' button. This gradient will now appear in the gradient presets for quick access. Click OK in the Gradient Editor and Gradient Map dialog boxes to commit the gradient.

18. Give your gradient a name and click on the New button to save this gradient as a preset. This preset can then be added to subsequent images that would benefit from the same toning. Click on the Save button to save Gradient Presets as a file that can then be loaded into other computers running Photoshop.

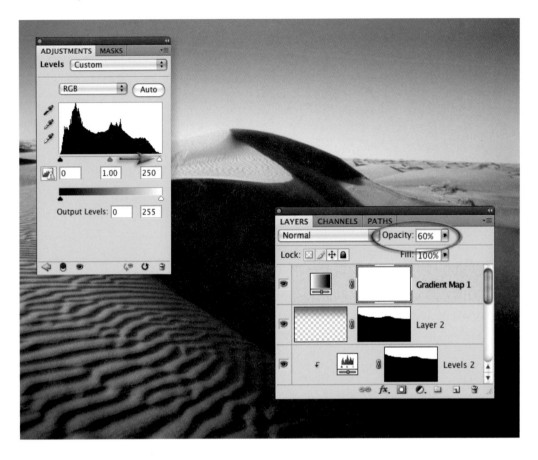

19. As a final check create one last Levels adjustment layer to ensure that your file still has a black and white point. If a small gap exists between level 0 or level 255 and the histogram make an adjustment as required. If a large gap exists check that your Gradient Map starts with a black color stop on the left and ends with a white color stop on the right.

To create a more subtle toning effect try lowering the opacity of the Gradient Map adjustment layer to let the original colors of the image blend with the introduced colors. Now all you need to do is lock yourself in the bathroom for half a day, dip your hands in some really toxic chemicals and you will have the full sensory experience of the good old days of traditional darkroom toning.

Gradient presets

A range of gradient presets including the one used in this toning activity can be downloaded from the supporting DVD and loaded into the 'presets' by double-clicking the gradients preset file or clicking on the Load button in either the Gradient Editor or the Preset Manager.

Lens Blur – Project 3

Most digital cameras achieve greater depth of field (more in focus) at the same aperture when compared to their 35 mm film cousins due to their comparatively small sensor size. Greater depth of field is great in some instances but introduces unwelcome detail and distractions when the attention needs to be firmly fixed on the subject.

Photography by Dorothy Connop

Sometimes when capturing a decisive moment with a camera the most appropriate aperture or shutter speed for the best visual outcome often gets overlooked. Photoshop can, however, come to the rescue and drop a distracting background into smooth out-of-focus colors. A careful selection to isolate the subject from the background and the application of a blur filter usually does the trick. Problems with this technique arise when the resulting image, all too often, looks manipulated rather than realistic. The Gaussian Blur filter will usually require some additional work if the post-production technique is not to become too obvious. A more realistic shallow depth of field effect, however, is created by using the 'Lens Blur filter'.

Lens Blur or Gaussian Blur?

The Gaussian Blur filter has a tendency to 'bleed' strong tonal differences and saturated colors from around your subject into the background fog, making the background in the image look more like a watercolor painting rather than a photographic image. The Lens Blur filter (when used with a mask) introduces none of the bleed that is associated with the Gaussian Blur technique. The filter is extremely sophisticated, allowing you to choose different styles of aperture and control the specular highlights to create a more realistic camera effect.

1. The first step in the process is to isolate the subjects that you would like to keep in sharp focus. The people in this project file cannot be selected quickly using any of the selection tools or by using the channel masking techniques. The Pen Tool was used to create paths around each of the children and the two parents holding hands. The three paths have been retained in the project file to fast-track the process of adjusting the focus. Hold down the Command key (Mac) or the Ctrl key (PC) and click on the Parents path in the Paths panel to load it as a selection.

2. In this step we will clear the background of some distracting elements before we move on to adjusting the focus. Go to the Layers panel and click on the 'Create a new layer' icon to create an empty new layer. Double-click on the layer name and name the layer 'Clone'. From the Select menu choose Inverse so that the background is selected instead of the people. Go to Select > Modify > Feather and choose 1 pixel. From the Tools panel choose the Clone Stamp Tool and in the Options bar choose a soft-edged brush and select the All Layers option. Hold down the Option/Alt key and set the clone source point in the sea to the left of the woman's legs. Proceed to clone out the legs of the child playing in front of the mother.

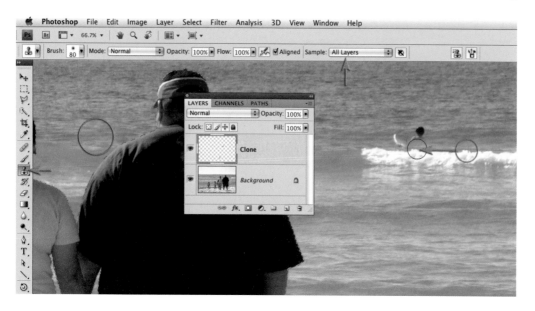

3. With the Clone Stamp Tool still selected proceed to clone out the man in the ocean just above the father's shoulder and boy on the body board just above the breaking wave on the right side of the image. The preview inside the clone stamp cursor allows you to line up the waves and the soft edge of the brush makes the cloning seamless.

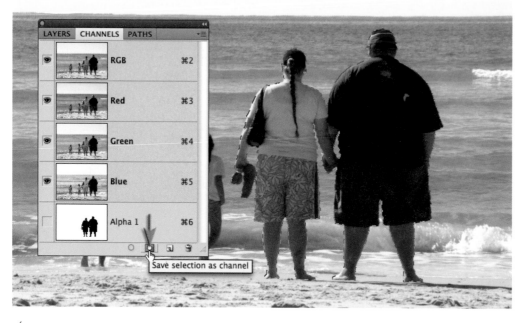

4. When you have finished cleaning up the background go to the Channels panel and click on the 'Save selection as channel' icon at the base of the panel. Go to Select > Deselect and you will now have an Alpha 1 channel which will act as a saved selection and allow us to create a depth map that can be used by the Lens Blur filter.

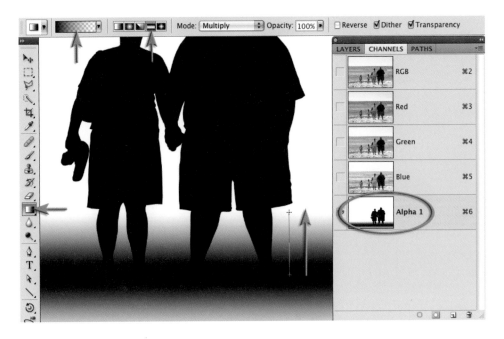

5. The mask will require further work to create an area of sharp focus in the background for positioning or anchoring the subject realistically in its environment. The subject will need to be planted firmly on an area of ground that is not blurred to prevent the subject from floating above the background. A simple gradient will allow us to anchor the subject and allow the background to fade gradually from focus to out of focus. Set the Foreground Color to black and then select the Gradient Tool from the Tools panel. Choose the 'Foreground to Transparent', 'Reflected Gradient' and 'Opacity: 100%' options in the Options bar. Drag the Gradient Tool (while holding down the Shift key to constrain the gradient vertically) from the base of the feet to the bottom of the shorts. The darker areas of this Alpha channel will help retain the focus in this part of the image.

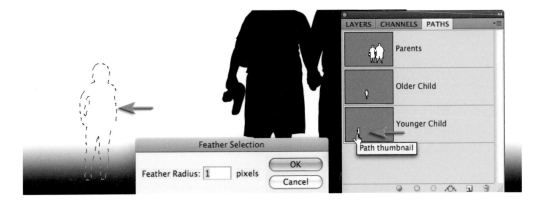

6. We will now add the children to this depth map but as they are a little further away from the camera they will not be as sharp as the parents. Go to the Paths panel and Command or Ctrl + click the Younger Child path to load it as a selection. Go to Select > Modify > Feather and choose a 1-pixel feather.

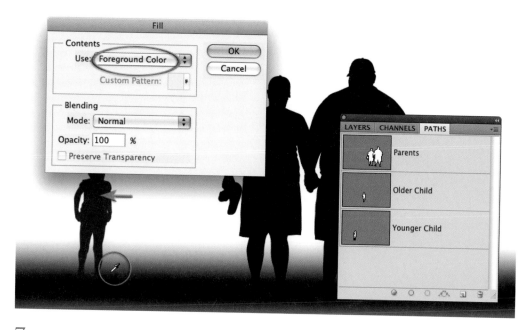

7. Sample the tone next to the child's feet using the Eyedropper Tool. This tone will become the Foreground color in the Tools panel. Go to Edit > Fill. In the Use menu in the Contents section of the Fill dialog box choose Foreground Color and select OK. The child should be slightly lighter than the parents and match the tone of the gradient at the feet. Go to Select > Deselect to clear the selection.

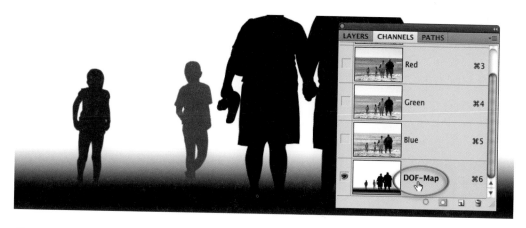

8. Repeat Steps 6 and 7 using the path of the older child. When filled with the Foreground Color the older child will be a slightly lighter gray than the younger child. The depth map is now complete and is renamed DOF-Map (by double-clicking on the name) so that it can be easily identified later. This depth map simulates the depth of field that would have been created if the image had been captured using an extremely wide aperture. Using a longer initial gradient would give you a greater depth of field in the final result. The plane of focus is falling away from the camera towards the horizon. A subject that stands vertically from this horizontal plane of focus must adopt the focus at that point in the gradient for the depth of field to appear realistic.

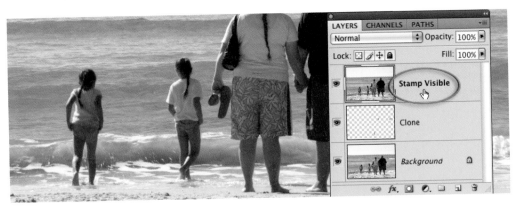

9. In the Layers panel stamp the visible elements from the two layers into a new layer. Hold down the Command, Option and Shift keys on a Mac or Ctrl, Alt and Shift keys on a PC and type the letter E. Rename the layer 'Stamp Visible'. Go to Filter > Blur > Lens Blur to open the Lens Blur dialog box.

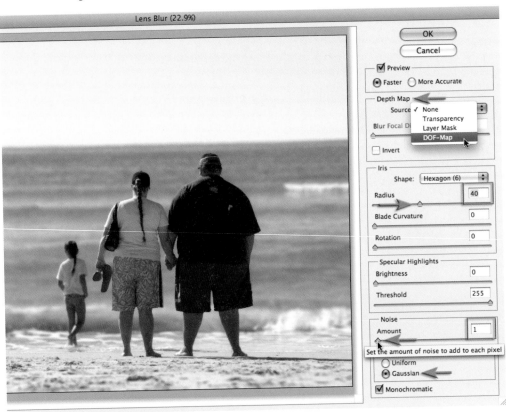

10. From the 'Depth Map' section of this dialog box choose your Alpha channel. Choose the depth of field required by moving the Radius slider. The Blade Curvature, Rotation, Brightness and Threshold sliders fine-tune the effect. Zoom in to 100% before applying a small amount of noise (1 or 2% Gaussian Monochromatic is usually sufficient) to replicate the noise of the rest of the image. Select OK to apply the Lens Blur and return to the main workspace.

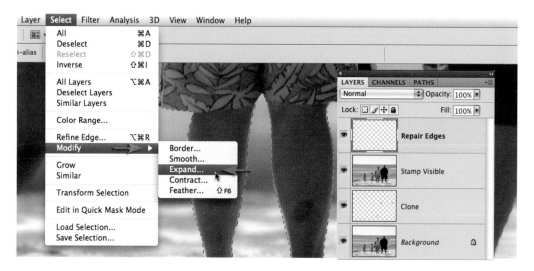

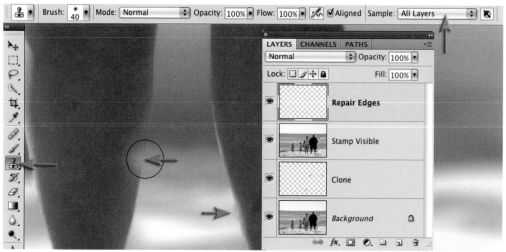

11. If part of the background along the edge of the subject is sharp when it should be blurred then this can be corrected using the Clone Stamp Tool. Create a new layer and name it Repair Edges. Load an appropriate path as a selection. From the Select menu choose Inverse and feather the selection by 1 pixel (Select > Modify > Feather). Expand the selection by 1 pixel also (Select > Modify > Expand). Select the Clone Stamp Tool from the Tools panel and choose the All Layers option from the Sample menu. Hide the selection edges by going to the View > Extras. Hold down the Alt/Option key and take a source point for the Clone Stamp Tool just next to the area to be corrected. Cloning away sharp pixels with blurred pixels will correct any minor errors that may exist. Remember to go to Select > Deselect to remove the hidden active selection before proceeding.

Note > Zoom in to 100% (Actual Pixels) and navigate around the edges. If part of the image that should have been sharp has accidentally been blurred (due to an inaccuracy with the original depth map) then add a layer mask to the Stamp Visible layer and paint with black to reveal the sharp image below.

12. To complete this project we need to correct one minor flaw and add some finishing touches. There is a small amount of pin-cushion distortion in the image that needs correcting. Stamp the Visible layers to another new layer (see Step 9) and name it Stamp Visible-Warp. Go to View > Rulers (Command or Ctrl + R). Drag a guide from the rule onto the horizon line. You will notice the horizon line curls up at each side of the image.

13. Make sure the Stamp Visible-Warp layer is selected. Go to Edit > Transform > Warp. Move your mouse cursor onto one end of the horizon line in the image window and click and drag down slowly until the horizon aligns with the guide. Move your mouse cursor to the other end of the horizon line and repeat the process until the horizon line is straight.

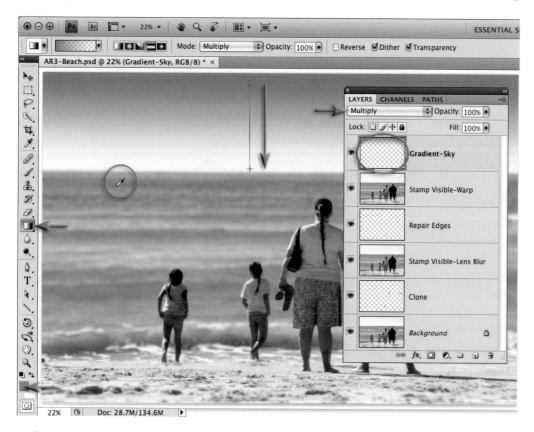

14. To breathe a little more life into that washed out sky we can add a simple gradient. Click on the 'Create a new layer' icon in the Layers panel to add a new layer named Gradient-Sky. Set the mode to Multiply. Select the Gradient Tool from the Tools panel. Hold down the Alt/ Option key and sample some of the dark blue water just below the horizon line. Select the Foreground to Transparent gradient, set to Linear gradient and drag a gradient from the top of the image down the horizon line (hold down the Shift key to constrain the line to a vertical).

15. Hold down the Alt/Option key again and this time sample a color from the sand. Using a Reflected gradient drag a short gradient from a position just below the feet to the edge of the water. Drag a second gradient in the same position if the sand needs darkening further.

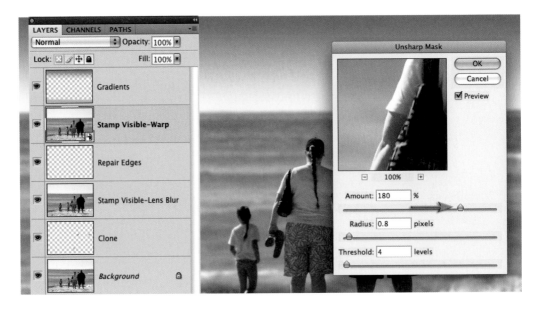

16. All that remains to finish the project is to sharpen the image. Click on the top Stamp Visible-Warp layer in the Layers panel (the one that was warped straight). Go to Filter > Convert for Smart Filters. Next go to Filter > Sharpen > Unsharp Mask. Sharpen the image using a generous amount and a small radius setting (between 0.5 and 1.0 pixel). There is no need to sharpen the gradients as there is no detail in this layer that requires sharpening.

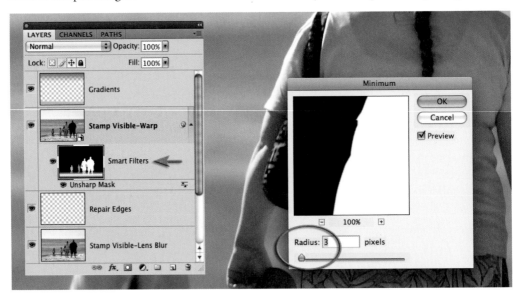

17. If the edges around the subject appear too sharp, select the Smart Filters mask thumbnail in the Layers panel, go to the Channels panel and Command or Ctrl + click on your depth map to load it as a selection. Fill the selection with Black (Edit > Fill > Black) and then go to Filter > Other > Minimum and choose a Radius of 3 or 4 pixels to expand the mask and protect the edge from the sharpening filter.

Surface Blur – Project 4

A fellow photographer was showing me some images the other day that he had captured with a camera that uses a plastic lens. The images had a certain attraction. Although the images had some pretty shocking vignetting and heavy distortion he was drawn to the beautiful liquid smooth tones that the plastic lens was offering up. Most women who look at photographs of themselves would agree that crunchy detail is just not a good look. A digital camera can be a very cruel tool that captures way too much information. Most people would prefer their skin to appear smooth, but not featureless, and will thank the photographer when they can reveal a skin texture that does not shout its detail and defects to the viewer.

Ozgurdonmaz (www.iStockphoto.com – image number 5009631)

The craft of professional skin retouching is the ability to render perfect skin without giving your model the appearance of a plastic-fantastic shop window mannequin. The image used in the project is a section of a larger image from iStockphoto.com (image number 5009631). A 12-megapixel DSLR with a professional grade lens at point blank range and a generous amount of in-camera sharpening is a very cruel combination for showing every minor imperfection in the skin's surface (check out the nose). The technique in this tutorial can be used at full throttle to render the skin suitable for use in a skin care advertisement, or toned down a little to return the skin to something approaching normal (rather than how the camera lens captured it).

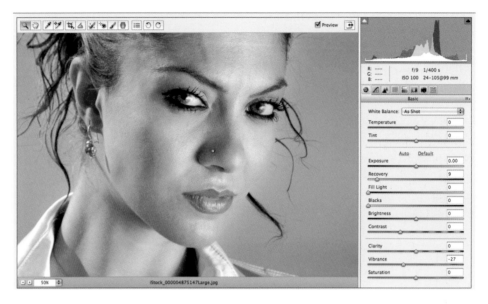

Ozgurdonmaz (www.iStockphoto.com – image number 4875147)

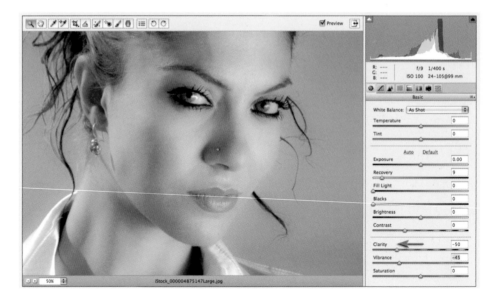

Adjustments in Adobe Camera Raw

Many of the basic image adjustments to a model's face that had to be performed in the main editing space can now be carried out much faster in Adobe Camera Raw (ACR). In Adobe Camera Raw 5 we now have the option to use a 'Negative Clarity' adjustment. This is useful to soften and suppress detail and texture. In the example above the Clarity slider has been dropped to −50 to illustrate how the adjustment can be used to reduce the excessive detail in the model's skin. Negative Clarity can also be painted with the Adjustment Brush to avoid haloes around high-contrast edges.

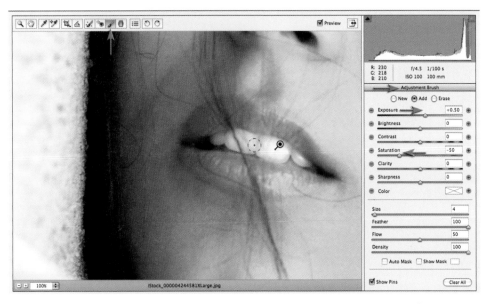

Angelika Stern (www.iStockphoto.com – image number 4244581)

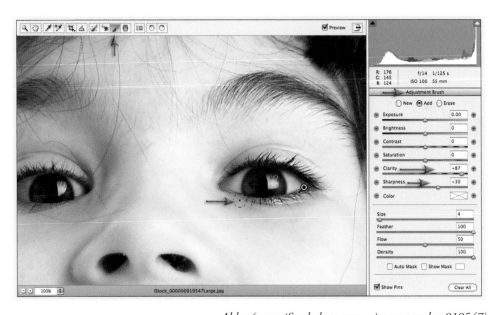

Aldra (www.iStockphoto.com – image number 919547)

The Adjustment Brush is new to Adobe Camera Raw 5 that ships with Photoshop CS4. The Adjustment Brush can be programmed to apply multiple adjustments at the same time, e.g. it can lighten the whites of the eyes and the teeth at the same time as lowering the saturation so that eyes look clean and bright (rather than dark and bloodshot) and teeth look white rather than yellow. The Adjustment Brush can also be used to quickly add depth and detail to eyelashes and eyebrows by using a positive clarity together with some sharpening. The adjustments that follow in the project are best carried out in the main editing space.

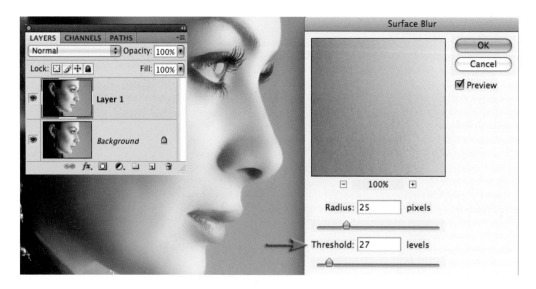

1. Start the process of smoothing the skin by duplicating the background layer using the keyboard shortcut Ctrl + J (PC) or Command + J (Mac). Then go to Filter > Blur > Surface Blur. This filter, unlike the Gaussian Blur filter, has a 'Threshold' slider that, if used correctly, will leave edges crisp and sharp while blurring the surfaces inside the edges. This will ensure there are no nasty haloes around the edges of your subject as a result of the blurring process.

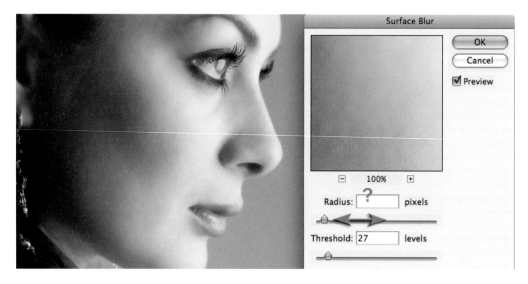

2. It is important to get the balance right between the Radius and the Threshold slider settings for each and every image (there is no one 'perfect recipe' that suits every image). To get a feel for what these two sliders do, set them both to a value between 20 and 25. Now move the Radius slider lower until you detect the surface tone becoming 'mottled' or 'blotchy' and then move it higher again until the surface appears very smooth. Finding the minimum radius that renders the surface smooth is your goal here.

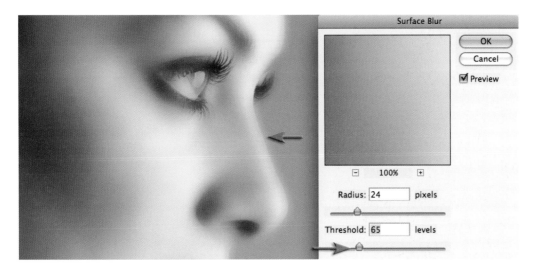

3. Now drag the Threshold slider higher until you see haloes appear around the edges of your subject. Back the slider off to a point where all of the haloes disappear. If you continue to move the slider lower, after the haloes have disappeared, you will start to reintroduce the finer detail that was removed by the Radius slider. Try to make the surface as smooth as possible at this stage as we will reintroduce the texture of the skin in a later step.

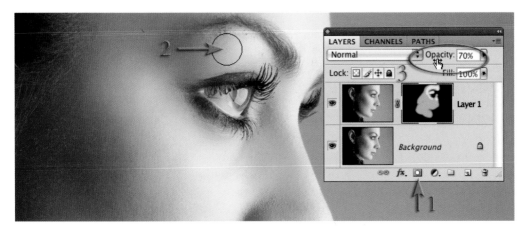

4. Select OK to apply the Surface Blur filter. Then hold down the Alt key (PC) or Option key (Mac) and click on the 'Add layer mask' icon at the base of the Layers palette. This will add a layer mask filled with black that conceals the surface blur on Layer 1. Select white as the foreground color in the Tools palette and then choose a soft-edged brush. Set the brush opacity to 60–80% in the Options bar. Make sure the layer mask is selected and then paint to reveal the blur in the areas of the skin only. You do not need to be too critical about accuracy as areas of fine detail such as the eyelashes and the contours of the face have already been preserved on the Surface Blur layer. You will, however need to avoid painting over areas such as the lips to ensure fine detail is not lost in these areas. Paint a second time to reveal additional softening where needed. Lower the opacity of the layer if you need to reduce the effects of your painting.

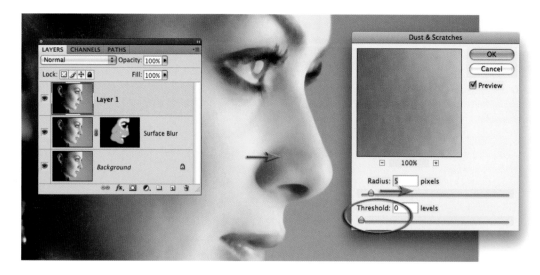

5. In this step we will eliminate minor imperfections in the skin that the Surface Blur filter could not smooth over. Rename the top layer in the Layers panel to Surface Blur and with this layer active hold down the Ctrl + Alt + Shift keys (PC) or Command + Option + Shift keys (Mac) and press the letter E to stamp the visible elements of the project to a new layer. Go to Filter > Noise > Dust & Scratches and set the Threshold slider to 0. Raise the Radius slider just enough to remove the imperfections from the nose (between 3 and 7 pixels). Don't worry about the lack of texture at this point in time, we will be adjusting the Threshold slider in the next step.

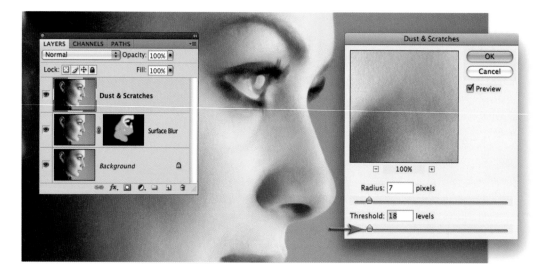

6. Raise the Threshold slider to reintroduce surface texture but stop just short of the point where the larger skin imperfections start to reappear. Select OK to apply the filter. Then hold down the Alt/Option key and click on the 'Add layer mask' icon at the base of the Layers palette to conceal the effects of this layer.

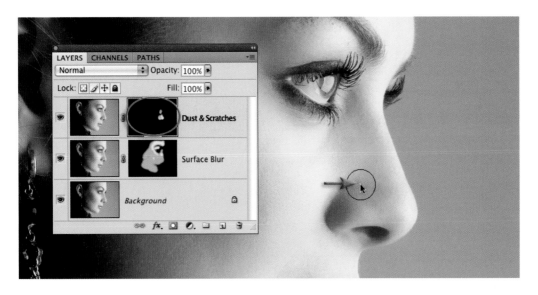

7. Select the Brush Tool and white as the foreground color in the Tools palette and set the Opacity to 100% in the Options bar. Zoom in to 200%, be sure the layer mask is selected and paint to remove any imperfections from the nose and around the eyes. Hold down the Spacebar and click and drag to move the image in the image window so that you can navigate around the surface of the skin to look for additional imperfections. The skin should now be rendered smooth but with realistic surface texture and free from all minor imperfections.

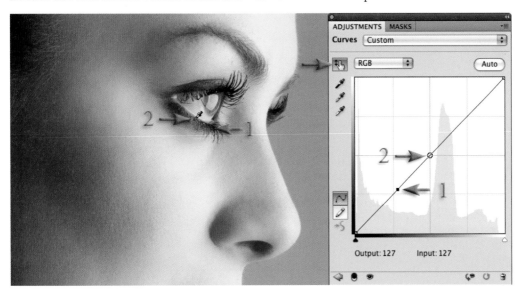

8. In this step we will brighten the white of the eye without upsetting the tonality of the eyeliner. Create a Curves adjustment layer and select the targeted adjustment tool icon in the upper left-hand corner of the Curves dialog box that looks like a scrubby slider icon. Click once on the black eyelashes and a second time on dark eyeliner to set adjustment points. These adjustment points will anchor these tones when we adjust the whites of the eye in the next step.

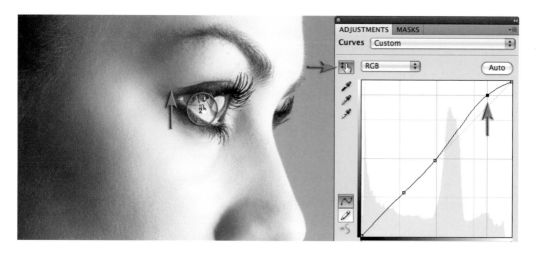

9. Move your mouse cursor over the white of the eye and click and drag upwards (do not let go of the mouse button as you drag) to raise the brightness of the whites of the eye. Set the blending mode of the adjustment layer to Luminosity to remove the shift in color saturation that this curve has created. Fill the adjustment layer mask with black. If you have black as the background color in the Tools panel use the keyboard shortcut Ctrl + Backspace (PC) or Command + Delete (Mac) or go to the Edit menu and choose 'Fill'.

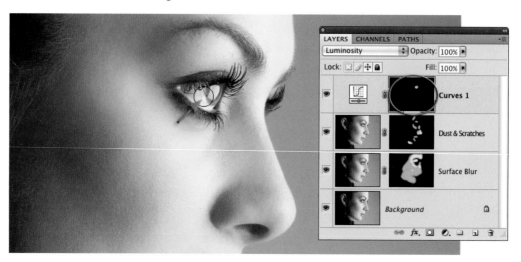

10. Make sure you still have white as the foreground color and select the Brush Tool in the Tools palette. Set the Opacity to 50% in the Options bar and then paint over the eye to lighten the white of the eye. If you accidentally brush over the eyelashes or eyeliner you will probably not see any change to these darker tones as the darker tones have been locked down by the initial adjustment points you entered into the Curves dialog. This technique for smoothing the skin and lightening overly dark shadows and the whites of the eyes provides excellent results without any finesse or expertise required in the use of the Brush or Airbrush.

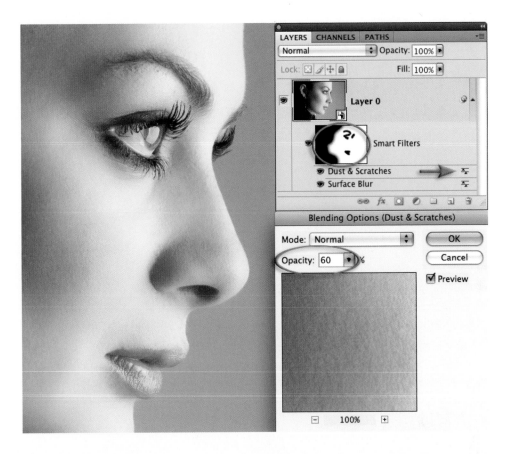

A Smart Filter approach (with limitations)

A simplified approach: This can be achieved by going to the Filter menu and choosing 'Convert for Smart Filters'. Apply the Surface Blur filter as before and then the Dust & Scratches filter. Use a conservative Radius setting for the Dust & Scratches filter as you only have a single layer mask to hide the effects of both the Surface Blur filter and the Dust & Scratches filter, i.e. hide the effects of one filter and you hide the other. Paint in the Smart Filters mask to shield the eye, eyebrows, lips and hair from the effects of these combined Smart Filters.

A complex approach: To overcome the limitations of a single mask for multiple Smart Filters it is also possible to place one Smart Object inside another Smart Object (with one filter applied to each Smart Object – thereby gaining access to separate layer masks for each Smart Filter). To adopt this more complex approach first apply the surface blur and complete the masking as outlined in Step 4 of this project. Then go to Layer > Smart Objects > Convert to Smart Objects (the option to Convert for Smart Filters will be unavailable). This action will place the Smart Object and its Smart Filter inside another Smart Object. You will then be able to apply the Dust & Scratches filter to this second Smart Object and be able to dedicate the new Smart Filter layer mask to masking just the Dust & Scratches. The downside to this approach is that you will not be able to see both Smart Filters at the same time.

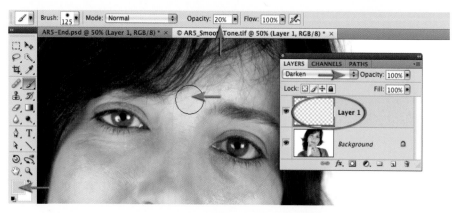

Carmen Martinez Banus (www.iStockphoto.com)

Removing shine from skin

Click on the 'Create a new layer' icon in the Layers panel and set the mode to 'Darken'. Select the Brush Tool from the Tools panel and choose a large soft-edged brush in the Options bar. Set the Opacity of the brush to 20%. Take a color sample by holding the Alt/Option key and clicking on an area of skin just outside the highlight and then paint over the areas to suppress these highlights. A couple of passes with the brush may be required. The blend mode will protect the eyebrows and hair as these are darker than the sample color.

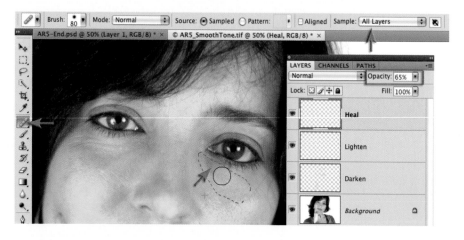

Reducing shadows and wrinkles

Click on the 'Create a new layer' icon in the Layers panel. Make a selection of the healing area that excludes the dark eyelashes and eyeliner (when working up against areas of different tone or hue you need to isolate the healing area from dark tones or saturated colors). Use a 1-pixel feather in the Options bar when using the Lasso Tool. Select the Healing Brush Tool (not the Spot Healing Brush Tool) from the Tools panel and select the All Layers option in the Options bar. Lower the Opacity of the healing layer to bring back some of the character to a face.

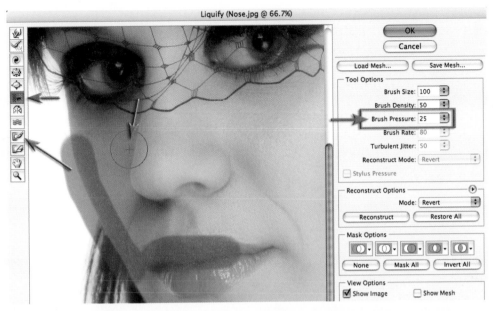

Photograph by Jennifer Stephens

Pixel surgery

The Liquify filter can reshape facial features, if this does not present an ethical dilemma for the retoucher or model. The various tools in the Liquify filter dialog box can be used to modify the shape or size of the sitter's features. The Pucker Tool and Bloat Tool can be used to contract or expand various features, e.g. grow eyes or lips and shrink noses. Perhaps the most useful of the Liquify tools, however, is the Shift Pixels Tool. This tool can be used to move pixels to the left when stroking down and to the right when stroking up. This tool is ideal for trimming off unsightly fat or reshaping features. In the illustration the brush pressure is dropped to 25%. The side of the face and the top of the lips have been frozen using the Freeze Mask Tool so that the side of the face and lips are not moved along with the nose. If things start to get ugly just remember the keyboard shortcut Ctrl/Command + Z (undo)!

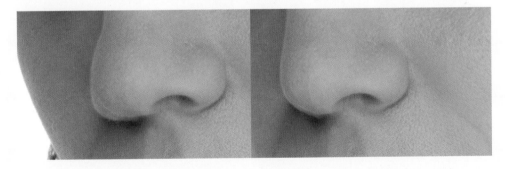

Note > It is important to exercise great restraint when using the Liquify filter, as the face can quickly become a cartoon caricature of itself when taken too far. The filter also softens detail that becomes obvious when overdone.

Motion Blur and Radial Blur (spin)

We have looked at Gaussian Blur, Surface Blur and Motion Blur in the preceding projects. The Motion Blur and Radial Blur filters help to extend the creative possibilities. The Motion Blur rather than the Radial Blur filter dominates the effect in the image above. The Radial Blur filter is, however, used to spin the wheels. When the wheels appear as an ellipse the following technique must be used to ensure a quality result.

Make a selection with the Circular Marquee Tool using a small amount of feather. Copy the wheel and paste it into a new layer. Use the Free Transform command and drag the side handle of the bounding box until the wheel appears as a circle instead of an ellipse. To get the best result from the Radial Blur filter we must present the wheel on the same plane to the one in which the filter works, i.e. front on. From the Blur group of Filters choose the Radial Blur filter. When you have applied the filter choose the Transform command again and return the wheel to its original elliptical shape.

iStock_000001143384 (Endless Highway 2 by ra-photos)
iStock_000001300100 (BMW 318i by felixR)

Radial Blur (zoom)

When the movement is towards the camera the illusion of movement can be created by using the Radial Blur filter instead of the Motion Blur filter. To reduce the effects of the blur in the distance the filter can first be applied to a duplicate layer and this duplicate layer can then be grouped with an adjustment layer that contains a radial gradient. The sky was also masked using a linear gradient in Multiply mode.

The car in this illustration came from a separate image and was masked using the techniques outlined in the chapter Montage Projects in this book. The original shadow was preserved using the techniques outlined in the Retouching Projects chapter.

Smooth tone and tonal mapping – Project 5

In commercial photography the post-production treatment is discussed early in the pitch to the agency or client. One of the cutting-edge treatments in commercial photography, that is all the rage at the moment, is where maximum detail and surface texture are expanded along with midtone contrast. The final effect is one where the image seems to be part photograph/part illustration. Take a look at http://www.davehillphoto.com/ to get an idea of how this treatment is being applied by one popular photographer in the USA.

Autumn in Bright, Victoria
Mark Galer

The treatment works best when there is directional light falling across the subject. Use either low directional sunlight or introduced photographic lights to create the optimal effect. In this project we will combine two techniques to create a signature style. The first technique is designed to smooth the overall tones of the image while the second exaggerates midtone contrast and creates greater depth within the finished image. The project culminates with localized saturation control, a vignette and sharpening to create a look that is part photographic and part illustration.

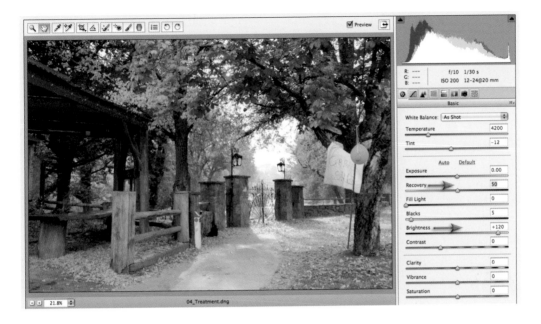

1. Open the .dng project image and protect the highlight tones in Adobe Camera Raw. The Raw file on the DVD has had the exposure of the brightest highlights lowered using both the Adjustments Brush and the Recovery slider (see Raw Processing) and the Brightness slider has been raised to increase the luminance of the midtone values.

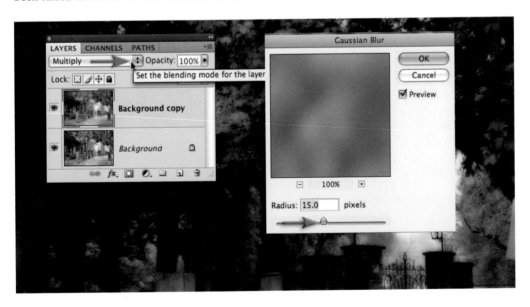

2. In the next three steps we will create some smooth tones before we expand the midtone contrast and surface texture. Start by duplicating the background layer by dragging it to the 'Create a new layer' icon in the Layers panel. Set the mode to Multiply. Next, go to Filter > Blur > Gaussian Blur. Use a Radius of around 15 pixels for images from an 8 to 14 megapixel camera. Decrease the amount for low-resolution images.

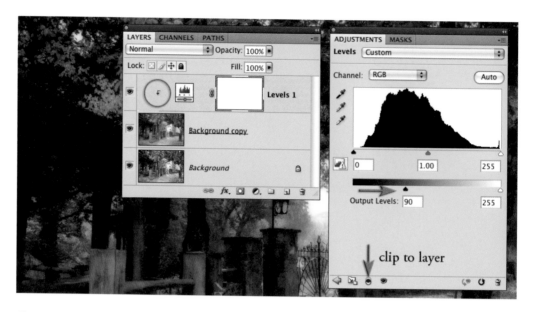

3. From the Adjustments panel choose a Levels adjustment and click on the 'clip to layer' icon at the base of the Adjustments panel. Raise the Output slider to a value of around 90 Levels to protect the shadows from becoming too dark.

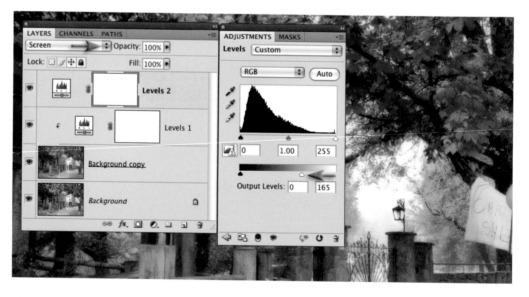

4. Return to the Adjustments list and create a second Levels adjustment and name the layer 'screen'. Do NOT clip this to the previous Levels adjustment as we need to lighten all tones (not just the ones on the background copy layer). Set the layer mode to Screen and drag the highlight slider to the left to a value of around 165 to protect the brightest highlights in the image.

Note > The first adjustment layer is designed to preserve the shadow detail and the second adjustment layer (the one set to Screen mode) controls the highlight brightness. Experiment with adjusting these sliders to achieve the correct balance using different images.

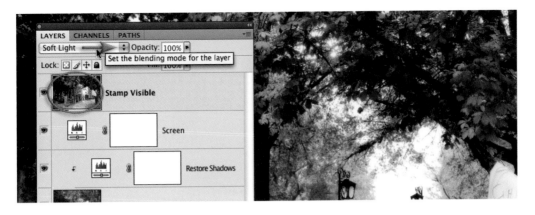

5. Hold down the Ctrl, Alt and Shift keys on a PC or Command, Option and Shift keys on a Mac and press the letter E to stamp the visible layers to a new layer (name the layer Stamp Visible). Set the layer mode to Soft Light and then desaturate the color from the layer using the keyboard shortcut (Command + Shift + U on a Mac or Ctrl + Shift + U on a PC).

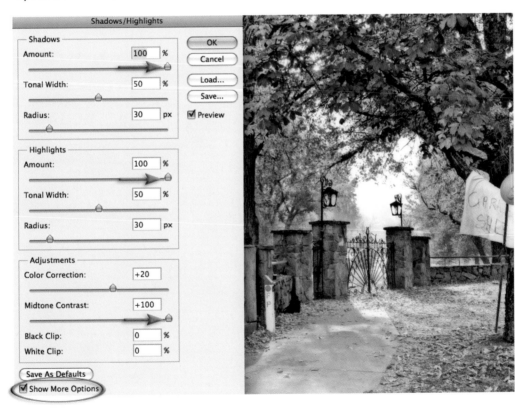

6. Go to Image > Adjustments > Shadows/Highlights and click on the Show More Options checkbox to expand the dialog box. Set the Amount for the Shadows, Highlights and Midtone Contrast to +100. Set the Tonal Width for the Shadows and the Highlights to +50 and then select OK to apply the changes.

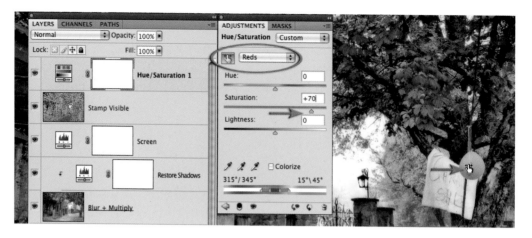

7. In this step we will selectively target just a few colors to remain fully saturated while the others can be subdued. From the Adjustments panel select a Hue/Saturation adjustment. Lower the overall saturation to –20 and then click on the targeted adjustment tool and click on the balloon and drag to the right to increase the saturation of the Reds to around +70. The targeted adjustment tool will automatically target the reds when you click on the balloon.

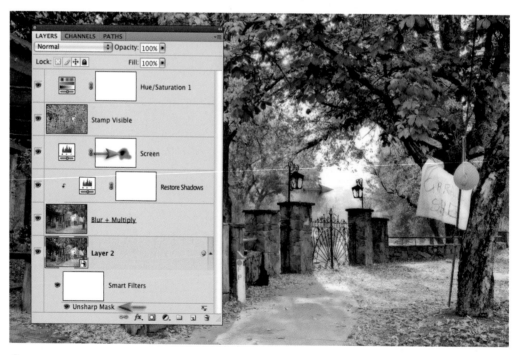

8. You may need to check that you still have a good spread of tones before signing off on the project. In the illustration above I have painted with black into the layer mask of the Screen layer to ensure those very bright highlights are not clipped to white. Finally the base layer is converted for Smart Filters and an Unsharp Mask is applied using the approximate settings of 180 for the Amount, 0.5 for the Radius and 3 for the Threshold.

Smart Objects – Project 6

Striking the right balance between ambient light and introduced light can be the difference between sweet success and dismal failure. This project (together with the Shadow/Highlight project in Retouching Projects) demonstrates the art of balancing the lighting in post-production rather than at the time of capture.

The original exposure is a compromise between background and foreground – neither delivers the goods but plentiful information is available in both to allow further work to be carried out

Instead of using the excellent Shadow/Highlight adjustment feature we now have the option with this project file of using the extended dynamic range of the Raw file format. Different exposures can be extracted from a single Raw file and combined in Photoshop's main work-space. This project will introduce the technique of using several Smart Objects, each being generated from the same Raw file. The initial Camera Raw settings used to create each Smart Object can be subsequently modified if required. This ability to double-click on a Smart Object (generated from a Raw file), open the ACR dialog box and adjust the settings is similar to reopening an adjustment layer or Smart Filter to modify its settings. Even if the project file is in 8 Bits/Channel mode, any changes or modifications to the Smart Object, via the ACR dialog box, are occurring at a higher bit depth so optimum quality is preserved.

New horizons

Modifying exposure is just the tip of the iceberg when it comes to the creative possibilities of using Raw files as Smart Objects, e.g. the photographer could change from a small color space to a large color space and simply access the additional colors from the ACR dialog box.

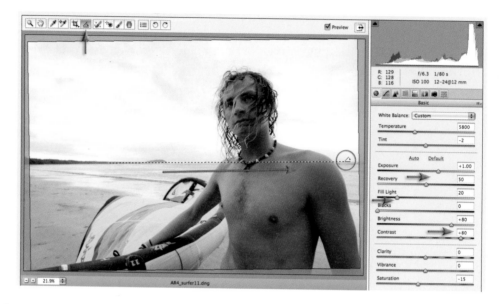

1. Open the Raw project file in the Adobe Camera Raw dialog box (ACR). Set the Color Temperature to 5800 and the Exposure slider to +1.00 to optimize the tonality for the young man. Raise the Fill Light slider to 20 and the Recovery slider to 50 to prevent any clipping in the sky and lighter strands of hair. The Brightness and Contrast sliders can also be raised to +80 to further enhance skin tones. Lower the Saturation slider to −15. Click on the Straighten Tool in the ACR dialog box (upper left-hand corner) and click and drag along the horizon line.

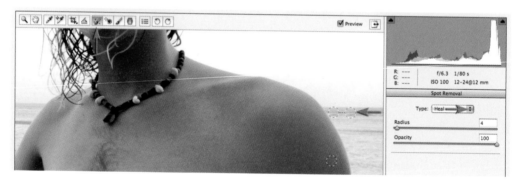

2. Click on the Spot Removal Tool (top left-hand corner of the ACR dialog box). Select 'Heal' from the 'Type' options. Zoom the image to 100% magnification and move to the area of the image just to the left of the man's shoulder (on the right side of the image). Remove the distracting dark item from the sea (just below the horizon line) by clicking on the center of the item and dragging until the selection area just covers the blemish. Let go of the mouse button for the healing action to work. Drag the second green circle (the source) to a new area for a better match (along the ridge of the wave). A small white dot (known as a 'hot pixel') appears on the man's arm close to the first retouching procedure (zoom to 200% if necessary). A third and final blemish can be removed from the sky on the left side of the image (a distant kite). Hold down the Shift key and select Open Object in the ACR dialog box to open this file into Photoshop's main workspace.

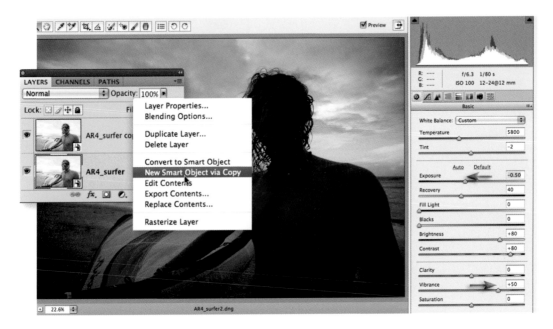

3. Right-click on the Smart Object in the Layers panel and choose the New Smart Object via Copy command. This will allow you to change the setting in Adobe Camera Raw without affecting the first Smart Object. Double-click on the Smart Object copy and the Adobe Camera Raw dialog box will open with the previous settings that were applied during Step 1. Modify these settings to optimize the file for the sky by lowering the Exposure slider to −0.50. Increase the Vibrance slider to +50 and select OK.

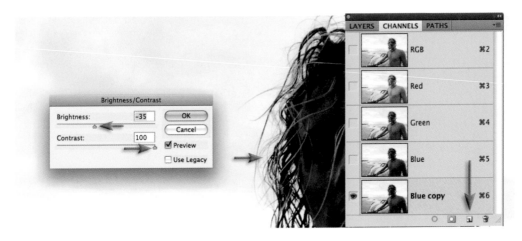

4. The goal of the following series of steps is to create an effective mask for the sky. Switch off the visibility of the copy layer in the Layers panel. In the Channels panel click and drag the Blue channel (the one with the best contrast between the sky and the foreground) to the 'Create a new channel' icon to duplicate it. From the Image > Adjustments menu choose Brightness/Contrast. Adjust the sliders to make the sky as light as possible without losing the fine detail in the hair (Brightness −35 and Contrast +100).

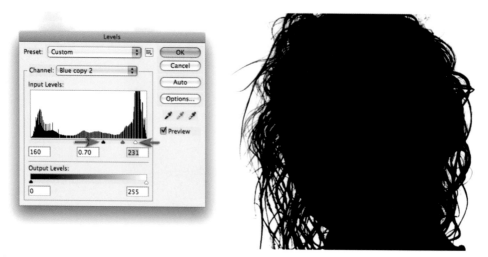

5. With the Blue copy channel still selected go to Image > Adjustments and choose Levels (Ctrl or Command + L). Drag the black shadows slider underneath the histogram to the right to clip all of the shadow tones to black. Drag the white highlights slider to the left to render most of the areas of sky white. You will need to zoom in and observe the fine detail in the hair as you drag the white highlights slider. You cannot render all of the sky white using this slider without losing the strands of fine hair.

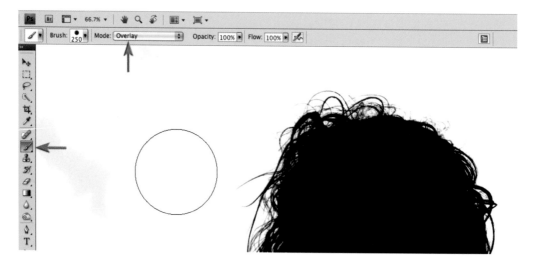

6. Select the Brush Tool from the Tools panel, choose a large soft-edged brush and set the foreground color to White. Set the Mode in the Options bar to Overlay (to protect the darker tones) and set the Opacity to 100%. Paint the gray areas of the sky white. Paint up to, but NOT over, the thin strands of hair. The Overlay mode will help in the process of creating an effective mask as you cannot paint white over areas that are already black, and black over areas that are already white, using this blend mode. The foreground will be masked in the following steps.

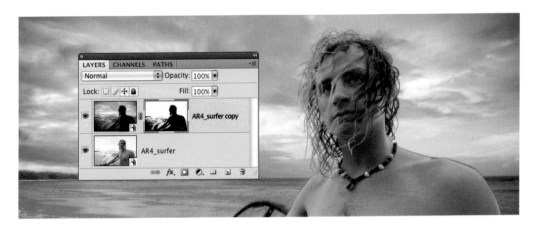

7. Load the Blue copy channel as selection (Ctrl/Command-click the channel thumbnail). Click on the RGB master channel to return to the normal RGB before returning to the Layers panel. Hold down the Alt/Option key as you click on the 'Add layer mask' icon in the Layers panel to mask the sky. Make a selection of the figure and sail using either the Pen Tool or the Lasso Tool (ensure no feather is applied at this stage).

Note > An alpha channel and path are available in a supporting TIFF file for this section of the image if you wish to fast-track the project (AR6_Surfer-Stage1.tif).

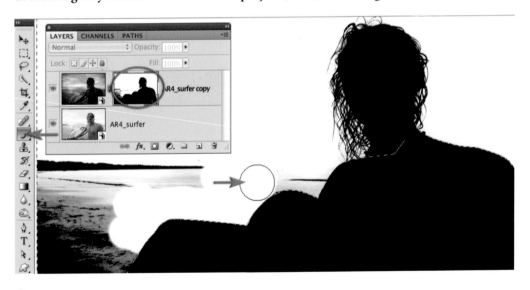

8. The goal of this step is to render the water and the beach in the mask completely white. Hold down the Option/Alt key and click on the layer mask thumbnail to view the layer mask contents. Fill the active selection of the figure and sail with black (Edit > Fill > Black). Invert the selection (Select > Inverse) and then select white as the foreground color. Set the blend mode to Normal and the Opacity to 100% and then proceed to paint all of the beach outside of the selection white. Be careful to avoid the hair in this procedure. From the Select menu choose Deselect. Click on the layer thumbnail to revert to the normal RGB view.

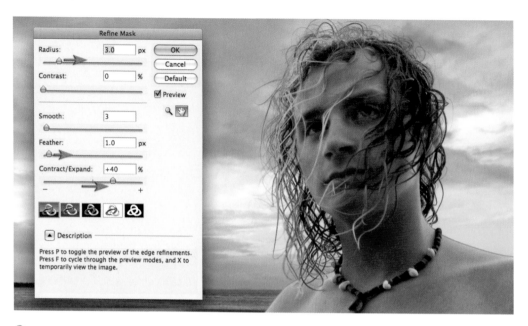

9. To further refine this mask go to Select > Refine edge. To hide the selection edges go to the main View menu and deselect Extras (Command + H on a Mac or Ctrl + H on a PC). Raising the Radius slider to a value between 1.0 and 3.0 pixels and selecting a Feather radius of 1.0 pixel may improve the quality of the hair. Move the Contract/Expand slider to the right to hide most of the dark edges from around the body. The Refine edge cannot adjust localized areas of the mask so this last step may leave some of the edges with a dark fringe. Ignore the lighter edges on the man's left arm on the right side of the image for now.

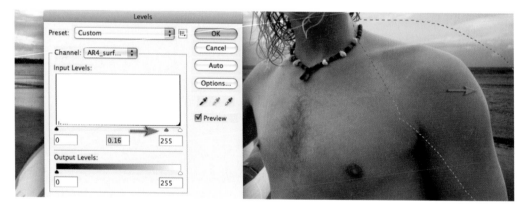

10. Select the Lasso Tool and set the Feather radius in the Options bar to 10 pixels. Make a selection of any localized portion of the edge that still has a dark fringe. Go to Image > Adjustments > Levels and move the center gamma slider in the Levels dialog box to the right to remove the remaining dark edges from the mask. Continue to make localized selections of any problem areas and move the mask edge using the levels technique to fine-tune the transition between the two layers. The Feather setting in the Options bar will render a smooth transition between the section of the edge that is being moved and so avoid creating a step in the otherwise smooth edge.

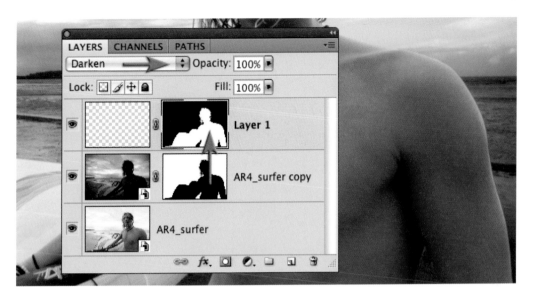

11. The following steps will set out to darken the light skin tones along the shoulder and arm that appear too light now that the background has been darkened. Click on the 'Create a new layer' icon and set the mode to Darken. Hold down the Alt/Option key and drag the layer mask from the surfer copy layer to the new layer (Layer 1). Use the keyboard shortcut Ctrl + I for a PC or Command + I for Mac to invert the mask.

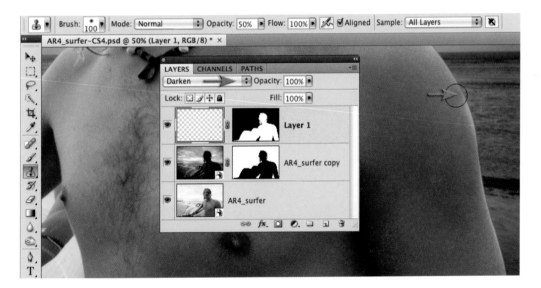

12. Select the empty image thumbnail (rather than its layer mask) to make it active. Choose the Clone Stamp Tool, set the Opacity to 50% and choose All Layers from the Sample menu in the Options bar. Hold down the Alt/Option key and click just to the left of the edge to select a clone source point. Click and drag to clone darker pixels along the lighter edge. A second pass may be necessary to create a satisfactory darker tone. Now that we have darkened the lighter edge we can also modify the shading.

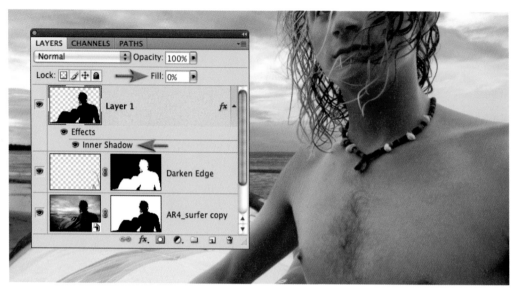

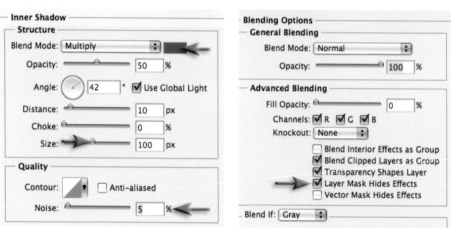

13. The lighting down the young man's left arm (right side of image) may appear too light even when the alignment of the mask is perfect (the arm is back lit against the lighter sky). Hold down the Ctrl key (PC) or Command key (Mac) and click on the layer mask thumbnail of the top layer (the one you set to Darken mode) to load the mask as a selection. Click on the 'Create a new layer' icon in the Layers panel to create an empty new layer. From the Edit menu choose 'Fill' and select Black as the fill color before selecting OK. Go to Select > Deselect. Lower the Fill for this layer to 0% in the Layers panel (the black pixels will now be transparent but still allow us to add a visible layer style). Click on the *fx* icon (Layer style) at the base of the Layers panel and choose 'Inner Shadow'. In the Layer Style dialog box adjust the opacity, distance and size to darken the light edge on the arm (ignore any excessive darkening in other areas). Add 5% Noise so this color is not flat. Click on the small color swatch and move into the image to sample a darker skin color from the image. Click on the Blending Options tab in the upper left corner of this dialog box and then check the 'Layer Mask Hides Effects' option before clicking OK to apply this layer style.

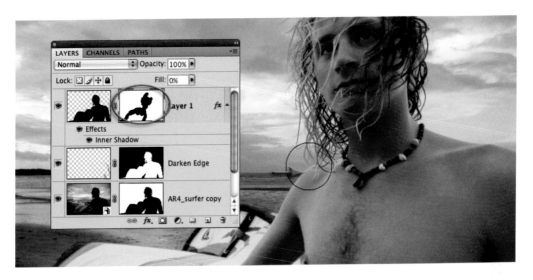

14. Add a layer mask to the layer and then paint with black at 100% Opacity to conceal any areas on the left side of the figure that do not require darkening. Lower the opacity and use a soft-edged brush to paint along the top of the shoulders to reduce the shadow in this area.

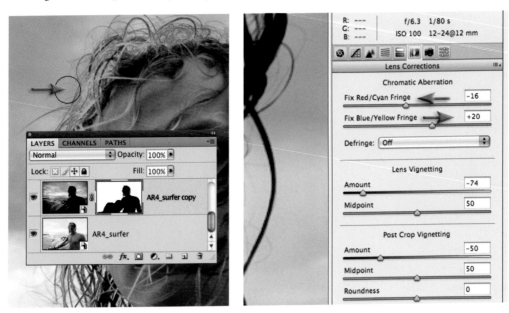

15. Zoom in and take a look at the quality of the hair. The hair may appear too light in some areas and this can be corrected by painting into the layer mask of the darker surfer copy layer with a black soft-edged brush at 20–30% Opacity. You may also notice when you zoom in that fringes of color are appearing around the thin strands of hair. This is chromatic aberration (misalignment of the RGB channels) that can be fixed by double-clicking the Smart Object to reopen the Raw file in Adobe Camera Raw. Go to the Lens Corrections tab and move the Red/Cyan slider to the left and the Blue/Yellow slider to the right to fix this problem. In the Lens Corrections tab we can also take the opportunity to add a vignette to the sky.

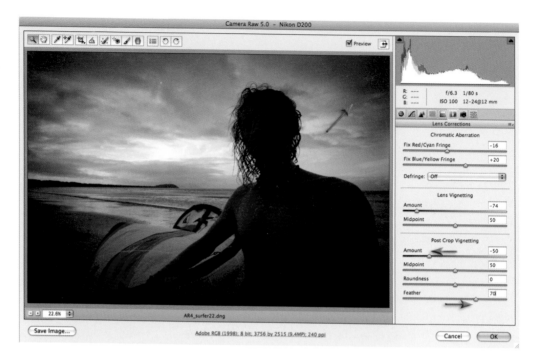

16. Click on the Lens Corrections tab and move the Amount slider in the Lens Vignetting section to −50. Move the Feather slider to 70 to soften the edge of the vignette. Click Done to apply the changes and update the file in the main workspace.

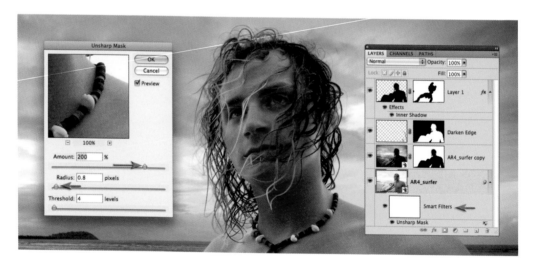

17. Click on the base layer in the layer stack. As this layer is a Smart Object you can apply sharpening as a Smart Filter. Go to Filter > Sharpen > Unsharp Mask. Sharpen using a generous Amount of sharpening (100+) using a low Radius (0.5–1.0). Raise the Threshold to 4 so that the noise does not get sharpened along with the edge detail.

High dynamic range – Project 7

Contrary to popular opinion – what you see is not what you always get. You may be able to see the detail in those dark shadows and bright highlights when the sun is shining – but can your CCD or CMOS sensor? Contrast in a scene is often a photographer's worst enemy. Contrast is a sneak thief that steals away the detail in the highlights or shadows (sometimes both). A wedding photographer will deal with the problem by using fill flash to lower the subject contrast; commercial photographers diffuse their own light source or use additional fill lighting and check for missing detail using the 'Histogram'.

Upper Yarra River by Mark Galer

Landscape photographers, however, have drawn the short straw when it comes to solving the contrast problem. For the landscape photographer there is no 'quick fix'. A reflector that can fill the shadows of the Grand Canyon has yet to be made and diffusing the sun's light is only going to happen if the clouds are prepared to play ball.

Ansel Adams (the famous landscape photographer) developed 'The Zone System' to deal with the high-contrast vistas he encountered in California. By careful exposure and processing he found he could extend the film's ability to record high-contrast landscapes and create a black and white print with full detail. Unlike film, however, the latitude of a digital imaging sensor (its ability to record a subject brightness range) is fixed. In this respect the sensor is a strait-jacket for our aims to create tonally rich images when the sun is shining – or is it? Here is a post-production 'tone system' that will enrich you and your images.

Note > To exploit the full dynamic range that your image sensor is capable of, it is recommended that you capture in Raw mode. JPEG or TIFF processing in-camera may clip the shadow and highlight detail (see Adobe Camera Raw).

1. If we can't fit all the goodies in one exposure, then we'll just have to take two or more. The idea is to montage, or blend, the best of both worlds (the light and dark side of the camera's not quite all seeing eye). To make the post-production easier we need to take a little care in the pre-production, i.e. mount the camera securely on a sturdy tripod. We need to then 'bracket' five exposures. Capture an image using the meter-indicated exposure (MIE) from the camera and then take two shots overexposing by first one stop, then two stops and repeat the process underexposing by one stop and then two stops from the MIE. Two stops either side of the meter-indicated exposure should cover most high-contrast situations.

Note > If you intend to use the new 'Automate > Merge to HDR' (High Dynamic Range) feature Adobe recommends that you use the shutter speed rather than the aperture to bracket the exposures. This will ensure the depth of field is consistent between the exposures.

Bracketing exposures

Setting your camera to 'auto bracket exposure mode' means that you don't have to touch the camera between the two exposures, thereby ensuring the first and second exposures can be exactly aligned with the minimum of fuss (the new Auto-Align Layers feature in CS3 does not work when your layers are Smart Objects). Use a cable release or the camera's timer to allow any camera vibration to settle. The only other movement to be aware of is something beyond your control. If there is a gale blowing (or even a moderate gust) you are not going to get the leaves on the trees to align perfectly in post-production. This also goes for fast-moving clouds and anything else that is likely to be zooming around in the fraction of a second between the first and second exposures.

Merge to HDR

The Merge to HDR (High Dynamic Range) automated feature has been improved for CS4. A series of bracketed exposures can be selected and the Merge to HDR feature then aligns the images automatically. The Merge to HDR dialog box then opens and the user is invited to select a bit depth and a white point. It is recommended to save the file as a 32-bit image. This allows the exposure and gamma to be fine-tuned after the image is opened into Photoshop by going to Image > Adjustments > Exposure. As editing in 32 Bits/Channel is exceptionally limited the user will inevitably want to drop the bit depth to 16 or 8 Bits/Channel at some stage to make use of the full range of adjustment features.

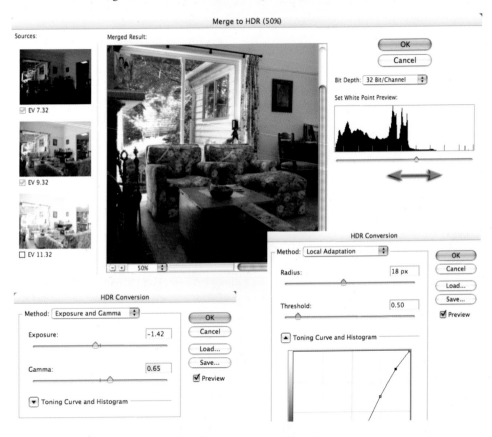

When the Photoshop user converts an HDR 32-bit image to 16 or 8 Bits/Channel the user can choose a conversion method that allows the best tonal conversion for the job in hand. With very precise working methods HDR images can provide the professional photographer with a useful workflow to combat extreme contrast working environments. For situations where HDR is required but people or animals are likely to move between exposures a manual approach to merging the exposures is highly recommended. The best manual technique for blending exposures is outlined in the following pages. The last two steps of the technique are also recommended for users who adopt the automated method as the results can often appear flat and unrealistic.

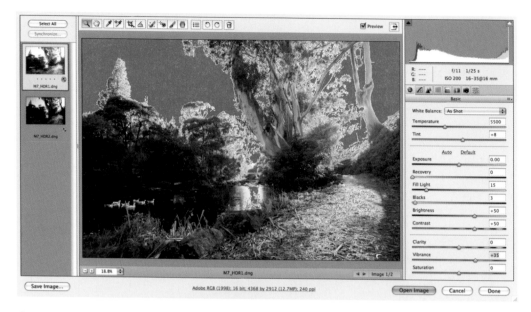

2. Select both of the HDR project images (AR7_HDR1.dng and AR7_HDR2.dng) and open them in Adobe Camera Raw. Click on the lighter image thumbnail and optimize the shadow detail (pay no attention to the highlights that will clip). Raise the Brightness, Contrast and Vibrance sliders to optimize the shadows (+50, +50 and +35).

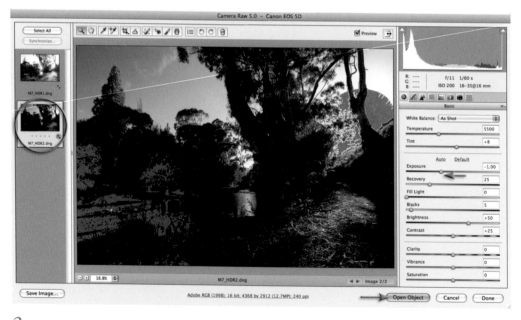

3. Click on the darker thumbnail and this time optimize the highlight detail. Drag the Exposure slider to −1.00, drag the Recovery slider to +25 and lower the Contrast slider to +25. A small amount of clipping will remain around the sun but this is perfectly acceptable. Click on Select All in the top left-hand corner of the ACR dialog box and while holding down the Shift key click on the Open Objects button.

4. Select the 'Move Tool' in the Tools panel and drag the dark underexposed image into the window of the lighter overexposed image (alternatively just drag the thumbnail from the Layers panel with any tool selected). Holding down the Shift key as you let go of the image will align the two layers (but not necessarily the two images).

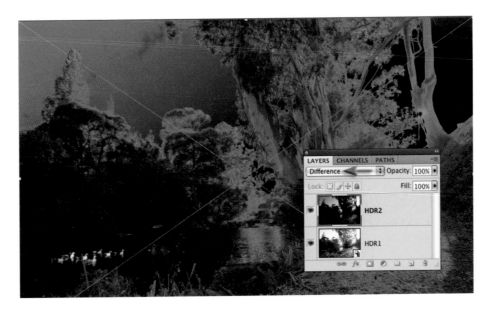

5. In the Layers panel set the blend mode of the top layer to 'Difference' to check the alignment of the two images. If they align no white edges will be apparent (usually the case if the tripod was sturdy and the two exposures were made via an auto timer feature or cable release). If you had to resort to a friend's right shoulder you will now spend the time you thought you had saved earlier doing the following steps. To make a perfect alignment you need to select 'Free Transform' (Edit > Free Transform). Nudge the left side into alignment and then move the reference point location in the Options bar to the left-hand side of the square. Highlight the numbers in the rotation field in the Options bar and then rotate the image into final alignment. Switch the mode of the layer back to Normal when aligned.

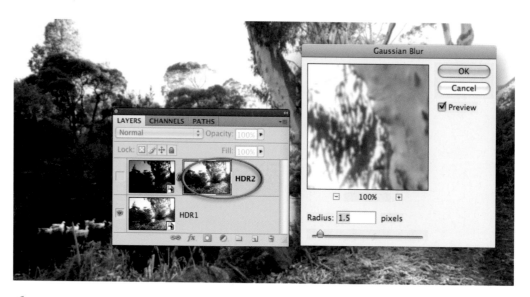

6. Click on the 'Add layer mask' icon in the Layers panel. Switch off the visibility of this layer by clicking on the eye icon next to the layer thumbnail. Choose 'All' from the Select menu (Ctrl/Command + A) and then choose Copy Merged from the Edit menu (Shift + Ctrl/Command + C). Hold down the Alt/Option key and click on the layer mask thumbnail. The image window should appear white as the layer mask is empty. Now choose 'Paste' from the Edit menu (Ctrl/Command + V). Go to Select > Deselect. Apply a 1.5-pixel Gaussian Blur (Filter > Blur > Gaussian Blur) to this mask. Alt/Command-click to return to the normal view.

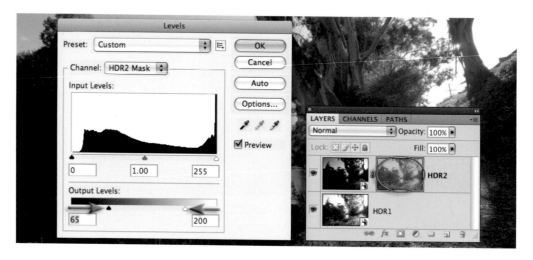

7. It is important to recreate the expanded contrast of the original scene otherwise the image will look slightly surreal if the overall contrast is low. The first technique to expand the contrast is to select the layer mask and apply a Levels adjustment (Ctrl/Command + L). Drag in the Output sliders (directly beneath the shadow and highlight sliders) until the final contrast appears high but not clipped (lowering the contrast of the mask increases the contrast of the final image).

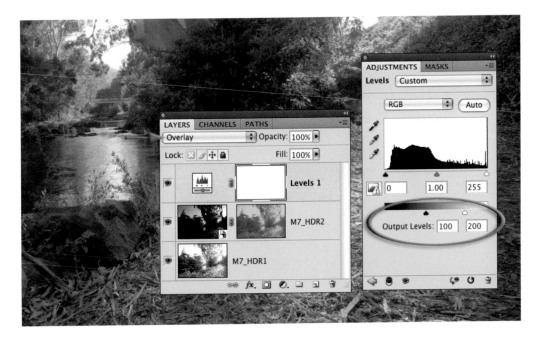

8. Create a Levels adjustment layer and set the mode to Overlay. In the Levels panel drag the two Output sliders towards the center of the gray ramp to limit the extra contrast to just the midtones (levels 100 to 200).

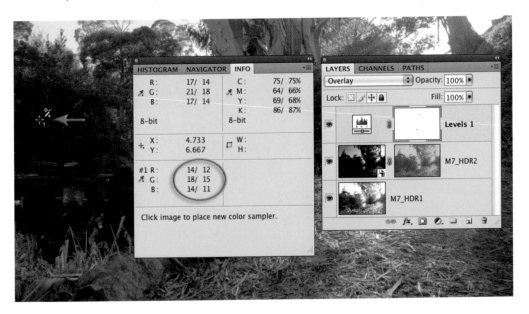

9. Open the Info panel and look at the RGB values when the mouse cursor is positioned over the dark shadow tones in the image window. If they are too dark to print to a typical output device (below level 15), you can double-click the bottom Smart Object to reopen the ACR dialog box. Raise the Fill Light slider as required. Select OK to apply the changes.

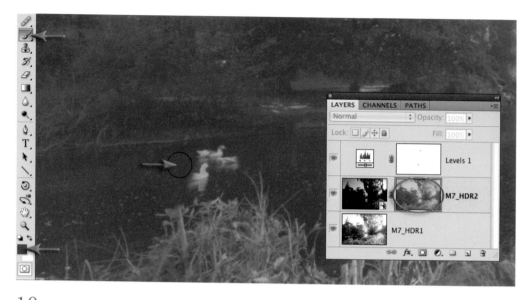

10. The observant among us will have noticed the ducks have been breeding. To remove the ghost images hold down the Alt/Option key and click on the layer mask thumbnail. Select the Brush Tool and hold down the Alt/Option key and click on a gray tone next to the ducks to sample the color. Paint over the ducks using a soft-edged brush. Click on the image thumbnail to return to the normal view.

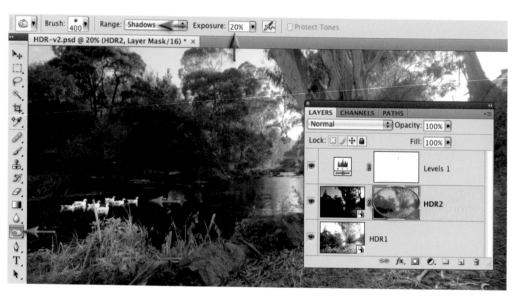

11. Select the Burn Tool from the Tools panel. Set the Range to Shadows and the Exposure to 20% or less. Click and drag along the river to darken the shadow tones in the layer mask and so remove the second set of ducks. The Burn Tool should leave any highlights in the mask relatively unaffected. Make several strokes with the Burn Tool if any ghosting remains.

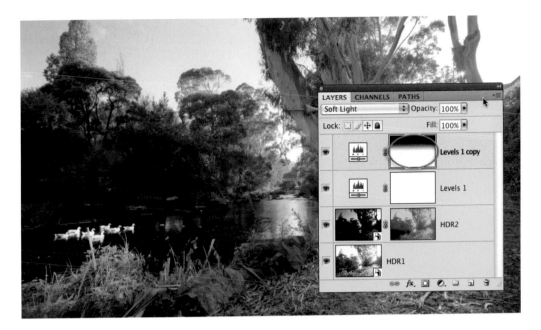

12. If the midtone contrast of the image needs to be increased further duplicate the Levels adjustment layer. If the contrast becomes too high lower the opacity of the duplicate layer or switch the blend mode to Soft Light. The sky can be protected from excessive contrast by adding a Black, White gradient into the layer mask.

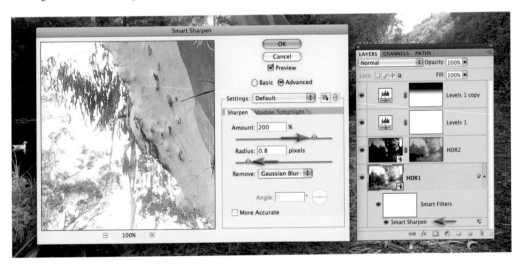

13. Complete the project by adding a Smart Sharpen filter to the base layer, as this is where the bulk of the fine detail resides in this composite image. Settings of 200% for the Amount slider and 0.8 pixels for the Radius slider have been used for this project image. Select OK to apply the changes. Applying a sharpen filter to this Smart Object (a Camera Raw file) instead of a rasterized layer (created by merging the visible elements to a new layer) means that we have deferred applying any 'destructive' changes to the image data in this file. The automated HDR feature would have to process the data to achieve the same result and the ducks would not be happy.

montage projects

Rory Gardiner- rorygardiner.com.au

essential skills

- Use Quick Mask mode, alpha channels and layer masks to create a simple montage.
- Create a simple montage using layer blend modes.
- Use the Pen Tool to create a smooth-edged mask.
- Use channel masking and a blend mode for a perfect hair transplant.
- Replace a sky and massage the tonality and color for a seamless result.
- Preserve the shadows of a subject and create realistic motion blur.
- Create a panoramic image using the Photomerge filter.

Layer masks – Project 1

A common task in professional digital image editing is to strip out the subject and place it against a new background – the simplest form of montage. The effectiveness of such a montage is often determined by whether the image looks authentic and not manipulated.

In order to achieve this the digital photographer needs to modify the edge of any selection so that it is seamless against the new background. A crude or inappropriate selection technique will make the subject appear as if it has been cut out with garden shears and is floating above the new background. A few essential masking skills can turn the proverbial sow's ear into the silk purse.

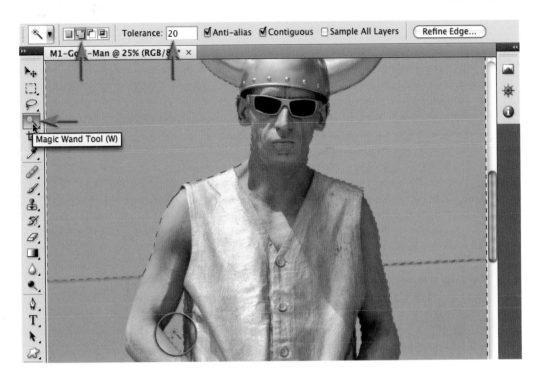

Part 1 – Changing the background

$1.$ Open the M1 start image and then select the majority of the background behind the subject using either the new Quick Selection Tool or the Magic Wand Tool. Selecting the background with the Magic Wand Tool with the Tolerance set to 20 in the Options bar is slightly quicker than using the Quick Selection Tool. Select the background rather than the subject; it is also quicker because there are less differences in tone or color. Select the 'Contiguous' option in the Options bar and click on the 'Add to Selection' icon or hold down the Shift key as you add the isolated areas between the legs and under the arms.

Quick Selection Tool alternative

Switch the 'Auto-Enhance' option in the Options bar off. Make an initial selection by dragging the tool over an area of the background. Then hold down the Option/Alt key and make a series of strokes around the inside edge of the subject to define the areas you don't want to be included in the selection. The effect of these subtractive strokes will not be immediately obvious at this stage, as you are only helping to educate the tool as to which pixels you intend to exclude from any further selections. These are pre-emptive strokes that will help prevent the selection made by the Quick Selection Tool from leaking outside of the area you wish to select. After making the subtractive stroke continue to add to the original selection until most of the background has been selected. Hold down the Option/Alt key and stroke any areas of the subject with a small brush to subtract any areas that have been included in the selection by mistake. Perfect the selection using the 'Quick Mask mode' (see next step) as no one tool can easily select the entire subject in this image.

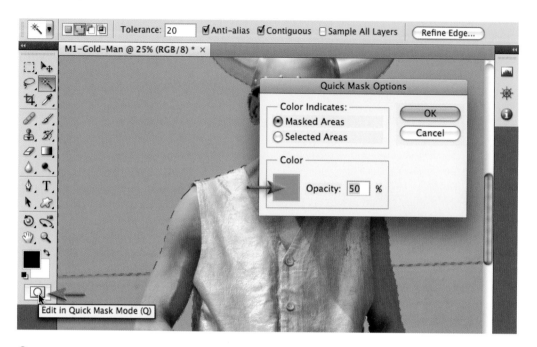

2. Set the foreground and background colors to their default setting in the Tools panel (press the D key). Next click on the 'Edit in Quick Mask Mode' icon in the Tools panel. Double-clicking the icon will open up the 'Quick Mask Options'. Click the color swatch to open the 'Color Picker' and select a color that contrasts with those found in the image you are working on. In this project it is appropriate to set the color to a saturated green with 50–70% Opacity.

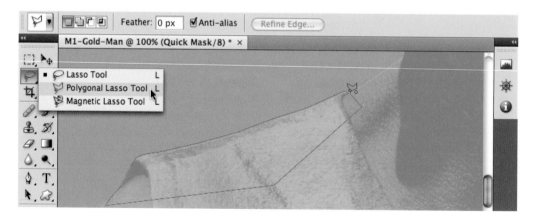

3. The selection can be further modified in Quick Mask mode by painting directly into the mask or by making selections and then filling the selection with either the foreground or background color. Painting or filling with black will add to the colored mask, while painting/filling with white will remove the mask color. When using any of the Lasso Tools, make sure you have the Feather set to 0 px in the Options bar (to ensure you match the current edge quality created by using the Magic Wand or Quick Selection Tools) and that you return to the starting point to complete the selection.

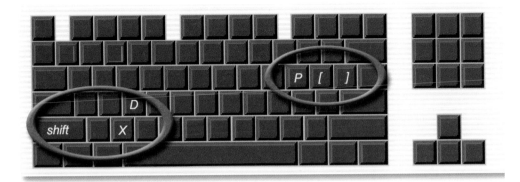

Useful shortcuts for masking work

Brush size and hardness
Using the square bracket keys to the right of the letter P on the keyboard will increase or decrease the size of the brush. Holding down the Shift key while depressing these keys will increase or decrease the hardness of the brush.

Foreground and background colors
Pressing the letter D on the keyboard will return the foreground and background colors to their default settings (black and white). Pressing the letter X will switch the foreground and background colors.

Fill with foreground or background color
Use the keyboard shortcut Command + Delete (Mac) or Ctrl + Backspace (PC) to fill a selection with the background color. Use the keyboard shortcut Option + Delete (Mac) or Alt + Backspace (PC) to fill a selection with the foreground color.

Zoom and Hand Tools
Use the keyboard shortcut Command + Spacebar (Mac) or Ctrl + Spacebar (PC) to access the Zoom Tool and the Spacebar by itself to drag the image around in its window.

Inverting the mask
Use the keyboard shortcut Command + I (Mac) or Ctrl + I (PC) to invert the mask if the mask is concealing the edge you are working on. The use of these shortcuts will make shorter work of creating accurate selections.

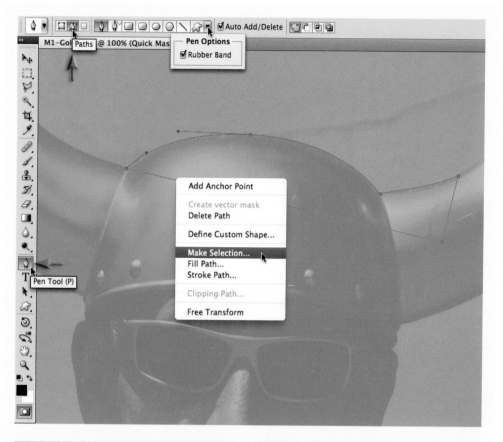

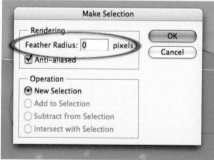

Modifying the mask using the Pen Tool

Making a path and then turning the path into a selection will create the smoothest edges.
Right-click after creating a path to access the 'Make Selection' option from the context menu.
Choose a 'Feather Radius' of 0 pixels and then select OK. Fill the selection with Black to add
to the mask or with White to remove a section of the mask (Edit > Fill).

**Note > See 'Selections from paths' in the Selections chapter and Project 2 in this chapter
to get more information on using the Pen Tool.**

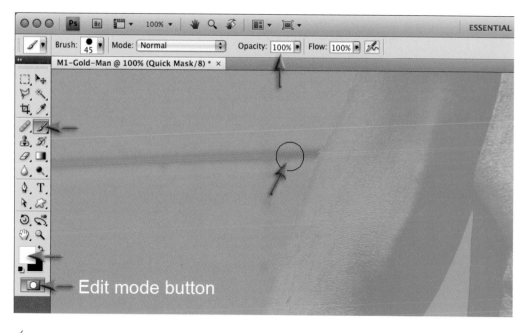

Edit mode button

4. Select the Brush Tool from the Tools panel and an appropriate hard-edged brush from the Options bar and be sure the brush opacity is set to 100%. The foreground and background colors can be switched when painting to subtract or add to the mask. Zoom in on areas of fine detail and reduce the size of the brush when accuracy is called for. When the painted mask is complete press on the letter Q on the keyboard or click on the 'Edit in Standard Mode' icon in the Tools panel.

Note > Adding an adjustment layer to temporarily brighten or darken an image may help you to paint an accurate mask against some edges that may otherwise be difficult to work with. Switch off or delete the adjustment layer when the painted mask is complete.

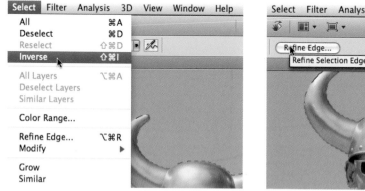

5. Go to Select > Inverse so that the subject rather than the background is selected. Click on the 'Refine Edge' button in the Options bar. If the button is not visible (due to the fact that a painting tool rather than a selection tool is selected) go to the Select menu and choose 'Refine Edge'.

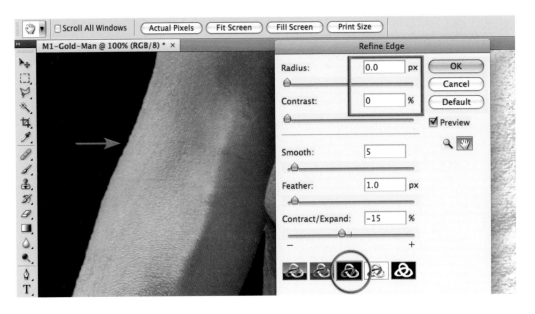

6. In the Refine Edge dialog box set the 'Radius' and 'Contrast' sliders to zero (these sliders do not need to be used as there are no soft edge transitions or fine detail around the edge of the subject that need to be modified or preserved). Choose the 'On Black' preview option. Turn your attention to the Smooth slider and take the slider back to 0 and check the quality of the edges at 100% magnification (Command + Option + 0 on a Mac and Ctrl + Alt + 0 on a PC and then hold down the Spacebar to drag the image in the image window). Selections created using the Magic Wand or Quick Selection Tools can often be lumpy, and raising the Smooth slider will disguise this fault. Settings of **Smooth: 5, Feather: 1.0 px** and **Contract/Expand** of –15% should soften the edge nicely and hide most of the background surrounding the edge. Click the OK button when you are satisfied with the settings. If the edge is too lumpy for your liking there are steps we can take later after this step has been completed. The Refine Edge dialog box works globally (on the entire edge) so a few compromises may be required at this stage.

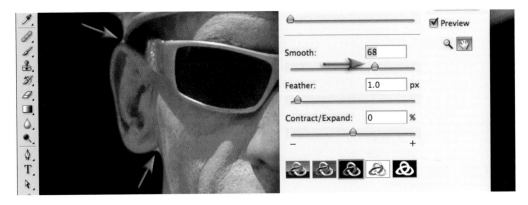

Note > Too much of a good thing results in webbed ears, i.e. if the Smooth slider is raised too high the corners of the selection will start to be 'rounded off', resulting in the old background showing through.

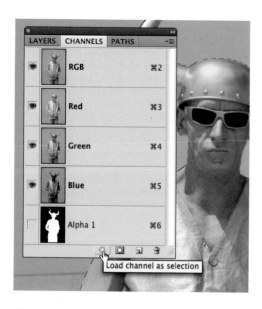

7. Save the selection as an 'Alpha' channel by going to the Channels panel and clicking on the 'Save selection as channel' icon. Now that the selection has been saved as an alpha channel save your work in progress (File > Save As). The selection can now be deselected (go to 'Select > Deselect') and reselected at any time during the editing procedure.

Note > Change the name of the original file and save as a Photoshop or TIFF file. Photoshop and TIFF files will save the record of your selection as an Alpha channel. JPEG files cannot contain Alpha channels. Alpha channels can be reloaded as a selection if the file is closed and reopened.

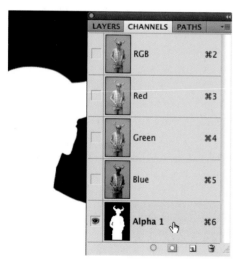

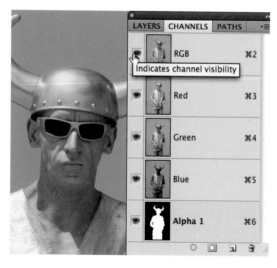

8. Click on the Alpha 1 channel to view the mask by itself or the 'visibility' or 'eye' icon to view the mask. Click on the RGB visibility icon to view the mask and image together. It is possible to continue working on the mask in this view as if you were in Quick Mask mode (the Alpha channel must be selected).

Quick Mask and Refine Edge

When edge contrast is poor the editing process usually requires a range of Photoshop's selection and painting tools to be brought into play. The best workspace for this type of work may still be the Quick Mask mode in many instances. The Quick Mask mode allows the user to contract and expand localized portions of the mask by first making a selection (or by creating a path and then converting the path into a selection) and then using the Maximum/Minimum filters or Levels technique (see Step 13 in this project). The user can also paint directly into the mask using any painting tools. None of these localized or painting options are available in the Refine Edge dialog box.

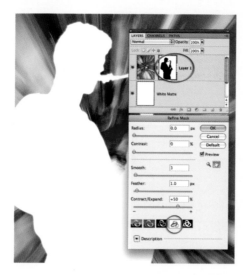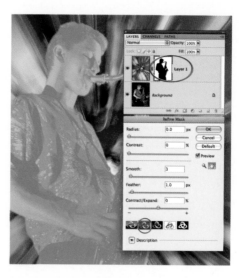

The layer mask is selected and the Refine Edge dialog box opened (Select > Refine Edge). Feedback as to the most appropriate settings to use in the Refine Edge dialog box may be compromised when the mask is not on the subject layer (the saxophone player). Although we can view the subject as a quick mask in the Refine Edge dialog box we are unable to edit this quick mask using the painting tools

Most professionals have traditionally preferred to refine masks rather than selections. Some may think that the new Refine Edge dialog box will change this working practice as Refine Edge can also be applied to masks (go to Select > Refine Edge). Although modifications to the selection edge in the Refine Edge dialog box are a vast improvement on the Feather and Modify commands found in previous versions of Photoshop, when the Refine Edge is applied to a mask attached to a new background layer (placed above the subject layer) the user may be unable to determine the appropriate settings to use in order to acquire the best possible edge. Unlike Quick Mask there are also no options to select a portion of the edge and then adjust the settings independently (not all edges of an object may appear equally sharp or soft and require the same global adjustment). If you make a selection of a portion of the mask and then use Refine Edge the dialog box defaults to working the edge of the selection rather than the edge of the mask. If quality of the visual outcome, rather than speed, is the primary objective when editing an image, then Quick Mask still offers many advantages over the new Refine Edge dialog box.

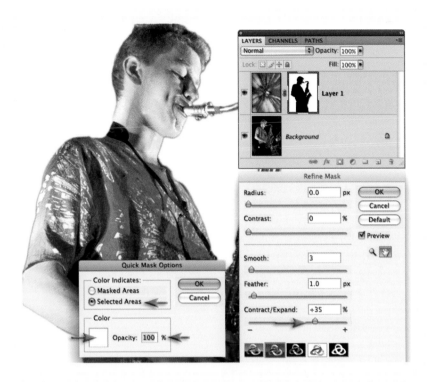

When using Refine Edge to work on a layer mask, the user may have to use a work-around in order to gain any useful feedback on the most appropriate settings to use. After the selection has been converted into a layer mask there may be no feedback when attempting to view the mask using the white or black matte options. The user must either view the mask in Standard mode and hide the selection edges (Command/Ctrl + H) or double-click the Quick Mask view and set the mask color to 100% black or white to create a black or white matte. You may also need to switch the Quick Mask option from 'Masked Areas' to 'Selected Areas' so that the background instead of the subject is masked. When switching to Selected Areas in Quick Mask Options the Contract/Expand slider then works in reverse.

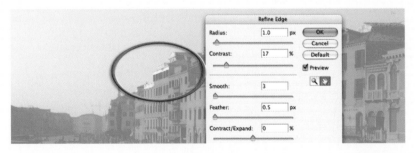

Quick selections may not, by their very nature, be very accurate selections. Missing elements cannot be added from within the Refine Edge dialog box. In Quick Mask mode, however, a selection can be made and then filled with black or the missing elements can simply be painted in prior to using Refine Edge or editing the edge quality from within the Quick Mask mode itself

9. Load the Alpha channel as a selection by dragging it to the 'Load channel as selection' icon or by holding down the Command key (Mac) or Ctrl key (PC) and clicking in the Alpha channel thumbnail. Before returning to the Layers panel, switch off the Alpha channel visibility and select the master RGB channels view at the top of the Channels panel.

Note > Leaving the Alpha channel as the active component in the Channels panel before returning to the Layers panel can create problems with some editing procedures, e.g. copying and pasting. If problems occur you may notice that the layer is grayed out in the Layers panel and the word 'Alpha' may appear in the title of the image window. If this occurs return to the Channels panel or use the keyboard shortcut listed on the RGB channel (Command/Ctrl + 2).

10. Instead of cutting out the subject it is preferable in a non-destructive professional workflow to mask the pixels (when we move the subject to a new background we may need to modify and refine the edge further). The pixels on a background layer cannot be masked until the layer has been converted to a normal (unlocked) layer. Double-click on the background layer to open the 'New Layer' dialog box. Just select OK if you do not want to rename it and then click on the 'Add layer mask' icon at the base of the Layers panel to add a mask that conceals the background pixels.

Note > It is important to note that although the background is no longer visible it has been masked and not removed permanently. The 'masked' and 'selected' areas are the reverse of each other. Areas that were not part of the original selection become the masked areas. Holding down the Alt/Option key as you select 'Add layer mask' reverses the layer mask so the selected areas become the masked areas.

11. Open the M1 background file and position the new background image alongside the image of the gold man. Click and drag the thumbnail of your subject in the Layers panel to the image window of the new background. Let go of the mouse button to create an image file with two layers (holding down the Shift key as you let go of the mouse button will ensure the new layer is centered).

Note > A border will appear momentarily around the host image before you let go of the mouse button to indicate that it will accept the new layer.

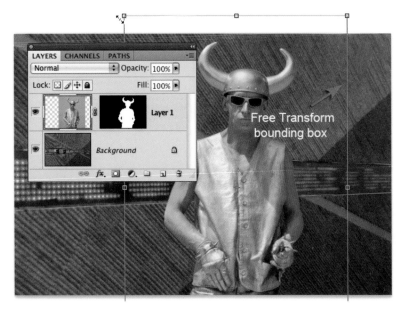

12. The image now comprises two individual layers and the layer mask you created. Select the top layer (your subject) and then go to 'Edit > Free Transform' (Command/Ctrl + T). Use the keyboard shortcut Command/Ctrl + 0 to fit the Transform bounding box on the screen. Hold down the Shift key and drag a top corner handle to resize the image. Holding down the Shift key as you drag will constrain the proportions of the images. Dragging inside the bounding box will move the image. Use the arrow keys for fine adjustments. Press the 'Commit' icon in the Options bar or press the Return/Enter key to apply the transformation.

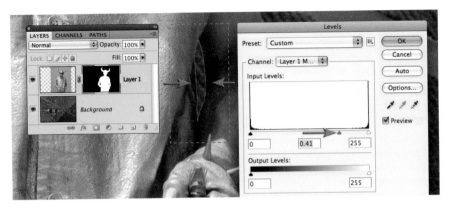

13. There are a number of ways we can modify the edge of a mask in localized areas if required (remember the Refine Edge command can only work on the entire edge). Make a selection of a portion of the edge where a light halo (the old background) may be apparent. If the selection crosses an edge be sure to use a small amount of feather (in the Options bar) so the changes to the edge do not result in a ridge. We can expand the mask and hide more of the background pixels by applying a Levels adjustment to the mask. Make sure the mask is the active component of the layer (click on it so that a second dark line appears around the thumbnail in the Layers panel). Go to Image > Adjustments > Levels and then in the Levels dialog box move the central gamma slider to the right. The edge of the mask can be made harder by moving the white and black point sliders in from the edges of the histogram.

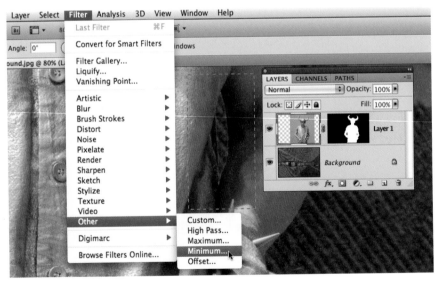

An alternative to using a Levels adjustment is to use the Minimum and Maximum filters to adjust the position of the edge of the mask. Go to 'Filter > Other > Minimum' to expand the mask (the Maximum filter moves the edge of the mask in the opposite direction). Although not as controlled as having a slider to move the edge, the advantage to this technique is that you can reapply the Minimum filter to other selected areas, after the initial application, very quickly by simply using the Command/Ctrl + F keyboard shortcut.

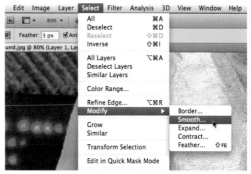

14. If you need to smooth out a section of the edge without smoothing the whole mask start by loading the layer mask as a selection (hold down the Command/Ctrl key and click on the layer mask thumbnail in the Layers panel). Select the Lasso Tool and select the 'Intersect' icon in the Options bar. Make a selection around the section you want to modify and then go to 'Select > Modify > Smooth'. Choose a generous 'Sample Radius' setting of 15 or 20 for the arm in this project. Check that the layer mask is selected, then fill the modified selection with white. This section of the edge may require some additional softening to match the rest of the edge that was modified using the Refine Edge command. Make a larger selection around the modified area, i.e. both sides of the edge, and then apply a 1-pixel Gaussian Blur (Filter > Blur > Gaussian Blur). When finished go to Select > Deselect.

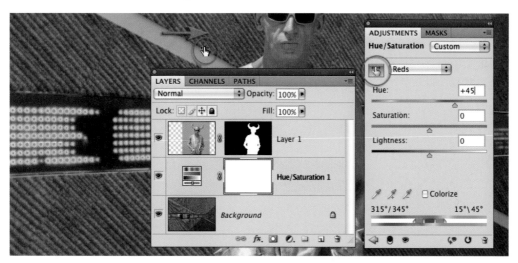

15. The next few steps will balance the color and tonality between the two image layers. Click on the bottom layer in the Layers panel and then choose a Hue/Saturation adjustment layer from the Adjustments panel. Select the 'On-Image Tool' in the Adjustments dialog (looks like the scrubby slider icon), hold down the Command key (Mac) or Ctrl key (PC) and then click and drag right on a red hue in the image window to adjust the reds in the image to yellows (approximately +45 on the Hue slider). Let go of the Command/Ctrl key (this will allow you to target the saturation rather than the hues) and then click and drag left on the background to desaturate the cyans in the image.

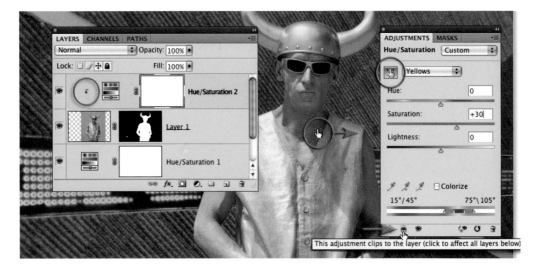

16. Select the top layer in the Layers panel and then hold down the Alt key (PC) or Option key (Mac) while you select another Hue/Saturation adjustment layer from the 'Create new fill or adjustment layer' menu. Holding down the Option/Alt key will open the New Layer dialog box. In this dialog box select the 'Use Previous Layer to Create Clipping Mask' checkbox and then select OK. Creating a Clipping Mask between the adjustment layer and the layer below will restrict any changes to just this layer and leave the bottom layer unadjusted. Increase the Saturation to match the yellow stripes on the bottom layer.

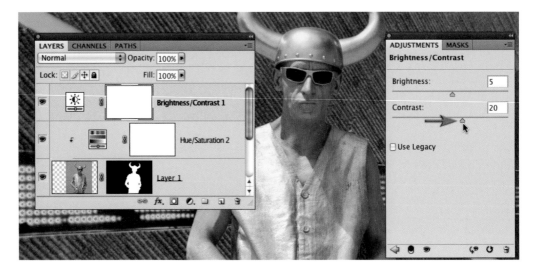

17. If you create an adjustment layer that is not part of the Clipping Mask it will affect all layers beneath it. In this project I have increased the Brightness and Contrast of both the image layers by creating a Brightness/Contrast adjustment layer at the top of the layers stack (the Brightness/Contrast adjustment feature is no longer destructive since CS3). Note how the Hue/ Saturation adjustment layer is indented and the layer name 'Layer 1' is underlined to show that the two layers form part of a Clipping Mask.

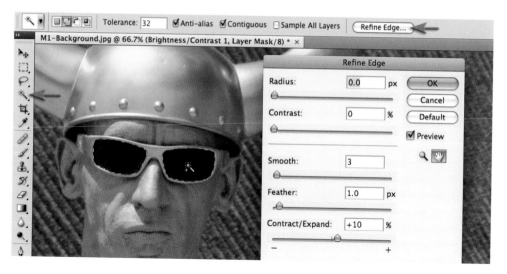

Part 2 – Finishing touches

$18.$ The next few steps will paste an interesting reflection in those very dark sunglasses. Choose the Magic Wand Tool from the Tools panel and set the Tolerance to 32 in the Options bar (its default value). Click on the 'Add to selection' icon in the Options bar and then click on each black lens in the sunglasses to select them both. Click on the 'Refine Edge' button in the Options bar and then choose values of 'Smooth: 3, Feather: 1 and Contract/Expand: +10' in the Refine Edge dialog box. Select 'OK' to apply the changes.

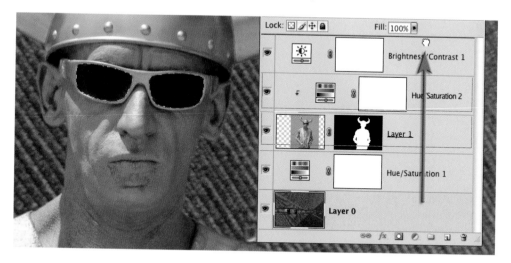

$19.$ Double-click on the background layer and in the New Layer dialog box that opens select OK to unlock the layer and convert it to Layer 0. Hold down the Alt key (PC) or Option key (Mac) and click and drag the bottom layer in the Layers panel to the top of the layers stack. This will copy the layer and place the copy layer on top. Be careful not to drop the layer below the Hue/Saturation 2 layer otherwise it will enter the Clipping Mask. Go to Edit > Undo if this happens and then repeat the process until the Layer 0 copy appears at the top of the layer stack.

20. Add a layer mask to this copy layer and break the link between the two thumbnails in the Layers panel by clicking on it. This action will allow us to modify the position and size of the image layer but leave the layer mask pin-registered to the precise location of the glasses. Click on the image thumbnail (rather than the layer mask) to make this the active component of the layer. Select 'Free Transform' from the Edit menu and then scale and rotate the layer so that the red stripes appear in the lenses of the sunglasses (remember that Ctrl/Command + 0 fits the image and transform bounding box into the window). You have the option to lower the opacity of the layer in the Layers panel if required.

21. Hold down the Alt/Option key again and click and drag the Hue/Saturation 1 adjustment layer to the top of the layers stack. This action will copy the adjustment layer and change the red stripes to yellow but it will also affect the color of the golden Viking. To limit the changes to the reflections in the glasses, create a clipping group by holding down the Alt/Option key and clicking on the dividing line between the adjustment layer (Hue/Saturation 1 copy) and Layer 0 copy in the Layers panel (alternatively you can choose the 'Create Clipping Mask' command from the Layer menu).

22. To give a sense of distance between the subject and new background you can add a drop shadow to darken the background selectively. Click on Layer 1, to make it the active layer, and then go to Layer > Layer Style > Drop Shadow (these layer styles are also available from the 'Add a layer style' menu in the Layers panel).

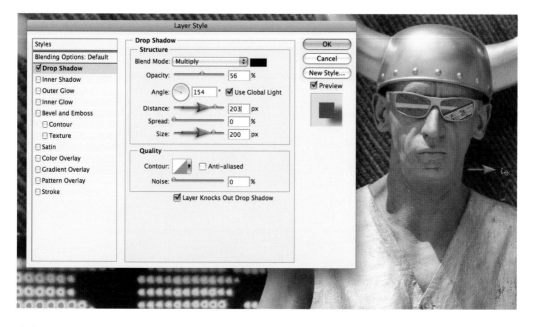

23. In the Layer Style dialog box increase the Distance and Size settings. Change the Angle so that the shadow is consistent with the direction of light that is falling on the golden Viking. You can also click and drag in the image window to drag the shadow to the correct location. Lower the Opacity of the shadow to around 20–35% and select OK to apply the changes.

The skills applied in this project are the professional techniques used to create the vast majority of high-quality montages where the viewer does not question the authenticity of the image.

Paths, masks and blend modes – Project 2

With the basic drawing skills covered in the Selections chapter we are ready to create a path that can be converted into a selection and then used as a layer mask. This project will see if you can create a path worthy of a Path Master (for the pen is sometimes mightier than the light sabre or magic wand). The resulting edge will be much smoother than an edge created with any of the selection tools. After an accurate path has been created we can use this to modify the subject and background separately.

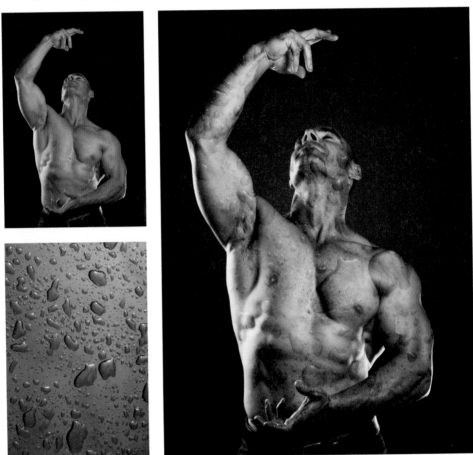

Photograph of body builder by Abhijit Chattaraj

In the montage above the image of the body has been blended with an image of raindrops on a car body. The texture blended takes on the shadows and highlights of the underlying form but does not wrap itself around the contours or shape of the three-dimensional form.

1. Select the Pen Tool in the Tools panel and the Paths option (rather than the Shape layers option) and the 'Add to path area' option in the Options bar.

$2.$ Zoom in using the keyboard shortcut Ctrl + Spacebar (PC) or Command + Spacebar (Mac) and work close. Drag the image around in the image window using the Spacebar key to access the Hand Tool. Make a path by clicking on the edge of the subject and dragging to modify the curves. If you encounter edges that are not well defined, work on the inside edge rather than the outer edge of the subject. Try to use as few anchor points as possible (see Selections, pages 169–173). Remember you can choose to cancel or move a direction line by holding down the Alt/Option key and clicking on either the last anchor point or its direction point before creating a new segment of the path.

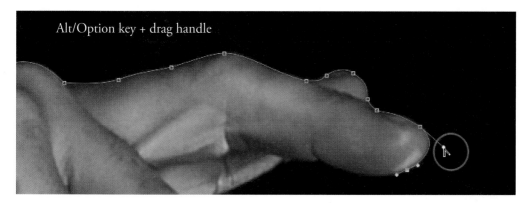

$3.$ You can backtrack at any time and Command + click (Mac) or Ctrl + click (PC) to select an anchor point to make it active again. Then hold down the Alt/Option key to adjust one of the direction lines or hold down the Control key (PC) or Command key (Mac) and click and drag an anchor point to reposition it. Moving the Pen Tool over a segment of the path already completed will give you the option to click and add an anchor point to the path. Moving the Pen Tool over a previous anchor point will enable you to click to delete the anchor points or drag out from the anchor point to add two new direction lines.

Note > Check that you have the 'Auto Add/Delete' option checked in the Options bar if the above is not happening for you. If you accidentally remove a direction line from an anchor point hold down the Alt/Option key and click and drag out from the anchor point to add new direction lines.

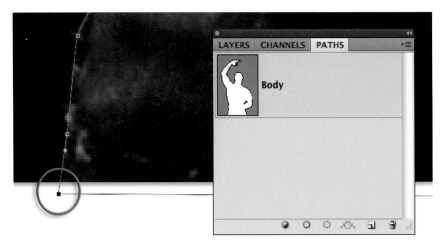

4. Where the blue jeans extend beyond the edge of the frame (at the bottom of the image window) place your anchor points outside of the image window rather than alongside the edge. Continue creating anchor points until you reach the point where you started drawing. When you click on the first anchor point you will close the path. Hold down the Alt/Option key as you click on the first point if the direction line on the first anchor points changes your last drawn curve.

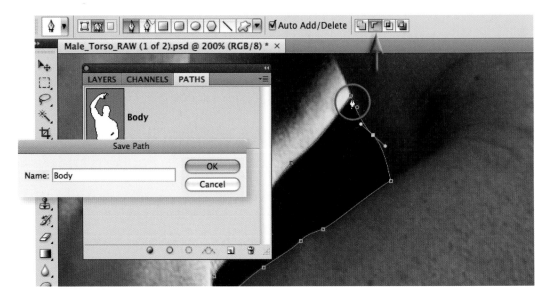

5. In the Paths panel double-click the Work Path. This will bring up the option to save the Work Path and ensure that it cannot be deleted accidentally. Name the path 'Body' and click OK to save it. A saved path can be modified by first clicking on the path in the Paths panel, selecting the Pen Tool in the Tools panel and then selecting the 'Add to' or 'Subtract from path area' icon in the Options bar. Select the 'Subtract from path area' icon and proceed to remove the area of background under the man's arm using the same pen techniques as before.

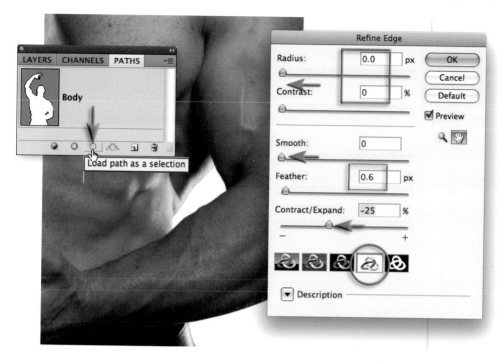

6. Load the path as a selection by clicking on the icon in the Paths panel. Go to Select > Refine Edge and set the Radius, Contrast and Smooth sliders to zero. Apply a 0.5–1 pixel feather. To test the effectiveness of the path it is best to preview the selection over a white background. In order to remove the old black background that may just be visible against the edge of the body you will need to move the Contract/Expand slider to the left slightly. Select OK to apply the changes.

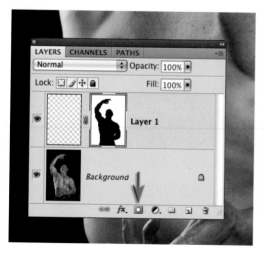

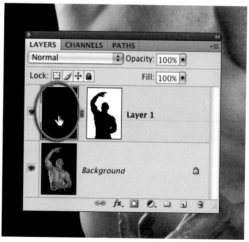

7. Click on the 'Create a new layer' icon in the Layers panel to create an empty new layer. Hold down the Alt/Option key and click on the 'Add layer mask' icon in the Layers panel. Then select the layer image and go to Edit > Fill and choose black as the contents. Select OK.

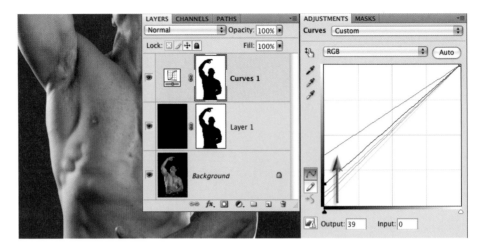

8. This step will create the effect of a backlight behind the subject that slowly fades to black in the corners of the image. Control-click (PC) or Command-click (Mac) on the layer mask to load the mask as a selection, click on the 'Create new fill or adjustment layer' icon in the Layers panel and choose a Curves adjustment layer. Select the Blue channel and click and drag the adjustment point sitting in the bottom left-hand corner of the diagonal line until the output value reads 90 or more. Repeat this process with the Red and Green channels but raise these only a little in order to desaturate the blue. In the master RGB channel raise the black point to raise the overall brightness of the color you have created.

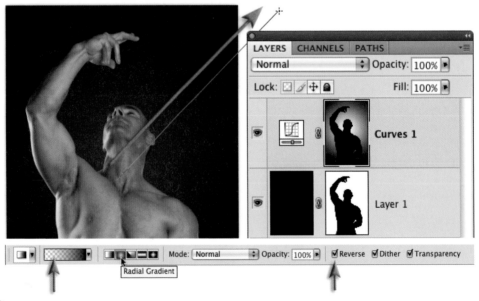

9. Select the Gradient Tool in the Tools panel. Select the Foreground to Transparent and Radial Gradient options with black selected as the Foreground color, set the Opacity to 100% and select the Reverse, Dither and Transparency options. Click and drag from a position in the center of the man's body out past the top right-hand edge of the image window to create the backlight effect.

Blending the texture

Blending two images in the computer is similar to creating a double exposure in the camera or sandwiching negatives in the darkroom. Photoshop, however, allows a greater degree of control over the final outcome. This is achieved by controlling the specific blend mode, position and opacity of each layer. The use of '**layer masks**' can shield any area of the image that needs to be protected from the blend mode. The blending technique enables the texture or pattern from one image to be merged with the form of a selected subject in another image.

10. Open the drops image from the supporting DVD. Click and drag the layer thumbnail of this image into the body image. Hold down the Shift key as you let go of the drops thumbnail to center the image in the new window. Use the Move Tool to reposition the texture if required. Use the Free Transform command (Edit > Free Transform) if required to resize the texture image so that it covers the figure in the image.

Selecting appropriate images to blend

Select or create one image where a three-dimensional subject is modeled by light. Try photographing a part of the human body using a large or diffused light source at right angles to the camera. The image should ideally contain bright highlights, midtones and dark shadows. Select or create another image where the subject has an interesting texture or pattern. Try using a bold texture with an irregular pattern. The texture should ideally have a full tonal range with good contrast. A subtle or low-contrast texture may not be obvious when blended. Alt/Option-click the document sizes in the bottom left-hand corner of each image window to check that the image pixel dimensions (width and height) are similar. It is possible to blend a colored texture with a grayscale image. If the color of the texture is to be retained when it is moved into the grayscale image containing the form, the grayscale image must first be converted to RGB by going to 'Image > Mode > RGB'.

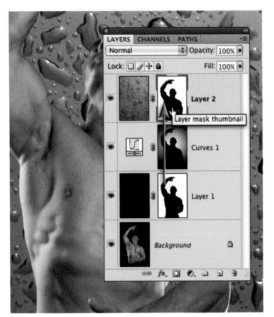
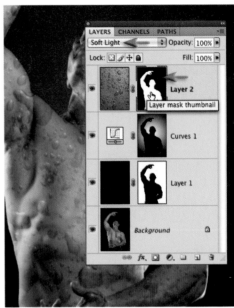

11. Hold down the Alt/Option key and drag the layer mask from Layer 1 to Layer 2 to copy it. Invert the mask using the keyboard shortcut Command + I for a Mac or Ctrl + I for a PC. Set the blend mode of the drops layer (Layer 2) to Soft Light or Overlay. Experiment with adjusting the opacity of the layer using the Opacity control in the Layers panel.

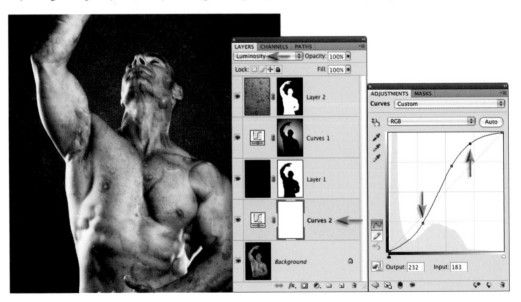

12. After experimenting with the opacity and blend mode of the top layer you can adjust the tonality of the underlying background layer to suit the blend. Select the background layer and select a Curves adjustment from the Adjustments panel. Expand the contrast of the underlying layer by creating an S-curve and set the mode of the adjustment layer to Luminosity if you do not want to increase the saturation levels.

Photography by Abhijit Chattaraj

Creating a displacement map

The layer '**blend**' modes are an effective, but limited, way of merging or blending a pattern or graphic with a three-dimensional form. By using the blend modes the pattern or graphic can be modified to respect the color and tonality of the 3D form beneath it. The highlights and shadows that give the 3D form its shape can, however, be further utilized to wrap or bend the pattern or graphic so that it obeys the form's perspective and sense of volume. This can be achieved by using the 'Displace' filter in conjunction with a 'displacement map'. The 'map' defines the contours to which the graphic or pattern must conform. The final effect can be likened to 'shrink-wrapping' the graphic or pattern to the 3D form. Displacement requires the use of a PSD image file or 'displacement map' created from the layer containing the 3D form. This is used as the contour map to displace pixels of another layer (the pattern or graphic). The brightness level of each pixel in the map directs the filter to shift the corresponding pixel of the selected layer in a horizontal or vertical plane. The principle on which this technique works is that of 'mountains and valleys'. Dark pixels in the map shift the graphic pixels down into the shaded valleys of the 3D form while the light pixels of the map raise the graphic pixels onto the illuminated peaks of the 3D form. The alternative to using a displacement map is to use the Liquify filter.

The limitation of the displacement technique is that the filter reads dark pixels in the image as being shaded and light pixels as being illuminated. This of course is not always the case. With this in mind the range of images that lend themselves to this technique is limited. A zebra would be a poor choice on which to wrap a flag while a nude illuminated with soft directional lighting would be a good choice. The image chosen for this project lends itself to the displacement technique. Directional light models the face. Tonal differences due to hue are limited. Note how the straight lines of the flag are distorted after the Displace filter has been applied. The first image looks as though the flag has been projected onto the fabric, while the second image shows the effect of the displacement filter – it appears as though it has been woven or printed onto the surface of the fabric.

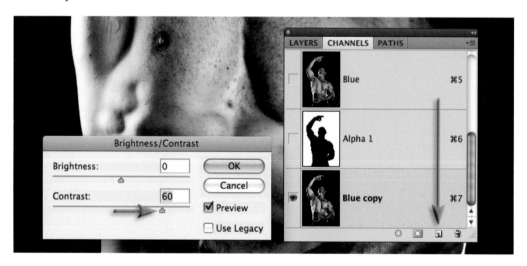

13. Switch off the visibility of the top two layers (the drops and the backlight effect). In order to apply the Displace filter you must first create a grayscale image to become the displacement map. In the Channels panel locate the channel with the best tonal contrast between the shadows and the highlights (in this case the Blue layer). Duplicate this channel by dragging it to the New Layer icon at the base of the panel. Increase the contrast of this channel using the Brightness/Contrast adjustment (Image > Adjustments > Brightness/Contrast). You can further enhance the hills and valleys by selecting the Dodge or Burn Tools from the Tools panel. Set the Exposure to 20% or lower when using these tools and then proceed to either lighten the hills or darken the valleys as you see fit. Remember this is a displacement map not a photograph.

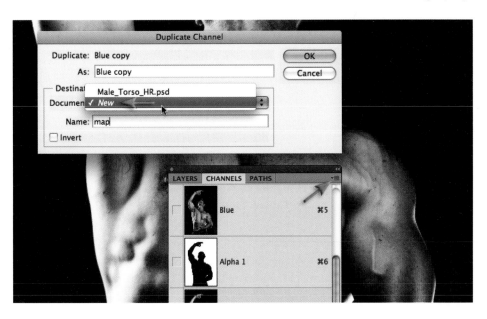

14. Export this channel to become the displacement map by choosing '**Duplicate Channel**' from the Channels menu and then '**Document > New**' from the Destination menu. When you select OK in the Duplicate Channel dialog box, a file with a single channel will open in Photoshop.

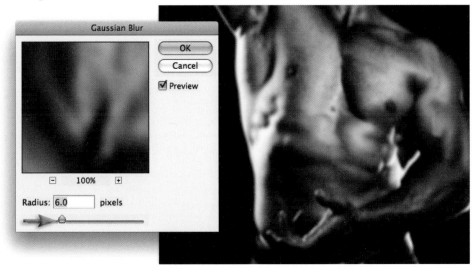

15. Apply 'Gaussian Blur' (Filter > Blur > Gaussian Blur) to the new file. Applying a higher Radius of Gaussian Blur (closer to a Radius of 10 pixels) will create a mask that produces a smooth-edged displacement (minor flaws in the skin will be ignored). Using a lower Radius of Gaussian Blur (1–4 pixels) will create a mask that produces a ragged-edge displacement (every minor flaw in the skin will lead to displaced pixels). Save this file as a Photoshop file (your 'displacement map') to the same location on your computer as the file you are working on. You will need to access this 'map' several times in order to optimize the displacement.

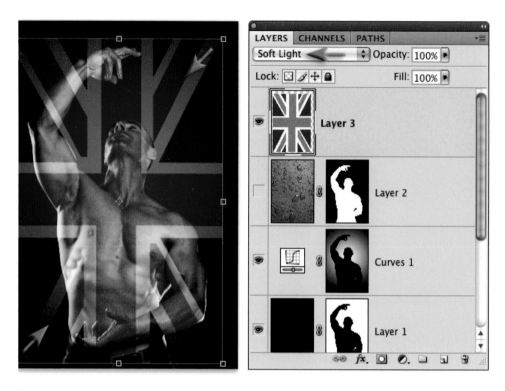

16. Open the flag image and drag the background layer thumbnail into the portrait image. Apply the 'Free Transform' from the Edit menu and drag the handles of the bounding box to achieve a 'good fit'. Hit the Return/Enter key to apply the transformation and then set the Opacity of the layer to 100% and the mode to either Soft Light, Overlay or Multiply.

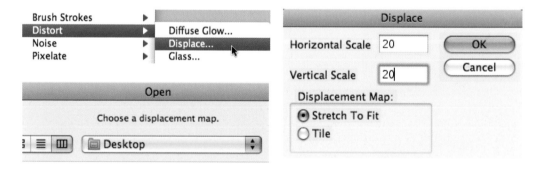

17. Choose 'Filter > Distort > Displace' and enter 20–30 in the Horizontal and Vertical Scale fields of the Displace dialog box. Select OK and then browse to the displacement map you created earlier. The displacement is then applied to the layer. The Displace filter shifts the pixels on the selected layer using a pixel value from the displacement map. Grayscale levels 0 and 255 are the maximum negative and positive shifts while level 128 (middle gray) produces no displacement.

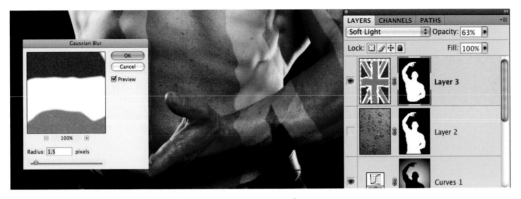

18. Apply a small amount of Gaussian Blur to the flag layer and then hold down the Alt/ Option key and drag the layer mask thumbnail from the drops layer (Layer 2) to the flag layer (Layer 3) to copy it. Lower the opacity of the flag layer to strike a good balance between the graphic and the tonality of the body.

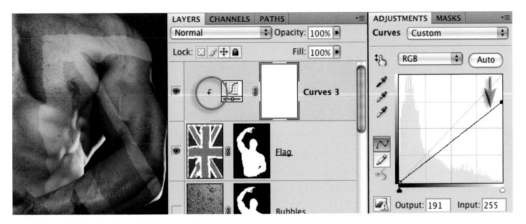

19. The tonality of the flag can be further optimized using adjustment layers that have been clipped to the flag layer. In this project a Curves adjustment was used to lower the brightness of the white tones in the flag and the saturation was reduced using a Hue/Saturation adjustment.

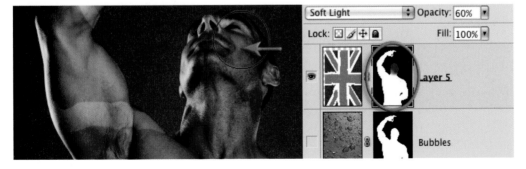

20. If you don't want the flag to appear on certain parts of the body you can paint with black into the layer mask. Use a soft brush at a reduced opacity if you want to fade the graphic in certain areas.

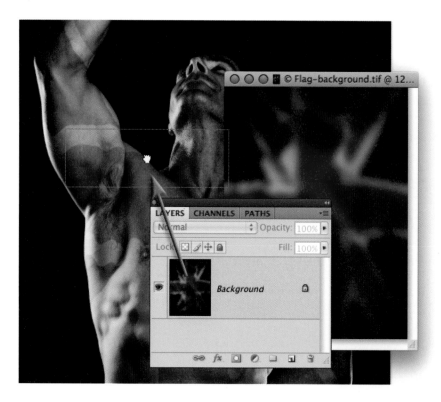

21. An alternative version of the composite image has been created by switching off the visibility of the Curves 1 layer that was creating the backlight effect. A new flag background (created using the same displacement technique) is pasted into the host image. A mask is copied from one of the underlying layers and inverted so that it only appears behind the subject. With so many alternative versions that are possible with just one layer mask (used many times) it is possible to keep track of them using the New Layer Comp panel.

Each time you create a version you like you can keep a record of the layers that were contributing to the overall effect. The New Layer Comp dialog will keep track of not only which layers are visible but also their opacity and position. If any layer styles are applied it will also keep track of these. After the comps have been created it is then easy to switch between the versions.

Alternative approach using the 'Liquify' filter

An alternative approach to distorting the flag using the Displacement filter in '**Project 2**' would be to use the '**Liquify**' filter. Instead of using the '**Blue copy**' channel to create a displacement map it can be used to '**freeze**' an area of the image prior to selectively displacing the unfrozen pixels using the '**Warp Tool**'. This alternative method of displacing pixels on one layer, to reflect the contours of another layer, is made possible in the Liquify filter due to the option to see the visibility of additional layers other than the one you are working on.

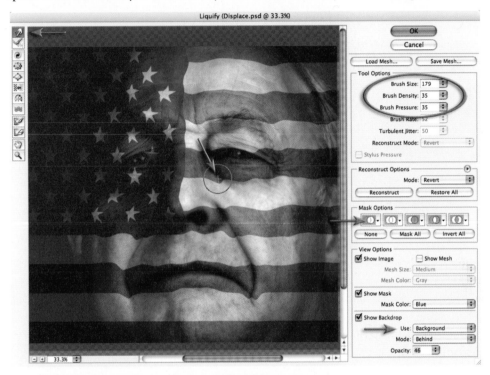

To try this alternative approach complete the first thirteen steps of 'Project 2'. When you reach Step 14, instead of creating a displacement map, click on the flag layer and go to Filter > Liquify. Check the 'Show Backdrop' option in the dialog box and select 'background layer' from the menu. Adjust the opacity to create the optimum environment for displacing the pixels. To selectively freeze the darker pixels in the image load the 'Blue copy' channel in the 'Mask Options'. Select a brush size and pressure and then stroke the flag while observing the contours of the face to displace the lighter pixels. Select 'Invert All' in the 'Mask Options' so that you can displace the darker pixels.

Note > The Liquify filter cannot be applied to a Smart Object but the technique, although labor intensive, does offer the user a little more control over the displacement process. It is possible to save the distortions carried out in the Liquify filter as a 'Mesh'. This Mesh is like a topographic landscape and can be loaded to distort subsequent graphics to the same topography to create a similar distortion.

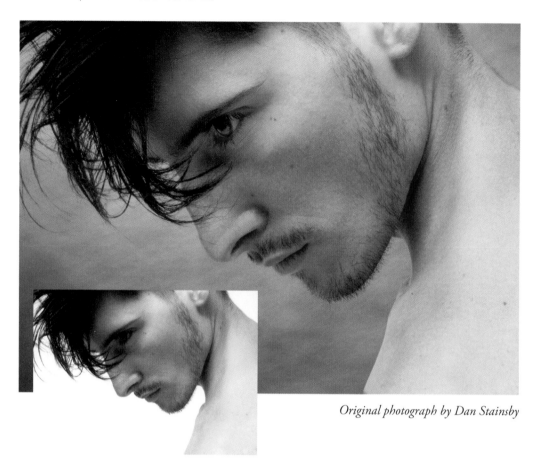

Original photograph by Dan Stainsby

Extracting hair – Project 3

One of the most challenging montage or masking jobs in the profession of post-production editing is the hair lift. When the model has long flowing hair and the subject needs to change location many post-production artists call in sick. Get it wrong and, just like a bad wig, it shows. Extract filters, Magic Erasers and Tragic Wands don't even get us close. The first secret step must be completed before you even press the shutter on the camera. Your number one essential step for success is to first shoot your model against a white backdrop. The background must be sufficiently illuminated so that it is captured as white rather than gray. This important aspect of the initial image capture ensures that the resulting hair transplant is seamless and undetectable. The post-production is the easy bit – simply apply the correct sequence of editing steps and apply the Multiply blend mode for a perfect result. This is not brain surgery and there are no lengthy selection procedures required (the Channels panel holds the secret to success).

Note > When masking hair that was captured against a black background the technique is basically the same as outlined in this project – just change the blend mode to Screen. See the Layer Blends chapter for additional information.

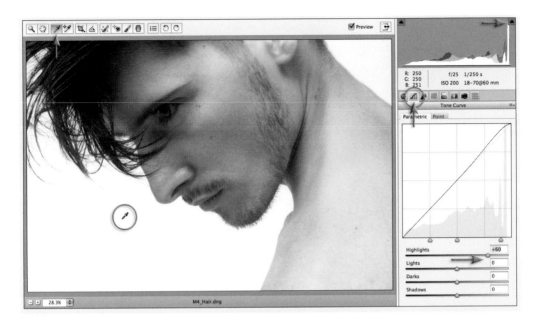

1. If you want to complete this step open the Raw file (M3_Hair.dng) instead of the JPEG or TIFF (the JPEG is ready to go). Select the White Balance Tool and click on the background in the image window to set the white balance. Raise the Exposure slider to +0.50 and then click on the Tone Curve tab. Raise the Highlights slider to +60 and make sure no tones are clipping (view the clipping warning in the histogram). These steps should render the background both neutral and bright.

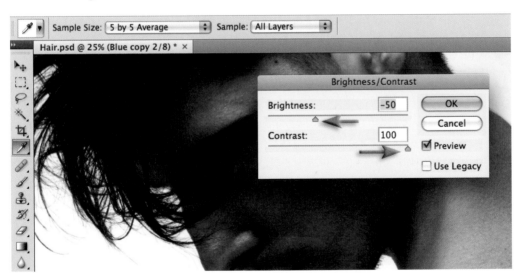

2. In the Channels panel drag the Blue channel (the one with the most contrast between the background and the skin tones) to the 'Create new channel' icon to duplicate it. Go to Image > Adjustments > Brightness/Contrast. Increase the contrast of the channel and lower the brightness to a point just before the background starts to visibly darken.

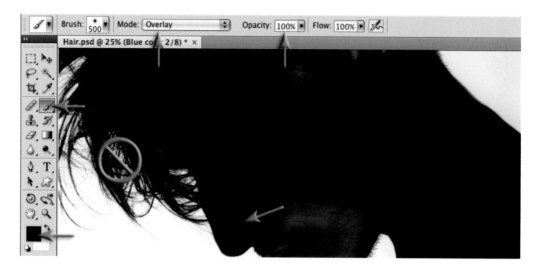

3. Select 'Black' as the foreground color and the 'Brush Tool' from the Tools panel. Choose a large hard-edged brush and 100% Opacity from the Options bar and set the mode to 'Overlay' (also in the Options bar). Painting in Overlay mode will preserve the white background and darken the rest of the pixels. Accuracy while painting in Overlay mode is not a concern when the background is white or is significantly lighter than the subject. Darken the body of the hair near the scalp but avoid the locks of hair that have white background showing through. Painting these individual strands of hair will thicken the hair and may lead to subsequent haloes appearing later in the montage process. Darken the skin on the chin, but not the stubble. The bright tones of the shoulders can be rendered black by repeatedly clicking the mouse in Overlay mode.

Note > If any of the white background has been darkened in the process of creating a black and white mask, switch the foreground color to 'White' and choose 'Overlay' in the Options bar. Paint to render any areas of gray background white.

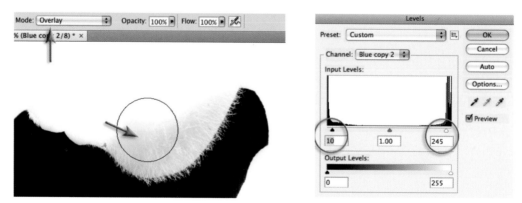

4. Invert the Channel to make it easier to see any tones that are not quite black. Paint with white in Overlay mode if you are working on an inverted channel. Go to Image > Adjustments > Levels and clip the shadow tones and highlight tones by 10 Levels at each end. Invert the mask again when the process is complete.

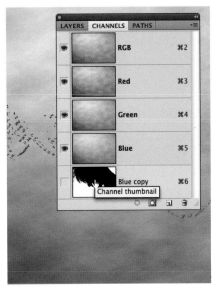

5. In the Channels panel click on the RGB channel. Open the background image from the supporting DVD and click and drag the background layer thumbnail (in the Layers panel) into the portrait image window. Hold down the Shift key as you release the mouse button so that the background image is centered. Close the texture file. In the Channels panel of the portrait image press the Command key (Mac) or Ctrl key (PC) and click on the Blue copy channel thumbnail to load the channel as a selection.

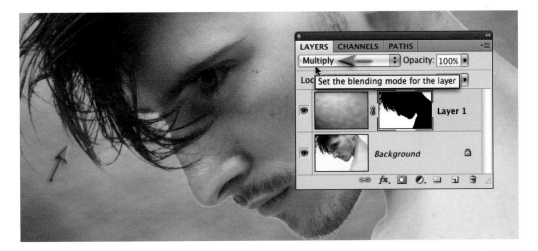

6. Apply a layer mask (using the active selection) to the texture layer. Set the blending mode for the layer to Multiply. Notice the difference in the quality of the strands of hair before and after you switch the blend mode to Multiply. Setting the blend mode of the adjustment layer to 'Multiply' will bring back all of the fine detail in the hair. The background will not be darkened by applying the 'Multiply' blend mode as white is a neutral color. The subtle detail in the fine strands of hair will, however, be preserved in all their glory.

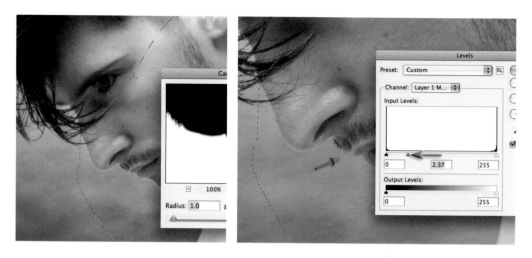

7. The accuracy and quality of the edge of the mask will usually require some attention in order for the subject to achieve a seamless quality with the new background. Make a selection of all of the edges that do not include any hair detail using the Lasso Tool with a small amount of feather set in the Options bar (don't worry about the neck area yet). With the layer mask selected choose the 'Gaussian Blur filter' (Filter > Blur > Gaussian Blur) and apply a 1-pixel Radius blur to the mask. Click OK and then from the Image > Adjustments menu choose a Levels adjustment. Move the central gamma slider underneath the histogram to realign the edge of the mask with the subject edge (no dark or light halo should be visible).

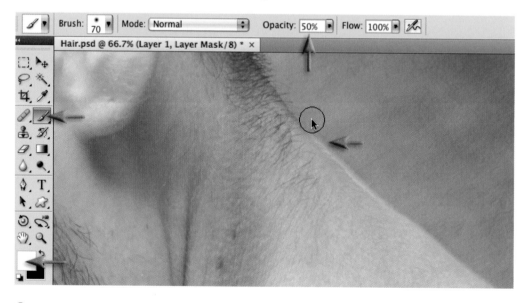

8. Zoom in to 100% Actual Pixels while working to accurately assess the quality of your mask. Any localized refinement of the mask can be achieved manually by painting with a small soft-edged brush directly into the layer mask. Paint with white at a reduced opacity to remove any fine haloes present in localized areas (be sure to change your mode to Normal if it is still set as Overlay). Several brush strokes will slowly erase the halo from the image.

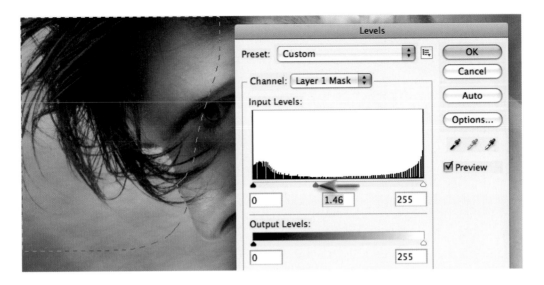

9. In most instances the hair is already looking pretty fabulous but to modify and perfect the hair even further you will need to make a selection of the hair only. Choose 'Levels' once again and move the central gamma slider to the left to increase the density of the hair and eliminate any white haloes that may be present. Moving the white slider to the left may help the process of achieving a perfect blend between subject and background. Select OK and choose 'Deselect' from the Select menu.

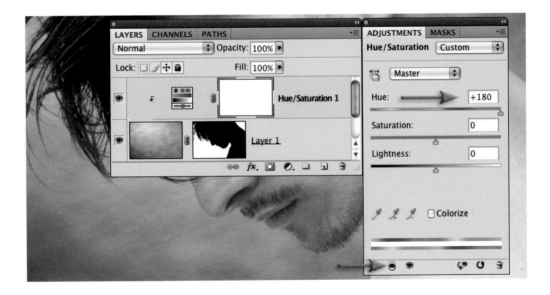

10. To modify the color of the new background without affecting the color of the skin select a Hue/Saturation adjustment layer from the Adjustments panel. Clip the adjustment to the layer below (Layer > Create Clipping Mask). In the Hue/Saturation panel drag the Hue slider to +180 to create a warm background color.

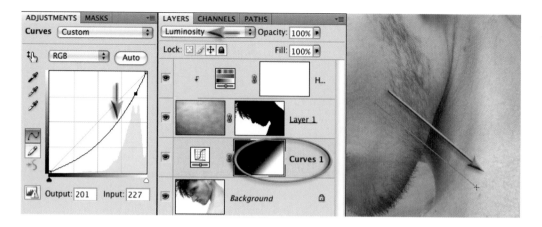

11. In this step we will darken the skin tones on the shoulder that are much brighter than the face. Click on the background layer in the Layers panel and then select a Curves adjustment layer. Set the mode of this adjustment layer in the Layers panel to Luminosity to remove any problems with saturation and then drag down on the curve to darken the image. Select the Gradient Tool from the Tools panel and choose the Black to White, Linear and 100% Opacity options in the Options bar and then drag a diagonal gradient from the chin to the shoulder to hide the adjustment from the face.

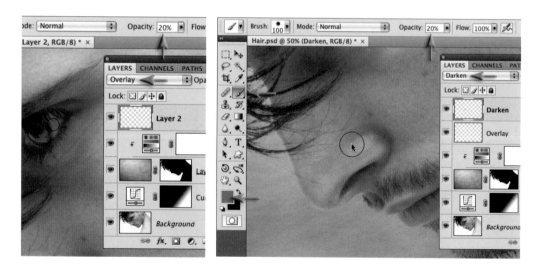

12. Select the Hue/Saturation layer, click on the 'Create a new layer' icon and set the mode of the new layer to Overlay and then name the layer Overlay. Select the Brush Tool from the Tools panel and paint with a soft-edged brush with white at 20% Opacity to lighten the eye. Paint several times to increase the effect. Create another new layer and set the mode of this layer to Darken and name the layer Darken. Hold down the Option/Alt key and click on an area of warm colored skin to sample the color. Paint with this color to remove the sheen on the nose. Increase the size of the brush and paint this color over the shoulders as well.

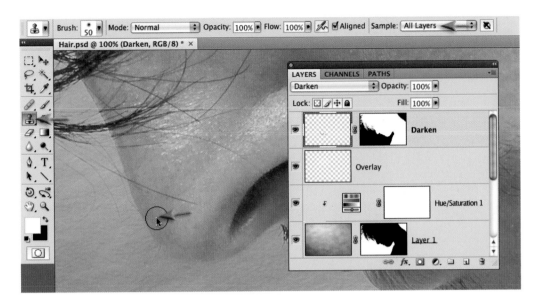

13. Occasionally the edges of a subject may appear too light when a new background is much darker than the original. The problem can be fixed by cloning darker background pixels into the lighter halo in the Darken layer. Hold down the Alt/Option key and drag the layer mask from Layer 1 to this new layer. Invert the mask using the keyboard shortcut Ctrl + I (PC) or Command + I (Mac). Go to Filter > Other > Maximum and choose a value of 1 pixel to move the edge of the mask slightly. Select the Clone Stamp Tool from the Tools panel and select the All Layers option in the Options bar. Command + click (Mac) or Ctrl + click (PC) on an area of darker skin next to the lighter edge and then clone these darker pixels into the lighter edge. Be sure to select the image area and not the mask before painting with the Clone Tool.

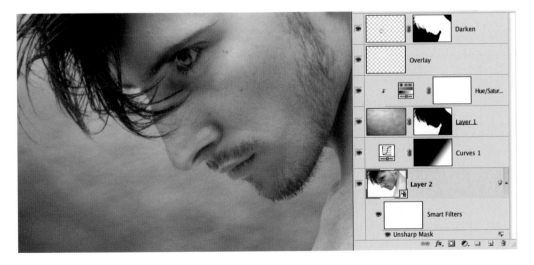

14. To complete the project select the background layer and go to Filter > Convert for Smart Filters. Apply either the Unsharp Mask or Smart Sharpen filter to this layer. The new background does not need to be sharpened so sharpening only the base layer is appropriate for this project.

Masking hair captured against a black background

When masking hair that was shot against a black background, setting the Levels adjustment layer (the one holding the mask) to the Screen Blend mode is the secret to success. Note the difference between Normal mode and Screen Blend mode in the illustrations above.

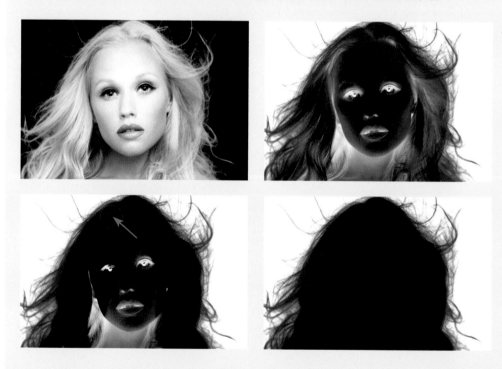

You will need to invert the layer mask when using a model shot against a black background (Filter > Adjustments > Invert) before painting in Overlay mode as in Steps 3 and 4 of the Extracting Hair project. Apply a Levels adjustment to the layer mask as in Step 9 to fine-tune the hair against the new background.

image courtesy of www.iStockphoto.com

Original Venice image by Craig Shell (sky by Mark Galer)

Replacing a sky – Project 4

The sky is an essential ingredient of any memorable landscape image. Unfortunately it is not something the photographer can control unless we have limitless time and patience. The commercial photographer is often required to deliver the goods on a day that suits the client rather than the photographer and weather forecast. In these instances it is worth building a personal stock library of impressive skies that can be utilized to turn ordinary images with bland skies into impressive ones. A digital compact camera set to a low ISO is ideal for capturing these fleeting moments. The most useful skies to collect are the ones that include detail close to the horizon line, i.e. captured without interference from busy urban skylines, such as can be found at the beach or in the desert. A stock library of skies is included on the DVD to help you start, or add to, your own collection. In this project we explore how a sky can be adapted to fit the landscape so the montage is not immediately obvious.

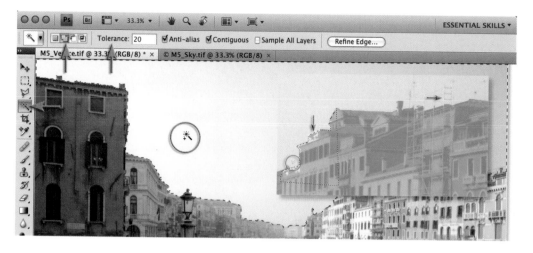

1. Open the file named M4_Venice.tif. Select the Magic Wand Tool from the Tools panel and set the Tolerance to 20 in the Options bar. Select the Add to Selection icon in the Options bar or hold down the Shift key as you click multiple times to select all of the sky. Zoom in to 100% or 'Actual Pixels' and select Quick Mask mode from the Tools panel. Invert the mask if necessary using the keyboard shortcut Command or Ctrl + I so that the buildings rather than the sky are masked. Make a selection using the Polygonal Lasso Tool to select any tops of the buildings that are not currently masked (due to the overzealous nature of the Magic Wand). Exclude the scaffolding and the TV aerials from the selection using the Brush Tool. Fill this selection with black (if black is the foreground color in the Tools panel you may use the keyboard shortcut Alt/Option + Backspace/Delete). Exit Quick Mask mode when this work is finished (keyboard shortcut is to press the letter Q). If the buildings rather than the sky is selected go to Select > Inverse.

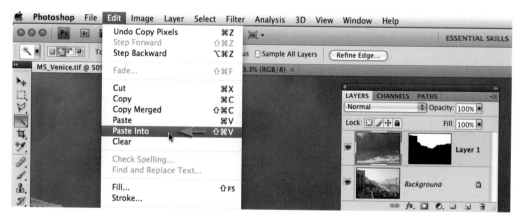

2. Open the Sky image used in this project and from the Select menu choose All. From the Edit menu choose Copy. Return to the Venice image and from the Edit menu choose Paste Into. Don't be alarmed at how bad it looks at the moment, we have several more steps to go before things start to look OK. For the moment we must be content that the sky was captured at a similar time of day to the Venice image and the direction of light is also similar.

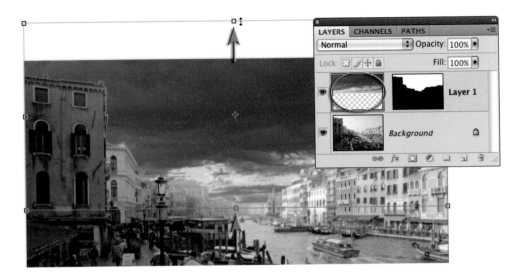

3. Make sure the image rather than the mask is the active component of the layer and then choose Free Transform from the Edit menu (Ctrl/Command + T). Click and drag inside the Transform bounding box to raise the sky into position. Click and drag on the top-center handle to further enhance the location and shape of the sky to fit the host image. Press the Enter/Return key to commit the transformation.

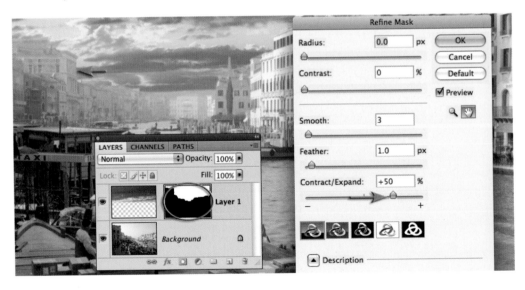

4. Click on the layer mask to make it active and then go to Select > Refine Edge. Choose a 1-pixel Feather and move the Contract/Expand slider to the right until the light halo from around the majority of the buildings has disappeared. It is not possible to remove the halo around the buildings on the extreme left-hand side of the image without removing too much edge detail from the rest of the skyline. The haloes around these building can be fully corrected using the Levels adjustment technique in combination with Lasso Tool selections as outlined in Project 1 of this chapter.

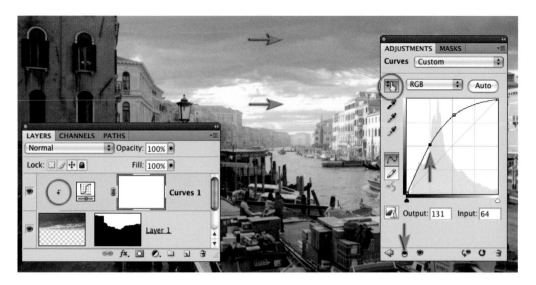

5. Select a Curves adjustment from the Adjustments panel. Clip the layer to the sky layer below by clicking the icon next to the visibility icon in the Curves panel. Create a curve that renders both the highlights and midtones of the sky very bright so that they match the tones of the distant buildings. Use the on-image adjustment tool and click twice to create two adjustment points on the Curve. Drag these higher to lighten the sky. Skies that have been captured in less humid conditions will always require this adjustment if they are to look at home in a location where there is reduced contrast together with lighter tones in the distant subject matter.

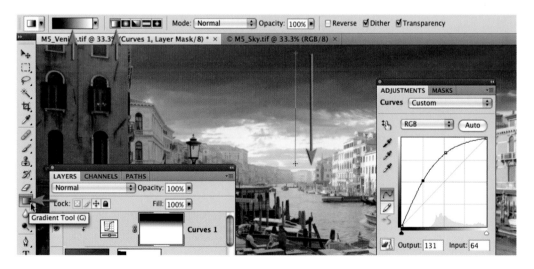

6. Select the Gradient Tool from the Tools panel. In the Options bar choose the Black, White and Linear Gradient options and an Opacity setting of 100%. Click and drag a gradient from the top of the image to a position just above the horizon line. Hold down the Shift key to constrain the gradient. This will give the sky depth and ensure the sky retains its drama above the buildings in the foreground.

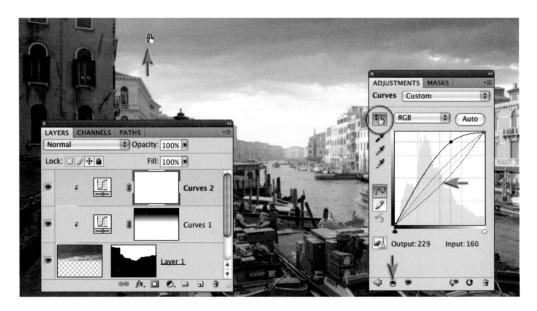

7. Create a second Curves adjustment and clip this to the layer below. The purpose of this second adjustment layer is to increase the intensity of the light on the left side of the image. This will help establish the light source that is bathing the buildings on the right side of the image in a warm afternoon glow and help establish a realistic effect. Increase the warmth by raising the red curve and lowering the blue curve and then raise the overall brightness using the RGB channel. Observe the effect above the foreground buildings on the left side of the image.

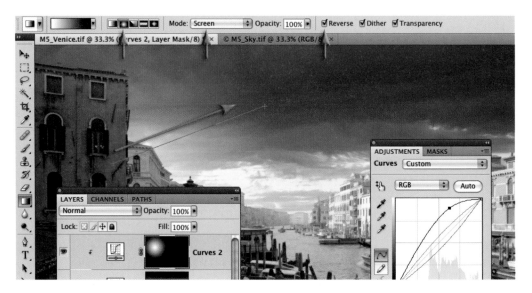

8. Fill the layer mask with Black (Edit > Fill > Black). Select the Gradient Tool from the Tools panel. Select the Black, White and Radial options. Set the mode to Screen and select the Reverse checkbox in the Options bar. Drag a short gradient from behind the buildings on the left side of the image to the top-center of the image.

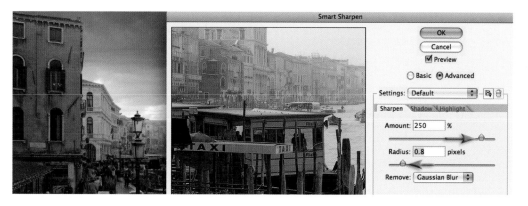

9. Click on the background layer and choose Convert Layer for Smart Filters. Go to Filter > Sharpen > Smart Sharpen. Sharpen the image and select OK. You can be generous with the sharpening as the opacity of the filter can be lowered or the settings modified at any point in the future in a completely non-destructive way.

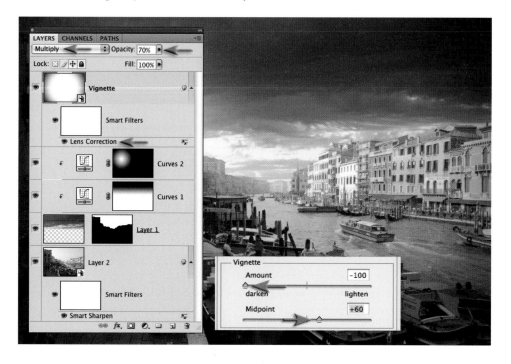

10. Select the top layer (Curves 2) in the Layers panel and then click on the 'Create a new layer' icon in the Layers panel. Fill this layer with white and set the mode to Multiply. Go to Filter > Convert for Smart Filters. Go to Filter > Distort > Lens Correction. Go to the Vignette section of the dialog box and lower the Amount slider to −100 and raise the Midpoint slider to +60 so that the vignette does not encroach too heavily on the buildings on the extreme right-hand side of the image. Select OK to apply these changes. Adjust the opacity of the layer to make the vignette a little more subtle. The project is now complete and the scene carries all of the mood of an old Venetian painting courtesy of a dramatic sky.

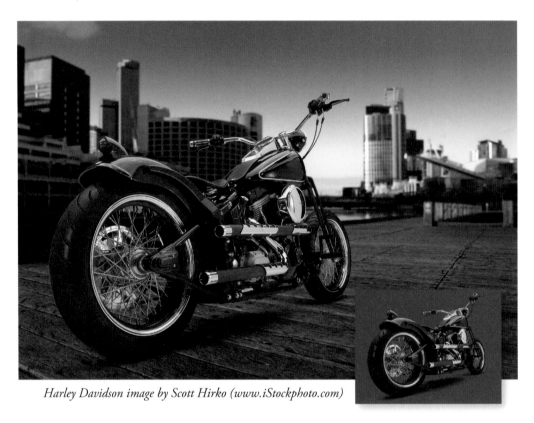

Harley Davidson image by Scott Hirko (www.iStockphoto.com)

Studio and location composite – Project 5

In the Retouching Projects chapter we learned how to prepare an image captured in the studio for a composite project. These techniques will enable the original shadow to be introduced into the new location rather than having to create an artificial one. When the subject is introduced into the new location there will be some additional work that needs to be carried out in order to create a realistic end-result. Sometimes a subject cannot be introduced into a particular location because of inconsistencies in the capture technique. To ensure a successful end-result it usually makes sense to capture the studio subject to match the location rather than having to scour the environment to find a location with the appropriate lighting to match your studio subject.

Critical factors in the creation of a realistic montage are as follows:

- Continuity of vantage point (the camera angle to the subject and the background should be the same).
- Continuity of depth of field (if in doubt shoot both the subject and the background at a small aperture and reduce depth of field in post-production).
- Continuity of perspective. Keep the same relative distance from your subjects (zoom in rather than moving close to small objects).
- Continuity of lighting. The angle of light source to the subject and background and the quality of lighting (harsh or diffuse) should be the same.

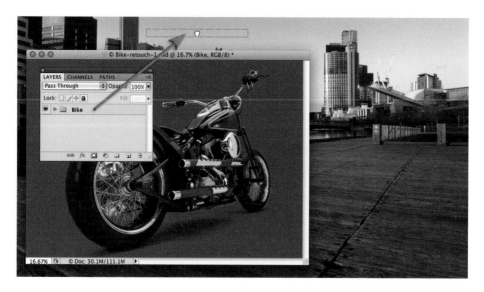

1. Open the M5 start image and your finished version of R6 image (or the finished R6 PSD image on the disk). Drag the Group that was created in Project 6 of the Retouching chapter into the host image. Double-click on the background layer and in the New Layer dialog rename the layer 'location' and select OK. In the Layers panel, drag the bike group so that it is below the location layer.

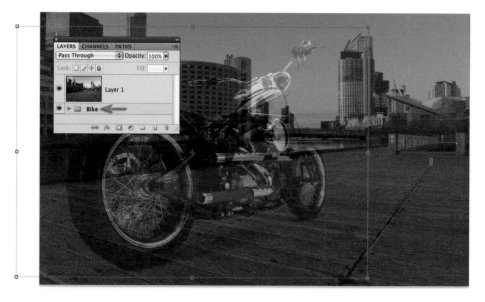

2. Lower the opacity of the location layer so that you can see the bike underneath. Select the Bike group and go to Edit > Free Transform. Hold down the Shift key and drag the corner handle of the Bike group to scale the bike proportionally and then click and drag inside the bounding box to reposition the bike in the bottom left-hand corner of the image (be careful not to double-click or you will commit the transformation before you are done). Press the Return/ Enter key to commit the transformation if you are satisfied with the scaling amount.

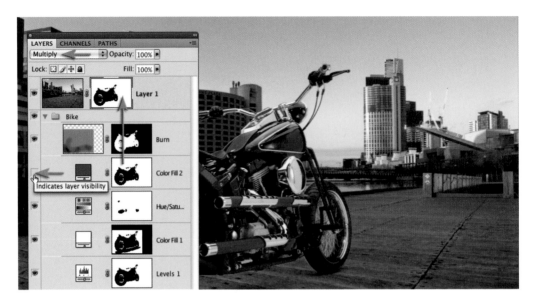

3. Open the group so that you can see the layers of the bike image. Hold down the Alt/Option key and drag the layer mask from the Color Fill 2 layer to the location layer to copy it. Switch off the visibility of the Color Fill 2 layer by clicking on the visibility icon. The bike should now be visible but without its shadow. Set the mode of the location layer to Multiply to reintroduce the shadow.

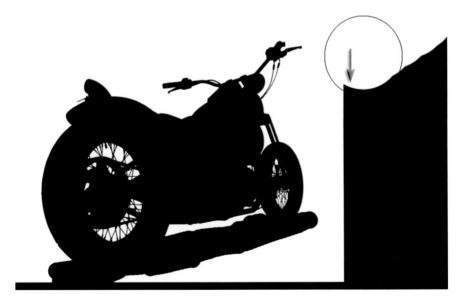

4. When a group of layers are scaled smaller the layer masks may acquire black edges that will need to be cleaned. In the illustration above this type of mask can create problems in the final image. To view the mask by itself hold down the Alt/Option key and click on the layer mask. To clean the mask select the Brush Tool and paint over the black edges as needed or make a selection using the Magic Wand Tool and fill with white.

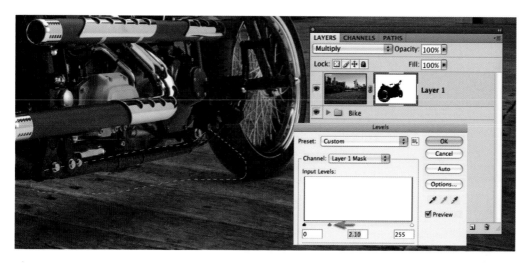

5. Select the layer mask of the location layer (Layer 1) and refine the edge so that no halo is visible. You will need to zoom in to 100% (Actual Pixels) to obtain an accurate view of the edge, i.e. a halo that may be apparent at 25% may not be visible when the file is magnified further, printed or flattened. Go to Select Refine Edge and move the Contract/Expand slider if required. You will not need to add any additional feather as the edge of the mask has already been blurred. If you need to remove a halo in a localized area of the image make a selection with the Lasso Tool and go to Image > Adjustments > Levels and move the central gamma slider to the left (see Project 1 in this chapter for extended guidelines to optimize the edge).

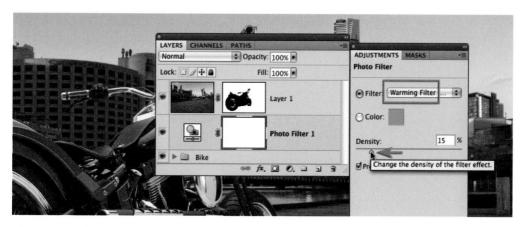

6. The white balance between the studio image and location image is unlikely to be the same and one of the images will need to be adjusted to match the other. In this image it was decided to retain the warm light of the location and warm the bike to match. This can be achieved with a number of different adjustments from the Adjustments panel. In the illustration above a Warming Filter from the Photo Filter adjustment was applied above the Bike group.

Note > If the Group is closed the Photo Filter will be placed above the group rather than inside the Bike group. It does not really matter where the Photo Filter is placed so long as it is below the location layer (Layer 1).

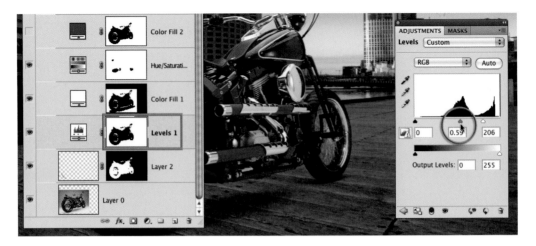

7. The density of the shadow can be adjusted to suit the new location by selecting the Levels 1 adjustment layer in the Bike group (this was the adjustment layer that was used to clip the background tones to white). Move the central gamma slider in the Levels panel (underneath the histogram) to the left or right to adjust the shadow so that it is consistent with the host image.

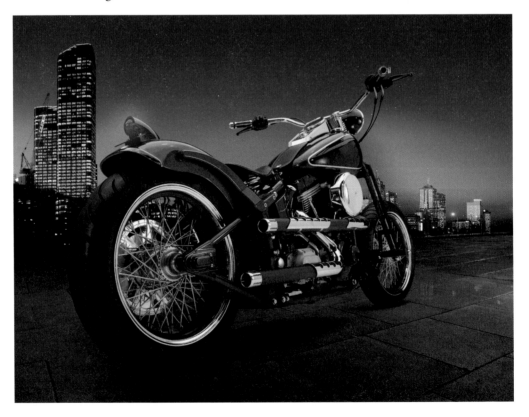

The bike can be moved to a variety of locations. In this alternative the bike has been moved to a location constructed from two images (foreground pavement and background nightscape). A cooling filter is applied and the lights are turned on to complete the picture.

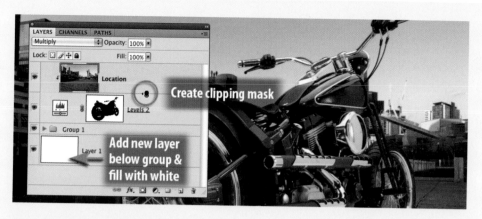

PERFORMANCE TIP

A non-destructive approach to adjusting the scale of the bike in this project is to transform the group after it has first been converted to a Smart Object. This allows the user to scale the Bike group repeatedly without compromising the quality. First add an empty new layer below the Bike group and fill it with white (this will prevent transparency from appearing around the group after it has been scaled). Next, create an adjustment layer below the Location layer. Drag the layer mask from the Location layer to the adjustment layer to replace it. Create a clipping mask between these two layers (Layer > Create Clipping Mask). Moving the layer mask to a separate layer enables you to scale the bike and the mask at the same time without scaling the Location layer.

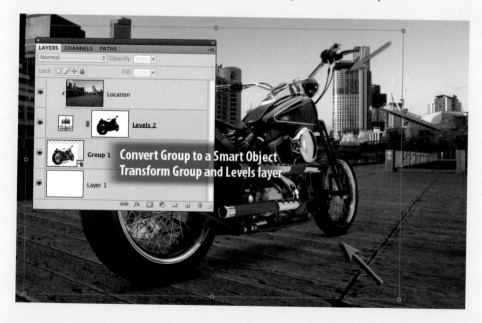

Right-click on the Bike group and choose Convert to Smart Object. Select the Bike Group and the Levels adjustment layer above (Shift-click the two layers) and then Transform the bike smaller (Command/Ctrl + T).

The best technique for subtle shadows

The technique to preserve shadows provides those photographers burdened with a meticulous eye a useful way of retaining and transplanting subtle and complex shadows. Observe the subtle shadow cast by the leaf above that would be virtually impossible to recreate using any other technique. The primary reasons for not being able to use this technique are when the shadow falls over a surface with a different texture to the one in the new location, or the surface over which the shadow falls is particularly uneven or moves from a horizontal to a vertical plane over the length of the shadow.

Original images and concept by Jakub Kazmierczak

PERFORMANCE TIP

This technique for preserving shadows does not have to be restricted to objects sitting on a white background. The technique is just as effective when isolating the shadow of a much larger object captured in its natural surroundings. If, however, the subject has been captured on a textured or rough surface this surface quality will be transferred to the new background when using this technique. A surface quality mismatch can occur that can make the shadow look unnatural.

To ensure a shadow with a rough surface texture does not look out of place against the smooth surface of a new background you can apply a small amount of Gaussian Blur to soften the quality of the shadow. In the illustration on this page a colored Linear gradient in Overlay mode has also been used to warm up the cool colors evident in the panels of the car. The detail in the car windows has also been softened using a Gaussian Blur. These measures ensure the car is perfectly at home in its new surroundings – even if it is balancing on water!

Creating shadows

If it is not possible to preserve the original shadow, try to capture a second image of the subject from the direction of the light source. This second image will allow you to create a more accurate shadow than simply using the outline of the subject as seen from the camera angle. Start this technique by making a mask of your subject and place it on a layer above a new background you wish to use. Import the second image (captured from the direction of the light source) and position it between the subject layer and the background layer. Make a selection of the subject in this second image, create a new empty layer and then fill your selection with black. You can then hide or delete the layer that the selection was made from. Place your new shadow layer in Multiply mode. Lower the opacity of your shadow layer and apply the Gaussian Blur filter. Use the Free Transform command to distort and move the shadow into position.

Studio photograph by Rahel Weiss

Replacing a studio background – Project 6

This project combines the skills learned from both the hair extraction project (Project 3) and the shadow preservation project in the Basic Retouching chapter. The purpose of this project is to demonstrate how the model's fine hair and the original shadows from the studio backdrop (cyclorama or 'cyc') can be preserved after creating a composite image using a new location image. The ideal background color for extracting hair for composite image is level 255 white or level 0 black, but when the model is standing or sitting on the studio 'cyc' it may not always be possible to render the background absolute white or black due to the limitations of lighting and the size of the backdrop available. The techniques in this project show you how to work around these issues.

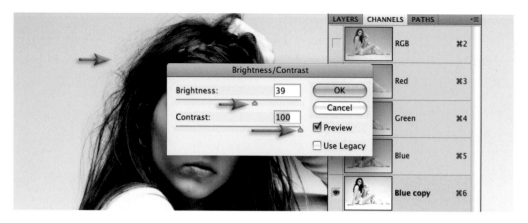

1. Open the Raw file in Adobe Camera Raw. Select the White Balance Tool and click on neutral tone in the image such as the white backdrop (the modeling lights of the studio flash used to capture this image confused the auto white balance setting in the camera). Then open the image in Photoshop. A JPEG image is supplied on the DVD with this step already completed. Go to the Channels panel to start the process of creating a mask. The following steps summarize the hair extraction techniques from Project 3. Find the channel with the highest contrast between the hair and the background by clicking on each one in turn. Duplicate the channel with the highest contrast by dragging it to the New Channel icon. Increase the contrast of the copy channel to further refine the mask. Use a Brightness/Contrast adjustment (Image > Adjustments > Brightness/Contrast) and raise the Contrast to +100 and the Brightness slider to a level just before you start to lose detail in the fine hairs.

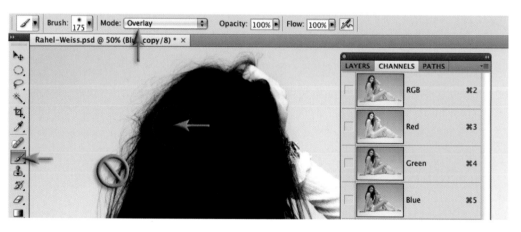

2. Choose the Brush Tool, Black as the Foreground color and set the mode to Overlay in the Options bar. Choose a soft-edged brush and be careful NOT to paint over fine strands of hair where the background is also visible. Move close to the edge of the hair but do not paint where any background is visible. Switch the mode of the Brush Tool back to Normal in the Options bar and paint with black to fill in any areas of white around the face. The first step of the mask is complete when the head and hair appears as a silhouette. The rest of the subject that has a more defined edge will be selected in the next step.

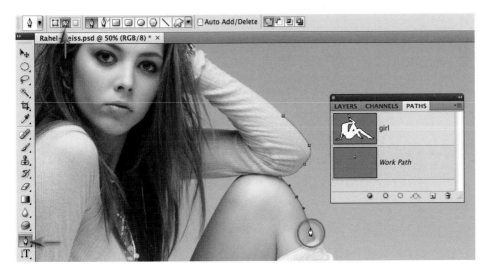

3. Create a path around the outline of the body excluding the hair (see Project 2). A finished path has been supplied with the tutorial image for your convenience. Hold down the Ctrl key (PC) or Command key (Mac) and click on the path you created to load the path as a selection. The edge of a vector path is not suitable for masking photographs. The path has to be converted to a selection so that the edge can be refined. Go to the Channels panel and click on the 'Save selection as channel' icon. You will now have a Blue copy channel and an Alpha 1 channel. The two of these channels will provide you with the mask you need to hide the studio backdrop. Choose Select > None.

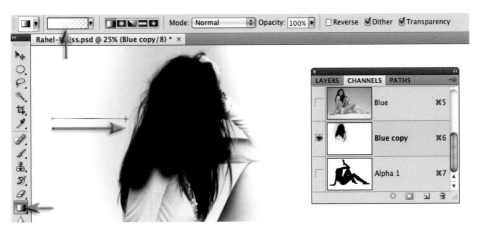

4. The background of the Blue copy Alpha channel is still too light so must be modified further. Select the Gradient Tool and choose White as the foreground color and the Foreground to Transparent and Linear options in the Options bar. Set the Opacity to 100%. Drag a series of gradients from the bottom, left and right sides of the hair that fall short of the hair to lighten all of the tones surrounding the hair. The Gradient Tool is a useful way of introducing a smooth transition. Using the Brush Tool to lighten the background may introduce harsh edges that may be detected later so this approach should be avoided.

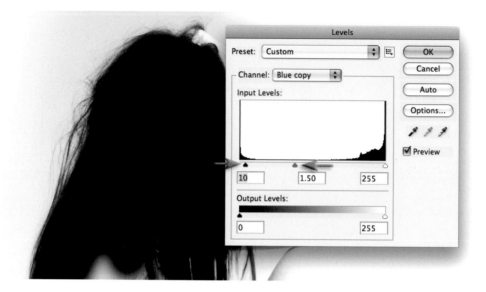

5. Darken any remaining gray tones by going to Image > Adjustments > Levels. Drag the central gamma slider beneath the histogram to the left. Do not go beyond 1.5 gamma so that you can preserve the fine detail in the hair. Drag the shadows slider to level 10 to clip any dark gray tones present in the body of the hair to black.

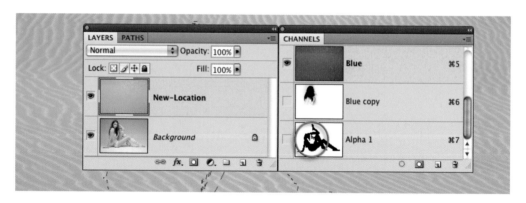

6. Click on RGB in the Channels panel. Open the M6_Sand image file and drag the background thumbnail from the Layers panel into your project image. In this example a fairly abstract background has been used but you can use any location providing the vantage point or angle of view and lighting is consistent with the subject photographed in the studio. Make sure you are in the Channels panel. Hold down the Ctrl key (PC) or Command key (Mac) and click on the Blue copy channel first to load it as a selection. Now hold down the Alt/Option key as well as the Ctrl/Command key and click on the Alpha 1 channel to add this to the selection. All of the background should now be selected.

Note > The modifier keys control how a second Alpha channel is loaded as a selection (add, subtract or intersect). The order in which you load the channels may also make a difference to the resulting selection.

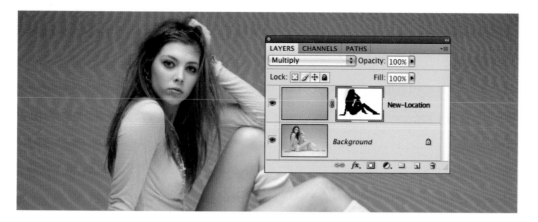

7. Go to the Layers panel and click on the 'Add layer mask' icon at the base of the Layers panel. Go the blending options and choose Multiply from the menu. This action will improve the fine detail in the hair and restore the shadows to the image. The new location will appear darker due to the gray tone of the white studio background on the background layer. This will be rectified later. There should be no active selection now that it has been converted into a layer mask.

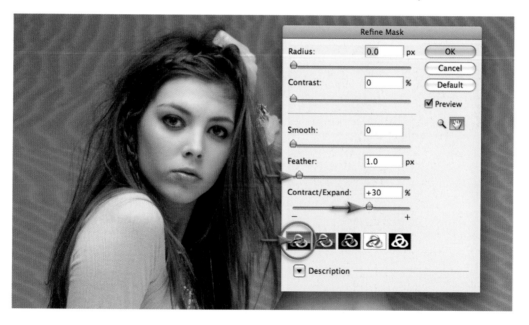

8. Go to Select > Refine Edge (we are now refining the edges of the mask and not the selection). Click on the Standard preview option. Hide the selection edges by going to the View menu and deselecting either the Extras or the Selection Edges in the Show submenu. The keyboard shortcut may not work in this instance. You need to hide the selection edges so that you can see the effect of your adjustments. Set the Radius, Contrast and Smooth sliders to zero. Raise the Feather slider to a setting between 0.5 and 2.0 pixels and raise the Contract/Expand slider to hide any haloes that may appear around your subject. Zoom in to 100% and take a look at both the smooth edges and the hair to choose appropriate values for both of these sliders. Select OK.

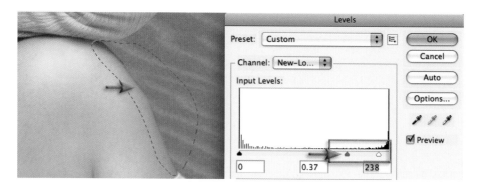

9. Hold down the Alt/Option key and click on the layer mask to view the contents. Look for any holes in the mask that may have appeared as a result of using the Refine Edge command. Set the brush mode to Normal and paint with black if you see any areas of gray in the main body of the mask. Do not paint in the areas of fine detail at the edge of the mask. If you have any haloes along the sharp edges of the mask make a selection of the problem area with the Lasso Tool. Go to Image > Adjustments > Levels and move the gamma slider to the right or left to perfect this localized portion of the mask. Moving the black or white sliders towards the center will increase the contrast of the mask in this area and may help you to perfect the edge.

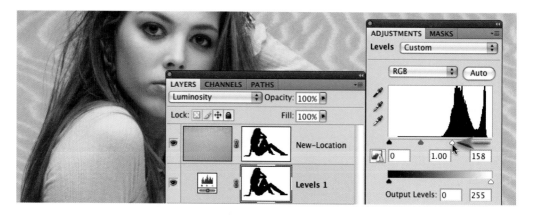

10. Hold down the Ctrl key (PC) or Command key (Mac) and click on the layer mask to load it as a selection. This selection will create its own mask when we create an adjustment layer in the next step. This will enable us to work on the tonality of the studio backdrop while protecting the tonality of the model. Select the background layer (the one with the woman). Create a Levels adjustment layer from the Adjustments panel. Set the mode of the adjustment layer to Luminosity. Drag the white input slider beneath the right side of the histogram to the left to clip the background tones to white. Stop dragging the slider when you notice it impacting on the fine detail in the hair. As the shadow tones are darker they should be some of the last tones that would be rendered white using this technique. If the shadow tones become too light move the middle gamma slider to the right. Select the Brush Tool in the Tools panel. Select Black as the foreground color and the Opacity as 50%. Paint over the cast shadows in the adjustment layer mask to restore the shadows to their original darkness.

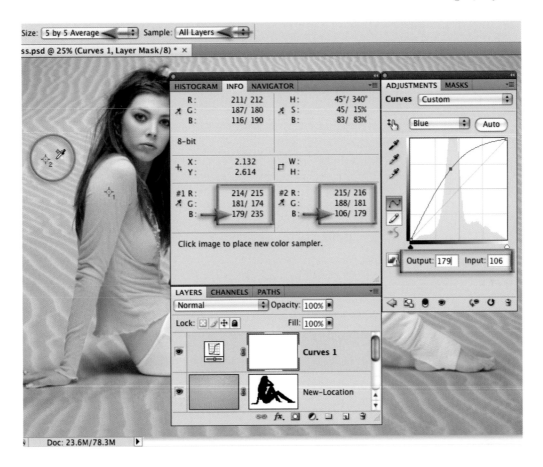

11. Invariably the color and tone of the subject and the new location image will need to be matched for consistency of contrast and white point. In this project the color of the sand is matched to the clothing the model is wearing. Choose the 'Color Sampler' Tool (behind the Eyedropper Tool) and set the Sample Size to a 5 by 5 Average in the Options bar. Click once on the clothing, making a mental note of the brightness value in the Info panel, and then move the Color Sampler to the sand and take a second color sample that is approximately as bright as the clothing sample taken (set the Second Color Readout to HSB in the Info panel options).

12. Select the location layer and then choose a Curves adjustment layer from the adjustments panel. Go to each of the three RGB channels in turn and click anywhere on the curve to set an adjustment point. In the Input field in the Curves panel type in the value that appears in the first set of values in the #2 sample RGB information in the Info dialog (in the illustration above, level 106 that appears in the Info panel has been typed into the Input field in the Curves dialog). Each of the output values is then changed so that they are the same as the #1 color sample values. By matching the output values in the Curves dialog to the values of the first color sample point we have effectively made the color of the sand the same color as the clothing prior to adding this Curves adjustment layer. Ignore the fact that the model and the clothing have turned magenta at this point!

13. In the Curves panel click on the overlapping circles icon to clip the Curves adjustment layer to the sand layer. This restricts the color adjustments to just this layer and restores the original color of the model. In the Options bar clear the color samplers or hold down the Alt/ Option key and the Shift key and click on each color sample target in turn to remove them.

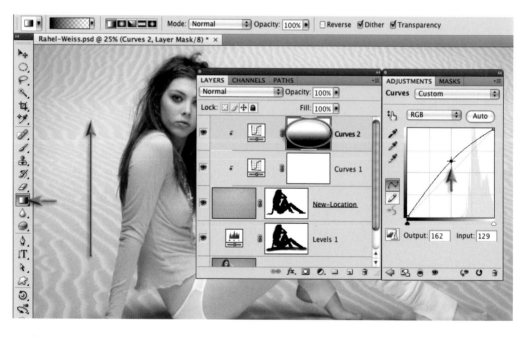

14. Create a second Curves adjustment layer and clip it to the layers below. Raise the RGB curve so that the sand is much brighter than before. Drag a Black, White linear gradient into the adjustment layer mask so that the bottom half of the sand is shielded from this adjustment. Just replace the contents of the sand layer with another background to transport the model around the world.

Jeff Ko

Jeff Ko

Jeff Ko

Bronek Kozka

Chris Mollison

Let's sea
a world of change!
WWF

OBSERVATION CHART MR 4

Every year, governments pour billions into subsidies for
their fishing fleets. But details of how these billions are
spent remain locked in government files.
With subsidies increasingly linked to overfishing,
it's time for greater transparency and accountability.

align and blend projects

Morten Haugen

essential skills

- Combine individual montage skills learned in the 'Montage Projects' chapter to create sophisticated montages.
- Replace the studio background with an alternative background.
- Combine elements captured in the studio and on location and retain continuity of vantage point, depth of field, perspective and lighting.

Rory Gardiner – rorygardiner.com.au

Composite lighting and action – Project 1

The lighting of a studio set is often compromised by either limitations of time or the complexity of the lighting that is required for the creative outcome. Take, for instance, the example above, where the ideal lighting required for the liquid and the label is different. Perfect the lighting for one and the quality of the other is compromised. The solution is remarkably simple of course. Perfect the lighting for one at a time and then create a composite image in post-production. The drama is further enhanced by adding a splash, ripples and the perfect background. Prior to CS3, pin-registering each exposure in-camera using a sturdy tripod was an essential requirement for the success of this technique. Small differences in camera position (such as knocking the tripod between exposures) can now be corrected using the new Auto-Align Layers command.

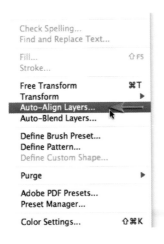

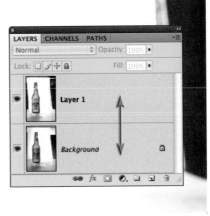

1. Open the two bottle images and make a composite image by dragging the background thumbnail (in the Layers panel) from the label image into the beer image. Shift-click both layers to select them. Select Auto-Align Layers from the Edit menu and select the Reposition option before selecting OK. Hold down the Ctrl key (PC) or Command key (Mac) and then click on the 'Create a new layer' icon at the base of the Layers panel to create an empty new layer below Layer 0. Fill this new layer with white (Edit > Fill).

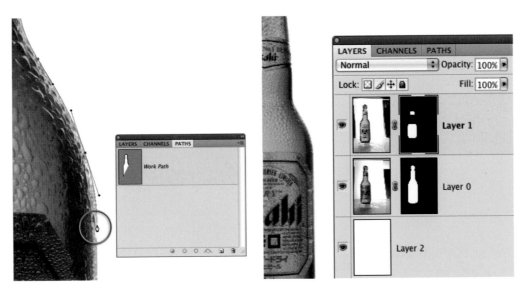

2. Make one path around the bottle and another path around the labels using the Pen Tool (see the Selections chapter and Project 2 in this chapter). Hold down the Command key (Mac) or Ctrl key (PC) and click on a Path thumbnail to load it as a selection. In the Layers panel select the corresponding layer, e.g. the label path for the label layer and then click on the 'Add layer mask' icon at the base of the Layers panel. Apply a 1-pixel Gaussian Blur to each layer mask (Edit > Blur > Gaussian Blur). Select the top two layers and use the keyboard shortcut to load them into a group (Command or Ctrl + G) and name the group 'Bottle'.

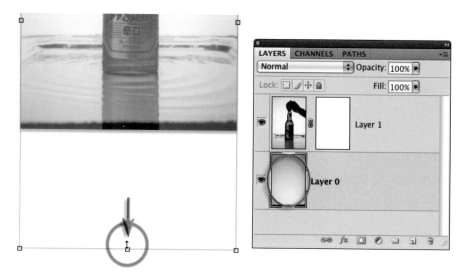

3. Open the Ripples and Background files. The Ripples file has had a +1.15 exposure increase and the Contrast slider has been raised to +75 in Adobe Camera Raw so that the tones match the background image. Make a composite image from these two files by dragging the background thumbnail (in the Layers panel) from the ripples image into the background image. Double-click on the background layer and select OK in the New Layer dialog. Add a layer mask to the top layer (the ripples) and lower the Opacity to 50%. Select Layer 0 and go to Edit > Free Transform. Drag the bottom-center handle of the bounding box down to increase the height of this layer so that clean background extends behind the ripples and commit the transformation (use the keyboard shortcut Ctrl + 0 (PC) or Command + 0 (Mac) to access the edges of the Transform bounding box).

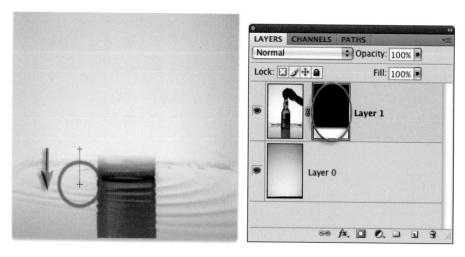

4. Select the Gradient Tool and choose the Black, White and Linear options and set the Opacity to 100% (make sure the Reverse option is deselected). Select the layer mask and drag a short gradient to hide the top of the tray containing the ripples and create a smooth transition between the new background below. Set the Opacity of Layer 1 back to 100%.

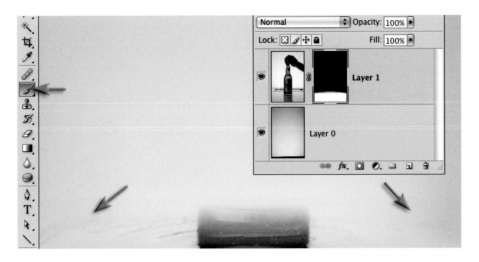

5. Select the Brush Tool and black as the foreground color. Choose a large soft-edged brush (0% hardness) and lower the Opacity to around 50%. Paint over any remaining signs of the top of the tray to remove them from view. Several strokes of the brush my be required to complete this task.

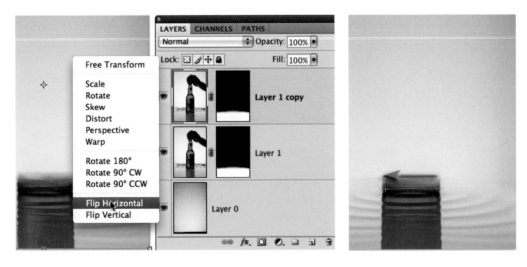

6. If you would like to make the ripples more symmetrical, duplicate the ripples layer and then go to Edit > Transform > Flip Horizontal. Select the Gradient Tool again, choose Multiply as the mode and drag a gradient from the right side of the bottle to the left side of the bottle. Stamp the visible elements of all the layers into a new layer (Command + Option + Shift + E for a Mac and Ctrl + Alt + Shift + E for a PC). This composite layer will enable you to warp the ripples into better shape (Edit > Transform > Warp). Drag down on the base of the bounding box to create a better shape for the ripples before committing the transformation. The background should now be ready to accept the bottle that we prepared earlier. Hold down the Shift key and select the top and bottom layers in the Layers panel and then use the keyboard shortcut Ctrl or Command + G to load the layers into a group. Name the group 'Background'.

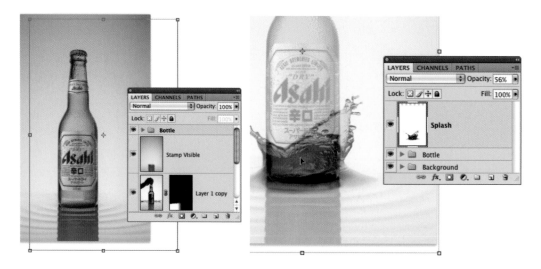

7. Drag the bottle group into the background and apply the Free Transform (Edit > Free Transform) so that you can move the bottle into position and scale if required. Zoom in and check the edge of the bottle against the new background at 100%. Refine the edge of the bottle mask on Layer 0 if required (Select > Refine Edge). Add the splash image to the composite file, lower the opacity of the layer and repeat the transformation process to position and scale the splash. Return the layer to 100% Opacity when finished.

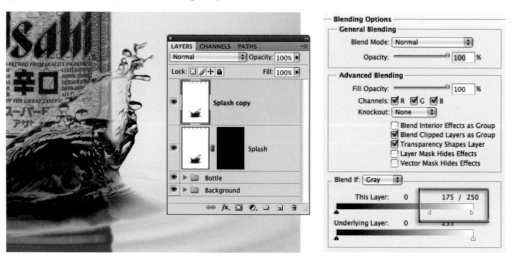

8. To mask the white background behind the splash we will need to duplicate the splash layer and add a black layer mask to the first splash layer (hold down the Alt/Option key as you click the 'Add a layer mask' icon in the Layers panel). Double-click the top splash layer away from the name of the layer so that the Layer Style dialog opens (if you double-click near the name of the layer you will be given the option to rename the layer instead). In the Blending Options section of the dialog drag the white slider on the This Layer slider to 250. Hold down the Alt/Option key and drag the left side of the slider again to split the slider. Drag this left side of the slider to 175 to create a smooth transition that will render the white background mostly transparent.

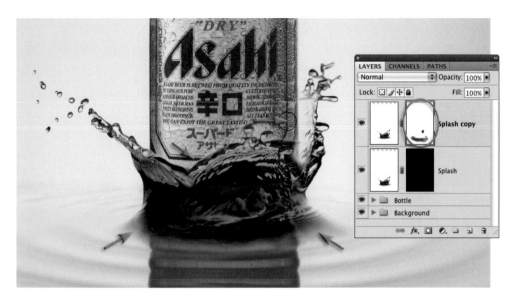

9. Select OK to apply the Advanced Blending options and then add a layer mask to this layer. Select the Brush Tool and black as the foreground color. Lower the Opacity in the Options bar to 50% and start to mask any traces of the white background that may still be visible. On the right side of the image mask the splash so that it appears to be going around the bottle rather than in front of the bottle. Adjust the size and hardness of the brush as required.

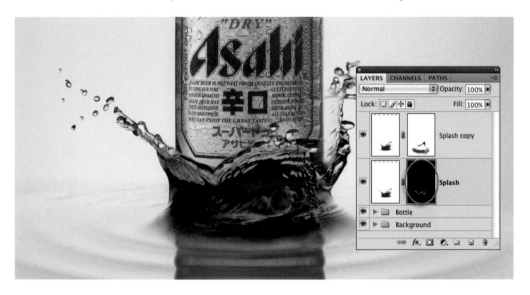

10. The previous two steps will have hidden the white background but also rendered the brightest highlights on the water droplets transparent as well. If you want to replace these bright highlights select the layer mask on the layer below and choose white as the foreground color. Select a small soft-edged brush and 100% Opacity and paint in the image to reveal these bright highlights.

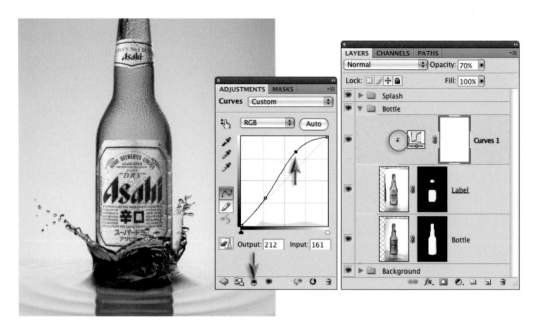

11. The final steps required in this project are to optimize the brightness and contrast of the bottle. Select the label layer in the Bottle group of layers and then create a Curves adjustment layer. Clip this Curves layer to the layer below and increase the brightness of the highlights while maintaining the tone of the black lettering.

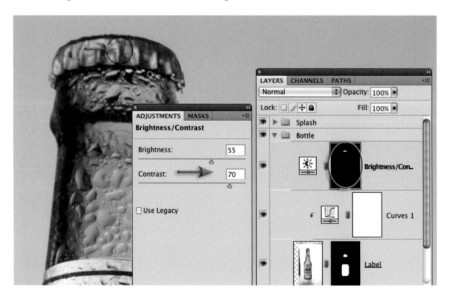

12. Create a second Brightness/Contrast adjustment layer to modify the tonality of the bottle cap. Raise both the Brightness and Contrast sliders and then fill the layer mask with black. Select the Brush Tool and paint with white to paint in the adjustment as required. Sharpen the completed image by selecting the Bottle group and the splash layer and converting for Smart Filters (Filter > Convert for Smart Filters). Apply either the Unsharp Mask or Smart Sharpen filter.

Haydn Cattach

Fixed position montage

The composite lighting technique used for Project 1 (the beer bottle) does not have to be confined to the studio. Working with the camera in a fixed position the photographer is free to light aspects of a large or complex scene with a single light source – one piece or frame at a time. Masking is relatively simple when most of the subject matter is not moving.

Beach House – Mark Galer

HDR panoramas – Project 2

It is important to note that the view of this particular building could not be captured by a conventional camera in one frame and achieve the same result. If I had moved back to encompass the entire view and then cropped down I would be left with less than 5 megapixels of data and the skyline above the building would be very busy (the buildings behind this beach house would have come into view). The dramatic sense of perspective would also be lost as I moved further away from the building. The Photomerge feature in Photoshop dramatically improved with the release of Photoshop CS3 but photographers still needs to be aware of the limitations of this feature if they want to avoid visual errors in the final composite image. Quality will be improved and errors less likely if you capture the component images with a 50% overlap in vertical format, use manual exposure, manual focus and manual white balance setting (or processed the images identically in Camera Raw). Creating vertical (portrait format) images will give you a little more sky and foreground in the component images (you will need information surplus to requirements if you do not want to create a problem when you come to crop the final composite image) and will also lead to less problems with converging verticals as the camera will not have to be tilted upwards to such a large extent. The results will now be truly seamless – an excellent way of widening your horizons or turning your humble digital camera into an ultra-high-resolution digital capture device.

The Photomerge feature in versions prior to Photoshop CS3 left a lot to be desired. All of the flaws and weaknesses of this feature disappeared with the release of Photoshop CS3 and the feature has been further enhanced with the release of CS4.

Notice how the curved lines in the image above are slightly crooked due to the fact that these images were shot with an 18 mm focal length and these lines are very close to the lens. Still pretty good – but not perfect

Now the only limitation you may run up against when hand-holding the camera or placing the camera on a standard tripod head is Photoshop's ability to align and blend strong geometric lines that come close to the camera lens. If you have not used a specialized tripod head designed for professional panoramic stitching work then the problem of aligning both foreground and distant subject matter is a big problem for any software (Photoshop handles it better than the rest). The camera should ideally be rotated around the nodal point of the lens to avoid something called parallax error. You will probably not encounter any problems with the new Photomerge feature unless you are working with strong lines in the immediate foreground.

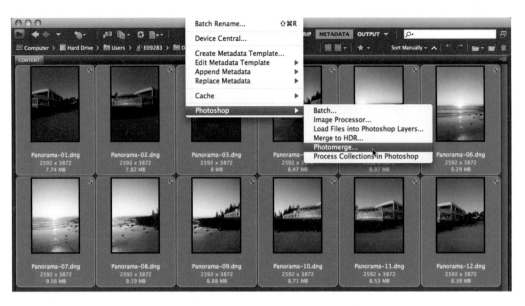

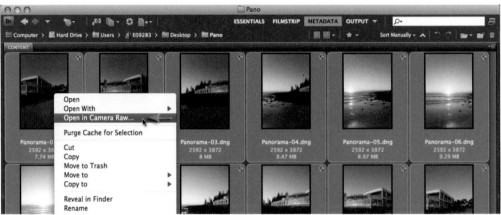

1. There is an option in Bridge to create a panorama from a group of selected photos (go to Tools > Photoshop > Photomerge). This option, however, will bypass the Raw dialog box, which is not a good idea if you have not first optimized the Raw settings of the files you want to stitch together. It is also unlikely that you will be wanting to stitch all of your Raw images together at maximum resolution. Browse to the Montage folder on the DVD using Bridge and then select the 12 Raw files. Select Open in Camera Raw by right-clicking on the selected files or by going to the File menu.

Note > The observant among you will notice there are two images for every section of this panorama. There are twelve images in total using two different exposure settings. The camera first captured a set of images with an exposure that was perfect for the rising sun in this scene (the brighter side of the panorama). A second set of six images was then created with an exposure that was optimized for the right side of the panorama (the dark side). Having the extra exposures helps in the creation of a higher quality result. We are then able to choose the best exposure for each aspect of the scene and blend the images together.

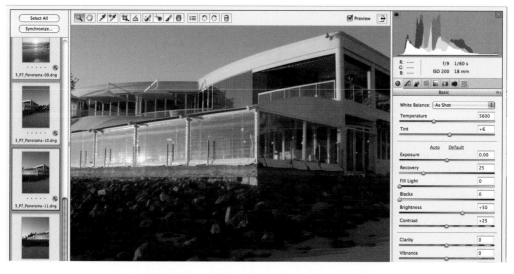

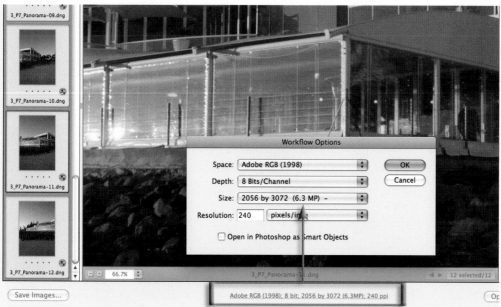

2. Choose one of the lighter images in the central portion of the panorama and optimize the Camera Raw settings for this file. After optimizing one file, click on the Select All button in the top left-hand side of the ACR dialog box and then click on the Synchronize button. In the Synchronize dialog choose Synchronize Everything and select OK. If you wish to make a monster panorama (there are 12 x 10 megapixel images used in this project) select all of the Camera Raw files and open them in Adobe Camera Raw as images (not objects). If you do not want to end up with a file that is over 1 gigabyte when finished it is recommended to click on Workflow Options and select 6.3 megapixels or less from the Size menu. It is also recommended to drop the Bit Depth to 8 Bits/Channel if you do not have a fast processor and more than 1 GB of RAM (or some patience). Select OK in the Workflow Options dialog and then choose Open Images in the ACR dialog.

3. Go to File > Scripts > Load Files into Stack. In the Load Layers dialog click on the Add Open Files button; this will load the open files into the scroll window. Do not click on the Attempt to Automatically Align Source Images button. Select OK to create a multi-layered file from all of the images that are open. Choosing **not** to align images at this stage will give you more choices in the next step as it will give you access to the Auto-Align Layers dialog with more options than would otherwise appear. There is another option to select Photomerge (from the Automate menu) when the files have been opened in the main editing space. It is, however, better to proceed a little more slowly to enable you to access some of the options that would otherwise be automated. When the multi-layered file has been created you may like to save the new file and close all of the component images if you want to maximize the speed of the stitching and blending that follows.

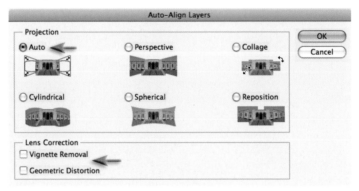

4. Select all of the layers in the Layers panel (Shift-click the top and bottom layers) and then from the Edit menu choose Auto-Align Layers. If the lens you have been using has excessive vignetting or geometric distortions such as barrel distortion or pincushion distortion then select the Lens Correction options. In most instances selecting the Auto radio button in the Projection options will create the result you are probably looking for. For a specific projection choose one of the other options. The illustrations and the advice that appears at the bottom of the dialog will give you a good idea of the sort of transformation that will be made to your images.

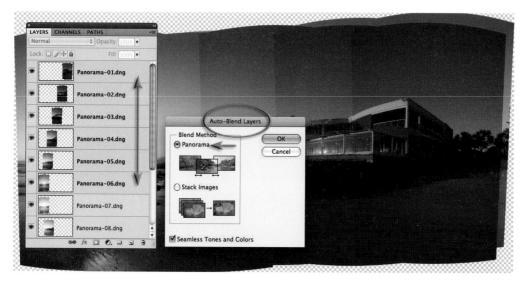

5. The next step is to select the layers you want to blend together (modify the color and tonality of the component layers to remove the seams). Select just six of the layers of one exposure (Shift-click the first and last layers in the sweep) and then from the Edit menu choose Edit > Auto-Blend Layers. In the Auto-Blend Layers dialog choose Panorama and then select OK. Select the top layer of these six layers and then stamp the visible elements to a new layer (Command + Option + Shift + E on a Mac or Ctrl + Alt + Shift + E on a PC).

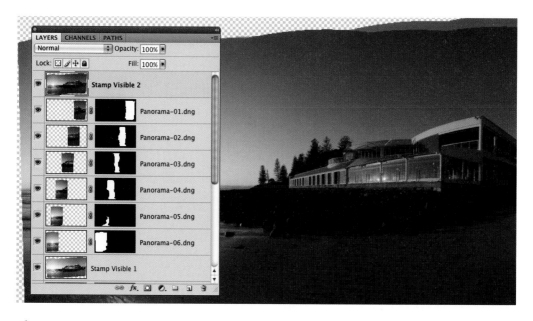

6. Repeat the process with the second set of exposures so that each sweep is blended separately. Switch off the visibility of the top six layers, select the top layer of the lower six layers and then stamp the visible elements to a new layer (Command + Option + Shift + E on a Mac or Ctrl + Alt + Shift + E on a PC).

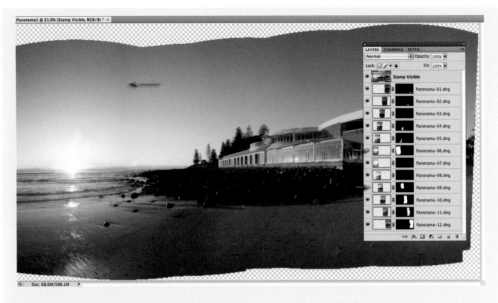

Problems with blending all layers at the same time

If you select all of the layers in this project and then go to Edit > Auto-Blend Images you will end up with a reasonably good (but not perfect) result. With these project images Photoshop has chosen the darker exposure for the rising sun and the lighter exposure for the right side of the building in shadow. The sky, however, is not as smooth as it could be as Photoshop has selected sections from both the darker and lighter component images.

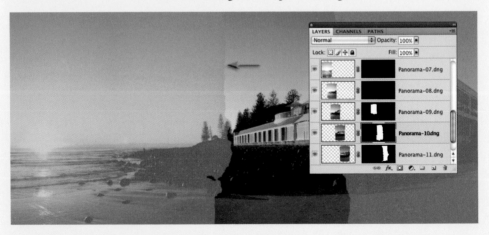

Non-editable masks

If you hold down the Alt/Option key and click on one of the layer masks you will see that the smooth transition between layers is not created using soft-edged masks. The transition of tone and color occurs in the images themselves up to where the hard-edged mask ends. If you attempt to correct or modify the panorama by painting into one of these masks you will reveal pixels where the color and tonality have not been modified. Modifications to these layer masks are almost certainly likely to make matters worse rather than better.

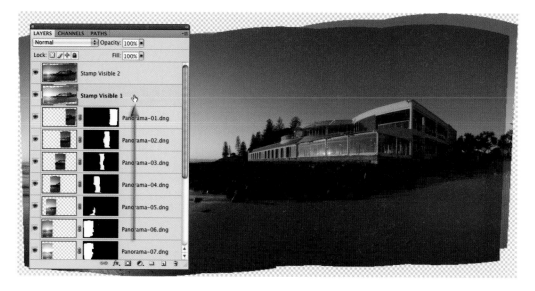

7. Drag the lower of the two stamp visible layers to just below the top Stamp Visible layer in the Layers panel. Even if you have opened the 6.3 megapixel images instead of the 10 megapixel images from the Adobe Camera Raw dialog box you will now have a file that is over 700 megabytes. If RAM is in short supply now would be a good time to delete all of the component layers below the two Stamp Visible layers.

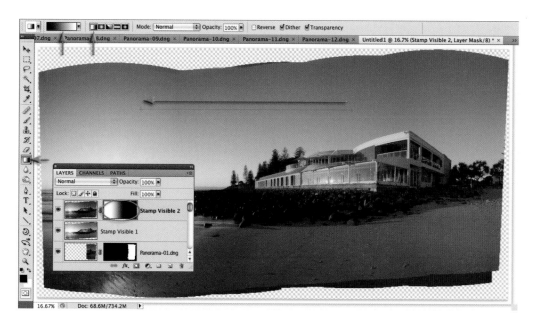

8. Add a layer mask to the top stamp visible layer and then select the Gradient Tool in the Tools panel. Choose the Black, White gradient and Linear options in the Options bar and drag a gradient from the right side of the image to a position just short of the rising sun on the left side of the image. You should now have a smoother transition in the sky.

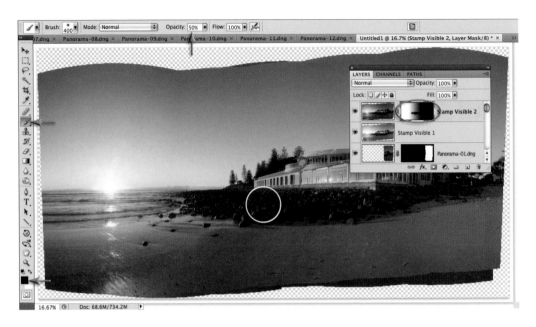

9. You can continue to work with optimizing the exposure by choosing the Brush Tool in the Tools panel and then painting with white or black in the layer mask. In the illustration above the Brush Tool has been used to hide the darker rocks on the upper layer to reveal the lighter rocks on the layer below.

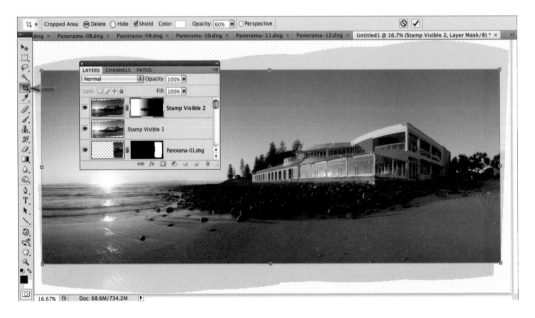

10. Complete the project by cropping away all of the transparency around the composite image. Sharpen the image by either creating another Stamp Visible layer or selecting both layers and converting them to a Smart Object (go to Filters > Convert for Smart Filters). You will then be able to apply either the Smart Sharpen filter or the Unsharp Mask (Filter > Sharpen).

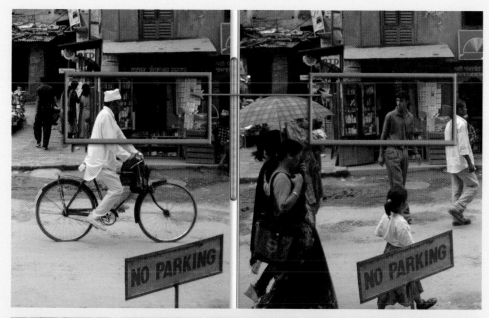

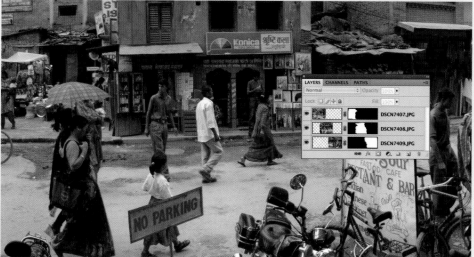

Philip Andrews

Aligning images with moving content

When creating a panorama with moving subject matter the information in the images may change in the region of the 50% overlap as subjects move out of, or into, the frame. The difference in content forces Photoshop to mask around the moving subject matter during the blending process (to avoid cutting subjects in two). This is not always successful as Photoshop finds it difficult to distinguish between different subjects when they overlap. In the illustration above Photoshop has successfully blended images where the subject matter is very different in the region of the overlap. Photoshop has completely ignored the moving bicycle in the resulting blend.

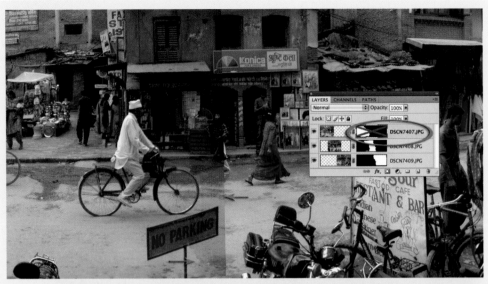

If we step backwards (Edit > Undo) to a point prior to the blend we can influence how Photoshop chooses the subject matter between the two frames in this section of the panorama. We cannot paint into the layer masks of these layers to adjust visible content after the blend is complete as the differences in tone and color between these two images are significant due to the auto exposure and auto white balance used. In the illustration above (top image) I have switched off the layer mask to illustrate how the colors that have been blended do not extend beyond the hard-edged layer mask (the mask is only used to define visible content). If we step back prior to the blending process, however, we can add a layer mask and paint into this mask to hide content that we do not want Photoshop to use in the resulting panorama (there is no need to be too precise about the painting). Painting in both layers in the area of transition, however, could result in transparency when the layers are blended.

After repeating the blending process we can see that we have now prioritized the bicycle instead of the pedestrians in the region of the overlap. We have, however, created new problems as Photoshop cannot distinguish between the rear end of the bicycle and a nearby pedestrian as the objects overlap. If we undo and add a little more paint into that mask before blending again we can finally resolve the problem in this region. If we turn our attention to the No Parking sign and parked bicycle in front of the restaurant sign we will see that all is not yet fixed. Going backwards and forwards like this can be time-consuming if we have a large number of high-resolution files to be blended each time. Shooting with manual white balance and manual exposure would allow us to fix up minor errors by painting into the mask, safe in the knowledge that the color and tone behind each layer mask is the same.

Auto-Align for pin-registering images

The Auto Align feature is an invaluable tool for photographers who need to be able to pin-register images that have been captured hand-held. This is, however, only recommended for those photographers who use a custom or manual white balance rather than auto white balance in-camera. In the illustration above the boy is blinking in one image and the dog is looking away in the second. The images were captured a split second apart but the best elements of each image can be combined to create one image even though the camera was hand-held. The two images have been combined by dragging the background layer from one file onto the image window of the other (hold down the Shift key as you let go of the mouse button). Dropping the Opacity of the top layer reveals the misalignment even though the boy was still.

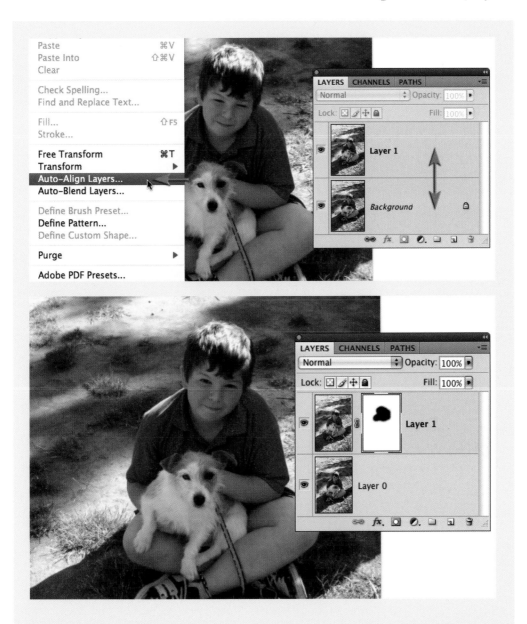

Select both layers in the Layers panel. From the Edit menu choose Auto-Align Layers. Now select only the top layer and click on the 'Add a layer mask' icon in the Layers panel. Choose the Brush Tool in the Tools panel and paint with black into the mask to shield any of the pixels you do not want to see on this layer. Painting over the boy's head will reveal the head with the open eyes on the layer below. You will need to crop the image to finish your project. If you can see the value of this technique then you will quickly realize that taking multiple shots the next time you are presented with a group (or even just one man and his best friend) ensures the decisive moment is history (sorry Henri).

Vertical panoramas – Project 3

In the image above if I had moved any further back there would have been power lines, telephone lines and tram lines between me and the front of this old theme park. Capturing a building so close will inevitably lead to aggressive converging verticals due to a combination of the wide-angle lens and the angle of view required to capture the top of the structure. If you allow the Photomerge to take control of the stitching you will end up with the result above left. Capture images using the horizontal (landscape) format for a vertical panorama. You can then achieve more professional results by intercepting the automated process by taking the action we did in Step 3 of the previous exercise (deselecting the Attempt to Automatically Align Source Images) and then use the following techniques.

1. Optimize the color and tonality of the Raw files in Adobe Camera Raw and then choose Select All and Synchronize before opening. Go to File > Scripts > Load Files into Stack. Select the Open files but do not select the Attempt to Automatically Align Source Images option in the dialog. When the files have been loaded into one image select the layer with the subject matter that is closest to the ground (the one with the least amount of converging verticals). Go to the Lock options in the Layers panel and click on the 'Lock all' icon to lock this layer. This action will force Photoshop to respect the perspective of this layer (the other layers will be forced to adopt the perspective of this layer when we align the images). Select all three layers in the Layers panel (Shift-click the top and bottom layers).

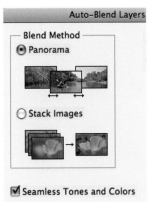

2. Go to File > Edit > Auto-Align Layers. In the dialog select the Perspective option and also select the Lens Correction options. Select OK to process the layers. After the images have been Auto-aligned make sure all three layers are still selected and then go to Edit > Auto-Blend Layers. Select the Panorama and Seamless Tones and Colors options and select OK to process the layers. In the Layers panel select only the top layer and unlock this layer before proceeding with the next step.

3. Select all three layers in the Layers panel again and then go to Filter > Convert for Smart Filters. Select the Crop Tool and crop the image to remove the transparency that surrounds this composite image. If you look at the image closely you will notice that there is a small amount of barrel distortion in this image (the sides of the building balloon or bow out). This defect cannot be accurately fixed using the Lens Correction filter as the distortions are not central to the cropped image. We can, however, use the Warp feature but first we need to create a perspective grid that we can work with. Click on the 'Create a new layer' icon to create an empty new layer.

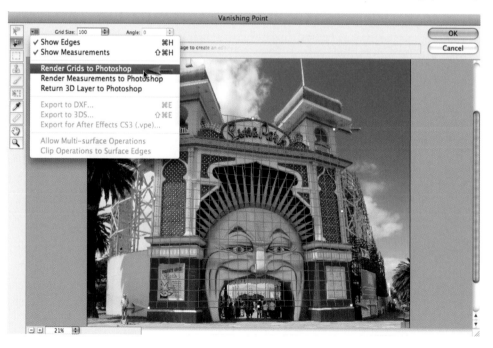

4. Go to Filter > Vanishing Point and select the Render Grids to Photoshop in the options. Using the Create Plane Tool click in each corner of the entrance to create a perspective plane. Zoom in to make sure you do this accurately. Select OK to export this grid back to Photoshop.

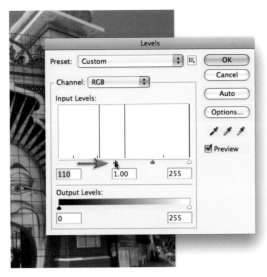

5. The grid is not very dark but can be made more prominent by going to Filter > Other > Minimum. Choose 1 pixel and select OK. From the Image > Adjustments menu choose Levels and drag the shadows slider underneath the histogram to the right to darken the grid.

6. Now we can set about correcting the perspective of all three layers at the same time (one of the advantages of working with layers nested inside a Smart Object). Click on the Smart Object in the Layers panel and go to Edit > Transform > Warp. The barrel distortion can be very accurately fixed by dragging the four corner handles of the Warp grid outwards and tucking the sides in until they align with the grid. Zoom in to ensure you have fixed the problem accurately. Go to Edit > Transform > Distort and then drag the top two corner handles out to reduce the extent of the converging verticals. The verticals of the building cannot be aligned to the sides of the image or vertical guides otherwise the shape of the building at the top appears misshapen. Click on the Commit Transform option in the Options bar and hide or delete the grid layer you have used as a reference grid.

Michelle lee

Exported grids

Grids exported from Vanishing Point can help the photographer capture additional elements that must conform to the perspective of the first image. The layer containing the grid can be dragged onto subsequent images to ensure 100% accuracy.

Abhijit Chattaraj

Glossary

ACR	Adobe Camera Raw.
Additive color	A color system where the primaries of red, green and blue mix to form the other colors.
Adjustment layer	Image adjustment placed on a layer.
Adobe Camera Raw	Adobe's own Raw conversion utility.
Adobe gamma	A calibration and profiling utility supplied with Photoshop.
Adobe Photo Downloader	Adobe's download utility used for transferring photos from card or camera to computer. The utility ships with Bridge.
Algorithm	A sequence of mathematical operations.
Aliasing	The display of a digital image where a curved line appears jagged due to the square pixels.
Alpha channel	Additional channel used for storing masks and selections.
Analyze/Analysis	To examine in detail.
Anti-aliasing	The process of smoothing the appearance of a curved line in a digital image.
APD	Adobe Photo Downloader.
Aperture	A circular opening in the lens that controls light reaching the film.
Area array	A rectangular pattern of light-sensitive sensors alternately receptive to red, green or blue light.
Artifacts	Pixels that are significantly incorrect in their brightness or color values.
Aspect ratio	The ratio of height to width. Usually in reference to the light-sensitive area or format of the camera.
Bit	Short for binary digit, the basic unit of the binary language.
Bit depth	Number of bits (memory) assigned to recording color or tonal information.
Bitmap	A one-bit image, i.e. black and white (no shades of gray).
Black and White	A color to grayscale adjustment feature. As well as customized mapping of colors to gray the feature can tint monochromes as well.
Blend mode	The formula used for defining the mixing of a layer with those beneath it.
Bridge	Adobe's sophisticated file browsing and organization program that ships with Photoshop.
Brightness	The value assigned to a pixel in the HSB model to define the relative lightness of a pixel.
Byte	Eight bits. The standard unit of binary data storage containing a value between 0 and 255.
Captured	A record of an image.

CCD	Charge Coupled Device. A solid-state image pick-up device used in digital image capture.
Channels	The divisions of color data within a digital image. Data is separated into primary or secondary colors.
Charge Coupled Device	See *CCD*.
CIS	Contact Image Sensor. A single row of sensors used in scanner mechanisms.
Clipboard	The temporary storage of something that has been cut or copied.
Clipping group	Two or more layers that have been linked. The base layer acts as a mask, limiting the effect or visibility of those layers clipped to it.
Cloning Tool	A tool used for replicating pixels in digital photography.
CMOS	Complementary Metal Oxide Semiconductor. A chip used widely within the computer industry, now also frequently used as an image sensor in digital cameras.
CMYK	Cyan, Magenta, Yellow and black (K). The inks used in four-color printing.
Color fringes	Bands of color on the edges of lines within an image.
Color fringing	See *Color fringes*.
Color gamut	The range of colors provided by a hardware device, or a set of pigments.
Color Picker	Dialog box used for the selection of colors.
Color space	An accurately defined set of colors that can be translated for use as a profile.
ColorSync	System level software developed by Apple, designed to work together with hardware devices to facilitate predictable color.
Complementary metal oxide semiconductor	See *CMOS*.
Composition	The arrangement of shape, tone, line and color within the boundaries of the image area.
Compression	A method for reducing the file size of a digital image.
Constrain proportions	Retains the proportional dimensions of an image when changing the image size.
Contact image sensor	See *CIS*.
Context	The circumstances relevant to something under consideration.
Continuous tone	An image containing the illusion of smooth gradations between highlights and shadows.
Contrast	The difference in brightness between the darkest and lightest areas of the image or subject.
CPU	Central Processing Unit, used to compute exposure.
Crash	The sudden operational failure of a computer.
Crop	Reduce image size to enhance composition or limit information.
Curves	Control for adjusting tonality and color in a digital image.
DAT	Digital Audio Tape. Tape format used to store computer data.
Default	The settings of a device as chosen by the manufacturer.

Defringe	The action of removing the edge pixels of a selection.
Density	The measure of opacity of tone on a negative.
Depth of field	The zone of sharpness variable by aperture, focal length or subject distance.
Descreen	The removal of half-tone lines or patterns during scanning.
Device	An item of computer hardware.
Device dependent	Dependent on a particular item of hardware. For example, referring to a color result unique to a particular printer.
Device independent	Not dependent on a particular item of hardware. For example, a color result that can be replicated on any hardware device.
Digital audio tape	See *DAT*.
Digital image	A computer-generated photograph composed of pixels (picture elements) rather than film grain.
Digital Negative format	Adobe's open source Raw file format.
DNG	Adobe's Digital Negative format.
Download	To copy digital files (usually from the Internet).
Dpi	Dots per inch. A measurement of resolution.
Dummy file	To go through the motions of creating a new file in Photoshop for the purpose of determining the file size required during the scanning process.
Dye sublimation print	A high-quality print created using thermal dyes.
Dyes	Types of pigment.
Edit	Select images from a larger collection to form a sequence or theme.
Editable text	Text that has not been rendered into pixels.
Eight-bit image	A single-channel image capable of storing 256 different colors or levels.
Evaluate	Assess the value or quality of a piece of work.
Exposure	Combined effect of intensity and duration of light on a light-sensitive material or device.
Exposure compensation	To increase or decrease the exposure from a meter-indicated exposure to obtain an appropriate exposure.
Feather	The action of softening the edge of a digital selection.
File format	The code used to store digital data, e.g. TIFF or JPEG.
File size	The memory required to store digital data in a file.
Film grain	See *Grain*.
Film speed	A precise number or ISO rating given to a film or device indicating its degree of light sensitivity.
F-numbers (f-stops)	A sequence of numbers given to the relative sizes of aperture opening. F-numbers are standard on all lenses. The largest number corresponds to the smallest aperture and vice versa.
Format	The size of the camera or the orientation/shape of the image.
Frame	The act of composing an image. See *Composition*.

Freeze	Software that fails to interact with new information.
FTP software	File Transfer Protocol software is used for uploading and downloading files over the Internet.
Galleries	A managed collection of images displayed in a conveniently accessible form.
Gaussian Blur	A filter used for defocusing a digital image.
GIF	Graphics Interchange Format. An 8-bit format (256 colors) that supports animation and partial transparency.
Gigabyte	A unit of measurement for digital files, 1024 megabytes.
Grain	Tiny particles of silver metal or dye that make up the final image. Fast films give larger grain than slow films. Focus finders are used to magnify the projected image so that the grain can be seen and an accurate focus obtained.
Gray card	Card that reflects 18% of incident light. The resulting tone is used by light meters as a standardized midtone.
Grayscale	An 8-bit image with a single channel used to describe monochrome (black and white) images.
Half-tone	A system of reproducing the continuous tone of a photographic print by a pattern of dots printed by offset litho.
Hard copy	A print.
Hard drive	Memory facility that is capable of retaining information after the computer is switched off.
HDR	High Dynamic Range image.
High Dynamic Range	A picture type that is capable of storing 32 bits per color channel. This produces a photo with a much bigger possible brightness range than found in 16- or 8-bit per channel photos. Photoshop creates HDR images with the Merge to HDR feature.
Highlight	Area of subject receiving highest exposure value.
Histogram	A graphical representation of a digital image indicating the pixels allocated to each level.
Histories	The memory of previous image states in Photoshop.
History Brush	A tool in Photoshop with which a previous state or history can be painted.
HTML	HyperText Markup Language. The code that is used to describe the contents and appearance of a web page.
Hue	The name of a color, e.g. red, green or blue.
Hyperlink	A link that allows the viewer of a page to navigate or 'jump' to another location on the same page or on a different page.
ICC	International Color Consortium. A collection of manufacturers including Adobe, Microsoft, Agfa, Kodak, SGI, Fogra, Sun and Taligent who came together to create an open, cross-platform standard for color management.

ICM	Image Color Management. Windows-based software designed to work together with hardware devices to facilitate predictable color.
Image Color Management	See *ICM*.
Image setter	A device used to print CMYK film separations used in the printing industry.
Image size	The pixel dimensions, output dimensions and resolution used to define a digital image.
Infrared film	A film that is sensitive to the wavelengths of light longer than 720 nm, which are invisible to the human eye.
Instant capture	An exposure that is fast enough to result in a relatively sharp image free of significant blur.
International Color Consortium	See *ICC*.
Interpolated resolution	Final resolution of an image arrived at by means of interpolation.
Interpolation	Increasing the pixel dimensions of an image by inserting new pixels between existing pixels within the image.
ISO	International Standards Organization. A numerical system for rating the speed or relative light sensitivity of a film or device.
ISP	Internet Service Provider, allows individuals access to a web server.
Jaz	A storage disk capable of storing slightly less than 2 GB, manufactured by Iomega.
JPEG (.jpg)	Joint Photographic Experts Group. Popular image compression file format.
Jump	To open a file in another application.
Juxtapose	Placing objects or subjects within a frame to allow comparison.
Kilobyte	1024 bytes.
LAB mode	A device-independent color model created in 1931 as an international standard for measuring color.
Lasso Tool	Selection Tool used in digital editing.
Latent image	An image created by exposure onto light-sensitive silver halide ions, which until amplified by chemical development is invisible to the eye.
Latitude	Ability of the film or device to record the brightness range of the subject.
Layer	A feature in digital editing software that allows a composite digital image where each element is on a separate layer or level.
Layer mask	A mask attached to a layer that is used to define the visibility of pixels on that layer.
Layer Stacks	A group of Photoshop layers that have to be converted into a Smart Object for the purposes of performing image analysis on the differences between the picture content of each layer.

LCD	Liquid Crystal Display.
LED	Light-Emitting Diode. Used in the viewfinder to inform the photographer of exposure settings.
Lens	An optical device usually made from glass that focuses light rays to form an image on a surface.
Levels	Shades of lightness or brightness assigned to pixels.
Light cyan	A pale shade of the subtractive color cyan.
Light magenta	A pale shade of the subtractive color magenta.
LiOn	Lithium ion. Rechargeable battery type.
Lithium ion	See *LiOn*.
LZW compression	A lossless form of image compression used in the TIFF format.
Magic Wand Tool	Selection Tool used in digital editing.
Magnesium lithium	See *MnLi*.
Marching ants	A moving broken line indicating a digital selection of pixels.
Marquee Tool	Selection Tool used in digital editing.
Maximum aperture	Largest lens opening.
Megabyte	A unit of measurement for digital files, 1024 kilobytes.
Megapixels	More than a million pixels.
Memory card	A removable storage device about the size of a small card. Many technologies available result in various sizes and formats. Often found in digital cameras.
Merge to HDR	Photoshop's feature for creating HDR images from a series of photos with bracketed exposures.
Metallic silver	Metal created during the development of film, giving rise to the appearance of grain. See *Grain*.
Minimum aperture	Smallest lens opening.
MnLi	Magnesium lithium. Rechargeable battery type.
Mode (digital image)	RGB, CMYK, etc. The mode describes the tonal and color range of the captured or scanned image.
Moiré	A repetitive pattern usually caused by interference of overlapping symmetrical dots or lines.
Motherboard	An electronic board containing the main functional elements of a computer upon which other components can be connected.
Multiple exposure	Several exposures made onto the same frame of film or piece of paper.
Negative	An image on film or paper where the tones are reversed, e.g. dark tones are recorded as light tones and vice versa.
NiCd	Nickel cadmium. Rechargeable battery type.
Nickel cadmium	See *NiCd*.
Nickel metal hydride	See *NiMH*.
NiMH	Nickel metal hydride. Rechargeable battery type.
Noise	Electronic interference producing white speckles in the image.

Non-destructive editing	An editing approach that doesn't alter the original pixels in a photo throughout the enhancement process. Typically used for Raw processing or in techniques that make use of Smart Object technology.
Non-imaging	To not assist in the formation of an image. When related to light it is often known as flare.
ODR	Output Device Resolution. The number of ink dots per inch of paper produced by the printer.
Opacity	The degree of non-transparency.
Opaque	Not transmitting light.
Optimize	The process of fine-tuning the file size and display quality of an image or image slice destined for the web.
Out of gamut	Beyond the scope of colors that a particular device can create.
Output device resolution	See *ODR*.
Path	The outline of a vector shape.
PDF	Portable Document Format. Data format created using Adobe software.
Pegging	The action of fixing tonal or color values to prevent them from being altered when using Curves image adjustment.
Photomerge	Adobe's own panoramic stitching utility.
Photo multiplier tube	See *PMT*.
Photoshop Document	The native file format used by Photoshop.
Piezoelectric	Crystal that will accurately change dimension with a change of applied voltage. Often used in inkjet printers to supply microscopic dots of ink.
Pixel	The smallest square picture element in a digital image.
Pixelated	An image where the pixels are visible to the human eye and curved lines appear jagged or stepped.
PMT	Photo Multiplier Tube. Light-sensing device generally used in drum scanners.
Portable Document Format	See *PDF*.
Pre-press	Stage where digital information is translated into output suitable for the printing process.
Primary colors	The three colors of light (red, green and blue) from which all other colors can be created.
Processor speed	The capability of the computer's CPU measured in megahertz.
PSD	Photoshop Document format.
Quick Mask mode	Temporary alpha channel used for refining or making selections.
Quick Selection Tool	A selection tool added to Photoshop in version CS3 that tries to predict the shape of the selection as you draw. The feature takes into account tone, color, texture and shape of the underlying photo as it creates the selection.

RAID	Redundant Array of Independent Disks. A type of hard disk assembly that allows data to be simultaneously written.
RAM	Random Access Memory. The computer's short-term or working memory.
Redundant array of independent disks	See *RAID*.
Reflector	A surface used to reflect light in order to fill shadows.
Refraction	The change in direction of light as it passes through a transparent surface at an angle.
Resample	To alter the total number of pixels describing a digital image.
Resolution	A measure of the degree of definition, also called sharpness.
RGB	Red, Green and Blue. The three primary colors used to display images on a color monitor.
Rollover	A web effect in which a different image state appears when the viewer performs a mouse action.
Rubber Stamp	A tool used for replicating pixels in digital imaging. Also called Clone Stamp Tool.
Sample	To select a color value for analysis or use.
Saturation (color)	Intensity or richness of color hue.
Save a Copy	An option that allows the user to create a digital replica of an image file but without layers or additional channels.
Save As	An option that allows the user to create a duplicate of a digital file but with an alternative name, thereby protecting the original document from any changes that have been made since it was opened.
Scale	A ratio of size.
Scratch disk memory	Portion of hard disk allocated to software such as Photoshop to be used as a working space.
Screen real estate	Area of monitor available for image display that is not taken up by palettes and toolbars.
Screen redraws	Time taken to render information being depicted on the monitor as changes are being made through the application software.
Secondary colors	The colors cyan, magenta and yellow, created when two primary colors are mixed.
Sharp	In focus. Not blurred.
Single lens reflex	See *SLR camera*.
Slice	Divides an image into rectangular areas for selective optimization or to create functional areas for a web page.
Slider	A sliding control in digital editing software used to adjust color, tone, opacity, etc.
SLR camera	Single Lens Reflex camera. The image in the viewfinder is essentially the same image that the film will see. This image, prior to taking the shot, is viewed via a mirror that moves out of the way when the shutter release is pressed.

Smart Filter	An extension of the Smart Object technology that allows the non-destructive application of Photoshop filters to an image.
Smart Object	Technology first introduced in Photoshop CS2 that maintains the original form of an embedded image but stills allows it to be edited and enhanced. Smart Objects are used in many non-destructive editing or enhancement techniques.
Snapshot	A record of a history state that is held until the file is closed.
Soft proof	The depiction of a digital image on a computer monitor used to check output accuracy.
Software	A computer program.
Stack	Several photos grouped together in the Bridge workspace.
Subjective analysis	Personal opinions or views concerning the perceived communication and aesthetic value of an image.
Subtractive color	A color system where the subtractive primary colors yellow, magenta and cyan mix to form all other colors.
System software	Computer operating program, e.g. Windows or Mac OS.
Tagging	System whereby a profile is included within the image data of a file for the purpose of helping describe its particular color characteristics.
Thematic images	A set of images with a unifying idea or concept.
TIFF	Tagged Image File Format. Popular image file format for desktop publishing applications.
Tone	A tint of color or shade of gray.
Transparent	Allowing light to pass through.
Tri-color	A filter taking the hue of either one of the additive primaries red, green or blue.
True resolution	The resolution of an image file created by the hardware device, either camera or scanner, without any interpolation.
TTL meter	Through-The-Lens reflective light meter. This is a convenient way to measure the brightness of a scene as the meter is behind the camera lens.
Tweening	Derived from the words in betweening – an automated process of creating additional frames between two existing frames in an animation.
UCR	Under Color Removal. A method of replacing a portion of the yellow, magenta and cyan ink, within the shadows and neutral areas of an image, with black ink.
Under color removal	See *UCR*.
Unsharp Mask	See *USM*.
Unsharp Mask filter	A filter for increasing apparent sharpness of a digital image.
URL	Uniform Resource Locator. The unique web address given to every web page.
USM	Unsharp Mask. A process used to sharpen images.

Vanishing Point	A Photoshop feature designed to allow the manipulation of photos within a three-dimensional space.
Vector graphic	A resolution-independent image described by its geometric characteristics rather than by pixels.
Video card	A circuit board containing the hardware required to drive the monitor of a computer.
Video memory	Memory required for the monitor to be able to render an image.
Virtual memory	Hard drive memory allocated to function as RAM.
Visualize	To imagine how something will look once it has been completed.
Workflow	Series of repeatable steps required to achieve a particular result within a digital imaging environment.
Zip	An older style storage disk manufactured by Iomega, available in either 100 MB or 250 MB capacity.
Zoom Tool	A tool used for magnifying a digital image on the monitor.

Keyboard Shortcuts

⌥ = Option ⇧ = Shift ⌘ = Command ⌫ = Delete/Backspace

Action	Keyboard Shortcut
Navigate and view	
Fit image on screen	Double-click Hand Tool or ⌘/Ctrl + 0 (zero)
View image at 100%	Double-click Zoom Tool or ⌥/Alt + ⌘/Ctrl + 0
Zoom Tool (magnify)	⌘/Ctrl + Spacebar + click image
Zoom Tool (reduce)	⌥/Alt + ⌘/Ctrl + click image
Full/Standard/Maximized screen mode	F
Show/hide rulers	⌘/Ctrl + R
Show/hide guides	⌘/Ctrl + ;
Hide panels	Tab key
File commands	
Open	⌘/Ctrl + O
Close	⌘/Ctrl + W
Save	⌘/Ctrl + S
Save As	⇧ + ⌘/Ctrl + S
Undo/Redo	⌘/Ctrl + Z
Step Backward	⌥/Alt + ⌘/Ctrl + Z
Step Forward	⌘/Ctrl + ⇧ + Z
Selections	
Add to selection	Hold ⇧ key and select again
Subtract from selection	Hold ⌥/Alt key and select again
Copy	⌘/Ctrl + C
Cut	⌘/Ctrl + X
Paste	⌘/Ctrl + V
Paste Into	⌘/Ctrl ⇧ + V
Free Transform	⌘/Ctrl + T
Distort image in Free Transform	Hold ⌘ key + move handle
Feather	⌘/Ctrl + ⌥/Alt + D
Select All	⌘/Ctrl + A
Deselect	⌘/Ctrl + D
Reselect	⇧+⌘/Ctrl + D
Inverse selection	⌘/Ctrl + I
Edit in Quick Mask mode	Q

Painting

Set default foreground and background colors	D
Switch between foreground and background color	X
Enlarge brush size (with Paint Tool selected)]
Reduce brush size (with Paint Tool selected)	[
Make brush softer	[+ Shift
Make brush harder] + Shift
Change opacity of brush in 10% increments (with Brush Tool selected)	Press number keys 0–9
Fill with foreground color	⌥/Alt ⌫
Fill with background color	⌘/Ctrl ⌫

Adjustments

Levels	⌘/Ctrl + L
Curves	⌘/Ctrl + M
Hue/Saturation	⌘/Ctrl + U

Layers and masks

Add new layer	⇧ ⌘/Ctrl + N
Load selection from layer mask or channel	⌘/Ctrl + click thumbnail
Change opacity of active layer in 10% increments	Press number keys 0–9
Add layer mask – Hide All	⌥/Alt + click 'Add layer mask' icon
Move layer down/up	⌘/Ctrl + [or]
Stamp Visible	⌘/Ctrl + ⌥/Alt + ⇧ then type E
Group selected layers	⌘/Ctrl + G
Create Clipping Mask	⌘/Ctrl + ⌥/Alt + G
Disable/enable layer mask	⇧ + click layer mask thumbnail
Preview contents of layer mask	⌥/Alt + click layer mask thumbnail
Preview layer mask and image	⌥/Alt + ⇧ + click layer mask thumbnail
Group or clip layer	⌘/Ctrl + G
Blend modes	⌥/Alt + ⇧ + (N, K, M, G, S, O, F, Y, C) Normal, Darken, Multiply, Lighten, Screen, Overlay, Soft Light, Luminosity, Color

Crop

Enter crop	Return key
Cancel crop	Esc key
Constrain proportions of crop marquee	Hold ⇧ key
Turn off magnetic guides when cropping	Hold ⌥/Alt ⇧ keys + drag handle

Web Links

Information and blogs

Essential Skills	http://www.photoshopessentialskills.com
Photoshop Support	http://www.photoshopsupport.com
Adobe Digital Imaging	http://www.adobe.com/digitalimag/main.html
Martin Evening	http://www.martinevening.com
Luminous Landscape	http://www.luminous-landscape.com
Digital Photography Review	http://www.dpreview.com
Digital Dog	http://www.digitaldog.net
Epson	http://www.epson.com
Photoshop Blog	http://www.photoshopblog.net/
John Nack	http://blogs.adobe.com/jnack/
Photoshop News	http://www.photoshopnews.com/

Tutorials

Adobe	http://www.adobe.com/designcenter/
Essential Skills	http://www.photoshopessentialskills.com
Russell Brown	http://www.russellbrown.com
Photoshop Support	http://www.photoshopsupport.com
Planet Photoshop	http://www.planetphotoshop.com
Photoshop Workshop	http://www.psworkshop.net

Illustrators

iStockphoto	www.iStockphoto.com
Magdelena Bors	www.magdalenabors.com
Samantha Everton	www.samanthaeverton.com
Rory Gardiner	www.rorygardiner.com.au
Chis Mollison	www.chrismollison.com.au
Chris Neylon	www.chrisneylon.net
Serap Osman	www.seraposman.com.au
Rod Owen	www.owenphoto.com.au
Craig Shell	www.craigshell.com
Daniel Stainsby	www.danstainsby.com
Akane Utsunomiya	akane@antsushi.com
Victoria Verdon Roe	www.victoriaverdonroe.com

Index